ABOUT THE AUTHOR

LUC FERRY IS A professor of philosophy at the Sorbonne (University of Paris VII, Denis Diderot) and the internationally bestselling author of *A Brief History of Thought*. From 2002 to 2004 he served as French Minister for Education. He has won numerous awards, including the Prix Médicis, Prix Jean-Jacques Rousseau, and Prix Aujourd'hui, in addition to being an officer of the French Legion of Honor and a knight of the Order of Arts and Letters. He lives in Paris.

The WISDOM of the MYTHS

The
WISDOM
of the
MYTHS

HOW GREEK MYTHOLOGY CAN CHANGE YOUR LIFE

LUC FERRY

Translated by Theo Cuffe

HARPER PERENNIAL

NEW YORK • LONDON • TORONTO • SYDNEY • NEW DELHI • AUCKLAND

HARPER PERENNIAL

HarperCollins books may be purchased for educational, business, or sales promotional use. For information please e-mail the Special Markets Department at SPsales@harpercollins.com.

FIRST EDITION

Library of Congress Cataloging-in-Publication Data has been applied for.

ISBN 978-0-06-221545-1

14 15 16 17 18 OV/RRD 10 9 8 7 6 5 4 3 2 1

for Moune, one and only

CONTENTS

PROLOGUE

Greek Mythology: For Whom? For What?

LET US BEGIN WITH beginnings: What is the underlying purpose of the Greek myths, and why today—more than ever, perhaps—should we pay attention to them? I believe the answer lies in a single passage of what is perhaps the most celebrated work of ancient Greece, the *Odyssey* of Homer, in which we see clearly the extent to which mythology is not what we so often think of it as being: an accumulation of "tales and legends," a collection of anecdotes more or less fantastical, whose sole end is to amuse us. Far from being reducible to literary entertainment, mythology is at the core of ancient wisdom, the foundation for that great edifice of Greek philosophy that would subsequently sketch out, in conceptual form, the blueprint of a successful life for human kind, mortal as we are.

Let us allow ourselves to be carried along for a moment on the tide of Homer's story, whose broad outlines I recall here but which we shall have reason to revisit later on.

After ten long years of absence fighting the Trojans, Odysseus—Greek hero par excellence—has won the day by cunning, thanks, of course, to the famous wooden horse that he left so ambiguously on the beach, outside the city ramparts. It is the Trojans themselves who wheel it into their citadel, otherwise unassailable for the Greeks. They take it to be an offering to the gods, whereas it is a war machine whose

ribs are packed with soldiers. Night falls; the Greek warriors emerge from the belly of this imposing statue and proceed to massacre the sleeping Trojans, down to the last man, more or less. It is an appalling and merciless carnage—pillage so dreadful as to excite even the anger of the gods. But at least the war is now over. Odysseus can think of returning home, to his island, Ithaca; to his wife, Penelope; his son, Telemachus—in short, he can reassume his place in the family and at the heart of the kingdom. We observe, already, that before reaching its destination in this harmonious fashion, in peaceful reconciliation with things as they are, the existence of Odysseus—like that of the universe as a whole—begins in chaos. The terrible war in which he has taken part, which has forced him unwillingly to quit the "natural place" he occupied beside his loved ones, takes place under the auspices of Eris, goddess of strife and discord. It is on her account that enmity first took root between Greeks and Trojans—and it is in the perspective of this initial conflict* that the hero's itinerary must be placed, if we are to grasp its significance as wisdom literature.

The dispute erupts over a marriage: that of the future parents of Achilles,† himself a Greek hero and one of the major protagonists of the Trojan War. As in the tale of Sleeping Beauty, everyone has "forgotten" to invite the wicked stepmother—or rather Eris, who plays that role in this story. This is to say that they deliberately pass over her on this festive occasion: wherever she appears everything is sure to turn to gall; sooner or later, hatred and anger always man-

*To which Homer alludes, but which seems to have been mentioned first in a work composed prior to the *Iliad*: the lost "Cyprian verses." The story is repeatedly aired thereafter, not least in the fables attributed to Hyginus, a Roman grammarian and poet of Spanish origin who lived in the first century BC. It is Hyginus's account that I follow here.

†Namely Thetis, a sea goddess, and Peleus, the human ruler of a city in Thessaly.

age to prevail over love and joy. Naturally, Eris the uninvited turns up, intent on disturbing the proceedings. She comes fully armed—with an apple, which she casts onto the table where the newlyweds are feasting, surrounded for the occasion by the principal gods of Olympus. On this magnificent golden apple are inscribed the words "For the fairest!" As is to be expected, all of the women present exclaim in unison: "It's mine!"—and the conflict insinuates itself, slowly but surely, that will in due course spark the Trojan War.

And here is how.

Around the banquet table are seated three magnificent goddesses, all equally precious to Zeus, ruler of the gods. Firstly Hera (Juno, in Latin), his immortal wife, to whom he can refuse nothing. But also present are his favorite daughter, Athena (Minerva), and his aunt Aphrodite (Venus), goddess of love and of beauty. As is to be expected, Eris's plot works its course, and the three women all claim the golden apple. Zeus, as head of the family, refrains as far as possible from taking sides in the quarrel: he is well aware that, having to choose between his daughter, his wife, and his aunt, he would have no peace. . . . Moreover, he must act impartially, and whatever his choice, he will be accused of prejudice by those he rules against. So he sends his faithful messenger, Hermes (Mercury), to discreetly seek out some young innocent to adjudicate between the three beauties. At first sight the young man in question appears to be a Trojan shepherd—but is in reality none other than Paris, one of the sons of Priam, king of Troy. Paris was abandoned at birth because an oracle predicted that he would cause the destruction of his native city. But he was rescued in the nick of time, and his life saved by a shepherd. The latter took pity on this infant and raised him to be the handsome adolescent who now stands before them. So in the guise of a young peasant

there is concealed a Trojan prince. With the ingenuousness of youth, Paris accepts the role of judge.

Each of the women, to claim his attention and secure the famous "apple of discord," promises Paris something corresponding to what she is herself. Hera, who reigns by the side of Zeus over the greatest of empires—namely the entire universe—promises, if he chooses her, that he likewise will rule over all earthly lands and have preeminent wealth. Athena, goddess of intelligence, of the arts, and of warfare, promises that if she emerges victorious he will be conqueror in every battle. As for Aphrodite, she whispers to him that with her help he can seduce the most beautiful woman in the world. . . . Paris, of course, decides in favor of Aphrodite. And then discovers, to the misery of mortals everywhere, that the most beautiful woman in the world is in fact married to a Greek—not merely a Greek, but Menelaus, king of Sparta, the most warlike of all cities. She is called Helen, the famous "belle Hélène" to whom poets, composers, and chefs have continued to pay tribute down the ages. Eris has attained her objective: a Trojan prince, Paris, charmed by Aphrodite, abducts the beautiful Helen from Menelaus, and the inevitable war between Trojans and Greeks is unleashed a few years later. . . .

And poor Odysseus will be forced to play his part in it. The Greek kings—of whom Odysseus is one, since he rules over Ithaca—have in effect taken an oath to uphold the marriage rights of whoever marries Helen. Her beauty and charms are such, it is feared that jealousy on her account, fueled by hatred, will sow discord between the kings. They have therefore sworn allegiance to whomever Helen selects. Menelaus being the chosen one, all the others must, in the event of any betrayal, come to his assistance. Odysseus, whose wife, Penelope, has just given birth to little Telema-

chus, does all he can to avoid this war. He pretends to be demented, he plows his fields back to front, he sows pebbles instead of good grain—but his ruse fails to deceive the wise old sage who is dispatched to seek him out, and in the end Odysseus must resign himself to sailing with the others. For ten long years he is separated from his "natural place," from his world, from his home in the universe, from his loved ones—dedicated to conflict and discord rather than to harmony and peace. Once the war is over, he has but one idea in his head: he wants to get home. But his troubles are only beginning. His return voyage will last ten long years and will be full of pitfalls: almost insurmountable trials that suggest that an ordered existence, personal salvation, and the path to wisdom are not to be taken for granted in this world. We have to earn them, at the risk sometimes of life itself. It is at the very outset of his return voyage—his journey from war toward peace—that the episode that now concerns us takes place.

Odysseus and Calypso: a successful life on this earth is preferable to a wasted immortality . . .

Striving to reach Ithaca, Odysseus must stop off on the island of Calypso, who is a minor divinity but nonetheless ravishingly beautiful and endowed with supernatural powers. Calypso falls hopelessly in love with Odysseus. In short order she seduces him and makes up her mind to hold him captive. In Greek her name derives from the verb *calyptein*, "to hide." She is as beautiful as the day is long; her island is paradisal, lush, inhabited by creatures and fruit trees that provide exquisite nourishment. The climate is soft; the resident nymphs who take care of the two lovers are beautiful

and obliging. It would seem that the goddess holds all the cards. And yet Odysseus is drawn irresistibly toward his own corner of the world, toward Ithaca. He must at all costs return to his point of departure, and every evening he weeps as he looks out to sea, in despair of ever reaching it. But he fails to reckon on the intervention of Athena, who for her own reasons—which include jealousy that the Trojan Paris did not choose her—has been supporting the Greeks throughout the war. Seeing Odysseus in the grip of such torments, she asks her father Zeus to send Hermes, his messenger, to command Calypso to release him so that he may find his natural place and live in harmony, finally, with the cosmic order—of which the ruler of the gods is, after all, both author and guarantor.

But Calypso has one more trump up her sleeve. In a final desperate attempt to keep her lover she offers him the impossible, as far as any human life is concerned: the chance to escape death—the common lot of mortals—and to enter the inaccessible sphere of those whom the Greeks refer to as "the blessed," which is to say the gods themselves. For good measure, she enhances her proposal with a far from negligible bonus: if Odysseus says yes, he will be forever endowed not only with immortality but also with the beauty and strength that are the exclusive attributes of youth. This additional clause is both important and amusing. If Calypso specifies youth as well as immortality, it is because she is remembering a slightly awkward precedent:* one that involved another goddess, Aurora, who also fell in love with an ordinary mortal, a Trojan by the name of Tithonus. Like Calypso, Aurora wanted to make her lover immortal so as never

*Recounted in one of the Homeric Hymns, mistakenly attributed by tradition to Homer.

to be separated from him. She begged Zeus, who granted her wish, but she forgot to ask him to confer youth as well as immortality upon her beloved. The result: over the course of time the unfortunate Tithonus cruelly wasted away and shriveled up until he became a desiccated husk, a sort of revolting insect that Aurora finally abandoned in a corner of her palace before deciding to transform him into a cicada so as to rid herself of him completely. This is why Calypso's request is so specific. She loves Odysseus enough not to want him either to die or to grow old. The conflict between love and death, as in all the great stories of salvation or of wisdom, is at the heart of our story. . . .

The proposition that Calypso dangles before Odysseus is irresistible, as is she herself, as is her island—an unprecedented offer for any mortal. To all of which, almost incomprehensibly, Odysseus remains unmoved. As unhappy as ever, he declines the goddess's uniquely tempting proposition. Let us be quite clear from the start: the refusal is of epochal significance. It contains *in nucleo* what is undoubtedly the most powerful and profound lesson of Greek mythology, which will subsequently be adopted by Greek philosophy* for its own purposes, and which can be summarized as follows: the ultimate end of human existence is not, as the Christians (further down the line) would come to believe, to secure eternal salvation by all available means, including the most morally submissive and tedious, to attain immortality. On the contrary, a mortal life well lived is worth far more than a wasted immortality! In other words, the conviction

*Or at least the branch of philosophy that is concerned with wisdom, and that extends from Parmenides to the Stoics via Plato and Aristotle. As with all interpreters of Greek thought, I distinguish this tradition from another, which could be described as already "deconstructive," and which exists in a "countercultural" relation to the first: a lineage that essentially passes through the Atomists, the Epicureans, and the Sophists.

of Odysseus is that the "diasporic" or displaced life—the life lived far from home, and therefore without structure, outside of ones's natural orbit, in the wrong part of the cosmos—is quite simply worse than death itself.

What Odysseus's refusal contains in a nutshell is a definition of the life well lived—from which we begin to glimpse the philosophical dimension of the myth. Following Odysseus, we must learn to prefer a condition of mortality in accord with cosmic dispensation, as against an immortal life doomed to what the Greeks termed *hybris* (pronounced "hubris"): the immoderation that estranges us from reconciliation to, and acceptance of, the world as it is. We must live in a state of lucidity, accepting death, accepting what we are and what is beyond us, in step with our people and with the universe. This is worth far more than immortality in a vacuum, denuded of meaning, however paradisal—with a woman we do not love, however perfect she may be, far from our own kind and from our hearth, in an isolation symbolized not only by Calypso's island itself, but also by the temptations of deification and eternity that estrange us in equal measure from what we are and from what surrounds us. . . . It is an inestimable lesson in wisdom for a secular age such as ours today—a lesson that breaks step with the logic of monotheisms past and future, and that philosophy will translate into the language of reason, with its doctrines of salvation without a God, and of the good life for ordinary mortals such as we are.

Clearly we must investigate further the motives for Odysseus's refusal. We shall see, throughout this book, how the major Greek myths illustrate, develop, and confirm, each after its fashion, the sovereign truth of this refusal, and furnish philosophy with the basis for its future development.

But let us first draw some conclusions from this initial engagement with Greek myth before stating the premises of our investigation as a whole. As a starting point, can we explain how a group of myths invented more than three thousand years ago, in a language and culture with almost no connection to those in which we are immersed today, can nevertheless speak to us with such force and intimacy? Each year, throughout the world, dozens of new books on Greek mythology are published. For a long time, films, animated cartoons, and TV series have routinely raided classical culture for the plots of their screenplays. All of us have at some point encountered the labors of Heracles, the travels of Odysseus, the loves of Zeus, or the war of Troy. I think there are two sets of explanations for this: cultural explanations, naturally, but also and even to a greater degree philosophical explanations, which I would like to raise in this prologue. In this respect, the present work can be seen as directly extending the investigation opened by my earlier *A Brief History of Thought* (volume one of *Learning to Live*).[*] I have tried to retell, in the simplest and liveliest terms, the principal stories of Greek mythology. But I have done so within a particular philosophical perspective, about which I should say a few words. In attempting to bring out the lessons in wisdom concealed within these narratives, I will try to explore the continued relevance of the myriad stories and anecdotes usually grouped together, in more or less jumbled fashion, under the name of "mythology." In order to better

[*]These two volumes will be followed by three more: on ancient sages and Christian thinkers (volume three), on the foundations of humanism (four), and on the birth of contemporary philosophy (five). The first volume of *Learning to Live* therefore constitutes the general outline of a larger project attempting a wider exploration of philosophy and its major historical trends, in order to explore current developments.

isolate what speaks to us so immediately in these tales of time past, I would like to suggest first of all what our culture owes to them.

<div align="center">In the name of culture: why we,
too, are ancient Greeks . . .</div>

Let us begin with our broad cultural inheritance of Greek myths.

Consider for a moment that many everyday images, figures of speech, and expressions are directly borrowed without our knowing their meaning or origin. Some commonplaces bear the memory trace of a mythical or fabulous episode, usually the crisis point in the adventures of a god or hero: to go off in search of the "Golden Fleece"; to "take the bull by the horns"; to "fall between Scylla and Charybdis"; to introduce a "Trojan horse" to our enemies; to cleanse the "Augean stables"; to follow "Ariadne's thread"; to have an "Achilles' heel"; to feel nostalgia for a "golden age"; to place our efforts under the shield, or "aegis," of someone; to look up at the "Milky Way"; to take part in the "Olympic" Games. . . . Other usages, more numerous still, allude to the dominant trait of a personality, the name for which is familiar to us often without our understanding the reason, nor the role it originally played in the Greek imagination: to describe an utterance as "sibylline"; to be confronted with an "apple of discord"; to play at "Cassandra"; to have (like Telemachus in the *Odyssey*) a "mentor"; to sink into the "arms of Morpheus" or to take "morphine"; to be blessed—or cursed— with a "Midas touch"; to lose oneself in a "labyrinth" of alleyways; to have a "*sosie*," or double (named after the ser-

vant of Amphitryon whose appearance was borrowed by
Hermes when Zeus descended to seduce Alcmena); to be
endowed with "titanic" or "Herculean" strength; to suffer
the "torments of Tantalus"; to be stretched on a "Procrus-
tean bed"; to be a "Pygmalion," in love with his creation,
or a "sybarite" (like the effeminately luxurious inhabitants
of the city of Sybaris); to consult an "atlas"; to swear "like
a carter";* to embark on a "Promethean" undertaking, or
upon an endless task akin to pushing a "Sisyphean" boulder;
to pass a ferocious concierge or "Cerberus" on the stairs; to
speak with a "stentorian" voice; to cut the "Gordian" knot,
or ride "Amazon"-style; to imagine "chimeras"; to be petri-
fied, as if by a "Medusa"; to spring fully formed as if "from
the head of Zeus"; to be chased by a "Harpy" or "Fury"; to
give way to "panic"; to open unwittingly a "Pandora's box"
of troubles; to have an "Oedipus complex"; to be a "narcis-
sist." . . . The list could be extended indefinitely. In the same
fashion, are we sufficiently aware in our everyday usage that
a hermaphrodite is literally the offspring of Hermes (mes-
senger of the gods) and Aphrodite (goddess of love)? Or that
"gorgon" refers to a plant that looks petrified, as if it has
met the gaze of Medusa; that "museum" and "music" derive
from the nine sacred Muses; that a lynx supposedly derives

*The origin of this expression, perhaps less familiar than the others, is entertain-
ing. I often wondered why—all things considered—a carter should be thought
of as swearing more than a plowman or a blacksmith. The answer derives from
an episode in one of the twelve labors of Heracles, for which Apollodorus is our
main source (*The Library*, Book II, 118): "After passing through Asia, Heracles
put in at Thermydrai, the harbour of Lindos. After releasing one of the bullocks
from the cart of a cowherd, he sacrificed it and feasted on its flesh. The carter,
unable to defend himself, stood on a certain mountain and cursed Heracles;
(because of which, even to this day, when they sacrifice to Heracles they do
so to the accompaniment of curses)." The unfortunate carter who went up the
mountain was unwilling to provoke the anger of that other mountain, made of
muscle, namely Heracles himself!

its keen sight from Lynceus, the Argonaut of whom it was said that he could see through an oak plank; that Echo, the nymph, still makes us hear her desolate cry at the loss of Narcissus, so long after her own disappearance; that the laurel is a tree sacred to the memory of Daphne, and the cypress, which can be found in so many Mediterranean cemeteries, is a symbol of mourning that remembers the unfortunate Cyparissus, who accidentally killed his companion—a tamed stag—as it lay sleeping in the woods, and whose grief was such that it transformed him into a cypress tree? . . . Numerous expressions likewise recall the famous sites of mythology: the Champs Elysées (Elysian Fields) or, more remotely, the Bosphorus, which literally means "river passage" for oxen (*bous*, βοῦς, "ox" + *poros*, πόρος, "means of fording a river, ferry")—but which is in fact a recollection of Io, the little nymph whom Hera pursued with her jealous hatred after her illustrious husband, Zeus, transformed his mistress into a charming heifer, to protect her from the wrath of his wife. . . .

In effect, we would need an entire book to do justice to all the mythological allusions embedded and then forgotten inside everyday language: to restore life to names such as Ocean, Triton, Python, and the other marvelous beings who inhabit our everyday language incognito. Charles Perelman, one of the greatest linguists of the last century, put it nicely when he spoke of the "sleeping metaphors" in our mother tongues. What Englishman still remembers that "lunatic" means moonstruck—and what Frenchman remembers as he grumbles about his mislaid *lunettes* (spectacles) that he is searching for "little moons"? One needs to be a foreigner to see these concealed features of a particular language, which is why a Japanese or an Indian often finds poetry in a term or a formula that seem to us perfectly ordinary—just as we

find the transliteration of the names they give their children charming or droll: Rose-Pearl, Brave Bear, Morning Sunshine. One of the aims of the present book is to "awaken" the sleeping metaphors deriving from Greek mythology, by retelling the uncanny stories that constitute their point of origin—if only for cultural reasons, so as to understand the countless legions of works of art and literature that line our museums and libraries, drawing their inspiration from these antique roots, and that remain entirely "hermetic" (another recollection of the god Hermes!) to those unacquainted with mythology. It is worth taking the trouble and, as we shall see, deriving the pleasure.

The extraordinary linguistic afterlife of classical mythology is clearly of significance. There are deep-seated reasons for this singular phenomenon—no philosophical system, no world religion, not even the Bible, can claim equivalent importance—whereby the canon of classical mythology, even where there is complete ignorance of its real sources, can claim so unshakeable a presence in our common culture. No doubt this is due in the first place to the fact that it proceeds from concrete stories rather than, as with philosophy, from abstract concepts. This is why mythology can, even today, address everybody: inspiring children with as much fervor as adults, crossing not only social class and age (if conveyed sensibly) but also traversing the generations, even to the present day—as it has done virtually without interruption for nearly three millennia. Although it was for a long time thought of as a mark of "distinction," as a symbol of the highest culture, the study of mythology is by no means confined to an elite, or restricted to those whose study is Latin and Greek: like the historian Jean-Pierre Vernant, who enjoyed telling his grandson these stories, everyone can understand them, including children—who should ideally

be introduced to them as early as possible. Not only does mythology bring them infinitely more than the animated cartoons they are routinely force-fed, it also profoundly illuminates their lives to come, provided that we give ourselves the trouble to understand the prodigious richness of these myths sufficiently to be able to communicate it in terms that are practical and intelligible.

And here we broach one of the purposes of this book: to make classical mythology sufficiently accessible to parents so that they can in turn pass on its riches—without, however, betraying or misrepresenting the ancient texts from which these stories are drawn. This point is crucial, and I would like to dwell upon it briefly.

In its aims and procedures, the present work bears no relation to the genre of popularization or "retellings" that are usually brought together in collections of "myths and legends," in themselves perfectly enjoyable. Generally speaking, because these are intended for children as well as for a wide readership, the authors cheerfully mix together all of the heterogeneous layers and accretions that have, over the course of time, accumulated around what is thought of as "the" myth in question. In most cases these disparate sources of conflicting authority are scrambled and "arranged" selectively for the needs of the moment. The origin and significance of the great mythic narratives are thus clouded, even falsified, to the point that they end up reduced in our memories to a collection of more or less credible anecdotes, to be placed somewhere between fairy tales and the superstitions inherited from primitive religion. Worse still, their coherence is lost beneath the ornamental frills, accretions, and errors with which modern authors cannot resist embellishing these ancient stories.

In effect, we need to remember that this or that "myth" is by no means the work of a single author. There is no original version, no canonical or sacred text comparable to the Bible or the Koran, piously preserved through the ages, thereafter carrying authority. On the contrary, we are dealing with a plurality of stories and variants, written down by storytellers, philosophers, poets, and "mythographers" (such is the term for those who assembled, collated, and edited the various compilations of myths from antiquity onward) over the course of twelve centuries or more: roughly from the seventh century BC to the fifth century AD—not to mention the various oral traditions, of which, by definition, we know comparatively little.

This diversity cannot be reduced, or dismissed on the grounds that we are not engaged in producing a work of academic authority. Although I do not address specialists in these pages but readers of all backgrounds, I try to avoid muddle and attempt to reconcile what erudition teaches and what a readership imposes without sacrificing the first to the needs of the second. In other words, for each of the myths I indicate the original sources, quote from the most authoritative texts where possible, and specify where relevant the principal variants that emerged over the course of time. My claim is that, far from compromising the intelligibility of these stories, a respect for the ancient texts—their complexity and heterogeneity—is on the contrary the necessary condition for understanding the myths. To trace the different inflections that a tragedian like Aeschylus (sixth century BC) or a philosopher like Plato (fourth century BC) brought to the myth of Prometheus, as originally told by the poet Hesiod (seventh century BC), is to be enlightened rather than led astray. Far from obscuring these narratives,

the process enriches our understanding of them. It would be absurd to deprive the reader of these clues to reading on the grounds of seeking to make the subject more accessible: the successive recastings of the myths serve only to make them more interesting.

The significance of classical mythology is not restricted to questions of linguistic and cultural heritage. Nor does it depend solely on the narrative qualities of the stories alone to deliver its lessons. This book does not restrict itself therefore to offering a set of narrative keys to what the Greeks would have called the "commonplaces" of the culture—not that such a guide is in any way negligible or to be dismissed. After all, it is with these stories that each of us starts, and from which we partially form our picture of the world and of man's place in it; to know our origins can only make us freer and more aware of ourselves. But beyond their inestimable historical and aesthetic significance, the stories we are going to discover or rediscover carry within themselves lessons in wisdom, of a philosophical profundity and actuality that I would like us to engage with from the outset.

In the name of philosophy: mythology as a response to our questions, as mortals, concerning the good life

Hundreds if not thousands of books and articles have been devoted to pondering the status of Greek myth: Should it be classified under "tales and legends," or filed under religion, or placed alongside literature and poetry, or perhaps on the same shelves as politics and sociology? The answer that the present book offers is quite simple. Classical myth is central to an entire civilization and polytheist religion, but is above all a philosophy in "story form": a magnificent and

concerted attempt to respond in *secular* form* to the question
of the good life by means of lessons in wisdom that breathe
and live—are clothed in literature, in poetry and epic—
rather than formulated in abstract argument. To my mind,
it is this essentially vernacular, poetic, and philosophical cast
of Greek myth that accounts for its continuing vitality and
involvement for us today—and what renders it singular and
precious in comparison with the legions of other myths,
fairy tales, and legends that, from a strictly literary point of
view, might seem to offer competition. I would like to dwell
briefly on this aspect, but sufficiently to make clear the orga-
nization of this book and the project that informs it.

In *A Brief History of Thought* (the first volume of *Learning
to Live*), I proposed a definition of philosophy that takes ac-
count of what philosophy has been and should, in my view,
still be in our time: a doctrine of salvation without a God,
and a response to the question of what constitutes a good life,
that relies neither upon some "supreme being" nor upon reli-
gious belief as such, but upon its own resources of reflection
and reason. An effort of lucidity as the ultimate condition
of serenity, understood in its simplest and strongest sense: as
a victory—no doubt relative and fragile—over our fears, in
particular the fear of death, which so insidiously and under
so many forms prevents us from living a full life. I tried also
to give both an idea of the major interventions or high points
that have shaped the history of philosophy, and an insight
into the responses over the course of time to what is, after all,
the central investigation of philosophy: that of wisdom itself,

*The adjective "secular" may seem surprising, given the quantity of gods and
goddesses in classical mythology. It is nonetheless justified by the fact that Greek
wisdom, as embodied by the major myths, accepts death as a nonnegotiable fact
of the human condition, so that these gods have none of the consolatory and
salvational function that they represent in the great monotheist religions: with
very rare exceptions, the Greek gods leave mortals to get on with their mortality.

as a state of being where the fight against our fears allows humans to be freer and more open to experience, to think for themselves and to live for others. It is within this same perspective that I now approach mythology: as a prehistory of philosophy, its moment of origin, or, put differently, as the matrix that alone explains the birth of philosophy in Greece in the sixth century BC—a cataclysmic event that we are in the habit of referring to as the "Greek miracle."

From this point of view, mythology delivers messages of astonishing profundity, perspectives that open up to mortals the vista of a good life without recourse to the illusions of a hereafter, affording us a means of confronting human mortality, of facing up to our destiny without dosing ourselves with the consolations that the great monotheistic religions claim to bring to mankind. In these terms—as drawn up in *A Brief History of Thought*—mythology traces, for the first time perhaps in the history of humanity, or at least in the West, the lineaments of what I have called a "doctrine of salvation without a god," a "secular spirituality," or, to put matters even more simply, a "wisdom for mortals." It therefore represents a uniquely important endeavor to assist mankind in "saving" itself from the fears and terrors that prevent us from acceding to the good life.

This notion may seem paradoxical: Are the Greek myths not populated by an innumerable crowd of gods, starting with those who sit in session on Olympus? Are these not, first and foremost, "religious" deities? Yes, clearly, on first inspection. But if we go beyond appearances, we soon realize that this plurality of gods is poles apart from the one unique God of our various religions of the Bible. Apparently closer to mortals, and more closely entangled with them, the Olympians are at the same time utterly inaccessible: they leave mankind alone to resolve, in lay terms, the question

of "how to live"—in stark contrast to the Immortals themselves, and with no hope of joining their ranks, but with full knowledge of the limits to their own mortal condition, which they must try to make sense of as best they can. In this respect the Greek attitude is more contemporary than ever before. And it is this that I would like to clarify, in my prologue, so that the individual stories that we shall follow in the course of this book do not seem a mere patchwork of anecdotes stripped of any common theme—but on the contrary are seen as stories full of meaning and, beyond their poetic lightness, the bearers of a profound and coherent body of wisdom.

To properly understand this axis between mythology and philosophy, and to measure the significance and reach of the lessons for living that they afford—each after its fashion, but interconnectedly so—we must start from the primary fact that, for the Greeks, the world of living beings, of individuals, divides first and foremost between mortals and Immortals, between men and gods.

This may seem self-evident, but on reflection it becomes clearer that the centrality of death—its place at the heart of the entire narrative enterprise—is far from casual. The fundamental characteristic of the gods is that they escape death: once born (since they have not always existed), they live forever and are cognizant of this fact. They are, according to the Greeks, "blessed." Of course, they experience adversity from time to time, like poor Hephaestus (Vulcan), for example, who discovers that his wife, the divine Aphrodite—goddess of beauty and of love—is deceiving him with his fellow god the fearful Ares (Mars). The blessed are, at least some of the time, fairly miserable! They suffer like mortals, and they feel unmistakably mortal passions—love, jealousy, anger, hatred. . . . On occasion they even tell lies and are

punished for it by their overlord, Zeus. But there is one tor-ment of which they are ignorant, and it is without doubt the most grievous of all: namely those emotions linked to the fear of death. For the gods, time does not count, so to speak; therefore nothing is definitive, or irreversible, or irremedi-ably lost. And this allows them both to endure and witness human passions with a superiority and from a vantage to which mortals cannot aspire. In their sphere, everything is sorted out and settled sooner or later. . . .

Our principal characteristic as mere mortals is quite the reverse. Contrary to the gods and the beasts, we are the only sentient beings in this world to have full consciousness of what is irreversible: the fact that we are going to die. Not only we ourselves, but also those we love: our parents, brothers and sisters, wives and husbands, children, friends. Unremittingly, we feel the passage of time. This, no doubt, sometimes brings us happiness—the proof of which is that we love life—but also remorselessly takes away from us all that we cherish most. And we are quite alone in this predicament, alone to per-ceive with unparalleled sharpness that there is in our lives—aside from the ultimate endgame, properly speaking, of death itself—the irreparable experience of "never again." The gods experience nothing of this for the simple reason that they are immortal. As for the animals, so far as we can tell, they barely give thought to these matters; or if they experience a glimmering awareness, it is no doubt in confused fashion and only when their end is very close. On the contrary, humans resemble Prometheus, one of the central figures of classical myth: they think "ahead"; they are "creatures of distance." They are constantly scanning the future and pondering it. And because they know that life is short and their time is al-lotted in advance, they cannot prevent themselves from ask-ing how they are to make use of it. . . .

Hannah Arendt explains, in one of her books, how Greek culture fastened upon this awareness of death as its central concern and how it concluded that there are two ways of confronting the questions raised by mortality, if we are to frame an adequate response.

In the first place we can, quite simply, choose to have children or—as we say—"descendants." But how does this relate to the yearning for immortality, awakened in us by the contrast between our certainty of death and our delight in life? Quite straightforwardly, it seems, in the sense that, through our children, something of us will survive our own demise, physically as well as spiritually: our facial features or physical resemblances, just like our traits of character, are preserved more or less intact in those we have raised and loved. So, too, education is always a handing on, and all transmission is in some sense the prolonging of a self beyond ourselves, of something that does not die with us. Nevertheless, whatever the magnanimity and the joys—the anxieties, too—of parenthood, it would be absurd to pretend that it suffices to have children for us to attain the happy life! Even less that it cancels the fear of death. Quite the contrary. For this mortal anguish does not necessarily or even centrally relate to one's own self. More frequently it concerns those we love, beginning (naturally enough) with our children—as witness the desperate efforts of Thetis, mother of Achilles, one of the great heroes of the Trojan War, to make her son immortal by plunging him into the unearthly waters of the Styx, river of the underworld. In vain, because Achilles will be killed by the Trojan Paris, struck by an arrow in the celebrated heel by which his mother held him when she plunged him into the divine water and which consequently remained mortally vulnerable: the Achilles' heel of Achilles. And Thetis, like all mothers, sheds bitter tears when she learns of the death of her

beloved son, whose heroic feats she had always feared would bring him to an early grave. . . .

An alternative strategy was therefore needed, one that Hannah Arendt shows as coming to occupy a central position in Greek culture: namely heroism, and the glory it procures. Here is the logic concealed behind this remarkable and singular conviction: the hero—Achilles, Odysseus, Heracles, Jason—is one who accomplishes feats unthinkable for ordinary mortals, and who by doing so escapes the oblivion that ordinarily engulfs all mortals. He snatches himself from the world of contingency, which has but one temporal dimension, so as to enter into a sort of perenniality, if not eternity, which in a sense allies him with the gods themselves. Let us be clear: heroic glory, in Greek culture, has nothing in common with what we would today call stardom. It is something else entirely, and profoundly so, deriving from the conviction that pervades the whole of antiquity, according to which humans are in perpetual competition, not merely with the immortality of the gods but also with the immortality of nature itself. Let us try to sum up in few words the reasoning that underlies this crucial assumption.

First, we must remember that, in classical mythology, nature and the gods were originally one and the same. Gaia, for example, is not simply the goddess of the earth, nor Uranus merely the god of the sky, nor Poseidon the god of the sea: they *are* respectively the earth, the sky, and the sea—and it was evident to the Greeks that these primal natural elements are eternal in the same sense as the gods who personify them. This perenniality of the natural order is, moreover, self-evident, experimentally verifiable. How do we know it? In the first instance, by simple observation. Everything in nature is, eventually, cyclical. Day follows night, and night

follows day; fine weather succeeds a storm, as summer succeeds spring and autumn yields to winter. Each year the trees lose their leaves with the first frosts, and each year they return with the sun, so that the principal events that punctuate the natural order remember themselves to us, so to speak. Put even more simply: there is no possibility of our forgetting them, and if such an eventuality arose, they would in both senses "return" to us. On the other hand, in the human world, everything passes; all is perishable and ends by being swept away by death and oblivion—the words we utter as much as the actions we accomplish. Nothing remains of it all . . . except writing! Indeed so! The written word preserves better than the spoken word, better than deeds or heroic "gests" themselves. And if, by virtue of his actions and the glory they procure him, a mortal hero— Achilles, Heracles, Odysseus—succeeds in becoming the principal subject of a work of history or epic, then he shall in some sense survive his own death, if only in our collective memory. The proof? One might answer that even today films are being made about the Trojan War or the labors of Hercules, or that most evenings some of us at least are describing to our children the exploits of Achilles, or Jason, or Odysseus—and all because a clutch of poets and philosophers, many centuries before Christ, *committed these exploits to writing.* . . .

Nonetheless, despite the force of conviction underlying this apologia for the glory that is made permanent by the written word, the question of salvation in the literal sense— what will save us from death, or, at least, from the fears associated with death—is not yet quite settled.

I recalled the name of Achilles just now, and some would say that in this sense he is not dead. In our memory, at least. But in reality? Go and ask his mother, Thetis, for her view

of the matter! Of course, that is a way of speaking because these characters are not real in the first place—rather they are legendary. But let us imagine the situation: I am sure that Thetis would give all the books ever written, and all the glorious actions in the world, merely to be able to hold her little son in her arms again. For her there can be no doubt: her son is well and truly dead, and the fact that he is "preserved" in written form, on the shelves of libraries, is assuredly small consolation. And Achilles himself, what would he say? If we are to believe Homer, it would seem that in Achilles's eyes a glorious death in the course of heroic combat was hardly worth the bother. . . . That at least is what one astonishing passage in the *Odyssey* tells us. Let us stay for a moment with this episode, which is of the greatest significance for the question of salvation and the closely related question of what constitutes the good life, defined as a mortal life "saved" from the fear of death. In effect, we shall see how this brief passage in the *Odyssey* also illuminates the world of classical mythology as a whole.

Here it is: on the enlightened advice of Circe, the sorceress, and thanks to her divine intervention, Odysseus is granted the privilege unique among mortals of descending to the underworld, to the realm of Hades and his wife Persephone (adored daughter of Demeter, goddess of crops and seasons), in order to consult a celebrated soothsayer named Tiresias about the trials that await him during the rest of his voyage home. And in this place—to which unfortunate humans repair after their deaths, this sinister region where they are reduced to unrecognizable and desolate shades—Odysseus comes across the valiant Achilles, at whose side he had fought during the Trojan War. Overjoyed to find his comrade, he addresses him in these optimistic terms:

"Time was, when you were alive, we Argive [Greek] warriors honoured you as a god: and now, down here, I see that you lord it over the dead in all your power. So grieve no more at dying, great Achilles!"

Odysseus here expresses the idea, which I have just expounded, that animates Greek heroism: that notion of a saving glory of which Hannah Arendt wrote. Even if he dies young, the hero who has been singled out by renown—rescued from anonymity and transformed into a quasi-god—can never be unhappy. Why not? Because he cannot be forgotten, precisely—he escapes the dreadful fate of *common* mortals, who, once dead, become (once more) "nameless," and therefore lose, as well as life itself, every marker of individuality or, in the proper sense, of personality. Unfortunately, however, the response of Achilles annihilates all illusions attaching to the idea of glory:

"None of your fine words about death to *me*, shining Odysseus! I'd rather be a slave on earth, looking after the cows for some dirt-poor tenant farmer who scrapes a living, than rule down here over all the breathless dead!"

All of which is a cold shower for his friend Odysseus! In two sentences, the myth of the death-conquering hero is exploded. And the only thing that remains of interest to Achilles in the underworld is to have news of his father and, more intently, of his son, about whom he worries. And as the news is very good, he fades back into the sinister shadows of the underworld with a heart that is a little less burdened, just like any father of a family stuck in everyday concerns—the diametrical opposite of the extraordinary and dazzling hero that was Achilles in life. In other words, he is perfectly indifferent to his former glory and splendor. . . .

Mythic wisdom—or why the good life is lived in harmony with the order of things

From this arises in turn the fundamental question, the one to which we must find an answer if we are to grasp both the philosophical import and the deepest unifying thread of Greek myth. If progeny and heroism—descendants and earthly renown—do not enable us to confront death with a greater degree of serenity, if these attributes afford no true access to the good life, toward what source of wisdom then can we turn? This is indeed the central issue, and one that mythology would indirectly bequeath to Greek philosophy. In many respects, the latter was—in its origins, at least—simply a continuation by other means (the claims of reason, rather than myth) of the first.

Philosophy likewise forged an indissoluble link between notions of the "good life," a life of wisdom, and that of a human existence reconciled to the universe, or to what Greeks called the "cosmos." A life lived in harmony with the cosmos—this is true wisdom, the authentic road to salvation, in the sense of saving us from our fears and making us thereby happier and more open to others. It was this powerful conviction above all others that Greek mythology was to express, in its mythic and poetic fashion, before philosophy stepped forward to reformulate it in conceptual and discursive terms.

As I explained in *A Brief History of Thought* (which is why I refer to it only briefly in these pages, merely to clarify the axis of influence between myth and philosophy), the Greek philosophical tradition thought of the world as, first and foremost, an overarching order: at once harmonious, just, beautiful, and good. The word "cosmos" connotes all of this. For the Stoics, for example, to whom the Latin poet

Ovid defers in his *Metamorphoses*—when reinterpreting after his fashion the great myths dealing with the origins of the world—the universe resembles a magnificent living organism. If we want to get an idea of this, we might think of what doctors or physiologists or biologists discover when they dissect a rabbit or a mouse. What do they find? Firstly, that each organ is marvelously adapted to its function: What is better constructed than an eye for seeing, than lungs for oxygenating the muscles, than a heart for pumping blood via an irrigation system? These organs are a thousand times more ingenious, more harmonious and complex, than almost all of the machines devised by man. Moreover, our biologist discovers something else: that the ensemble of these organs, which considered individually are sufficiently astonishing, together form a quite perfect and "logical" whole—what the Stoics indeed named the *logos*, to refer to the coherent ordering of the world as well as to verbal discourse—and a whole that is infinitely superior again to any human invention. From this point of view, we must humbly acknowledge that the creation of even the humblest being—a tiny ant, a mouse, or a frog—is still far beyond the reach of our most sophisticated scientific laboratories. . . .

The fundamental idea, then, is that within the cosmic order that philosophical inquiry would subsequently explore—the order established by Zeus (according to the inaugural mythological narratives) after a series of wars against the forces of chaos—each of us has his appointed or "natural" place. In this perspective, wisdom and justice consist fundamentally in the effort by humans to find this place. A lute maker adjusts one by one the multiple pieces of wood that constitute his instrument before they can enter into harmony with each other (and if the sound post of the instrument, sometimes referred to as the *âme*, or "soul"—the

small dowel of white wood that spans the top and back plates of the lute—is badly positioned, then the latter will cease to sound properly, will fail to be harmonious). So, too, we humans must, in the image of Odysseus of Ithaca, find our place in life and occupy it under pain of not otherwise being able to accomplish our mission in the scheme of things, in which event we shall encounter nothing but unhappiness. This is indeed the message that Greek philosophy, for the most part, was to draw from the mythological past.

But what connection does this have to the cardinal separation between mortals and Immortals? And how can this vision of the cosmos help us to measure up to the question of salvation? And why should this solution seem superior to that which rested on the notion of descendants or earthly glory?

Behind this will to adjust the self to the world and find our rightful place within the cosmic order, there is concealed a more recondite thought that connects directly back to our questioning of the meaning of mortal life for those who know they are going to die. The burden of the entire philosophical tradition inherited from mythology leads to the realization, in effect, that the cosmos—the order that Zeus created and that philosophy will attempt to reveal to us so that we can find our place in it—is itself *eternal*. What is the significance of this? one might ask. Well, it mattered to the Greeks for a reason that can be stated in approximate and simplified form as follows: *once inserted into the cosmos, once his individual life is set going in harmony with the cosmic order, the wise man understands that we simple mortals are merely a fragment of this whole, an atom of eternity, so to speak, one element of a totality that cannot disappear. So that, ultimately, for the sage, death ceases to be truly real. In a nutshell, death is but a passage from one state to another—and, considered as such, it should no longer hold*

any terrors for us. Whence the fact that Greek philosophers recommended their disciples not to rely on words, not to content themselves with pure abstractions, but concretely to practice exercises with a view to aiding others to emancipate themselves from their absurd death-induced terrors so as to live "in harmony with the greater harmony," in accord with the cosmos.

The above is, needless to say, merely an abstract and, so to speak, skeletal summary of this ancient insight into the nature of things. In actual human terms, the work of adjustment to the world takes many forms. It is, as we shall see in respect to Odysseus and his voyage, a singular task in all senses of the term: a task out of the ordinary—only those who aspire to wisdom can embark upon it; the ordinary run of mortals will, in effect, remain in ignorance. But it is also a "singular" undertaking in the sense that each of us needs to approach it on our own account and after our own fashion. It is easy to hire someone else to do work for us—someone to clean, someone to tend the garden—but no one can take our place along that road that leads to the conquest of our fears, so that we can adapt to the world and find our right place in it. The ultimate end, in general terms, is indeed harmony, but each individual must find his particular way of achieving it: finding one's own path, which is not the path of others, may become the task of a lifetime.

Five fundamental questions that underlie Greek myth

It is within this perspective that I would like to reinterpret and retell the stories of classical mythology in these pages. I see in myth, first of all, a prehistory of philosophy, whose study is indispensable for any understanding, not only of the origins

of philosophy but also of its deeper purpose. But beyond this theoretical or intellectual aspect, mythology—by its attempt to think through the human condition as such—furnishes lessons in wisdom that, just like Greek philosophy, speak to us still through the representation of the world and of our selves, to which they bear witness. Considered from this point of view, the major Greek myths seem to be animated fundamentally by five questions that we should keep in mind if we want to appreciate (beyond their beauty or singularity) the meaning of the individual stories that follow. These five pointers will in fact serve me as a thread and organizing principle so that my readers will not lose themselves in the detail.

The *first question* concerns, logically enough, the origin of the world (chapter one) and of humankind (chapter two), and the birth of this celebrated cosmos—to which mortals, from the moment of their first appearance, will be invited to discover their own way of attuning themselves. All of Greek mythology starts thus, with a narrative of the origins of the cosmos and of mortal life, expounded for the first time by Hesiod in the seventh century BC, in two seminal poems: *Theogony* (whose title in Greek signifies quite simply "The Birth of the Gods") and *Works and Days*. These works deal with the first coming-into-being of the world itself, of gods and men. Their narrative is very compressed, sometimes difficult to follow, and I shall attempt in these opening chapters to retell it as lucidly as possible because it is worth the effort: everything starts from Hesiod.

I ought here to make one point, so as to remove a misunderstanding still frequently encountered: contrary to an idea that was for a long time current but quite incorrect, this mythic account or reconstruction of origins, albeit abstract and often theoretical in its formulation, makes absolutely no claim to scientific truth. Despite what some

commentators still suggest today, it has nothing to do with a "first approach"—as yet naive and "primitive" (or even "magical")—to scientific questions that the irresistible "progress" of our positivistic science has allowed us to render harmlessly obsolete. On the contrary, mythology is by no means the infancy of humanity: it concedes nothing, for profundity and intelligence, to modern science, of which it is not a more or less rough approximation or trial run. It would, for example, be wholly absurd to try and compare the physics of Greek myth with what is taught today concerning the Big Bang and the first moments of the universe. Let us insist once more, since the scientific and progressivist vision is so entrenched in our thinking: the vision enshrined in Greek mythology is something quite other than the modern scientific spirit. It is in no sense the latter's primitive forerunner. Its concern is not objectivity, nor even knowledge of the real as such. Its true focus is other and elsewhere. Through a form of storytelling that is itself lost in the mists of time, and that, in truth, has no explanatory force in the senses understood by contemporary science, myth seeks to offer mortals the means to make sense of the world that surrounds them. Put differently, the universe is not considered here as an *object of knowledge* but as a *lived reality*—as the field of play, so to speak, in which human existence must find its proper position. Which is to say that the aim of these archaic narratives is not so much to arrive at a factual truth but rather to construct a possible sense for human life by inquiring as to what the successful human life might be within an ordered, harmonious, and justly ordained universe—such as that in which we find ourselves, and in which we are placed in order (precisely) to find our way. What is a good life, then, for those who know that they are going to die, and who seem uniquely

endowed to do ill and tragically to lose their way? What is a successful life for these ephemeral beings who—unlike trees or oysters or rabbits—possess a sharpened awareness of what philosophers would later term "finitude"? This is the only worthwhile question, the only question that in truth underlies these narratives of origin. Which is why they are so vested in constructing a "cosmos" in the victory of the forces of order over those of disorder—for it is in this cosmos, at the heart of this idea of order, that we will find our place, each after his fashion, if we are to achieve the good life.

This primordial narrative, as found in Hesiod, possesses from the start one very striking characteristic: it is told almost entirely from the viewpoint of the gods, or nature, which amounts to the same thing. The protagonists of this strange and magnificent story are in the first place superhuman forces, entities at once divine and natural: chaos, the earth, the ocean, the sky, the forests, the sun. And even when it describes the appearance of humanity, the story is told from the global perspective of the gods and of the universe.

However, once this structure has been created, we need to reverse the perspective completely and be led by a *second question* that, in truth, justifies the entire edifice: How are men going to insert themselves into this universe of gods that does not seem, in any a priori sense, to have been made for mankind? After all, we must remind ourselves that it was not gods but humans who invented and composed all of these stories! And if they did so, clearly it was to give a meaning to their lives, to situate themselves in meaningful relation to what surrounded them. This is not always easy, as witness the innumerable obstacles that punctuate the long voyage home of Odysseus (chapter three). In this respect, Odysseus furnishes the archetype of a quest that is ultimately

crowned with success, of the good life construed as the search (different and unique for each of us) for our place at the heart of a cosmic order constructed by the gods.

In truth, as we shall see in chapter one, these two questions are two paths that cross each other. There is in Greek myth a progressive humanizing of the gods, and equally a progressive divinizing of men, by which I mean that the very first gods are utterly impersonal: they are, like Chaos or Tartarus, abstract and faceless entities, without character or personality. They simply represent cosmic forces that evolve progressively, without any will, toward consciousness. But little by little, with the next generation of gods, the Olympians, we see characters appearing, personalities, specific functions. In other words, the gods are humanized, after a fashion: they are more aware, more intelligent, more distanced from brute nature, because the organization of a cosmos needs intelligence as well as brute power! Hera is the jealous wife, her husband Zeus is a skirt chaser, Hermes is a crook, Aphrodite knows all the tricks of love, Artemis is frigid, Athena absurdly oversensitive, Hephaestus somewhat simple when it comes to emotions but brilliant with his hands, and so on. In place of the power relations that govern all transactions between the first gods, there slowly evolves a logic that is more human, less governed by brute nature, more nuanced. Even if cosmology and the natural order still carry the day, psychology and a cultural order begin to occupy a larger place in the behavior of the gods. Parallel to this, the opposite tendency asserts itself in respect to primitive men: the more they reflect upon things, the more they come to understand that their deepest interest lies in adapting to this divine world that is the cosmic order. The humanizing of the divine is answered by a gradual divinizing of the human— never completed, of course, for we are and will remain

forever mortal, but that nonetheless shows the way forward, the task ahead: reconciliation to the world and to the gods will appear henceforth as an ideal of life. The whole sense of the voyage of Odysseus, which we shall trace or retrace in chapter three, starts here: the good life is the life reconciled to what is the case, the life lived in its natural place, within the cosmic order, and it behooves each of us to find this place and accomplish this voyage if we want one day to arrive in the harbor of wisdom, of serenity.

Nietzsche was to reiterate this, long after the Greeks—which proves in passing that their message preserves an actuality such as can still be found in modern philosophy: the ultimate end of human life is what Nietzsche calls *amor fati*, or "love of one's fate." To embrace everything that is the case, our destiny—which, in essence, means the present moment, considered as the highest form of wisdom, and the only form that can rid us of what Spinoza (whom Nietzsche regarded as "a brother") named, equally memorably, the "sad passions": fear, hatred, guilt, remorse, those corrupters of the soul that bog us down in mirages of the past or of the future. Only our reconciliation to the present, to the present moment—in Greek, the *kairos*—can, for Nietzsche, as for Greek culture as a whole, lead to proper serenity, to the "innocence of becoming," in other words to salvation, understood not in its religious meaning but in the sense of discovering ourselves as saved, finally, from those fears that diminish existence, stunting and shriveling it.

But we are not all Odysseus, and the instinct to withdraw oneself from the human condition in order to escape death is powerful. There are many of us who would answer Calypso in the affirmative . . . which is why the *third question* that runs through Greek myth concerns *hubris*, the mismeasure of those lives that choose to set themselves against that di-

vine and cosmic order whose difficult birth is recounted in the *Theogony*. Once mortals appear on earth and are thereby integrated into the universe, what then happens to those individuals who, contrary to Odysseus, do not tune themselves to this harmony and, through pride or arrogance or immoderation—hubris, in other words—revolt against the cosmic settlement established through the wars of the gods? The answer is, a great deal of trouble. To which the stories of Asclepius, Sisyphus, Midas, Tantalus, Icarus, and a host of others all bear witness. . . . We shall retell and examine some of these stories in detail (chapter four), selecting those that are the most profound and rewarding. But the message is clear enough from the outset: if wisdom consists in finding our natural place in a divine and everlasting order, so as to live our lives reconciled to the present moment, the madness of hubris consists in a contrary attitude, a proud and "chaotic" revolt against our human condition as simple mortals. A large number of mythological stories revolve around this crucial theme, and it is important to resist reading them—as is so often and so mistakenly attempted—according to a modern ethical framework inherited from Christianity.

Fourth question: Between these two possible trajectories, that of Odyssean wisdom and that which yields to the folly of hubris, how do we situate those out-of-the-ordinary heroes or demigods who populate nearly all of the major Greek myths? Neither sages nor fools, they pursue on this mortal earth the fundamental task that was originally that of Zeus: to struggle against the ceaselessly regrouping forces of chaos so that order may prevail over disorder, cosmos and concord over discord. Such is the story of these extraordinary men (literally speaking), glorious destroyers of all the monstrous reincarnations of the forces of disorder, which we shall have occasion to describe (in chapter five). Thus Theseus, Jason,

Perseus, and Heracles will continue, in the image of Zeus struggling against the Titans, to hunt down and extirpate the whole tribe of baleful and monstrous entities that symbolize the constantly self-renewing threat posed by the original forces of chaos—or, which amounts to the same thing, symbolize the permanent fragility of the cosmic order.

There remains, finally, *the fifth question*: on the one hand there is the cosmos, and on the other hand those who subscribe to it, like Odysseus, or who refuse its laws and live in hubris, or who help the gods to reestablish order and so become heroes. But there are also the millions of other beings, simple mortals like you and me, who are neither wise nor wicked nor heroic, and who watch paralyzed as unforeseeable catastrophes swoop down upon them, no doubt interspersed with moments of joy and happiness, but for the most part ills of every kind—sicknesses, accidents, natural calamities— without ever understanding the why or the wherefore! How do we explain to ourselves that a supposedly harmonious world, a cosmos that we are told is just and good, established and maintained by the all-beautiful and blemish-free Olympians, can allow misfortune to strike the good and the evil indifferently? It is in reaction to this question, impossible to evade when we think of a cosmos founded upon harmony and justice, that the Oedipus and Antigone myths in particular formulate their response (chapter six).

Finally, by way of conclusion, we shall see, through a consideration of the figure of Dionysus, how mythology effects the necessary reconciliation of discord and order, of chaos and cosmos—before asking what contribution is made to this synthesis by philosophy, and why mankind passed from Greek religion to more conceptual doctrines of salvation. It is on this point, as we shall see, that the Greek prehistory of philosophy so strikingly illuminates its entire history.

This book begins, then, at the beginning . . . which is to say with the birth of the gods, of the world, and of mortal men, as expounded in the most archaic, as well as the most complete and most important, of the texts that have come down to us: that of Hesiod. To which I shall supply, whenever it seems illuminating, a number of complementary or variant versions, *always specifying their separate origin and making clear the relevance of these accretions,* so that the reader (even the novice) is not led astray from the outset and progressively confused—but on the contrary is enlightened and enriched by a knowledge of myth that aspires not to erudition but to straightforward elucidation. Of course, in this labor, which aims to be at once rigorous and accessible, I have naturally been guided by the works of my predecessors. I must express here my debt, on this point as on many others, to the late Jean-Pierre Vernant. The primer that he wrote for his grandson* has not only served me for inspiration but also to a large extent provided the model for the present book, as have his other works. The same goes for the work of Jacqueline de Romilly on Greek tragedy. I had formerly held discussions with these two scholars while serving at the Ministry for Education, concerned as they were about the decline of the "classical humanities." I shared their concern, or at least their love of antiquity, and I tried (unsuccessfully, perhaps) to reassure them, and to set in train "measures" to check the educational collapse, real or imagined, that they feared. . . . But on this point, as on others, I think that books are more effective than political fiat: the latter comes up against so many constraints, obstacles, and shackles, from so many directions, as to render its effects forever uncertain.

The Universe, the Gods, and Men: Ancient Greek Myths, trans. Linda Asher (New York: Perennial, 2001).

I owe a great deal also to other works that I will cite in passing, notably the classic *Dictionary of Classical Mythology* compiled under the general editorship of Pierre Grimal. In addition to the original texts, which I have had to read or reread, the most precious of all precursors has been the work of Timothy Gantz, *Early Greek Myth*. This is a life's work; with infinite patience and scholarly care, as well as interpretative tact and the humility of a researcher, Gantz succeeded in attributing myths to particular authors, classifying them chronologically, and thereby identifying, for each story, both the original version (insofar as we can be certain) and the slow accretion of variants that enriched the narrative, completed it, or on occasion contradicted it. This richness, not to say profusion, was restored to us by Gantz in an ordered manner, for the first time, which has enabled us all to reliably find our bearings in the literature of Greek myth.

A final word on style, on the organization of this book, and on what it contains for children

As with *A Brief History of Thought*, I have chosen to address my readers informally, for two reasons: firstly because I have, so to speak, "tested" these Greek stories on my own children (and on a few others who are close to me), all of whom I principally address in this book. To write for them, I must first visualize one or another individual at any given moment. The second reason is that this child reader, at once idealized and real, compels me to write clearly, to refrain from obscure allusions or from supposing that my audience possesses any prior knowledge of Hesiod, of Apollodorus, of Nonnus of Panopolis, of Hyginus—or any prior familiarity with the meaning of such words as "theogony," "cos-

mogony," "mythographer," "cosmos," and so forth: words to which I shall have constant recourse but which my informal approach compels me almost automatically to define and clarify as I proceed—which I would certainly forget to do were I to use a more formal register.

The conviction that has motivated all of my work, over the years, is that, in this strange blend of frenetic consumption and disenchantment that characterizes the society into which we find ourselves plunged today, it is more essential than ever that we offer our children—and ourselves: mythology is for everybody—the chance to make a detour through the major works of classical literature before entering adulthood and signing up for the world of getting and spending. The reference here to consumption is neither facile nor a rhetorical device. As I had occasion to explain in my study of the history of the family,* the logic of consumerism, which none of us can pretend entirely to escape, follows that of any other addiction. To the image of the addict, who cannot prevent himself from increasing the dosage and frequency that supposedly makes life bearable, the well-trained consumer would shop ever more frequently, and buy more with each and every foray. It suffices to watch the television channels that cater to children for a few moments and observe how they are continually interrupted by advertisements for us to understand that one of their principal purposes is to transform children insofar as possible into model consumers. This logic, into which they are inserted at an ever-younger age, has destructive consequences. It works on us by an insidious mechanism: the less we experience a rich interior life on a moral, cultural, and spiritual level, the more we are given over to the frenetic need to acquire and consume. The

Familles je vous aime: politique et vie privée à l'âge de la mondialisation (Paris: XO Editions, 2007).

"rental of empty head space" that the television affords advertisers is thus their golden opportunity. By its ceaseless self-interruption, television aims literally to plunge audiences into a condition of *lack*, of *need*.

Let us avoid misunderstanding: I have no intention of indulging in yet another neo-Marxist diatribe against "consumer society," even less of trying my hand at the now ritual critique of the publicity machine. It is not all at clear, to my mind, that the suppression of advertising would in any sense change the underlying problems. Quite simply, as a father and a former Minister for Education, it has seemed to me crucial for us to put the frenzy of acquisition and ownership in its place—secondary, despite everything—and to make our children understand that acquisition is not the alpha and omega of existence: that it does not remotely begin to map the horizon of human life. To help children resist the pressures imposed by advertising, to allow them to free themselves or at least establish some inner distance, it is essential—perhaps even a matter of survival, if we remember how addiction is sometimes fatal—to provide them as early as possible with the elements of an interior life that runs deep and is lasting. To which end we must, I think, hold fast to the fundamental principle I have just outlined, according to which the more that individuals are endowed with strong values (cultural, moral, spiritual), the less they experience the need to acquire for the sake of acquisition and to press the "buy" button for no reason; the less, accordingly, will they be weakened by the chronic dissatisfaction created by an infinite multiplication of artificial needs. Put differently, we must help our children to accord greater importance to the logic of Being as against the logic of Having. It is in this spirit that I dedicate this book to all parents anxious to make a true present to their children—one that accompanies them

on their search and that is not discarded on Christmas morning as soon as the wrapping has been removed.

It is in this perspective that I believe it is crucial for us to return to the sources of Greek mythology, so as to share their essence with others. Of course this is not the only aim of this book, which attempts primarily, as I have said, to cast new light on the earliest moments of Western philosophy. But when I speak of children it is from experience rather than theory: when I began to relate the most famous Greek myths to my own children, when they were five years of age, I saw their eyes light up as never before. They fired questions from all sides, involving all the thousand and one aspects of the adventures I recounted. Never had I seen children's stories received with more enthusiasm, not even the classic fairy tales (magnificent as these are) of Grimm, Hans Christian Andersen, or Charles Perrault—to say nothing of the TV series that amuse, no doubt, but hardly engage their resources in the same manner. I am convinced that the deepest messages carried by the Greek myths, touching on the creation of the world, birth and death, the agitations of love and war, but also dealing with justice and the meaning of punishment, or with courage, risk, and the taste for adventure—that these all powerfully help children to understand their own actions and the world around them with a uniquely penetrating regard, which bears no comparison to what is ordinarily dispensed from the television or computer screen. Nor have I any doubt that these archaic narratives are inscribed in their memory, to accompany them for the rest of their lives. Furthermore, it goes without saying that the myths that we are going to discover or rediscover together are addressed quite as much to adults as to their children—which explains why this book will sometimes change register, and why its mode of address varies: sometimes I am addressing adults about the

origins of philosophy, at other times I recount the legends as if to an audience of children, and at other times I offer interpretations of certain episodes that seem to merit a more searching analysis. I am aware that this combination gives the book a somewhat parti-colored aspect, as indeed was the case with *A Brief History of Thought*. But this is a decision, and any inconvenience has seemed to me finally outweighed by the advantages of employing different registers.

I am also aware that over the course of these chapters the reader will inevitably have certain questions—historical, philological, and even metaphysical—to which I cannot respond without burdening my narrative to the point of unreadability: When, how, and why did the Greeks invent mythology? Did they believe in their myths in the same sense that a contemporary believer relates to his or her religion? Did these myths have a metaphysical function, for example one of consolation or reassurance in the face of death? Were the Olympian gods worshipped in quasi-religious ceremonies? What connection is there between the surviving texts and the earliest oral traditions? Did Greek parents tell their children at bedtime the adventures of Odysseus and Heracles? Or were these reserved for adult audiences, as was often the case with the lays of the troubadours in medieval Europe, or with fairy tales in the seventeenth century? I shall attempt to return to some of these entirely valid questions during the course of this book, when it seems opportune to do so. But to speak of them now would be to place the cart before the horse, and it seems preferable on all counts to begin with the great mythological stories themselves before reflecting any further on their significance or their cultural status.

I

The Birth of the Gods and of the Universe

IN THE BEGINNING OF the world, a somewhat strange deity first emerges from the void. The Greeks referred to it as Chaos. It is not a person, not even a fictional personage. We must imagine this primordial divinity as having no human traits: neither body, nor face, nor any defining characteristics. In truth, it is an abyss, a black hole at the heart of which nothing recognizable can be found. No object, no figure can be made out in the absolute darkness that reigns at the core of what is, fundamentally, total *disorder*. Moreover, at the origins of our story there does not yet exist anyone to see whatever is or is not there: no creatures, no men—not even any gods. Not only are there no living and sentient beings, there also is no sky, or sun, or mountains, or sea, or rivers, or flowers, or forests. . . . In short, in this gaping abyss that is Chaos, there is total obscurity. All is flux, confusion, and disorder. Chaos resembles a gigantic invisible precipice. As in a nightmare, were you to fall inside, you would fall forever . . . but that cannot happen, because neither you nor I nor anyone else exists as yet in this flux.

And then, quite suddenly, a second divinity bursts from this chaos for no discernible reason. A sort of miracle: an event of primary and fundamental significance, which Hesiod, the first poet to tell this story a long time ago (seventh century BC), makes no attempt to explain. With good reason: he has

no explanation to offer. Something emerges from the abyss, that is all. A formidable goddess, in fact, called Gaia—which in Greek means "the earth." Gaia is solid ground at last, the nourishing earth upon which plants will shortly grow, rivers spout forth, animals and gods and men be able to walk. Gaia, the earth, is at once the first element, the first piece of nature that is quite tangible and dependable—and is, in this sense, the contrary of chaos: from now on, whatever exists will not fall into nothingness because it is supported and held in place. But Gaia is also the first mother, mother earth, the original matrix from which all future beings, or almost all, will shortly begin to emerge.

Nonetheless—in order that the rivers and forests and mountains, the sky, the sun, the animals, mankind, and (above all) the other gods can spring into being one day upon Gaia, the goddess earth, or for them to emerge from Chaos, which will also produce its share of immortal beings—there needs a third divinity, in addition to Chaos and Gaia. This is Eros, or love. Like Chaos, Eros is certainly a god, but not an individual god. A life force rather, which makes other lives spring into being. Put differently, a vital living principle. It is therefore imperative not to confuse Eros, which can neither be seen nor assimilated, with a mere individual, with that other diminutive god of the same name who will put in an appearance much later, and whom the Romans will call Cupid. This latter-day Eros, if you like—so often represented as a chubby infant fitted out with little wings and a bow and arrows, whose darts unleash the passions—is a different god entirely from the primordial Eros of whom we speak: this abstract principle, as yet, whose primary purpose is to help all future divinities emerge from the shadows into light.

It is from these three primordial entities—Chaos, Gaia,

and Eros—that everything will come to life, and the world will progressively organize itself. This must, in turn, raise the first and most fundamental question of all: How do we pass from the absolute disorder of origins to the harmonious and beautiful world we recognize around us? In other words, which will shortly be those of philosophy, how do we pass from chaos to "cosmos": from disorder to the perfect and just regimen of a magnificently ordained natural dispensation upon which the sun gently shines? Here is where begins our first story, which tells the origins of all things and all beings—be they elements, men, or gods. It is the founding narrative of Greek mythology, and it is where we, too, must begin.

To come straight to the point, I must here mention a fourth "protagonist" in our strange drama. Hesiod's poem, which serves as our guide at this point, mentions that another divinity is present at this moment of origins, namely Tartarus. Again, this is not an individual, at least not in any human sense of the term. It is first and foremost a place, obscure and terrifying, moist and mildewed, and forever plunged in total darkness. Tartarus is situated at the profoundest depths of Gaia, in the most subterranean basement of the earth. It is in this place—subsequently to be identified with hell—that the dead, when there are such, will be relegated, but also equally the vanquished or banished gods. Hesiod gives us an interesting clue as to how to locate or imagine this celebrated Tartarus, who or which is at once a god and a place, like the others: a divinity capable of having children, for example, but at the same time a piece of nature, a corner of the cosmos. Hesiod tells us that Tartarus is buried deep in the earth, as far below the surface as the sky is above it, and he adds an image that perhaps speaks most vividly: imagine a heavy anvil—in other words

an enormous bronze table of the kind used by blacksmiths to hammer metal objects into shape. Yes? Well, it would take nine days and nine nights for this enormous and massy bronze object falling out of the sky to reach the earth, and a further nine days and nights for it to fall through the surface of the earth to the bottom of Tartarus! Which is another way of saying how profoundly this infernal place, which will terrify humans and gods alike, is embedded in the deepest abysses of Gaia.

Let us turn our attention back to Gaia, for it is here that things will really start happening—and let us tell the story in its proper order, rather than putting carts before horses, for as yet there is no sky or mountains, no men nor even any gods beyond those primordial entities that are (just to remind ourselves, and to name them in order of appearance) Chaos, Gaia, Tartarus, and Eros. Nothing else, as yet, has come into existence.*

But now, no doubt under the impetus of Eros, Gaia gives birth—all alone, without husband or lover, out of her own depths and her own resources—to a formidably powerful god: Uranus. And Uranus is the starry sky that, located above the earth (stretched out, in effect, or elongated: in

*With the exception of the children of Chaos, from whom there spring two other divinities, whom we shall leave aside for the moment: Erebus, the personification of darkness, and Nyx, the Night, which embodies a different darkness. Erebus is first and foremost the obscurity that reigns in the lower depths, for example in Tartarus. Night, on the other hand, is the obscurity of outdoors, above ground, beneath the sky. Rather than absolute, the latter is therefore relative—and relative to the day that precedes and succeeds it . . . an everyday phenomenon! Erebus and Night make love and promptly give birth to two other divinities. Ether is the luminous fog that drapes the tops of mountains, forever clothed in brilliance and situated above the clouds. It is this light that will illuminate the seat of the gods, Mount Olympus, and that constitutes the absolute contrary to Erebus, the blackness of the deeps. And then, born next to Ether, there is Hemera, the Day, which every morning succeeds or dethrones Night.

other words, lying upon her), is its celestial double. Wherever Gaia is found—wherever, in effect, the earth is to be found—there is also Uranus, or sky, overhanging it point for point. A mathematician would say these are two sets of perfectly equal extension: there is not a square centimeter of Gaia to which there does not correspond the same square centimeter of Uranus. . . . Notwithstanding, and once again without need of any other god, Gaia produces further offspring from her loins: the mountains, called the Ourea, and the nymphs who inhabit them—ravishing young girls, though not human since they, too, are divinities—and, finally, Pontus, the sea god or liquid entity. As you see, the universe, the cosmos, is beginning to take shape—even if very far from finished.

You will also note that all aspects of the physical universe so far mentioned are considered at once "elements of nature" and divinities. The earth is the ground upon which we walk, the compost from which the trees grow, but also a great goddess who bears a name just like you or me: Gaia. So, too, the sky is one of the elements, the beautiful azure above our heads, but at the same time a divine entity, already individualized and likewise endowed with his own name: Uranus. The same for Ourea, the mountains; Pontus, the salt sea waves; or Tartarus, the infernal underground buried in the bottommost depths of the earth. As the case arises, these divinities will pair off and have children in their turn, which is how thousands of other more or less divine creatures will be born of these first gods. For the moment, let us leave the majority of them to one side so as to focus on the main thread of the narrative and the characters who play an indispensable part in the terrible drama that will soon unfold before an ordered world can finally be established—a

true cosmic order, harmonious and stable, where humans are able to live and die.

In this primordial mythic narrative, the births of the natural world and of the gods are one and the same—which is why they overlap within the same story. Basically, to recount the birth of earth, sky, or sea is to recount the adventures of Gaia, Uranus, or Pontus. And the same goes for the rest, as we shall see. It is important to remember, for this same reason, that these earliest divinities, despite their having names, like you or me, are elemental forces of nature rather than individuals endowed with their own characters and psychologies. To set the world on course, it will be necessary subsequently to call upon other gods, cultural rather than natural forces, who will be more reflective and self-aware than are these earliest natural forces with which the universe began. It is, moreover, this path toward consciousness, ruse, calculation—in short, this progressive humanizing of the Greek gods—that will provide some of the most intriguing human interest (so to speak!) of our whole mythological saga. . . . But for the moment what is important is that, in the beginning, the births of the gods and of the natural elements merge into one. I realize that the two terms I am about to employ may be unfamiliar and thus seem complicated: "theogony" and "cosmogony." What do they mean? In truth, these archaic Greek terms are quite simple, as well as interchangeable. The birth (-gony) of the world (cosmos) and the birth (-gony) of the gods (theo) are one and the same: the cosmogony, the birth of the cosmos, is also and reciprocally a theogony, a story about the origins of divinity.

Two things to be born in mind at this point: firstly, that the cosmos, albeit eternal like the immortal gods, has not existed forever. In the beginning it is not order but chaos

that rules. Not only are the most complete disorder and most complete darkness in charge of proceedings, but also (as we shall see shortly) the first gods, far from being full of wisdom, as might be expected of gods, are on the contrary fueled by hatred and the most brutal passions—very rough-hewn, to the point that they are immediately at war with one another, in the most terrifying fashion. To say that at the outset the gods are not harmoniously disposed would therefore be an understatement, which is why the birth of the world, and of a cosmic order, is a protracted story that culminates in a "war of the gods." A tale full of sound and fury, but one that also carries within it a kernel of wisdom: that the life lived in harmony with the order of things, even if doomed one day to perish, as is the case with us mortals, is far preferable to all other forms of existence, preferable even to an immortality that is "disordered," so to speak, or "out of joint."

Let us note secondly that during this epoch of origins, there is no dimension of space, properly speaking: between heaven and earth, between Uranus and Gaia, there is no void, there are no interstices, so closely are they entwined. The universe, consequently, does not have its present appearance at the very outset, with an earth and a sky separated by distance—as Hesiod's image of the bronze anvil attempts to make us understand. Nor is there a dimension of time, or at least not in any sense comparable to what we experience, since the roll call of generations—at once symbolized and incarnated by the birth of new progeny—has yet to establish itself. Besides, those who live in time are, by definition, mortals, and mortals have yet to appear on the scene.

Let us see now how the universe as we know it will emerge progressively from these primordial elements.

The painful separation of the sky (Uranus) and earth (Gaia): the birth of space and time

Uranus, the sky, is not as yet "overhanging"—is not yet "up there," in the firmament, like a vast ceiling. He is, on the contrary, lashed down securely to Gaia, as closely as a second skin. He touches her; he caresses her all over, unceasingly. He is, so to speak, as clingy as it is possible to be, or, to speak plainly, Uranus makes love to Gaia continuously, unceasingly. It is his only activity. He is a monomaniac, obsessed by a single idea, that of erotic passion: he covers her with kisses, ceaselessly embracing her, burying himself in her—with the inevitable consequence that he fathers a whole string of children by her! And it is here that matters really start to get complicated.

For the children of Uranus and Gaia are in effect the first "real gods," the first gods who are no longer abstract entities but instead become veritable "characters." As I have been suggesting, we witness a progressive humanization of the divine, with the appearance of new gods possessed finally of an individual allure, with fully developed personalities and a psychology, with passions that are less brutal and more nuanced than their forebears—even if (as we shall see) these remain frequently conflicted, even ruinous: as we have noted, the Greek gods—unlike, for example, the Christian or Muslim or Jewish God—are far removed from the condition of perfect wisdom. And it is these divine offspring who will be called upon when it comes to creating order out of disorder, and the birth of a cosmos out of primary chaos. And they are going to need all the character they can muster, as well as courage and assorted other qualities, to set in tune a primordial universe that is becoming ever more complicated: this cannot be achieved blindly, by the mere

play of natural forces, like Newton's gravity. This order is so beautiful and so intricate that it must perforce depend on intelligent decisions being taken. . . . Whence that evolution to which the birth of the gods gives rise, progressively, as I shall now unfold.

Who in effect are these first descendants of Gaia and Uranus, of earth and sky? And what are their adventures prior to the full emergence of a balanced cosmic order?

Their number includes in the first place those whom their father Uranus calls the Titans: six boys and six girls, the latter sometimes referred to as "Titanes" and "Titanides" to distinguish them from their brothers. These Titans have three characteristics in common. Firstly they are, like all gods, perfectly immortal: no hope therefore of killing them if you find yourself going to war against them! Secondly they are endowed with colossal force, inexhaustible and superhuman, of which we can have no conception. This is why we still speak today of a "titanic" force and have given the name "titanium" to a particularly dense and resistant metal. Finally, these Titans are all of a consummate beauty. All in all, these are beings at once terrifying and fascinating, and of an extreme violence since they bear the mark of their origins: born in the depths of the earth and the nether regions of Tartarus, that infernal place that remains close to the primordial chaos from which Gaia herself perhaps emerged—Hesiod tells us that she came "after" Chaos, without making clear whether she was actually born of Chaos, though that is a plausible hypothesis. In any case, it is clear that the Titans are forces of chaos rather than of cosmos, beings of disorder and destruction rather than of organization and harmony.*

*Here are their names—but it is the youngest of them all, Cronus, whom we must remember, for he will play one of the key roles in the story that follows. In order of appearance: Oceanus, the great stream of water described in mythology

In ADDITION TO THESE six Titans and six sublime
Titanides, Uranus begets three monstrous beings with Gaia,
"in other respects like gods" says Hesiod, with the difference
that they only have a single eye, enormous and planted in the
middle of the forehead! These are the Cyclopes, who will
also play a decisive role in the construction of an ordered
and harmonious cosmos. Like their brothers the Titans, each
Cyclops is endowed with extraordinary strength and limitless
violence. Their individual names, in Greek, indicate this
clearly enough, for they all evoke storm and tempest: first
there is Brontes, which means "thunderer"; then Steropes,
"lightning flash"; then Arges, "thunderbolt." It is these
beings who will give the future ruler of the gods, Zeus, his
most fearful weapons: namely his thunderbolt and lightning
flash, which Zeus will deploy against all adversaries, to blind
them or strike them down.

Finally, the union of sky and earth gives birth also
to three entirely terrifying beings, more frightening (if
possible) than even the twelve Titans and three Cyclopes:
they possess fifty heads each, and from their monstrous
shoulders spring a hundred arms of unimaginable strength.
For which reason they are called the Hecatoncheires, which
in Greek means simply the "Hundred-Handed Ones." They
are so impressive that Hesiod proposes—before giving their
names, nonetheless—that it is better not to name them for
fear of rousing them and attracting their attention: the first
is Cottus, the second Briareus, and the third Gyges. They,

as encircling the world; then Coeus, Crius, Hyperion, Iapetus, followed by
Cronus, who is always referred to by Hesiod as "crooked-scheming," for reasons
we shall understand in a moment. And on the female side there is Theia (whose
name in Greek means "divine one"), Rhea, Themis ("justice"), Mnemosyne
("memory"), Phoebe ("luminous one"), and Tethys, queen of the sea, who
inspires love.

too, will play an important role, alongside the Cyclopes, in constructing the order of things to come.

The war of the gods: conflict between the first gods, the Titans, and their children, the Olympians

The order to come: because, as I have remarked, we are still far from the achieved and harmonious cosmos that Gaia—from all we can deduce about her from her solidity (in contrast to the gaping abyss of Chaos)—must be wishing for in her prayers. In fact, so extreme are these contrasts that all-out warfare looms inexorably on the horizon. The primitive forces of disorder, themselves so close to the original chaos, will in effect be unleashed—and must be mastered, muzzled, and civilized, so far as possible, if a viable and ordered world is to emerge. But where will this gigantic conflict break out? And how will it end? This is the central subject of Hesiod's founding narrative of Greek mythology—his cosmogony or "theogony"—for it is through this story that we shall pass finally from primitive disorder and violence to a well-regulated cosmic order that men will be able to inhabit and where they will seek, for better or worse, their destiny as mortals.

Here is how it starts.

Uranus loathes his children equally: the twelve Titans as much as the Cyclopes or the Hundred-Handed Ones. He bears a very particular hatred toward all of them. Why? No doubt because he fears that one of them will usurp him: not merely challenge his supreme power but steal from him she who is both his mother and his wife, namely Gaia. This is why Uranus (the sky) covers Gaia so closely and so effectively as to prevent their children from seeing the light of

day. He leaves no space, not the least chink through which they might leave the womb of their mother earth. He relegates them indeed to the profoundest depths, the chaotic regions of Tartarus—for which his offspring will not forgive him. Nor does Gaia, who is pregnant with all these children and cannot keep within her all these unborn and compressed sons and daughters! So she addresses them, urging them to revolt against this dreadful father who has prevented them from freeing themselves, from spreading their wings and growing up—prevented them, literally as well as figuratively, from seeing the light of day. Cronus, the youngest, hears the call of his mother, who suggests a dreadful stratagem against Uranus, his own father: with the molten metal that flows in her entrails, at the deepest subterranean levels, Gaia forges a reaping hook (other versions of the story specify that is made of flint, but I stay faithful to Hesiod who refers to gray adamant—presumably meaning iron). The instrument is certainly trenchant and, specifies Hesiod, "sharp-toothed." Gaia hands it to Cronus and invites him in plain terms to castrate his father!

The narrative of the castration of Uranus is very specific. It goes into details because these will have "cosmic" consequences, which is to say decisive effects upon the construction of the world. Arming himself with the iron sickle, Cronus waits for his opportunity. Uranus, as is his habit, stretches out in every direction and enters Gaia: Cronus takes his chance and grabs his father's genitals with his left hand (a later accretion to the myth will claim that it is from this moment that "left-handed" comes to mean "sinister" and bear the stamp of infamy) and with his right hand quickly severs them with a single sweep. With his left hand, equally, he flings the unfortunate and bleeding genitals over his shoulder, "to lie where they might"—a detail that is by no means

superfluous, or invented solely to add sadistic piquancy to the story, since from the drops of Uranus's blood, which are all received by the earth and the oceans, further dreadful or sublime divinities will in due course be spawned.

I will say something more here about these divinities since we shall encounter them again in numerous mythological stories.

The first three beings to be born from the severed sex of Uranus are gods of hatred, vengeance, and discord ("discord" = *eris*, in Greek), for they bear the trace of their violent origins. The fourth, on the contrary, belongs not to the empire of Eris but to that of Eros, or love: namely, the goddess of beauty and of amorous passion, Aphrodite. Let us examine this more closely.

From the severed genitals of the unfortunate Uranus, and from his blood that soaks into the earth (Gaia), the first-born are three terrifying goddesses named by the Greeks the Erinyes (Furies).*According to the poet Virgil, there are three of these avenging spirits, called Alecto, Tisiphone, and Megaera. It has to be said that the Erinyes are far from amiable: they are, as I have said, divinities of vengeance and hatred who pursue those guilty of crimes committed within the family, and who inflict unspeakable torments and tortures. They are preconditioned for this role from birth, so to speak, since their principal purpose is to avenge their father Uranus for the crime perpetrated upon him by his youngest son, Cronus. But beyond their personal vendetta, they play an important role in a number of mythological stories,

*Hesiod tells us neither their number nor their names. We have to wait six centuries to discover a little more about them, thanks to Virgil (first century BC). I mention this detail in passing to give a sense of the time needed for these famous mythological stories to take their full shape: they were not created in a single narrative act, nor by a single author, but were constantly modified by poets and philosophers over the course of centuries.

where they act as avengers of all family crimes and, even more broadly, all crimes against hospitality—in other words, crimes committed against individuals who, although strangers, should be treated as members of the family. It is they, for example, who engulf poor Oedipus in the earth, who, without intending or wishing to do so, kills his father and weds his mother. They are also known as the Eumenides, which is to say the "well-wishers"—not in Hesiod's poem but, for example, in the tragedies of another and slightly later Greek poet (sixth century BC), Aeschylus. In fact, this gentle appellation of "well-wishers" is devised to mollify them, and is used to avoid attracting their wrath. In Latin they would be known as the Furies. Hesiod does not speak of them in any detail, but later poets describe them as females of atrocious aspect: dragging themselves along the ground, baring their frightful claws, with wings that allow them instantly to overtake their prey, brandishing whips, their hair entangled with snakes, their mouths dripping with blood. . . . And since they incarnate destiny itself, which is to say the laws of cosmic order to which all beings must submit—even the gods are obliged more or less to abide by their decisions, which means that everyone (mortal or immortal) fears and detests the Erinyes. . . .

Next, with Gaia still covered in the blood of Uranus, which has soaked into the earth—into Gaia herself—a whole pleiad of nymphs springs forth. They are named the Meliai, which in Greek means young girls born of what we would now call ash trees. These, too, are formidable and warlike deities, since it is with the wood of the ash tree—from which the most effective arms are made, notably the bows and lances used in battle—that they extend their dominion.

In addition to the Erinyes and the Meliai, other equally terrifying beings are spawned from the blood of Uranus that

soaks into the earth: namely the giants, or Gigantes, who spring out of the ground fully armed and armored, wholly dedicated to killing and carnage. Nothing frightens them, and nothing suits them better than wars and massacres. Here they are comfortably in their element. Hesiod tells us nothing more about them, but later versions of this same myth suggest that there was a revolt of the giants against the gods, which even gave rise to a dreadful war, referred to as the Gigantomachy, or "combat of the giants." From which the gods, of course, emerged victorious, but to do so they needed the assistance of Heracles*—of whom more will be said later.

As we can see, all of the characters born thus far from the blood of Uranus mixed with the earth of Gaia are fearful beings, vowed to vengeance, hatred, or war. It is in this sense that the Erinyes, the Meliai nymphs, and the giants, or Gigantes, come firmly within the domain of that divinity named Eris: the personification of discord, from whom all conflict arises. Eris is, moreover, an obscure and shadowy entity, one of the daughters of Night, Nyx, and engendered after the manner of Gaia, without any need of husband or lover.

But, as mentioned above, from the sexual organs of the Sky springs another goddess, who this time belongs not to Eris but on the contrary to Eros, and who is dedicated not to discord and conflict but to love (the closeness in Greek of those words seems to indicate a closeness in reality: that it is easy to slip from Eros to Eris, from love to hate)—and this is none other than Aphrodite, goddess of beauty and love. You will recall that the blood of the severed genitals of Uranus fell to earth, but Cronus flung the genitals as such

*This story derives for the most part from Apollodorus, a mythographer of the second century BC.

over his shoulder, a great distance, and they disappeared into the sea—where they were carried on the waves and, blending with the white foam of the sea (in Greek, foam is *aphros*), gave birth to this young girl, Aphrodite, most beautiful of all the divinities. Goddess of tenderness, of mildness, of love's sidelong smile. But equally, goddess of sexual brutality and of the ruses and duplicity necessary to seduce, to please the other, to place oneself in the most flattering light, or to flatter another—devices that are not always (to put it mildly) used in the service of the truth. Aphrodite is all of these things: she is the art of pleasing, of seduction and gloss, of vanity and jealousy; she is mildness itself, but she is also the flash of anger and hatred born of thwarted passions. In which respect, once again, Eros is never far away from Eris; love is never far from quarrel and conflict. When she emerges from the ocean foam either in Cyprus or at Cythera, according to Hesiod, she is already accompanied by two other minor deities who serve as her "retinue," her companions and confidants: Eros is one of these, famously—and this time it is indeed Eros minor, of whom we spoke earlier, the diminutive figure who is often represented (long after Hesiod) as a small chubby boy armed with a bow and arrows. Secondly, at Eros's side there is Himeros, or desire, which properly speaking always precedes love. . . .

On a cosmological level, in other words, in terms of the building of our cosmos—the world in which we mortals have yet to appear—the castration of Uranus has one absolutely crucial result, of which I shall speak briefly before we move on finally to the celebrated story of the war of the gods. This consequence is, quite simply, *the birth of space and time.*

The birth of *space*, firstly, because the unfortunate Uranus, under the effect of the atrocious agony caused by his mutilation, "takes flight," at the end of which he finds him-

self taped to the ceiling, so to speak, thereby creating the space that separates earth and sky. Secondly, the birth of *time*, for a far more profound reason that is one of the keys to the whole of classical mythology: thanks to the opening up of space, the imprisoned children of Uranus—the Titans, in the first instance—can finally emerge from the earth. Which is another way of saying that the future, formerly blocked by the pressure of Uranus upon Gaia, opens up. Henceforth, future generations will inhabit the open air of the present tense. All those offspring symbolize life but also history. Moreover, life and the possibility of history—first incarnated by the Titans, who can finally leave the dark womb of earth—also entrain movement, disequilibrium, and, by the same token, the open and permanent possibility of disorder. Each new generation is a dynamic rather than stable addition, tilting the scales toward the chaotic and away from the cosmic—so much so that one thing at least is already entirely clear: fathers must beware their sons! And Cronus is better placed than anyone to understand this: it is he who has mutilated his own father, Uranus, and therefore he who is first to realize that his own children represent a threat to the status quo, to the one who already holds power. Put differently: we must be wary of Time, the creator of new life, but also the native realm of all disorders, of all the troubles and imbalances that are held in store. Cronus takes stock of this new incontrovertible reality: that history is full of dangers, and that if one wants to hold onto what has been gained and secure one's power, it would be better to abolish history, so that nothing can ever change again. . . .

It is difficult to overestimate the profundity of the existential problem that begins to take shape in the crucible of this first and original mythological narrative. What it implies is that all existence, even that of the immortal gods,

will find itself trapped in the same insoluble dilemma: Either one must block everything, as Uranus blocked his children in the womb of Gaia, in order to prevent change and the attendant risk that things will deteriorate—which means complete stasis and unspeakable tedium, such as must ultimately overwhelm life itself. Or, on the other hand, to avoid entropy one accepts movement—History, Time—which includes accepting all the fearful dangers by which we are most threatened. How, henceforth, can there be any equilibrium? This is the fundamental question posed by mythology, and by life itself! The answers provided by these stories are therefore full of interest, even for us today. . . .

But let us return to our story.

Cronus devours his children . . . except
Zeus, the last and littlest, who escapes
and in turn revolts against his father

Cronus, as I have said, is more conscious than anyone of the dangers that children pose for their fathers. And with good reason. He liberates his brothers and sisters, Titans and Titanides, still imprisoned underground by the violence of Uranus, but he takes a very different course of action with his own children. He weds his sister, Rhea, but each time she conceives and brings into the world a newborn, Cronus immediately swallows it whole, to avoid the possibility of his offspring rebelling against him one day, as he rebelled against his father, Uranus. For the same reason, no doubt, Cronus declines to liberate the Cyclops and the Hundred-Handed Ones from below earth. They are a little too dangerous, a little too violent not to provoke change, too, and therefore they pose a threat. Better, for the moment, to keep them

locked up in the depths of Gaia, in the obscurity of Tartarus, the realm of mists and damp, which takes its toll on all of its inhabitants. These in turn conceive an inextinguishable hatred for their brother turned keeper.

With his sister, now his wife, the Titanide Rhea, Cronus will have six magnificent children: Hestia, goddess of the hearth, which means protector of the family; Demeter, goddess of the seasons (named Ceres in Latin, from which "cereal" derives); Hera, soon to become the wife of Zeus, future ruler of the gods; Poseidon, god of the sea; Hades, god of the underworld; and, finally, Zeus himself—last and littlest, who will become ruler of all the others. . . . But each time, as soon as the infant emerges from his mother's womb and arrives, as Hesiod says, "at his father's knee," the latter swallows him whole and sends him straight to prison in the depths of his stomach. It is worth bearing in mind that Cronus's parents, Gaia and Uranus, have warned him, predicting quite openly that one day or other he will have a son who will dethrone him and steal all of his powers.

Be that as it may, both his mother, Gaia, and his wife, Rhea, are dismayed by his behavior. Gaia ended by detesting her husband, Uranus, for preventing her children from leaving her womb and seeing the light of day. Rhea, in turn, begins to hate Cronus because, worse still, he consumes all her little ones, to the point that just before the last of them is born—we are speaking here of Zeus—Rhea goes and seeks advice from her mother and father, Gaia and Uranus: What can she do to avoid little Zeus being swallowed whole, just like all the others? Her parents advise her to leave immediately for Crete, or more precisely for Lyktos, where Gaia, who is better placed than anyone else to perform this rescue operation—since she is herself the earth—will shelter the newborn infant in a gigantic grotto concealed inside a

mountain, itself covered by a forest. No risk here of Cronus detecting the existence of Zeus. However, to allay his suspicions, Cronus must be given something to swallow instead of a baby! So Rhea wraps up a large stone in swaddling clothes, and Cronus swallows it without noticing anything unusual.

In a safe place, and well concealed from the gaze of his father, little Zeus grows, nourished by the milk of the goat Amalthea, whose skin, it is said, could be pierced neither by arrows nor lances. It is with this hide that Zeus will create his famous shield, the "aegis," which he will lend when the need arises to his daughter Athena. For the moment, he is turning into a magnificent adolescent, shortly to become an adult radiant with strength and beauty. The plot forged by Gaia and Rhea against Cronus meanwhile pursues its course. They arrange a stratagem by which Cronus is made to vomit and thus spit forth, one by one, all of his swallowed children, beginning with the youngest—in other words, with the stone that served as a decoy for Zeus.

Meanwhile, Zeus does something both very cunning and very prudent, still acting on the instructions of Gaia, who clearly wants the cosmos to be constructed with the active participation of all her children and grandchildren, without exception: he frees the Cyclopes whom Cronus had left chained in the depths of the earth. Overcome with gratitude, the latter present him with two magnificent gifts that will prove to be precious above all others since they will enable Zeus to become the most powerful and most feared of all the gods: namely the thunderbolt and the lightning flash, which will deafen, blind, and strike down all his enemies. For the same reasons, Zeus is smart enough to release the Hecatoncheires, the infamous Hundred-Handed Ones, brothers likewise of the Cyclopes and the Titans. In other words, by

this act of liberation Zeus makes important and lasting allies. We may notice, in passing, all that is being gained by this progressive individualizing of the gods, which renders them more naturalistic, more cunning, more aware of the consequences of their actions as individual agents. Put differently: without intelligence or any sense of justice, without these more naturalistic attributes, the achievement of a harmonious world order would be inconceivable.

As might be expected, the revolt of Zeus and of his brothers and sisters—Hestia, Hera, Demeter, Poseidon, and Hades—against Cronus and the other Titans unleashes a monstrous war, a conflict of which we can have no conception: it is the whole universe that trembles, and the emerging cosmos finds itself on the brink of being returned immediately to chaos. . . . Mountains are hurled as you or I would throw stones! The entire universe is shaken to its foundations and threatened with annihilation. But what is unimaginable, for us mortals, is that no one can perish in the course of this conflict, waged as it is by beings who are perfectly immortal. The end therefore is not to kill, but to subjugate and reduce the adversary to immobility, to powerlessness. And the stakes are high: it is a question of ensuring that chaos—absolute disorder—does not triumph permanently over the possibility of a new order, the emergence of a veritable cosmos. In the end, thanks to the thunderbolt given by the Cyclopes, and thanks likewise to the formidable power of the Hundred-Handed Ones (in gratitude for their deliverance by Zeus), it is the second-generation gods—namely Zeus and his brothers and sisters, referred to hereafter as the "Olympians" because they conduct their war from the top of a mountain called Olympus, which will subsequently become their home—who carry the day. The Titans are blinded by lightning and buried alive under the rocks hurled by the Hundred-

Handed Ones. Overwhelmed, they are finally chained and held hostage in Tartarus, the realm of black darkness, mists, and damp. Poseidon, one of the brothers of Zeus, constructs giant doors in bronze, impossible to break or to open, and the three Hundred-Handed Ones undertake to mount guard, all the more zealously given that their brother Titans had so few scruples about keeping them locked up underground, before Zeus liberated them. . . .

Henceforth, the Olympians—or at least the six original Olympians, of the generation of Zeus—are well and truly installed in power. Soon they will be twelve, as if to match the twelve Titans and Titanides. Zeus in effect has five brothers and sisters: Hestia, goddess of the hearth and of the home, protectress of the family; Demeter, goddess of crops and seasons; Hera, empress-in-waiting, who will become the wife of Zeus; Hades, god of the underworld, who will reign over Tartarus; and Poseidon, god of the rivers and seas, who makes the earth tremble with his famous trident. In the generation above, we will also count as an Olympian—that is to say as senior gods, those who rule over this world and carve up its affairs between them—Aphrodite, goddess of beauty and of love, who as we have seen was born of the blood of the castrated Uranus mixed with the foam of the sea. She is spared during the conflict of the gods because she is not born of Eris, or Discord. She can be considered therefore both as a sister of Cronus—of the same generation and sharing a father—but also as one of Zeus's aunts. And then, from the generation that comes after Zeus and his five siblings, there are, of course, the children of the principal masters of Olympus, Hera and Zeus: these are Hephaestus, god of the forge and of craftsmen, and Ares, the terrifying god of war, followed by Athena, goddess of the ruse and of the arts, favorite daughter of Zeus, whom he conceived

by his first wife, Metis. Athena, too, will sit on Olympus, where we shall also find those twins Apollo, handsomest of the gods, and Artemis, goddess of the hunt, who were born of the extraconjugal love of Zeus and Leto, herself the daughter of the Titans Coeus and Phoebe—which therefore makes Leto a first cousin of Zeus. Then there is Hermes, messenger of the gods, patron of eloquence, of travelers and of commerce. And, finally, Dionysus, strangest of all the Olympians, god of wine and of feasting, born (again) of the extramarital activities of Zeus and—uniquely among the Olympians—of a mortal mother: Semele, daughter of Cadmus, king of Thebes.

It should be made clear at this point that all these Olympian gods—and a number of Greek heroes such as Heracles (Hercules) and certain of the Titans, such as Cronus (Saturn)—will be given new Latin names by the Romans, who adapt and take Greek myth into new territory: Zeus will become Jupiter, Hestia becomes Vesta, Demeter becomes Ceres, Hera becomes Juno, Hades becomes Pluto, Poseidon becomes Neptune, Aphrodite becomes Venus, Hephaestus becomes Vulcan, Ares becomes Mars, Athena becomes Minerva, Apollo on occasion becomes Phoebus, Artemis becomes Diana, Hermes becomes Mercury, and Dionysus becomes Bacchus. This is the reason why, very often, we are more familiar with the Greek gods under their Latin appellations than by their original names. Despite which, they are the same personages: Hercules is none other than Heracles, Venus is none other than Aphrodite, and so on. It is, moreover, essential to be aware, at least roughly, of their respective powers and functions, for it is they who will carve up the world between them—and it is this division of powers, extending to the universe in its entirety and underwritten by Zeus, that is at the heart of

the cosmic settlement. Further acquaintance with their roles and responsibilities will allow us, moreover, to understand a little more about them as individuals. Together with their respective tasks, different personalities also begin to emerge: little by little we enter the realm of culture, of politics, of justice—in short, the progressive humanizing of the divine of which I have spoken.

I will indicate these roles briefly, in summary form, without entering into detail as yet, and in each case I give both Greek and Latin names, so as better to follow the conclusion of this inaugural narrative:

Zeus/Jupiter Ruler of the gods and master of Olympus.

Hestia/Vesta Goddess of the hearth, who protects families and homes. Eldest daughter of Cronus and Rhea, she is therefore the first to be swallowed by Cronus and the last to be regurgitated by him; she is also therefore one of the sisters of Zeus.

Demeter/Ceres Goddess of seasons and of crops, she causes the flowers to grow, and the trees, and of course the "cereals." She will have a daughter, Persephone, whom she adores, and who will be abducted by Hades to become his wife. In effect, Hades and Demeter will share Persephone. Each will have her for six months of the year, which is why nothing grows in fall and winter: Persephone is with Hades during this time, while her mother grieves and mopes and stops work. When Persephone returns, in spring, the sun comes back and everything revives!

Hera/Juno The "empress," wife of Zeus. Frequently deceived by him and fearfully jealous, she pursues with her wrath the numerous mistresses of her husband, as well as

their offspring born of adultery, like Heracles, whose name nonetheless signifies "glory of Hera": it is she, in effect, who will ask him to accomplish the twelve famous (Herculean) "labors" in the hope that he will be killed while carrying out one or another of these tasks, because Heracles is not her son but the offspring of Alcmena, whom Zeus seduced by appearing to her in the guise of her husband, Amphitryon—for which Hera will never forgive him. Heracles nonetheless becomes a sort of lieutenant, Zeus's second-in-command on earth, with a brief to kill monsters and thereby help maintain cosmic order.

Poseidon/Neptune God of the sea, it is he who unleashes tempests and hurricanes, by striking the ground with his trident. The offspring of this strange and disturbing god will include an impressive number of unruly monsters, including Polyphemus, the Cyclops whose one eye will be gouged out by Odysseus. . . .

Hades/Pluto Reigns over the underworld, together with his wife, Persephone, daughter of Demeter. More or less universally feared, even on Olympus, he is said to be the richest (*ploutos*) of all the gods because he rules over the greatest number of people: all of the nameless dead.

Aphrodite/Venus Goddess of beauty and of love, who is all charm but also practices every ruse and is mistress of every untruth.

Hephaestus/Vulcan God of the forge, of diabolical dexterity in his art, he is also the limping god (some accounts claim that he was thrown from the top of Olympus by his parents), the only god who is ugly, and yet he marries the most beautiful of goddesses, Aphrodite, who cuckolds him constantly, not least with Ares.

Ares/Mars Brutal, violent, even bloodthirsty, he is the god of war and one of the principal lovers of Aphrodite (there are plenty of others).

Athena/Minerva Favorite daughter of Zeus, and of his first wife, Metis (goddess of cunning). The story goes that Athena was born directly from the head of Zeus. In effect, Zeus swallowed Metis when he learned that she was pregnant, because it had been predicted that, if ever she had a son, he risked—like Uranus with Cronus, like Cronus with Zeus—being usurped. As it turned out, Metis was pregnant with a daughter, Athena, who thus found herself coming into the world inside Zeus, and who exited . . . through his head—which has a certain logic, after all, since she is the goddess of intelligence. She is also, like her brother Ares, a deity of war, but with this difference: that she wages conflicts with finesse, cunning, and intelligence—even if she is also able to wage arms with impressive ferocity when necessary. In this latter respect she is also the goddess of arts and technology or industry. It is war under its strategic aspect that she symbolizes rather than its brutality. At bottom she is like her father and embodies in feminine form all of his qualities: strength, beauty, intelligence.

Apollo/Phoebus The handsomest of the gods (as we say "an Apollo" to designate male beauty), one of the most intelligent, too, and the most musically gifted of them all. He is the twin brother of Artemis (Diana in Latin), goddess of the hunt. Both are the children of Zeus and Leto, who is herself the daughter of two Titans (Coeus and Phoebe), and therefore cousin to Zeus. Apollo is the god of light and of intelligence. He also inspires the most famous of all oracles, that of Delphi, which is to say the

priests who claim to foretell the future. In Greek, Delphi means "dolphin," because—according to certain mythological accounts posterior to Hesiod—Apollo, on arriving at Delphi, changed into a dolphin so as to lead a ship into port with the aim of turning its passengers into the priests of his new cult. He also killed a monstrous creature, which is called the Python, by leaving it to rot in the sun (in Greek "to rot" is *pythein*) after decapitating it. This snake or serpent had terrorized the inhabitants of Delphi, and in its place, Apollo installed his oracle, which is why Pytho is the ancient name for Delphi.

Artemis/Diana Also a daughter of Zeus and Leto, and twin sister of Apollo. Goddess of the hunt, she can be fearsome and cruel. For example, one day, when she was surprised entirely naked by a young man while bathing in the river, she changed him into a stag and let her hounds devour him alive. . . .

Hermes/Mercury Born of the union between Zeus and the nymph Maia, he is the most deceptive and knowing of all the gods. He is the messenger of Zeus, an intermediary in every sense of the term, which makes him as much the god of journalists as of tradesmen. . . . Many newspapers throughout the world still bear his name (the former *London Mercury*, the *Mercure de France*, *Mercurio* in Chile, *Merkur* in Germany, etc.). He gives his name to the science of "hermeneutics," which concerns itself with the interpretation of texts. But he is also the god of thieves: while still an unweaned infant, only one day old, he manages to steal his brother Apollo's entire herd of cattle! He even has the idea of marching them backward so that their hoof marks would mislead those who were looking for them. When Apollo discovers the theft, little Hermes of-

fers a musical instrument to pacify him, the lyre, which he has constructed with the shell of a tortoise, drawing the strings from the guts of a cow. This will be the ancestor of the guitar, and since Apollo loves music above all else, he allows himself to be lenient toward this very singular urchin. . . .

Dionysus/Bacchus The strangest of all the gods, described as having been born from the "thigh of Jupiter," meaning Zeus. In effect, his mother, Semele—daughter of Cadmus, king of Thebes, and of Harmonia, herself the daughter of Ares and Aphrodite—had imprudently asked Zeus to show himself to her in his true, divine form, without human disguise. Alas, humans cannot support the sight of the gods, least of all Zeus in all his blinding radiance. Granted the revelation of seeing Zeus "as himself," poor Semele caught fire—while pregnant with Dionysus. Zeus snatched the fetus from its mother's womb, saving it just before she was completely consumed by fire, then sewed the fetus into his thigh, removing it when it reached full term.

In the course of these pages we shall have frequent occasion to return to different aspects of these Olympian identities. You may already have noticed that the twelve have in the above summaries turned into fourteen. This is explained by the fact that ancient mythographers were not always in agreement as to a definitive list of gods, as is witnessed by the archaeological evidence drawn from monuments, which also offer contradictory lists. Sometimes Demeter, Hades, or Dionysus are not numbered among the Olympians, so that if we count all those mentioned in various accounts, there are indeed fourteen rather than twelve divinities. This is of no

consequence, moreover, and changes nothing in our story: the essential point is to understand that there are higher gods and lower divinities, and that these fourteen—as listed above—are the principals, the most important players in the cosmogony, because it is these who, under the aegis of Zeus (which is to say under the protection of his famous shield fashioned from magical goat skin), will have the character and imagination to divide the world equably and arrange the organization of the universe so as to create a magnificent harmonious cosmic order.

Having said this, there are (as in a crime thriller) too many characters at the outset for us to keep them all clearly in mind, so I propose a small table to help us keep track of them all. You will soon become familiar with them, as I summarize their stories and list their individual characteristics. Let us begin our thumbnail theogony at the beginning, from the first divinity Chaos down to the Olympians, following their chronological order of appearance. I will restrict myself to the important deities, of course—to those who have major roles in the construction of the cosmos, which is what interests us here:

Cast of Principal Gods

1. There are, in the first place, six gods—from whom all others are descended:

 Chaos, the dark and backward abyss.

 Gaia, mother earth, solid and reliable.

 Eros, life principle, the love that makes everything reach toward the light of being.

 Tartarus, at once dreadful deity and infernal place, situated in the profoundest depths of Gaia, full of black darkness, mist, and damp.

Uranus, the sky, and **Pontus**, the sea, both of which are self-engendered by Gaia, without benefit of lover or spouse.

With the exception of Gaia, who has incipient traces of personality, these first gods are not yet proper individuals endowed with consciousness or character traits; rather they are forces of nature, primordial elements from which to construct a cosmos.[*]

2. The offspring of Gaia and Uranus, comprising three distinct sets—first, the Titans and their sisters, the Titanides:

Oceanus

Coeus

Crius

Hyperion

Iapetus

Cronus

And, on the female side:

Theia

Rhea

Themis

Mnemosyne

Phoebe

Tethys

Secondly, the three **Cyclopes**, who will be imprisoned underground by Cronus and who will give Zeus his thunderbolt after he releases them—respectively:

[*]For the sake of completeness, here is the lineage of offspring "generated" by Chaos, and that of Gaia, likewise self-engendered. From Chaos descends Erebus, the darkness that reigns inside the earth, and Nyx, the night that reigns above it. The courtship of Erebus and Nyx results in the first grandchildren of Chaos: Ether, the luminous fog that will enshroud the future home of the gods on the summit of Mount Olympus, and Hemera, goddess of the day, which succeeds night. This line of descent will play no particular role in the war of the gods, and can be left to one side; I mention it here for the record.

Brontes (thunderer)
Steropes (lightning flash)
Arges (thunderbolt)
Finally, the "**Hundred-Handed Ones**," or **Hecatoncheires**:
Cottus
Briareus
Gyges

3. The offspring born of the severed sex of Uranus, whether from the drops of his blood falling to earth (Gaia) or from his genitals cast into the sea (Pontus). These are all brothers and sisters—or, in the case of Aphrodite, the half sister—of the Titans, the Cyclopes, and the Hundred-Handed Ones. There are once again three new lines of descent, to which is added Aphrodite.

The **Erinyes**, goddesses of vengeance (they are out to avenge the affront suffered by their father at the hands of Cronus). We know from the Latin poets that there are three of them and that the youngest is named Megaera. They are also (euphemistically) called the **Eumenides**, which means "Well-Wishers"; the Romans named them the **Furies**.

The **Meliai** nymphs, goddesses of the ash tree, which furnished the wood to make weapons of war during this epoch.

The **giants**, who come into the world fully armed and armored.

Aphrodite, goddess of beauty and of love, born likewise from the discarded sex of Uranus, but in this case mixed with the foam of the sea rather than with the earth.

Note that the three first-mentioned divinities (the Erinyes, the giants, and the Meliai) are gods of war, of

Discord—which Hesiod also characterizes as a divinity: **Eris**, a daughter conceived singlehandedly by Nyx, the Night, without any lover—while Aphrodite proceeds not from the domain of Eris but from that of **Eros**, or Love.

4. The children of Cronus and of his sister, the Titanide Rhea. Succeeding the Titans comes the second generation of "real" gods, namely the original Olympians:

Hestia (**Vesta** in Latin), goddess of the hearth.

Demeter (**Ceres**), goddess of crops and seasons.

Hera (**Juno**), empress, second and last wife of Zeus.

Poseidon (**Neptune**), god of the sea and of rivers.

Hades (**Pluto**), god of the underworld.

Zeus (**Jupiter**), ruler of the gods.

5. Olympians (second generation):

Hephaestus (**Vulcan**), god of the forge, son of Zeus and Hera.

Ares (**Mars**), god of war, brother of Hephaestus, son of Zeus and Hera.

Athena (**Minerva**), goddess of war, of cunning, of arts and industry, daughter of Zeus and Metis.

Apollo (**Phoebus**) and **Artemis** (**Diana**), the twins: god of beauty and intelligence, goddess of the hunt, born of the involvement of Zeus and Leto.

Hermes (**Mercury**), Zeus's messenger, son of Zeus and Maia.

Dionysus (**Bacchus**), god of wine and of feasting, son of Zeus and the mortal Semele.

Let us now take up the reins of our story.

The original settlement, and the genesis of the idea of a cosmos

Zeus finally marries Hera, who will remain forever his true and final spouse. Nevertheless, not only does he have innumerable liaisons with other females, mortal and immortal, but he also has already previously been married—not once but twice. This is relevant because these two marriages have "cosmic" implications and an essential role in the construction of the world, which is what interests us here. In effect, Zeus is married first to Metis, then to Themis—firstly to the goddess of cunning or, if you prefer, of intelligence, and secondly to the goddess of justice.

Why Metis? Metis of the ruse, of intelligence, is daughter of the Titanide Tethys and of one of the first Titans, Oceanus— Ocean—which is to say, in the vision of the world implicit in Hesiod's poem, the gigantic river that encircles the whole of the earth. Of Metis, Hesiod tells us only that she knows more than the other gods and (it goes without saying) more than any mortal man: she is intelligence itself, ruse personified. In short order she is also pregnant, expecting a daughter of Zeus, the future Athena, who will appropriately become the goddess of cunning, of intelligence and the arts of warfare— albeit, as we have seen, of tactical and strategic war rather than the messy and brutal conflicts that are the province of Ares. The grandparents of Zeus, Uranus and Gaia— who, you will recall, saved him from being swallowed by Cronus by prompting his mother, Rhea, to conceal him in an underground grotto—warn Zeus of the dangers lying in wait for him: if one day Metis has a son, he, too, will dethrone his father, as Cronus dethroned Uranus and as Zeus himself dethroned Cronus. Why so? Hesiod does not say, but we may suppose that any son of Zeus and Metis will

necessarily be endowed with the attributes of his parents: the greatest possible strength, that of the thunderbolt, allied to his mother's intelligence, which as we know is superior to that of all other mortals or Immortals. Not to be trusted, therefore: this child could turn into an absolutely fearsome adversary, even for the ruler of the gods. (Let us note in passing that the Greeks are not as misogynist or "antiwomen" as they are often made out to be: it is very often women who embody intelligence, without in any way diminishing their other assets such as physical attraction and prowess.)

Be that as it may, in order to avoid having a child who will usurp him, Zeus quite simply decides to swallow his wife (swallowing is a peculiarity of this family), the unfortunate Metis. A later variant to the story claims that, among her other resources and ruses, Metis has the capacity to change her form and appearance at will. She can transform herself whenever she likes into an object or an animal. Zeus is going to do exactly as Puss in Boots did when faced with the ogre: in the fairy tale, the cat asks the ogre to change himself into a lion, which terrifies her dreadfully. Then, acting the innocent, she asks him to change into a mouse . . . at which point she pounces on him and gobbles him up. Zeus does the same: he asks Metis to change into a droplet of water . . . and, as soon as she does so, he drinks her up! As for Athena—the daughter with whom Metis is pregnant when she is swallowed—she will be born directly from the head of Zeus. She springs from his cranium to become, in her father's image, the most intelligent and, in combat, the most redoubtable goddess of them all.

Let us not forget one important detail in this story: swallowing is not the same thing as eating, chewing, or crunching. The one who is swallowed is not only still alive but unharmed. Just as the children of Cronus remain alive

in their father's stomach—the proof of which is that when Cronus regurgitates, they reappear in rude good health—so, too, Metis, swallowed by Zeus, remains alive and, so to speak, undamaged. We will encounter this notion again in our fairy tales, for example in Grimm's "Seven Little Kids," where the kids, although swallowed by the wolf, are discovered alive and kicking when the wicked wolf's stomach is opened up! In the case of Metis, being swallowed signifies, symbolically of course, that Zeus is going to endow himself by this stratagem with all the qualities that the son of his union with Metis would doubtless have been endowed. He already has the power conferred on him by the Cyclopes presenting him with thunderbolt and lightning flash, but he now possesses in addition—thanks to Metis, concealed in his inmost depths—intelligence superior to all other mortals and Immortals.

This is why Zeus is henceforth invincible—why he becomes ruler of the gods: because he is at once the strongest and the most intelligent; the most brutal, if need be, but also the wisest. And it is precisely this wisdom that will persuade him (contrary to Uranus and Cronus) to practice *the greatest justice in organizing the new cosmos, and in dispensing honors and responsibilities between those who have helped him to overcome their forebears, the generation of Titans.*

This point is absolutely essential to Greek myth: it is always through justice that one gains one's ends, ultimately, because justice is fundamentally nothing more than a form of adherence to—adjustment to—the cosmic order. Each time someone forgets this and goes against the rule of order, the latter is in the end restored, destroying the interloper. This lesson of human experience emerges already in veiled form in mythology: only a just order is permanent, and the days of injustice are always numbered.

This is why, having married Metis and, so to speak, incorporated her—literally concealed her inside himself—Zeus takes a second wife, who will be just as important as the first in helping him to maintain power at the heart of a nascent cosmos: namely Themis, or Justice. Themis is one of the daughters of Uranus and Gaia. She is therefore a Titanide, with whom Zeus will have children who symbolize perfectly the virtues necessary to the construction and maintenance of a harmonious and balanced cosmic order: this being always the focus of our story, which, as we can now see, tells how everything passes from initial chaos to a viable and magnificently organized cosmos. Among the children of Zeus and Themis is Eunomia, meaning "wise laws," or *dikè*, justice in the sense of a proper division of things. Then there are the deities known as the Moirai, goddesses of destiny—also referred to as the Fates—whose task is to distribute good and ill fortune among mortals and also to determine the lifespan of each individual.* Often they arrange things so that this apportioning occurs randomly, in other words according to what the Greeks looked upon as the higher justice: after all, in life's lottery we are all equals; there are no favorites, no special passes. . . . Finally, there is a group of goddesses whose names evoke harmony: these include the Three Graces, goddesses of such things as charm, beauty, creativity, and so forth.

We can therefore see quite plainly what this second marriage of Zeus signifies: *just as it is not possible to be ruler of the gods and master of the universe by brute force alone without the aid of intelligence as symbolized by Metis, so, too, it is impossible*

*According to myth, the Moirai are three sisters—Clotho, Lachesis, and Atropos—who decide the span of each individual life by means of a thread that the first goddess spins, the second measures, and the third cuts at the moment of death. In Latin the Moirai were called the Parcae.

to assume these responsibilities without invoking justice—in other words without Themis, the second wife of Zeus, who will be as indispensable to him as the first. In other words—and contrary to Cronus and Uranus, his father and grandfather—Zeus understands that he who would rule must exercise justice. Even before the end of the war against the Titans, moreover, he already promises those prepared to join him in the fight against the first gods that the division of the world will be carried out with fairness, in a harmonious and equal manner. Those who already enjoy privileges will retain these; those who lack privileges will be granted them. Hesiod gives the following account of Zeus's decision:

> The Olympian Zeus, great Lightener, called all the immortal gods to Olympus, and said that whoever of the gods would fight the Titans with him, he would not withdraw from them any of their privileges, but each would keep the honour he had held hitherto among the immortal gods. And he added that whoever was unhonoured by Cronus, and unprivileged, he Zeus would set him in the path of honour and privileges, as is right and just [*Themis*].

This is to say that Zeus proposes to all the gods an equal division of rights and obligations, of responsibilities and honors, the latter of which will subsequently be rendered to them by men in the form of cults and sacrificial offerings. For as we know, the Greek gods adore being adored, and they especially appreciate the fragrant odor of grilled meat prepared for them by mortals in the course of their magnificent "hecatombs," referring to due and proper sacrifices. Hesiod goes on to describe how Zeus determines to reward the Hundred-Handed Ones and the Cyclops, as well as those Titans who, following the example of Oceanus, chose not to league against him with Cronus. In particular, Oceanus has the good sense to persuade his daughter Styx—

the goddess who is also the river that runs through the underworld (once more, a deity is coterminous with a piece of the physical cosmos) to join Zeus's camp together with her children, Kratos and Bia, god of power and goddess of force. In recompense for which, Styx will be honored eternally and her two children will bear the greater honor of forever remaining by Zeus's side. Without going into too much detail, this whole episode shows Zeus's understanding that a durable cosmic settlement must be founded on justice: *to each must be allotted his fair share, and it is only by such means that the order established will remain stable.* To maintain power requires justice and intelligence as well as force. Not only are the Cyclopes and the Hundred-Handed Ones needed, but so, too, are Themis and Metis.

The birth of Typhon and his struggle against Zeus: maximal threat, but also a chance finally to bring life and time into equilibrium

You would think that by now they have all had enough of warfare. Not by a long shot, however, for a formidable adversary lies in wait for Zeus: namely Typhoeus or Typhon (Hesiod gives him both names), born of Gaia and her union with the dreadful deity Tartarus. Of all monsters, this is the most terrifying. To start with, out of his arms there spring a hundred serpent heads whose eyes flash fire. In addition, Typhon possesses something even more terrible: from these heads issue voices that give out every kind of indescribable sound. For they can speak all languages: they can talk to the gods intelligibly, but equally bellow like a bull, or roar like a lion, or—worse, because the contrast is so appalling—

imitate the adorable yappings of a young puppy! In short, this monster has a thousand facets, symbolizing his proximity to chaos. As Hesiod intimates, were he to carry the day against Zeus and become master of mortals and Immortals alike, no power will ever again be able to challenge him. The resulting catastrophe is easy to imagine: with Typhon, the forces of chaos threaten to triumph once and for all over those of the cosmos, disorder over order, violence over harmony.

But the question remains: Why Typhon? How do we explain why he is aided by Gaia, who has always taken the side of Zeus—who saved him from his father, Cronus, who warned him of the risks in having a son who might usurp him in turn, who gave him the idea of swallowing Metis and, moreover, advised him (so judiciously) to set free the Cyclopes and the Hundred-Handed Ones if he wanted to win the war against the Titans . . . Why would this kind and loving grandmother wish at this stage to harm her grandson by unleashing against him an appalling purpose-built monster in league with the dreadful Tartarus? The reason is not clear. Hesiod tells us absolutely nothing concerning the motives of mother earth.

We can, however, risk two plausible hypotheses: the first and more obvious explanation is that Gaia is unhappy with the fate Zeus has visited on her elder children, the Titans, by incarcerating them in the pit of Tartarus. Even if she has not always looked out for them, they are her children, and she cannot merely resign herself to the dreadful end assigned to them. This is true, no doubt, but there is something unsatisfying about a merely psychological explanation: after all, this is a serious business; we are talking about the creation of the world, the cosmos itself, and moods or scruples do

not really enter into it. A second hypothesis is more likely: if Gaia created Typhon to confront Zeus, it is because the forces of disorder and chaos needed to be harnessed in order for the world to be brought into equilibrium. By unleashing this new monster, *Gaia will in effect give Zeus the chance to integrate the forces of chaos into the cosmic order once and for all.* In this sense, what is at issue in this episode is not merely the seizure of political power, as has so often been remarked, but cosmology as such. What Typhon incarnates, therefore, is nothing less than time, history, life itself. Cosmos and chaos must be fused—this is undoubtedly what Gaia intends, *for if the "forces of order" triumph entirely, the world will be completely rigid and devoid of life.*

In Hesiod, the account of the combat between Typhon and the Olympians is therefore central, albeit briefly and summarily described: we learn only that the struggle is terrifying, of unimaginable violence, that the earth is shaken to its Tartarean foundations, to the point that Hades himself—lord of the underworld, who inhabits its profoundest depths—trembles, as do the Titans, Cronus foremost, who have been incarcerated in this hell since they lost their struggle against the Olympians. We also learn that, as a result of Zeus's thunderbolts and the fire breathing of Typhon, the earth catches fire, is transformed into lava, and runs like molten metal. All of this has significance, of course: the poet wants to make his audience understand that what is at stake in this fearful combat is nothing less than the cosmos itself. With Typhon, the entire universe is threatened in its harmony and structure. But in the end Zeus will carry the day, thanks to the weapons the Cyclopes have given him: thunderbolt and lightning flash. One by one, the heads of Typhon are scorched on every side, and the monster is sent packing to where he belongs: Tartarus!

As Jean-Pierre Vernant has correctly insisted, it is not without relevance that Hesiod's terse account is embroidered and heightened by subsequent mythographers. Given what is crucially at stake in this final episode in the construction of the world—a case of knowing which will triumph, ultimately, chaos or order, but also of understanding how life itself is brought within the realm of order, and time integrated into an everlasting equilibrium—it is hardly surprising that this theme became elaborated in later tellings and retellings. If Typhon triumphs, the construction of a just and harmonious cosmos is a lost cause. If Zeus obtains victory, on the contrary, justice will reign over the universe. With the stakes so high, it would be truly surprising, even disappointing, not to have a more beefed-up account of this conflict—something a little more cliff-hanging and dramatic than what is in truth the somewhat bare account in Hesiod. Later mythographers therefore gave themselves wholeheartedly to the story, and it is interesting to trace the successive elaborations in two texts that, each after its fashion, attempted to synthesize preceding versions of the story.

The first of these works is titled *The Library* of Apollodorus. I should say something about the title and about the author, since we will have frequent recourse to them, and there is room for confusion here. Firstly, the word "library" generally does not refer to a single book but rather to a place—a room, shelves—where books are stored. Moreover, if we look at the origins of the word, this is entirely correct: in Greek *theke* means a chest or box in which something is deposited, in this case books (*biblios*)—hence (in French) *bibliothèque*, or "library." However, the word "library" was often used figuratively, to mean a compendium that, by analogy with a piece of furniture, contains within itself all that is known about a particular subject—which exactly describes the *Bib-*

liothèque, or *Library*, of Apollodorus, in whose pages we find a sort of digest of all the available mythological knowledge of the age. It is, therefore, a work that summarizes many other works, which is why it has come to be known as a library. The second crux: it was believed for a long time that this work, an indispensable source for Greek myth, had been compiled in the second century BC, by one Apollodorus, a scholar, grammarian, and mythographer. We now know that this is by no means the case, that *The Library* was probably compiled in the second century AD (rather than BC), by an author who is therefore quite other than this Apollodorus, and about whom we know precisely nothing. And since we know nothing of him, and because old habits die hard, we continue today to refer to "*The Library* of Apollodorus," even though it is not a library and it was not compiled by Apollodorus! The work is no less precious for our purposes, however, since its author—whoever he was—had access to texts that are now lost, any distant recollection of which we owe to him.

But let us return to our story, and to the version given by our "pseudo"-Apollodorus. In his account, the suspense is already a lot more drawn out than in Hesiod. What in the theater is called dramaturgy, in other words the staging of the action, is also more intense because, at the outset, contrary to what occurs in Hesiod, it is Typhon who succeeds in bringing down Zeus. The unfortunate Zeus, as we shall see, literally "loses his nerves." In effect, Typhon, as we know, is a full-fledged monster, a being whose appearance is so terrifying that on seeing him the gods of Olympus themselves are overcome with panic. They take flight toward Egypt and, so as to pass unnoticed and avoid the fearful blows of Typhon, transform themselves into different animals—not, it must be said, one of their proudest moments. . . . Zeus, however,

stands his ground. Courageous as ever, he attacks Typhon with his thunderbolts but also, seizing him bodily, with a sickle—no doubt the same that his father, Cronus, used to cut off the sex of the unfortunate Uranus. But Typhon disarms Zeus and, using the sickle against him, manages to cut the tendons from his arms and feet so that the ruler of the gods, although not mortally wounded—which, being immortal, is of course impossible—is nevertheless completely incapacitated. Unable to move, he lies on the ground like the wreck of himself, closely guarded by Delphyne, a fearful she-dragon in the service of Typhon.

Fortunately, Hermes is at hand, and as you will see, it is not for nothing that he is, among other accomplishments, the god of thieves. In this instance he enlists the help of one Aegipan—probably another name for Pan, one of Hermes's sons, known as the god of flocks and shepherds. He is also said to have invented a flute with seven reeds that he called the syrinx, after the nymph of that name, with whom he fell in love but who transformed herself into a reed to escape his attentions. . . . Unlikely as it may seem, it is with the soft airs from this flute that Pan succeeds in distracting the attention of Typhon, during which time Hermes manages to steal back the divine sinews of Zeus, which he hastens to restore to Zeus's body. Upright once more, the latter resumes battle, launching himself in pursuit of Typhon, thunderbolt in hand. But here again external assistance is required. The three Moirai—daughters of Zeus and the goddesses who decide the destiny of men but also sometimes of gods, destiny being the law of the universe and therefore superior even to the Immortals—lay a trap for the monstrous Typhon: they give him a taste of fruits that they promise will make him invincible. In effect, these are drugs that destroy his strength, so that Typhon, enfeebled, is finally vanquished by Zeus. He

is struck down and incarcerated beneath Mount Etna, whose eruptions are meant to signify the final convulsions of this terrifying creature!

In order to give an idea of how these myths were being presented at this time—the second century BC—I will quote from the text of Apollodorus himself. Then we shall see how, three centuries later, in the hands of another mythographer called Nonnus, the same story has become substantially enriched and elaborated.

After reminding his audience of Gaia's indignation at Zeus's treatment of her firstborn children, our pseudo-Apollodorus gives the following account (as before, my own remarks appear in italics and between brackets):

> When the gods had defeated the giants, Gaia, whose anger was all the greater, had intercourse with Tartarus and gave birth to Typhon, in Cilicia. He was a hybrid between man and beast, and in both size and strength he surpassed all the other offspring of Gaia. Down to his thighs he was of human form, but of such prodigious size that he rose higher than all the mountains, and often his head even scraped the stars. With arms outstretched he could reach the west on one side and the east on the other; and from these arms there sprang a hundred dragons' heads. From the thighs downward he had massive coils of vipers, which, when they were fully drawn out, reached right up to his head and emitted violent hissings. He had wings all over his body, and unkempt hair springing from his head and cheeks floated around him on the wind; and fire flashed from his eyes. Such was Typhon's appearance and such his size when he launched an attack against heaven itself, hurling flaming rocks, hissing and screaming all at once, and spouting a great stream of fire from his mouth. When the gods saw him rushing at heaven, they took flight for Egypt, and when pursued by him they transformed themselves into animals. While Typhon was still at a distance, Zeus pelted him with thunderbolts, and as the monster drew close, struck

at him with an adamantine sickle, and as he fled pursued him closely as far as Mount Casion, which rises over Syria. And there, seeing that Typhon was severely wounded, he grappled with him in hand-to-hand combat. But Typhon enveloped him in his coils and held him fast; and wresting the sickle from him, he cut the tendons from his hands and feet. And raising him on his shoulders, he carried him through the sea to Cilicia, and put him down again when he arrived at the Corycian cave [*the grotto where Typhon lives*]. Likewise he placed the tendons there, hiding them in a bear's skin, and set to guard them the she-dragon Delphyne, who was a half-beast and half-woman. But Hermes and Aegipan made away with the tendons and fitted them back into Zeus without being observed. When Zeus had recovered his strength, he made a sudden charge from heaven, on a chariot of winged horses, pelting Typhon with thunderbolts and pursued him to the mountain called Nysa [*this will also be the birthplace of Dionysus, whose name signifies "god of Nysa"*], where the Fates tricked the fugitive, persuading him that if he tasted the ephemeral fruits he would be strengthened thereby. Coming under pursuit once more, he arrived in Thrace, and joining battle near Mount Haimos, he began to hurl entire mountains. But when these were thrust back on him through the force of the thunderbolts, a stream of blood gushed from him onto the mountain, which is said to be why it was called Haimos, "the bleeding mountain." And when he started to flee across the Sicilian sea, Zeus hurled Mount Etna at him, which lies in Sicily. This is a mountain of enormous size, and there rise up from it, even to this day, eruptions of fire that are said to issue from the thunderbolts hurled by Zeus. But that is quite enough on this matter.

This text shows clearly enough how mythical subject matter was treated at this period. There is, in effect, sufficient "sensational" detail so that storytellers could embroider around the basic narrative, thus keeping their audiences on tenterhooks.

We find the same basic scenario, but infinitely more developed and enriched with anecdotes and dialogue, in the hands of our second author, Nonnus of Panopolis, in a lengthy work of mythography titled the *Dionysiaca*, whose two opening cantos are devoted to the combat between Typhon and Zeus. Nonnus is known above all for this epic poem, which is mostly concerned with the adventures of Dionysus (as its title suggests). The work was written in Greek, in the fifth century AD—thus three centuries after *The Library* of Apollodorus and ten centuries after Hesiod, which gives some idea of the time required to constitute what we read today as "Greek mythology," as if this were a single work rather than the accumulation of many sources and versions. The text of Nonnus is particularly precious for our purposes since it constitutes a veritable trove of information about Greek myths.

In Nonnus, the account of Typhon and Zeus is slightly different from that of Apollodorus. Principally, as we shall see, it is richer, more intense and more dramatic. Nonnus constantly underlines what is at stake "cosmically" in this conflict—with a luxuriance of detail that tells us a great deal today about how these myths were understood by contemporary audiences. For Nonnus, there is no doubt that the survival of the cosmos literally depends on the outcome of this conflict: if Typhon wins, the Olympian gods will be categorically subjected, one and all, to the usurper—who will assume the place of Zeus, to the point of seating himself next to Zeus's wife, Hera, whom Typhon has always coveted, hoping to take her from Zeus.

But let us look more closely at how the story unfolds in Nonnus's account.

As in Apollodorus, the gods of Olympus are at first overtaken by fear at the sight of Typhon and, as in Apollodorus, they

flee—literally terrified. And in this account, too, Zeus "loses his nerves": his tendons are severed and hidden in a place known only to Typhon. But here it is no longer Hermes who plays the principal role in the comeback of Zeus. Instead, Zeus himself conceives a plan of battle and enlists the help of Eros—who has the ear of Aphrodite—and Cadmus, the wily king and legendary founder of the city of Thebes, who is also brother to the beautiful Europa, whom Zeus has just abducted by transforming himself into a bull. To recompense Cadmus for the services he will render to Zeus, the latter promises to him in marriage the ravishingly beautiful Harmonia, herself none other than the daughter of Aphrodite and Ares, god of war. He also promises Cadmus a supreme honor: that the gods of Olympus will be present at his wedding (note in passing how all these stories are interwoven, for it is one of the daughters of Cadmus and Harmonia, Semele, who will fall in love with Zeus and give birth to his son Dionysus).

The stratagem dreamed up by Zeus deserves close attention, as it indicates the cosmic scale of the struggle against Typhon. In effect, Zeus asks Cadmus to disguise himself as a shepherd. Armed with the syrinx of Pan, that superb instrument that produces the most enchanting sounds, and assisted by Eros, Cadmus plays music so soft and so seductive that Typhon falls under its charms. Typhon now promises Cadmus a thousand things (including the hand of Athena) if only he will keep playing, and likewise play at the forthcoming wedding of Typhon and Hera—Zeus's wife, whom Typhon still counts on making his own just as soon as he has dealt with her illustrious husband. Certain of himself, Typhon walks into the trap and falls asleep, lulled by the panpipes. Cadmus can now recover the sinews of Zeus, who fits them back and is now ready and able once again to seize victory.

This version of events, as I have said, is highly significant.

Worth noting especially is that it is through music—the cosmic art above all others since it relies entirely upon a structure of sounds that must, so to speak, "rhyme" or accord with one another—that the cosmos is saved. This is also underlined by the fact that the victory prize, for Cadmus, is indeed the hand of Harmonia herself.

Here again, I prefer to cite the original text so that you can hear for yourself the terms that Zeus employs to invite Cadmus and Eros to set the trap for Typhon:

> "Look alive, Cadmus, pipe away and there shall be fine weather in heaven! Delay, and Olympus is scourged, for Typhon is armed with my heavenly weapons . . . [*as well as possessing the sinews of Zeus, Typhon has in effect stolen his thunderbolt and lightning flash, which, as you may imagine, Zeus is anxious to recover as quickly as possible*]. Become a herdsman just for one day; make a tune on your sorcerous shepherd's pipes, and save the Shepherd of the Universe [*i.e., Zeus, master of the universe, speaking of himself in the third person*]. . . . Bewitch Typhon's wits by the sovereign remedy of your coaxing pipes and their melodies! I will give you ample recompense for your service, two gifts: I will make you saviour of the world's harmony, and husband of Harmony. You also, Eros, life principle and patron of fecund marriages, bend your bow, and the universe is no longer adrift [*for Typhon, charmed not merely by the music but also by the arrows of Eros, will fall into the trap prepared for him, thereby allowing the world to be saved*]."

It is indeed the cosmos itself, in its entirety, that appears at this point to be menaced with destruction by Typhon and that must be saved, through Zeus, by the music the goddess Harmonia will bring to her marriage with Cadmus. So Cadmus plays the flute, and Typhon, the measureless brute, falls beneath its charms like a mere girl. And, as we have said, he makes a thousand promises to persuade Cadmus to accompany his triumph on the day of his wedding to the

wife of his immortal enemy. And Cadmus leads him into the trap: he proposes that with a different instrument, the lyre, which is a stringed instrument, he might play far superior music than is possible with the flute of Pan. He would even surpass Apollo, the god of musicians. Quite simply, what he needs are strings, if possible made out of divine tendons, which can be tuned to a pitch for true music making! The lyre being an instrument capable of harmony, in the exact sense: unlike the humble flute, several strings can be played simultaneously, and consequently, chords can be played that "accord" several different sounds at the same time. The lyre can therefore be regarded as the more "harmonious" instrument and, in this sense, as more "cosmic" than the flute, whatever its other merits (we shall encounter this opposition between melody and harmony again in the story of Midas). Of course, the stratagem devised by Cadmus is aimed at recovering the tendons of Zeus:

> He finished; and Typhon bowed his flashing eyebrows and shook his locks: every hair belched viper-poison and drenched the hills. Quickly he ran to his cave, brought out the sinews of Zeus, and handed them to the crafty Cadmus as a gift of hospitality, those sinews which had fallen to the ground in the battle with Zeus. The guileful shepherd thanked him for the immortal gift; he handled the sinews carefully, as if they were later to be strung on his harp, then hid them in a hole in the rock, kept safe for Zeus giant-slayer. Then with pursed-up lips he let out a soft and gentle breath, pressing the reeds and muting the notes, so as to sound a melody more seductive than ever. Typhon pricked up all of his many ears and listened, and knew nothing. The Giant was bewitched, while the counterfeit shepherd piped by his side, as if sounding the rout of the Olympians with his pipes; but he was celebrating the imminent victory of Zeus, and he sang the death of Typhon to Typhon sitting by his side.

As soon as Zeus is on his feet again, warfare resumes, menacing even more than earlier the entire cosmic order:

> The earth's hollows were revealed, as the monster's missiles cleft it often. Doing so, he freed a liquid vein, and as the chasm opened, the subterranean channel bubbled up with flooding springs, pouring out the water from under the uncovered bosom of the earth. And rocks were thrown up, falling from the air in torrential showers which were hidden in the sea. . . . And from these hurtling masses of earth new islands were born, which rooted themselves spontaneously in the sea. . . . Already the foundations of the steadfast cosmos are shaking under Typhon's hands. . . . The indissoluble bonds of harmony are dissolved. . . .

In a manner that helps us vitally to understand the meaning of this whole narrative, the goddess Nike (meaning "victory"), who accompanies Zeus and is yet another direct descendant of the Titans, declares, in her terror, to the master of Olympus:

> "Even if I am called a Titanid [*which is to say the daughter of a Titan*], I wish to see no Titans reign on Olympus, but you and your children."

This perfectly illustrates, once more, what is at stake: If Typhon wins, the forces of chaos—such as animated the earliest divinities—will carry the day, and the cosmic idea will be extinguished once and for all. Furthermore, when Typhon launches into battle he makes no bones about desiring this outcome, as is seen in the way he mobilizes his "troops," namely the innumerable limbs that form his own vast body. He does not hesitate to command them to destroy all order, and even to declare openly that when the conflict is over he will set free those gods of chaos incarcerated by Zeus in the pit of Tartarus, starting with Atlas, one of the sons of the

Titan Iapetus, who is said to carry the entire cosmos on his shoulders—just as he will likewise free Cronus:

> "Smash the house of Zeus, O my hands! Shake the foundation of the universe, and the blessed ones with it! Break the divine bar of Olympus, which turns of its own accord! Drag down to earth the heavenly pillar, let Atlas be shaken and run away, throwing down the starry vault of Olympus, and fear no more its circling course. . . . And cannibal Cronus, eater of raw flesh [*who devoured his own children*], I will drag up once more into the light, who is also my brother [*they are all in effect descendants of Gaia and of the gods of Chaos*] to help me in my task, out of the underground abyss; I will break those constraining chains [*just like Zeus, who had freed the Cyclopes and the Hundred-Handed Ones, Typhon has grasped that he, too, needs to make allies*]. I will bring back the Titans to the Ether [*i.e., into the light of heaven, which contrasts with the shades of Tartarus*], and I will settle under the same roof as myself, in the sky, the Cyclopes, those sons of Earth. I will make them forge new weapons of fire; for I need many thunderbolts, because I have two hundred hands to fight with, not a paltry single pair like the Cronides [*which is to say Zeus—Cronides signifying merely 'son of Cronus'*]."

Observe how transformed the story has become since Apollodorus, but also how "logical," so to speak, and how significant these transformations are. For example, Cadmus rather than Pan is now the key figure. At the same time, they are as alike as brothers: Pan is the god of shepherds and inventor of the pipes; Cadmus disguises himself as a shepherd, and it is by means of these pipes that he will outwit Typhon. It is easy to imagine how, in the course of telling and retelling the same stories, more by oral transmission than by written word, such transformations would have occurred.

In the end, of course, as in Hesiod and as in our pseudo-Apollodorus, victory is granted to Zeus. More so than his

precursors, though in the same spirit, Nonnus lays emphasis above all on the fact of harmony restored, and the reversion to a cosmic order that was so threatened during the conflict. The great morsels of earth, like the stars in the sky, will find their proper places again, and nature will position them in harmonious relation to one another once more:

> After which, Nature—who governs the universe and regenerates its substance—closes up the gaping rents in earth's broken surface. She seals once more with the bond of indivisible joinery those island cliffs which had been rent from their beds. No longer is there turmoil among the stars: the Sun puts back the flowing-maned Lion, who had been dislodged from the path of the Zodiac, in position beside the Maiden who holds the corn-ear; the Moon-goddess takes the Crab, now crawling over the forehead of the heavenly Lion, and fixes him in place once more, opposite cold Capricorn.

Or, to put the matter plainly, everything is restored again, and the stars are back in their original position, so that Zeus can keep his promises and celebrate the marriage of Cadmus and Harmonia. . . .

But what remains of Typhon? The answer is that what remains of him are two scourges for humans to endure, and here Nonnus is completely faithful to Hesiod. On the sea there are those hurricanes or tempests called "typhoons," which is to say ill winds against which unfortunate mortals can do nothing—other than perish, of course. And on land, there are the terrible storms that periodically ravage the crops men put all their care into cultivating. Which means, significantly, that it is essentially for the benefit of the gods, rather than for mankind, that the cosmos attains, from here on, a form of perfection. The forces of chaos are all under control, and any persisting minor disturbances are exclusively confined to the human sphere. As Jean-Pierre Vernant has

emphasized, by confining the residue of Typhon's harmful powers to earth, the gods signify their intention to export the dimensions of time, disorder, and death to the world of mortal men—the sphere of the Immortals being sheltered henceforth from any and all adverse weather. Which is to say that, in their eyes, all remaining imperfections in the order of things are secondary and superficial. Besides, if we reflect more deeply on the matter, it is not even certain that these are truly imperfections, for if there were no dimension of time, of history, and therefore not a modicum of disorder, of disharmony and disequilibrium, nothing would ever happen! A perfectly harmonious and balanced cosmos would be completely ossified. Nothing would move; everything would be condemned to total immobility; we would all be bored to death. In this sense, it is fortunate that there remains a portion of chaos, that the conquered and incarcerated Typhon should make himself heard from time to time: this is perhaps the ultimate significance of those columns of steam and those violent blasts of wind that persist after this final episode of the cosmogony.

If we follow Hesiod, we have now covered all the stages through which the Olympian gods pass to arrive at the creation of the cosmos. However, according to certain later traditions, for which Apollodorus as usual provides the echo, there is an intermediate stage between the Titanomachy and the war against Typhon—namely a "Gigantomachy," or "war against the giants." According to this version, in effect, Gaia, before "constructing" Typhon with the aid of Tartarus, had come to the rescue of the giants who revolted against the gods—and it was indeed because her children were annihilated by the Olympians that she created Typhon in retaliation. As I have said, there survives no trace of this Gigantomachy in the archaic accounts, neither in Hesiod

nor in Homer. The hypothesis, however, is not illogical: it fits well with the story of Typhon, or in other words with the idea that all the forces of chaos have to be progressively mastered, including those represented by the giants, before arriving at a balanced cosmos.

Which is why it is worth spending a moment on this famous quarrel.

The Gigantomachy: the combat of gods and giants

As we have seen, the giants are born of the blood of Uranus, which has been shed over the earth by his son Cronus. Thus they belong, like Typhon and like the Titans, to the most archaic circle of divinities, those who are still close to Chaos and who unceasingly menace the creation of that balanced, just, and harmonious order to which Zeus has vowed himself. For Hesiod, the construction of this beautiful universe is manifestly achieved with the victory of Zeus over Typhon. As I have suggested, however, certain later authors considered that it must first have been necessary also to muzzle the giants to arrive at a perfected cosmos. In thrall to that form of immoderate and literally deranged arrogance that the Greeks called hubris, the giants (on this account) decide to storm Olympus. The poet Pindar makes several allusions to this episode.[*] But as so often we have to wait until Apollodorus for a more detailed account of this war, although it is mentioned by the Latin poet Ovid (first century AD), whose *Metamorphoses* is one of the earliest sources to offer a coherent account of it. Both authors place the Gigantomachy

[*]Notably in the first Nemean ode, where he remarks that Gaia has warned the gods that they can only win this war with the help of two demigods, in this case Dionysus and Heracles.

before the struggle against Typhon. In Apollodorus, as I have said, it is because Gaia is furious at Zeus for bringing down the giants that she conceives Typhon, so as to ensure that the chaotic and Titanesque forces—of which she is also the mother—should not disappear totally in the interests of an immutable and motionless order.

It is in this perspective that we should read these two accounts, equally interesting and revealing of the problem posed by the need to integrate all of the anticosmic forces, without exception.

In Ovid, first of all: The struggle unfolds at a time when the earth is already peopled by a human race, the "race of iron"—an especially corrupt, disreputable, and violent crew. But Ovid adds that the higher regions of the Ether—in other words the summits of Olympus where the gods reside—are at this time no better off than the lower regions. No longer are they a safe haven, for the giants have decided to make themselves lords of everything, and as they are truly gigantic, they simply pile huge mountains on top of one another so as to make a sort of staircase allowing them to scale Olympus and besiege the gods! Ovid does not say much about the war as such, except that Zeus resorts to his favored weapon, the thunderbolt, to make the mountains fall upon the giants, who find themselves immediately buried under colossal masses of earth. Wounded, they lose great rivers of blood, and Gaia, anxious to prevent this race from being wiped out entirely—for they, too, are her children—produces from the mixture of blood and earth that flows from the rubble a new living species with a "human form," but which nonetheless exhibits a violence and taste for slaughter that recall its origins.

Apollodorus's account is more detailed. He describes, blow by blow, how each of the Olympian gods gets stuck into the

task of getting rid of the giants: Zeus, of course, but also Apollo, Hera, Dionysus, Poseidon, Hermes, Artemis, the Moirai, etc. The combat is of extreme violence, dreadfully bloody. To give an example, Athena is not content with slaying the giant named Pallas, but flays him alive to make out of his skin a sort of shield with which she protects her own body during the battle. As for Apollo, he shoots an arrow straight into the right eye of one of his adversaries while, for his part, Heracles places another arrow in the victim's left eye. In short, no quarter is given to the enemy. . . . Above all, in keeping with what Pindar suggests, the aid of a demigod is required in the struggle to categorically put an end to the giants: it is Heracles who, each time a giant is floored by a god, assists in finishing him off. . . . As always, however, force alone is not enough. Gaia, who plays her usual two-sided game—she wants the creation of a durable and balanced cosmos, but at the same time she does not want the primordial forces of chaos to be entirely eliminated—plots to help the giants by giving them an herb that will make them immortal. After all, the giants are her children and it is normal that she should protect them. But as always with Gaia, a deeper motive intervenes: without the forces of chaos, the world will be inert, a place where nothing will ever happen again. Balance and order are no doubt necessary, but if it is left to them alone, the universe will ossify. Therefore the other aspect of her legacy must also be preserved, which incarnates—even at the cost of violence—the principle of movement that is essential to all life.

Meanwhile Zeus, who is all-knowing, sees her coming and takes it upon himself—and here is a measure of his cunning and intelligence, his *metis*—to go and cut all the herbs of immortality that Gaia has caused to grow so that the giants have now lost all chance of victory. . . .

With this last episode, the cosmogony is complete. For this war was truly the final episode in the history of the construction of the world. After the death of the giants and the victory of Zeus over Typhon, the forces of chaos we have seen at work during the whole course of this primordial narrative are finally muzzled or—more precisely—integrated into the fabric of the whole and, in the literal sense of the phrase, "put into their place" beneath the earth. The cosmos is finally and solidly established. Clearly there remain, within the human world, some ill winds, occasional earthquakes, the odd volcanic eruption. But by and large, the cosmos is now erected on foundations that are built to last.

It remains for us to know what place we mortals are to occupy in this scheme of things. It remains to be seen likewise how we come into being, and why.

2

From the Birth of the Gods to That of Mortals

AT THE END OF this opening fresco, we have already learned
a number of things. Not only have the principal personages
of Greek myth, the gods of Olympus, already appeared
onstage, but the cosmos, the ordered and balanced universe
willed into being by Gaia and Zeus, is finally established also.
The forces of disorder and chaos, incarnated at least in part
by the Titans and (even more so) by Typhon and the giants,
have been brought to heel, either destroyed or sent down to
Tartarus and firmly incarcerated in the inmost depths of the
earth. Not only has Zeus demonstrated colossal force and
unprecedented intelligence during these various conflicts,
but he has, moreover, divided the universe impartially,
according to the claims of justice, so that each divinity knows
his rights and privileges, her roles and responsibilities. And
as Zeus is henceforth at once the most powerful, the most
cunning, and the most fair-minded of all gods, there is no
turning back: it is he who controls the cosmos, the guarantor
for all eternity of the harmonious, just, and beautiful order
that must henceforth rule all things.

From this primordial narrative, philosophically speaking,
three fundamental ideas can be deduced that we will need to
bear in mind so as to understand what follows. They are of
considerable interest in themselves, and besides, it is they that
covertly inform most of the great mythic narratives, which

resemble skillful, inventive, and colorful dramatizations of these abstract ideas—such that it is impossible truly to understand the adventures of Odysseus or Heracles or Jason, or the misfortunes of Oedipus, Sisyphus, or Midas, unless we grasp how these notions provide, so to speak, the underlying thread.

The first such thread is that the good life, even for the gods, should be defined as a life lived in harmony with the cosmic order. Nothing is higher than a justly conducted existence, in the sense that justice (in Greek: *dikè*) is first and foremost *aptness*, the condition of being at one with the organized and well-divided world that has emerged so painfully out of chaos. Such is henceforth the law of the universe, a law so fundamental that even the gods themselves must submit to it. For as we have seen, again and again, the gods are often far from reasonable. On occasion they even quarrel like children. When discord (*eris*) arises among them and, to settle their differences, one or another party begins to tell untruths—*in other words, to say things that are not just, that are not adjusted to the cosmic order*—they take a very big risk. . . . For Zeus can easily require them to swear an oath on the waters of the Styx, the divine river that flows through the underworld. And if their word conflicts with the truth, the erring divinity, however Olympian, is in a literal sense "put in his place": for an entire year, Hesiod tells us, he is "deprived of breath," recumbent on the ground, winded, voiceless. He is forbidden to lay hands on ambrosia or nectar, those divine foods reserved exclusively for Immortals. A "trance" takes possession of him for the whole year, and when he has finished with this initial round of deprivations, he is still "deprived of Olympus," cut off from the other gods for nine whole years, during which he must accomplish various thankless and difficult tasks. For example, according

to some mythological sources, Apollo revolted against his father, Zeus, thereby threatening to overturn the order of the universe by undermining its very protector. For his punishment Apollo is reduced to slavery and placed in the service of an ordinary mortal, as it happens a king of Troy, Laomedon, whose flocks he must watch like any common herdsman. For Apollo has committed hubris, a cardinal concept of which I have already spoken and which can be translated in different ways—arrogance, insolence, pride, immoderation—all of which convey something of the meaning of this sin against the cosmic order or against those who have shaped it, starting with Zeus himself. "Hubris" describes someone who has lost his way, or who rebels to the point of no longer respecting the hierarchy and apportioning of the universe instituted after the war against Typhon and the Titans. And in these circumstances the god who has transgressed is "brought to order," like the commonest mortal, and is, so to speak, *rehabilitated* by the punishment imposed by Zeus. As you can see, not only does the law of the world, the cosmic justice deriving from the original settlement, apply to all beings, mortal or immortal, but also the corollary is that nothing is ever settled: discord is an ever-present menace. It may come from any direction, even from Apollo or some other god who loses his way through overweening passion, so that the work of Zeus and of the various heroic figures who pursue the ends of Zeus is never fully achieved, which in turn is why these mythological narratives are potentially endless. There is always a disorder to set right, a monster to combat, an injustice to correct. . . .

The second idea proceeds directly from the first. It is merely the reverse side of the same proposition: if the construction of a cosmic order is the most precious conquest of the Olympians, then it follows that the greatest sin that

can be committed, for the Greeks, and one that the whole
of mythology continuously diagnoses, is none other than
this celebrated hubris—this proud immoderation that pushes
individuals, whether gods or men, to step outside their place
in the scheme of things. In essence, hubris is finally none
other than the return of the dark forces of chaos or, to speak
like a latter-day ecologist, a "crime against the cosmos" as
such.

By contrast—and this is the third idea—the greatest virtue
is *dikè*, or justice, which is defined in exactly opposite terms as
a state of accord with the cosmic order. We all know that on
the temple at Delphi—the shrine to Apollo—is inscribed one
of the most famous mottoes in the whole of Greek culture:
"Know Thyself." The injunction has nothing to do with
practicing what is called introspection, as is sometimes assumed
today—in other words the attempt to know your innermost
thoughts and unmask your unconscious self. It is not a question
of psychoanalysis. The meaning is quite other: that you should
know your limits. To know yourself is to know your "natural
place" in the cosmic scheme. The motto invites us to find
this just place within the great All, and especially to remain
in it, to avoid sinning through hubris, through arrogance
and immoderation. The injunction is often associated with
another—"Nothing to Excess"—also inscribed in the temple
at Delphi, and which has the same sense.

For mortals, the greatest hubris consists in defying the
gods or, worst of all, in taking oneself for their equal. In-
numerable mythological stories, as we shall see, turn upon
this central question. One example, among others, is a ver-
sion of the famous myth of Tantalus: Because he is in the
habit of visiting the gods, and of being invited to their table
on Mount Olympus, Tantalus ends by telling himself that
he is not after all as different from them as might be imag-

ined. He even begins to doubt that the gods, starting with Zeus, are in truth as clairvoyant as they claim to be and, in particular, that they really know everything about mortals. So he invites some of them to dine at his home—already a singular lapse of taste, but which might pass at a pinch were the invitation made in all humility and modesty. But the contrary is the case: to assure himself that they are not omniscient, nor more knowing than he, Tantalus tries to deceive them in the worst possible manner, by serving them as a repast none other than his own son Pelops! No chance: the gods are indeed omniscient. They know everything about us poor mortals—in which respect Tantalus has strayed further than can easily be imagined. They are immediately aware of his paltry and sinister maneuver and are disgusted by it. The punishment, as always in classical myth, fits the excesses of the crime. Is it by means of food that Tantalus has sinned? Then this is how he shall be punished: chained in the underworld, in the pit of Tartarus, he is condemned to suffer from hunger and thirst for eternity—but also from terror, since an enormous rock suspended just above his head threatens unceasingly to fall and crush him to inexistence—just to remind him that he is not immortal after all. . . .

The *cosmos*, harmonious order of things; *dikè*, or justice, which is to say agreement with the order of things; and *hubris*, resistance, the acme of disaccord or immoderation: these are the three passwords of the philosophical message that begins slowly to emerge from Greek myth.

However, we are still very far from having exhausted the meanings of this message. We are still at the stage of abstractions, so primitive and rustic that they might give an impression that Zeus is a sort of superrepresentative of officialdom, if not a traffic policeman: cosmos against chaos, civility against brute force, and so on. We shall need to

complicate this picture little by little, in stages, and for one simple reason: this entire history so far has been narrated exclusively from the perspective of the gods. In other words, at the point we have so far reached human beings do not yet exist, and therefore have yet to be allotted their place in this well-regulated system set on course by the Immortals alone. The single most profound question that mythology now begins to confront, and that it will then pass on to philosophy, has a double aspect. First of all, why mankind? Why on earth, so to speak, do the gods feel the need to create a humanity that, without any doubt, will immediately introduce a significant quantity of disorder and confusion into this hard-won cosmos of theirs? And secondly, if we reverse the perspective and look at the matter from our own mortal standpoint (and we must keep reminding ourselves that all these myths were after all, and without exception, devised by us mortals: by Homer and Hesiod and Aeschylus and Plato and the rest!), how does mankind see itself as fitting into the vision of the world that is slowly emerging from this majestic structure? What place or room is there for us in this universe of gods, in this cosmic order that seems ordained expressly for them rather than for us mere mortals? More fundamentally, how should each individual conduct himself, given his or her peculiarities, tastes, shortcomings; given his or her familial, social, and geographical context; in brief, given everything that makes us singular? . . . How should each life be led, if we are to find a little happiness and a little wisdom in this divinely appointed whole?

It is in response to these questions that the myths narrated in this chapter attempt to provide a response: the myth of the golden age, or that of Prometheus, with its profound consequences for us mortals; the appearance on earth of Pandora, the first woman, who will turn all our destinies

upside down. . . . But before coming to these core narratives, and by way of farewell to abstractions, I will give an initial example of the three ideas we have been considering, by looking at the extraordinary tale of Midas, after which we can return to our theme and take up the story of the creation of humanity, in all its strangeness.

The myth of Midas is, at least on the surface, pure comedy: one of those myths where hubris, or immoderation, vies with plain stupidity. As a result, most works devoted to Greek mythology pass over it in silence, or regard it as so unimportant that they mention it only in passing, as a fabliau without much import or significance. As we shall see, however, this is gravely mistaken: the Midas affair (as we would refer to it today) is on the contrary as profound as one could wish, provided of course that we take the trouble to see it in terms of the cosmological context that I have been describing.

I. Hubris and cosmos: King Midas and "the golden touch"

Midas is a king. More precisely, he reigns over a region named Phrygia. Some say he is the son of a goddess and a mortal. Possibly so, but what is clear is that Midas is not a very bright king. He is even, to speak plainly, an arrant fool. He thinks too slowly, "after the fact," too late. He acts without reflecting, and his stupidity, as we shall see, gets him into some dreadful scrapes.

The affair that interests us begins with the misadventures of another important character in Greek myth: Silenus, an inferior god, a secondary divinity, although nonetheless a son of Hermes (and a brother of Pan, according to some

sources). Reference is sometimes made to "a silenus" to designate anyone of his stock. He possesses two remarkable characteristics. Firstly, his appearance is such as to frighten small children. He is of scarcely credible ugliness: large, fat, bald, and potbellied, he sports a monstrously flattened nose and horse's ears, pointed and hairy, which give him a terrifying aspect. Aside from that he is a sensible and intelligent being. It is not for nothing that Zeus confides to him the education of his son, Dionysus, after delivering the latter from his own thigh. Having become, over the course of time, the companion of Dionysus, whose foster father he has been, Silenus has been initiated into the profoundest secrets of the god of wine and feasting, and is as a result an authentic sage . . . with the exception that, as part of the motley crew of roisterers who accompany Dionysus at all times, he sometimes goes heavy on the libations and abuses the bottle. Put differently, at the point where our story begins, Silenus is as drunk as a lord or, if you prefer, incapable of remembering his own name. As Ovid puts it—whose account I follow in the main—Silenus staggers under the double burden of age and wine, and when Midas's followers come upon this inebriated and fearful-looking down-and-out, they lose no time in arresting and binding him with sturdy creepers so as to lead him straight to their master.

But it so happens that Midas, himself no stranger to orgies and other such generously fueled occasions, recognizes Silenus. And since he is well aware of the latter's connections, both of family and of friendship, with Dionysus—a powerful god whose wrath is better avoided—he immediately orders the release of Silenus. What is more: in the hope of drawing down the favors of the god, he marks the presence of his guest, as befits the occasion, with lavish feasting that goes on for ten days and ten nights. At the end, Midas restores his

new best friend to the young but very powerful Dionysus. The latter, in gratitude, naturally offers Midas a reward of his own choosing: "a desirable but dangerous gift," as Ovid nicely puts it, because, as I have remarked already, Midas is not very bright. Moreover, he is avaricious and concupiscent. So inevitably he is going to abuse the generosity of the god—which is where the hubris starts. Midas comes up with an exorbitant demand, quite out of proportion: he asks the god to arrange things so that everything he touches turns instantly to gold! The famous "golden touch." Imagine for a moment what this actually means: wherever he lays his hand, whatever he brushes against—whether vegetable, mineral, animal, or human—is instantly transformed into the precious yellow metal. . . . At first the imbecilic Midas is delighted, mad with joy. Like a child, on the road back to his palace he amuses himself by turning everything he encounters into gold. He sees an olive branch and, *pop!*—the beautiful green leaves turn to a tawny glittering orange! He picks up a stone, or a miserable lump of earth, or he pulls a few dry ears of corn, and all is ingots! "Rich, I am rich, I am the richest man in the world!" the poor fool keeps exclaiming, still without any inkling of what lies in store for him.

For, as you have no doubt already guessed, what Midas takes for an absolute good turns out to be a deadly ill— literally so, bringing death and signaling the end of his idiot contentment. In effect, as soon as Midas is back in his by now sumptuous palace—whose walls and furnishings and floors he has obviously paved with shimmering gold—he asks to be brought food and drink. His joy has given him an appetite. But at the moment he grasps the goblet of cool wine to quench his thirst, his mouth fills instead with a nasty yellow powder. For gold is not good to drink . . . and when he seizes a leg of chicken handed to him by a

servant and begins to eat with gusto, it nearly breaks his teeth! Midas now understands, a little late in the day, that he cannot rid himself of his new gift, and that he is plainly going to die of hunger and thirst. So he begins to curse all this gold that surrounds him, detesting it, just as he begins to detest the greed and stupidity that drove him to act without thinking of the consequences. Very fortunately for Midas, however, Dionysus (who has, of course, foreseen everything) is magnanimous. He agrees to relieve him of this gift that has become a curse. Here, according to Ovid, is how he addresses Midas:

> "You cannot remain encased in the gold which you have so foolishly desired. Go to the stream which flows by the mighty town of Sardis, pick your way climbing the slope, up the tumbling stream, until you come to the river's source. There plunge your head and body beneath the foaming fountain where it comes leaping forth, and by this means wash your sin away." The king went to the stream as bid. The power of his golden touch imbued the water and passed from the man's body into the source. And even to this day, receiving the seed of the original vein, the fields are hard and yellow, their soil soaked with water of the golden touch.

It is by bathing in the river that Midas recovers his normal condition. A richly symbolic moment: from the pure water of the river he is cleansed equally of his gold and of his folly. But the river itself will remain forever affected: it is claimed that, since this time, it continues to carry magnificent nuggets of gold. And the river is named the Pactolus, which even today remains in some languages a byword for treasure and good fortune.

However, I am not convinced that, from this distance in time, we can still make out the true meaning of this myth. Our modern temperament, marked by twenty centuries of

Christianity, leads us to see the fable as signifying broadly that Midas sinned above all through avarice or concupiscence. For us, the moral of the story can be summarized roughly thus: Midas mistakes appearance for essence, and believes that riches or gold, together with the power and possessions they confer, constitute the ultimate end of human life. In which respect he confuses having with being, and appearance with truth. For which he is rightly punished. All well and good. But in reality the Greek myth goes much further. It possesses, albeit covertly, a cosmic aspect that is not remotely contained by the pious commonplace that "money does not equal happiness."

With his golden touch, in effect, Midas became a sort of monster. Potentially it was the whole cosmos that he menaced: everything he touches dies, for his terrifying power converts the organic into the inorganic, the living into the inanimate, no less. He is in a sense the obverse of a creator of worlds, rather a sort of antigod, even a positively demonic figure. Leaves, branches, flowers, birds, the animal world at large—whatever he touches ceases to fulfill its place and function in the order of the universe, with which, until that instant, it existed in perfect harmony. It suffices for Midas to brush past them and they change their nature, and his destructive power is potentially infinite, without limits: no one can say where it might have ended. The cosmos as such might have found itself altered for the worse: imagine Midas traveling, and managing to transform the world into a gigantic metal ball, gilded but dead, totally deprived of those qualities that the gods had succeeded in conferring upon it at the outset, when the primordial settlement was made by Zeus after his victory over the combined chaos of Titans, giants, and Typhon. . . . The progress of Midas would be the end of all life and of all harmony.

If we must apply a Christian analogy, it needs to probe a lot deeper than we would initially think. Like the myth of Frankenstein, which takes its inspiration from German legends of the sixteenth century, the misadventures of King Midas in truth tell us a story of tragic dispossession.

Dr. Frankenstein, too, wanted to become the equal of the gods. He dreamed of giving life, like his creator. He spends his entire existence trying to revive the dead. And one fine day he succeeds. He collects cadavers, stealing them from the hospital morgue, and, drawing electricity from the sky, manages to galvanize the monster he has put together from decomposing corpses. At the start all goes well, and Frankenstein takes himself for a medical genius. But the monster takes on a life of his own, little by little, and manages to escape. Because of his abominable appearance, he sows terror and destruction wherever he goes, and in reaction he himself becomes nasty and threatens to lay waste to the land and its inhabitants. Tragic dispossession: the creature escapes from his creator, who is in turn frustrated. He has lost control—which, of course, in the Christian perspective, which dominates this story, signifies that the man who takes himself for God is heading for catastrophe.

It is in an analogous sense that we must understand the myth of Midas, even if the gods (multiple gods since we are talking about the Greeks) are not Christian. Midas, like Frankenstein, wants to acquire divine powers through his golden touch, straying far from any human wisdom (and far beyond his own somewhat challenged abilities): in effect he desires the power to overturn order. And like Dr. Frankenstein, he soon loses all control over his newly acquired advantages. What he thought himself in control of escapes him at every turn, so he is compelled to beg the gods, in this case Dionysus, to be turned back into a simple mortal again.

It is significant that this same threat—of chaos engendered by hubris—propels the sequel of the Midas myth, and this time the poor simpleton will be severely punished by Apollo.

How Midas received his ass's ears: a contest between Pan's flute and Apollo's lyre

Let us take our lead, once again, from the account given by Ovid.

It would seem that Midas has calmed down after the humiliating and disastrous business of the golden touch. He seems finally to have learned some humility, if not modesty. Far from the splendor and riches that he hoped for from his gold, he now lives a retired life in the forest. Far from his sumptuous palace, he is content with rustic simplicity; in the fields and meadows he likes to wander alone, or sometimes in the company of Pan, god of forests and of shepherds. You should know that Pan bears a striking resemblance to Silenus and his attendant satyrs. He is, in point of fact, a god of literally shocking ugliness: those who come upon him are rooted to the spot, seized with horror by the fear known as "panic," which is named after Pan, as if in negative homage. In appearance, Pan is half man, half beast: covered in hair, horned, and bizarrely shaped, he sports the antlers and legs, or rather the hindquarters, of a goat. His nose is flattened, like that of Silenus; his chin protrudes; his ears are huge and hairy like a horse; his hair stands on end and is filthy, like that of a tramp. . . . It is sometimes claimed that his own mother, a nymph, was so terrified when he was born that she abandoned him. He was picked up by Hermes, who brought him to Olympus to show him off to the other gods—who (it is said) literally howled with laughter, amused beyond words by so much ugliness. Seduced by this deformity, Dionysus, who always likes what-

ever is odd and different, decided on the spot to make Pan one of his playmates and traveling companions at a later date. . . . Prodigiously strong and swift-footed, Pan passes most of his time chasing nymphs, and also young boys, whose favors he tries to obtain by all means to hand. It is even said that one day he pursued a nymph called Syrinx, who preferred to drown herself in a river rather than submit to his "advances." . . . In one version of the myth, this Syrinx was transformed into a reed on the riverbank, whereupon Pan, taking hold of the still-trembling reed, is said to have fashioned it into a flute, thereby creating his signature instrument: the famous "Pan's pipe," which is still played today. Many centuries later, the composer Debussy would write a piece for this instrument (in reality for a transverse flute), which he would justly name *Syrinx*, in memory of the unhappy nymph. . . . And the god Pan was often to be seen, with Silenus and the satyrs, in the company of Dionysus, dancing demoniacally, feasting, and drinking wine to the point of delirium—which is to say that there is nothing especially "cosmic" about this particular god! He is no friend to order, rather a fervent advocate of all that is disordered and disorderly. He belongs clearly within the line of descent of the forces of chaos, to the extent that certain myths do not hesitate in claiming him for a son of Hybris, goddess of insolence and immoderation. . . .

From which we might deduce that Midas, as a companion of Pan, is perhaps not after all as settled and subdued as might seem to be the case. All the more so since his stupidity and slowness of wit are still firmly in charge of his poor brain. One day, while playing his famous flute to try to charm some young girls, the god Pan gets carried away by boastfulness—as often happens in such circumstances—and declares that his musicianship surpasses even that of Apollo. Unable to stop himself, and to cap everything in the hubris

stakes, he goes so far as to openly challenge this Olympian adversary! A musical contest is promptly organized, between the lyre of Apollo and the flute of Pan, to be judged by Tmolus, a god of the mountain. Pan begins by blowing on his pipe: the sounds that emerge are raucous, uncouth, as befits the performer. They can be described as charming, of course, but it is a rough charm, even brutish: the sounds that his breath forces through the reed pipes are like those the wind draws from the trees. The lyre of Apollo, on the other hand, is a highly sophisticated instrument, which makes exact mathematical use of the relations between the length of the strings and their respective tension to produce perfect harmonic intervals, themselves symbolic of the larger harmony with which the gods have tuned the universe. Apollo's lyre is an instrument both delicate and civilized: at the opposite extreme to the rusticity of the flute, its power to seduce is imbued with soft persuasion.

The audience falls under its charms and votes unanimously for Apollo—with one exception: the fathead Midas, who raises a dissonant voice amid the concert of praise for Apollo. Habituated as he is to the life of forests and fields, and as an ally of Pan, Midas has lost his veneer of civility. He now loudly and strenuously declares his preference—by a long shot—for the guttural noise of the flute against the delicate sonorities of the lyre. Woe to him! Apollo is not lightly crossed, and—as always in such cases—the punishment will fit the "crime": the unfortunate Midas, having sinned against both hearing and intelligence, will be punished at the level both of his ears and his wits.

Here is how, according to Ovid:

> The Delian god [*Apollo*] did not suffer ears so dull to keep their human form, but lengthened them out and filled them

with shaggy, grey hair; he also made them flexible at the base and gave them power to move in every direction. Human otherwise, Midas was punished in this, that he wore the ears of a sluggard ass.

Of course, Midas is mortified by his new donkey ears. He cannot think how to conceal from the eyes of the world the ugliness with which he is now and forever saddled—an ugliness that points him out to others not merely as a creature without any ear, any musical sense, but also as an imbecile, with no more spirit than a ruminant. He tries to conceal his new attributes beneath a variety of headgear, bonnets, headscarves, with all of which in turn he carefully wraps his head—to no avail. His barber notices and cannot refrain from remarking: "But what has happened to you, your majesty? One would almost say you had grown donkey's ears . . ." This barber has cause to rue his words, for niceness is no more Midas's strong point than smartness: he threatens the poor man that if ever he reveals to anyone else what he has seen, he will be summarily tortured and killed. The latter does all in his power to keep the calamitous secret to himself. But at the same time (put yourself in his place), he burns with desire to tell his friends and family, and he trembles at the thought that someday, inadvertently, an indiscreet word might escape his lips. To unburden himself, he has an idea: "I will go and dig a big hole," he says to himself, "and then I will confide my secret to the depths of the earth and cover it over again instantly. In this way I shall be relieved of a burden that is too heavy for me." No sooner said than done. Our barber finds a corner of a field beyond the village, digs up the earth, shouts and even yells his message into the ground, then carefully fills the hole again and comes back home with a lighter heart. But the following spring, a dense patch of reeds has sprung up in

the freshly dug ground. And when the wind blows, one can hear a voice raised, becoming louder and louder, proclaiming to whoever cares to listen: "King-Midas-has-ass's-ears, King-Midas-has-ass's-ears, King-Midas-has-ass's-ears . . ."

AND THIS IS HOW Midas was punished by Apollo for his lack of discernment. You may say that in this instance it is not so easy to see how exactly poor Midas represented a threat to world order. Certainly, he defied a deity, even one of the principal gods, for of course Apollo (god of music and medicine) sits on Olympus. But surely it was in the end nothing more than a question of taste, where each party has a right to his opinions, and if Apollo was wounded then he was wounded merely in his self-esteem, if not his vanity. Consequently, his reaction seems excessive, or even a little ridiculous. . . . But this impression holds only for as long as we fail to attend to the workings of the story and (as before) remain content to see it through modern spectacles. For if we look more closely, what is involved here (as with the outcome of the struggle between Zeus and Typhon) is the discipline of music, which is not to be trifled with, for it involves nothing less than our relation with the harmonious disposition of the world. As I have explained, the lyre is a harmonic instrument, whereas the flute is melodic and can play but one note at a time. The lyre, like the guitar, can perfectly accompany song, and even if the Greeks were unfamiliar with harmony as understood by composers like Rameau or Bach, they nevertheless began to place different sounds in a relation of consonance, whereas with the flute this harmonizing of unlike sounds is impossible to achieve. Under cover of a purely musical competition, what is being played out in reality is the cardinal opposition of two worlds: that of Apollo, civilized and harmonious, versus that of Dio-

nysus (whose proxy is Pan), as dissonant and disordered as one of his feasts, where events can turn to horror from one moment to the next. In the famous Bacchanalia organized by Dionysus and his followers—which is why they are called Dionysiac—the women or "Bacchantes" who surround the god sometimes give themselves up to orgies that go beyond our ordinary understanding: in the grip of Dionysiac frenzy, they pursue small animals and tear them to pieces, devouring them raw; sometimes it is not merely animals that they subject to the worst abominations, but also children or even adults—such as Pentheus, king of Thebes, torn to pieces and devoured by the Bacchantes, who in their frenzy mistake him for a boar. To understand how brutal the opposition is between these two worlds—the cosmic order of Apollo, the chaos of Dionysus—it is worth retelling a related myth, a more fearful variant upon this same musical contest, and one that stages the torture of the hapless Marsyas.

A sadistic variant upon the musical contest: the atrocious torture of the satyr Marsyas

A parallel myth to the one that we have just been exploring, this story is very similar to the tale of the contest between Apollo and Pan. Except that in this case it is the satyr Marsyas who plays the role of Apollo's adversary (or perhaps a silenus called Marsyas—there is not much to choose between these two types who belong in the retinue of Dionysus, both characterized by bodies that are half human, half animal, and of an ugliness matched only by their sexual appetites . . .). Now this Marsyas, like Pan, is also remembered as the inventor of a musical instrument, the "aulos" (in effect, a type of wind instrument with two pipes, which nonetheless plays only one note at a time). According to the Greek poet Pindar

wrote in the fifth century BC, that we learn the rest of the story, as follows.

Athena, whom you will recall is the goddess not only of war but also of the arts and sciences, is extremely proud of her new invention. And with reason. After all, it is not every day that someone invents an instrument that will still be played in every country on earth thousands of years later. However, realizing that her cheeks look ridiculously swollen and that her eyes pop out when she plays her "aulos" (and oboists will forgive me for saying that, to this day, they all have the same comical expression as Athena when playing!), she throws it to the ground and stamps on it in her rage. So we should note in passing that this instrument makes for ugliness, that it shatters the harmony of the face—another point against it. Hera and Aphrodite, about whom we know that charity is not their strong suit, never miss a chance to express their jealousy of Athena. Noticing the popping eyes and swollen cheeks of the music-making goddess, they burst into extravagant laughter. They even take to mocking her and imitating her foolish expression when she blows into the unfortunate pipe. Athena, mortified, retreats some distance in order to verify for herself how she looks while playing—finding the nearest body of water, a pool or lake, in which to examine her reflection. Once she is quite alone, sheltered from the scrutiny of the two wicked goddesses, she leans over the water and cannot fail to notice that, when she plays, her face is contorted to the point of becoming grotesque. Not only does she fling the instrument away, but she also places a terrible curse on whoever might find it and have the audacity to use it.

Now it so happens that this Marsyas, strolling in the woods, as is his habit, on the off chance of pursuing some hapless nymph or other, discovers Athena's flute. And of course he falls under the charm of the pipe, which suits

(fifth century BC), who is the earliest source for this story, it was in fact the goddess Athena who first devised and made this instrument.* The manner in which she conceived and then finally discarded it merits our attention, for it indicates why the sound of the flute is unacceptable to the ears of the goddess.

The story begins with the death of Medusa. According to myth there are three strange and maleficent beings named Gorgons. Their appearance is terrifying, far worse even than that of Pan, the sileni, and the satyrs combined: their hair consists of snakes; enormous tusks protrude from their mouths, like wild boars; their claws are of bronze; and their golden wings enable them to catch up with their prey in all circumstances. . . . Worst of all, their gaze instantly turns anyone unfortunate enough to look at them to stone! This is why we still call "gorgons" those marine plants that float stiffly in the water as if petrified by the baleful glance of one of these monsters.

Now, these three sisters, although terrifying to us, love each other tenderly. Two of them are immortal, but the third, named Medusa, is a mere mortal. She will be killed by Perseus, in circumstances that we shall encounter later on, and according to Pindar, it was while hearing Medusa's sisters howling with grief, when Perseus exhibited the decapitated head of the Gorgon, that Athena first conceived the idea of the flute. As much as to say that this instrument came into being under circumstances far removed from the harmony and civility that characterize the lyre of Apollo.

It is from another poet, Melanippus of Melos,† who also

*In his Pythian odes, strophe 12, verses 6–8.

†Very brief allusion to the story (four lines only) is made by Herodotus (*Histories*, VII, 26) and Xenophon (*Anabasis*, II, 8); on the other hand there are complete accounts of it in Ovid and Hyginus.

him to perfection since he himself embodies all that is discordant! And he practices it so often and so well that he ends by thinking himself superior to Apollo—to the point of challenging the god to a contest, in which he commits the fatal error of choosing the Muses as judges. Apollo accepts the challenge on one condition: that the victor can do as he pleases with the loser. Apollo wins, of course—in this respect continuing the good work of Zeus against Typhon and all manifestations of chaos: ensuring with his lyre the triumph of harmony over the harsh and savage melody of the flute. But this time he is not content, as he had been with Midas, to impose a simple punishment, lighthearted and suited to the crime in question. He has given ample warning: the winner can dispose of the loser as he pleases! In consideration of which, Apollo quite simply has the unfortunate Marsyas flayed alive. . . . The blood that spurts from Marsyas will become a mountain stream, and his skin will serve to mark the place of the grotto from which the waters will thereafter spring. . . .

In his *Fables*, Hyginus summarizes the story as follows (as elsewhere, I quote the original text to show how these myths were transmitted in antiquity):

> Minerva [*Athena*] is said to have been the first to make pipes from deer bones and to have come to the banquet of the gods to play. Juno [*Hera*] and Venus [*Aphrodite*] mocked her because she was grey-eyed and because she puffed out her cheeks when playing. So she went to the forest of Ida, and, as she played, she viewed herself in the water of a pool, and saw that indeed she was rightly mocked. Because of this she threw away the pipes and vowed that whoever picked them up would be punished severely. Marsyas, a shepherd, son of Oeagrus, one of the satyrs, found them, and by practicing assiduously kept making sweeter sounds day by day, so that he challenged Apollo to play the lyre in a contest with him. When Apollo

arrived, they chose the Muses as judges. Marsyas was depart-
ing as victor, when Apollo turned his lyre upside down, and
played the same tune—a thing which Marsyas couldn't do
with the pipes. And so Apollo defeated Marsyas, bound him
to a tree, and turned him over to a Scythian who stripped his
skin from him limb by limb . . . and from his blood the river
Marsyas took its name.

Ovid, who were he alive today would no doubt be writing
scripts for horror films, describes in these terms the agony
inflicted by Apollo (my comments, as always, are in italics):

"Why do you tear me from myself?" he cried [*referring, of
course, to the fact that Apollo strips the skin of the satyr and, so to
speak, separates him from himself*]. "Oh, I repent! I repent! A
flute is not worth such a price!" As he screams, his skin is
stripped off the surface of his body, and he is all one wound:
blood flows down on every side, the sinews lie exposed, his
veins throb and quiver with no covering: you could count
the entrails as they palpitate, and the vital organs clearly
showing in his chest. The country people, the sylvan deities,
fauns and brother satyrs, Olympus [*father of Marsyas*] . . . and
the nymphs all wept for him, so that the fruitful earth was
soaked, and soaking caught those tears and drank them deep
into her veins. . . . Thence a stream was born, and had the
name of Marsyas, the clearest river in all Phrygia.

The punishment is appalling, a thousand times worse
than what was meted out to Midas. The two myths, that of
Marsyas (judged by the Muses) and that of Pan (judged by
Midas and Tmolus), are nonetheless very close to each other,
to the point that they are often confused.* In both cases,

*Moreover, in another version (Hyginus's *Fable*, 191), it is not the Muses but
Midas who is the arbiter of the contest between Apollo and Marsyas—proof that,
in the minds of the mythographers, the two stories are in effect one and the same
myth: "King Midas was chosen as judge, at the time when Apollo contested with
Marsyas, or Pan, on the pipes . . ." Whereas some gave the victory to Apollo,

music—the cosmic art par excellence—is at the heart of the myth, and both likewise involve a conflict between a god who prizes harmony above all else and, on the other hand, chaotic types armed with rustic instruments that can only charm coarse spirits such as Typhon and Midas. It is for this reason besides that Ovid describes Midas, after his misadventures with gold, as confining himself to the woods, like Pan, and in contact therefore with uncivilized tendencies. This is why—like a donkey—he prefers the harsh and savage notes of Pan's flute to the harmonious and gentle chords of Apollo's lyre. We need to be aware that this lyre, from which such harmonious sounds are drawn, has its own story. It is no ordinary instrument, but wholly divine in origin, according to another myth whose main source is in Homeric Hymns (dating probably from the sixth century BC):* according to which it was devised, constructed, and presented to Apollo by Hermes himself, at the end of a fairly extraordinary adventure that I shall now describe.

Midas preferred Marsyas. Angered, Apollo then said to Midas, "'You shall have the ears that match your judgement,' and promptly gave him the ears of an ass." Why does Hyginus conflate the two myths, that of Midas/Pan and that of Marsyas, given that none of the archaic sources link them? The answer is quite simple: as in the work of "condensation" described by Freud in relation to dreams, there are several points of resemblance that support the association of Midas with the affair. Firstly, the flute (whether of Marsyas or of Pan), unlike Apollo's lyre, is not a harmonic instrument: it can imitate the sound of the human voice, the wind in the trees, the cry of a wild creature—but not by harmonic progression. Secondly, the action takes place in Phrygia, of which Midas is king, and the earliest poem to refer to the story—or at least the earliest to have survived—is Pindar's Pythian ode 12, which is dedicated to "the flautist Midas." Finally, both Marsyas and Pan are "Dionysiac" beings, in other words lords of chaos, of feasting, madness, and disorder, not (like Apollo) Olympian guarantors for the cosmic labors of the founding father Zeus.

*As so often, a vividly pointed version of the myth appears in Ovid's *Metamorphoses*.

Hermes invents the lyre, instrument of
cosmic harmony; opposition between
the Apollonian and the Dionysiac

Hermes is one of Zeus's favorite sons. Zeus even makes him his principal ambassador: the one he sends forth when something exceptionally important has to be done or communicated. Hermes's mother is the beautiful nymph Maia, one of the seven Pleiades, themselves the "daughters of Pleione" and of the Titan Atlas, whom Zeus punished by making him bear the burden of the world on his shoulders. It is no exaggeration to say that little Hermes is extremely precocious. "Born in the morning," the author of the Homeric Hymn tells us, "he was able to play the cithara by midday and by the evening had stolen the cattle of the archer Apollo . . ." For an infant who has been alive for merely a few hours, he is already an accomplished musician and expert thief! As soon as he opens his eyes on this world, barely emerged from his mother's womb, we must imagine Hermes as chasing Apollo's cattle. On his way, he discovers a tortoise in the mountains and bursts into laughter: immediately, merely by looking at it, he understands the use to which it may be put. He lifts it up and runs back home, where he eviscerates the poor creature, then kills a cow, stretches its hide across the shell of the tortoise, makes strings out of its guts, puts in the horns, and fits a crosspiece over them, stretching out the strings so as to tune them. The lyre is born, with which Hermes can produce sounds of perfect harmonic accuracy, more harmonious than Pan's flute! Not content with this first invention, Hermes takes off in search of the immortal cattle of his elder brother.

Coming upon the herd, he selects fifty of them and, so that the theft will pass unnoticed, he leads them backward, turn-

ing their tracks around, reversing the marks of their hooves, and attaches makeshift wickerwork sandals to disguise his own footprints. He leads the beasts into a cave. Moments later, he works out—entirely of his own accord—how to invent fire, sacrifices two cows to the gods, and ends his first day by quenching the embers and scattering the ashes. . . . Then he returns home to his own shelter, where he had been conceived by Maia, where his cradle stands, and goes back to sleep with the air of an innocent newborn. . . . To his mother, when she complains and asks him where he has been, he merely replies that he has had enough of their poverty, and that he is going to become rich. We can already see why he will turn into the god of merchants, of journalists, and of thieves. The first day of this infant deity has been very well spent. . . .

Of course, Apollo eventually discovers what has happened. And when he gets hold of Zeus's nursling he threatens to throw him into the pit of Tartarus unless he hands over the cows. Hermes swears by the gods (the phrase is apt) that he is innocent. Apollo brandishes him at arm's length as if to hurl him far away, but Hermes invents so many excuses that Apollo laughingly lets him go, and the dispute is brought finally before the tribunal of Zeus . . . who also bursts into laughter at such precocity. In fact, he is altogether proud of his newborn son. The dispute between Apollo and Hermes runs its course until the latter produces his ultimate weapon, his lyre, which he begins to play with such artistry that Apollo (like Zeus) admits defeat, finally, and falls under the spell of this prodigious infant. Apollo, the god of music, is overwhelmed by the beauty of the sounds produced by this new instrument. In exchange for the lyre, he promises to make Hermes rich and famous. But the infant keeps bargaining and negotiating, and he secures in addition the

job of keeper of the cattle for his elder brother's entire herd! Apollo even offers him, for good measure, his shining whip and also the magic staff, which will serve as the emblem of Hermes, his famous "caduceus"—the story of which I will tell shortly. . . .

It is in this context that the lyre appears as the very type of divine instrument, and as the key attribute of Apollo. To fully understand the ramifications of the myth of Midas— usually and quite incorrectly considered as of minor significance—we must understand that, in the scheme of things, Apollo stands in for Zeus, as one of the Olympians who labor unceasingly to uphold the cause of cosmic order. This cause is just—deriving from the original settlement established by Zeus after his victory over the Titans—as well as beautiful, good, and harmonious. And on the other side, the earthbound forces of Chaos, including their multifarious lineage from Typhon onward, unceasingly threaten this fragile harmony. Apollo here represents an Olympian force: anti-chaos, anti-Titanesque, wholly identified with the famous injunction "Know Thyself," which decorates his temple at Delphi, meaning: "Know your natural place in the scheme of things, and stay within its bounds!" No hubris, no arrogance, no immoderation such as would disturb the beautiful cosmic solution. If Apollo loves music, it is because music is a metaphor for the cosmos. Dionysus is, in many respects, the inverse of Apollo. Clearly he, too, is an Olympian, a son of Zeus, and we shall see later how he reconciles within himself both cosmos and chaos, eternity and time, reason and madness. But in the first instance, what strikes us about him is his "acosmic" aspect: addicted to feasting, wine, and sex to the point of the murderous lunacy that possesses the women who follow in his retinue. Dionysus, too, is a god of music, of course, but the music he prefers is not that of

Apollo: neither gentle nor harmonious, but bestial and out of control. It does nothing to soften or civilize; on the contrary it expresses in openly indecent fashion the pulse of the most archaic passions, which explains why its chosen instrument should be the flute of Pan and of Marsyas.

Here is how the young Nietzsche described, with such precision and profundity, the difference between Apollo and Dionysus:

> Apollo, as an ethical divinity, demands moderation from his followers and, so that they may observe self-control, a knowledge of themselves. Which is why, alongside the imperative of aesthetic beauty, runs the demand to "Know Thyself" and "Nothing to Excess." Whereas arrogance and excess are considered the daemons most hostile to the Apollonian sphere, and therefore characteristic of the pre-Apollonian period, the age of the Titans, the world beyond the Apollonian: that is, the barbarian world. . . . To the Apollonian Greek, the effect aroused by the Dionysian seemed "titanic" and "barbaric." But he could not conceal from himself that he too was also internally related to those deposed Titans. . . . Indeed, he must have felt that his entire existence, with all its beauty and moderation, rested on a hidden ground of suffering and knowledge, revealed to him once again through the Dionysian impulse. So Apollo could not live without Dionysus! The Titanic and the barbaric were, in the end, just as necessary as the Apollonian! And now let us imagine how in this world, artificially constructed on illusion and moderation, the ecstatic sound of Dionysiac feasting rang out with a constantly more beckoning and bewitching magic. . . . Let us try to imagine what the psalm-chanting Apollonian artist could have done—with his harp and its bloodless sonorities—faced with this daemonic popular song! . . . Excess revealed itself as truth. Contradiction, the ecstasy born of pain, spoke of itself directly from the heart of nature. And so, wherever the Dionysian gained ground, the Apollonian was abolished and destroyed.

Nietzsche, himself a fine musician, has consummately understood three essential things. Firstly, that the theme of a musical contest is not merely anecdotal but essential to Greek myth, and for a profound reason: because it places harmony at the center of art, it becomes a metaphor, an analogue of the cosmos, or, as Nietzsche himself writes: "a re-working of the world and its second casting." Secondly, that the opposition between Apollo and Dionysus—here his representatives, Pan or Marsyas, are on stage, but everyone realizes that these are puppets, figures who merely stand in for Dionysus—is once again, as always (since the origins of the world), the old struggle of chaos and cosmos, of the Titanic versus the Olympian. Thirdly, that even if these two equally divine universes—the harmonious calm symbolized by Apollo, the conflicted and earsplitting din of Dionysus— are in appearance radically opposed, quite clearly they are in reality inseparable: without cosmic settlement, chaos will carry everything before it and all will be laid waste; without chaos, the cosmic order will ossify, and all life, all history will disappear.

At the time he was writing on Greek tragedy, Nietzsche was profoundly influenced by a philosopher, Schopenhauer, whom he still considered his mentor (but from whom he would subsequently distance himself). Now, this latter had recently published an important book, with what initially seems like an incomprehensible title: *The World as Will and Representation*. Without attempting to summarize this difficult and ambitious work, I can nevertheless draw attention to one of its principal themes: the animating conviction, for Schopenhauer and adopted by Nietzsche, that the universe is divided in two. On the one side, there is an immense chaotic *flux*—disordered, riven apart, absurd and denuded of sense, fundamentally the realm of the unconscious—which

Schopenhauer calls "the will"; on the other side, there is a desperate opposing attempt to put things in order, to revert to calm, to achieve consciousness, to make harmonious sense of things, which is what Schopenhauer terms "representation." Nietzsche applies this distinction to the Greek world. The universe of will, meaningless and pulling apart, corresponds to the original chaos of titanic forces—and the god who incarnates this best, at the hub of Olympus, is Dionysus. And the world of representation corresponds to the cosmic order established by Zeus, with its harmony, its calm, and its beauty. It follows that the lyre of Apollo belongs to the order of "representation," and the flute—Dionysiac, Titanesque, chaotic, uncivilized, acosmic—belongs to that of Schopenhauerian will. Likewise, two distinct kinds of music will always be opposed to each other: the gentle, cosmic, and civilized order of harmony and on the other hand the chaotic, harsh atonality that mimics the unconscious passions of the will in its primitive state. In truth, all perfected music must, in imitation of the Greek cosmos, combine these two worlds. . . . Midas, a vulgar creature and close to the state of nature, leans to the Dionysiac. It is not by chance that Dionysus is his companion, like Silenus and Pan. Nor is it by chance that the followers of Dionysus are often half animal, half human, with immoderate sexual desires and ungovernable appetites for wild partying.

Put differently, what is played out or repeated in the little fable of Midas, apparently so anodyne, is once again the victory of Zeus over the Titans. And if it puts Apollo in such a fury, this is not because he is merely "piqued," as is sometimes remarked so obtusely—for how can the judgment of a poor imbecile like Midas be of any concern to Apollo, a sublime deity?—but because he must of necessity combat hubris in all its forms. His Olympian mission is to root out

hubris at its source: a light sentence for Midas, directed at where he has sinned (in and through his ears), taking care to fit the punishment to the crime—but atrocious suffering for Marsyas. Midas is a cretin, a rustic who understands nothing of the cosmic stakes involved in the musical contest. He deserves merely to be put back in his place, as one would rein in a poor beast, a donkey. A simple punishment suffices. But in the case of Marsyas an example has to be set: Marsyas is a menace, and unlike Midas he has issued a direct challenge to a god. We cannot understand the violence of his punishment until we see that such a challenge is all the more intolerable because the cosmic order is a fragile and even superficial victory: beneath this apparently ordered and peaceful settlement there is the unchained sea of chaos that threatens constantly to break its bounds. The fury of Apollo was difficult for contemporaries to understand, and some mythographers went so far as to invent an aftermath in which he repented for having killed Marsyas. But this is an elaboration, and not the property of the myth.

So we see that the story of Midas, which starts in somewhat comic mode, ends strangely in tragedy: equally, that one of the most reliable and most dramatic devices of Greek tragedy is to show with what brutality a threatened cosmos—as embodied by the gods—invariably reasserts its rights against the hubris of mortals. . . .

But let us not look too far ahead. Despite this small anticipatory digression, the place of mortals in the scheme of things at this point, and of men in particular (for there are also the animals to be considered), is not yet fixed. We know where the Titans are to be found, along with Typhon—in Tartarus, heavily chained and guarded by the Hecatoncheires—and we can gauge the menace they represented that is now securely contained. We also know

the place or the role assigned to each individual god: the sea to Poseidon, the underworld to Hades, the earth to Gaia, the sky to Uranus, love and beauty to Aphrodite, violence and war to Ares, communication to Hermes, intelligence and the arts (cunning included) to Athena, the deepest darkness to Tartarus, and so forth. But what in the whole of this universe is the role assigned to mortals? No one can say at this stage.

The question is clearly crucial, since it includes (needless to say) the human beings who have devised all of these myths, this entire immensely sophisticated theological and cosmological mechanism. And if they did so, it was not merely to entertain themselves, but to make sense of the universe surrounding them and the life they should lead within it. To try and understand what they are doing on this earth, to try and sift the meaning of their existence. It is through three myths—that of Prometheus, that of Pandora (the first woman), and, famously, that of the golden age, each of which is inseparable from the others—that Greek culture will begin to respond to these fundamental questions. In his poem titled *Works and Days*, Hesiod carefully interwove these three narratives that were to have such a pervasive afterlife in Western literature, art, and philosophy. It is these stories that I now propose to follow. After which we can consider the major myths dealing with hubris and *dikè*: deranged acts of immoderation perpetrated by certain individuals, or heroic and just acts performed by those others known as "heroes."

II. From Immortals to mortals: How and why was humanity created?

In the works of Hesiod, who was the first to describe it, the myth of the golden age merges with that of the five ages of

man, or, as the Greek more accurately has it, the "five races" of man. For this is above all what is at issue: Hesiod describes five distinct humanities, five human types who succeeded one another over the course of time, but who we can equally say remain potentially present within our current humanity.

This myth turns entirely upon the question of the relations between hubris and *dikè*.[*] It traces a fundamental connection between those human lives lived in harmony with the cosmos, with justice, and conversely those existences given over to the hubris of pride and immoderation. It is sometimes said that Hesiod's poem was inspired by personal circumstances, which is perhaps partly true. Hesiod had just undergone a painful episode in his own life, involving a serious falling-out with his brother, Perses (to whom the poem is addressed): on the death of their father, Perses claimed more than his share of the family inheritance (and thereby sinned through hubris). He even bribed the authorities charged with adjudicating the case to find in his favor. It is therefore natural that the poem dedicated to him by his brother should treat of justice, or *dikè*. But Hesiod, by linking his personal affairs to questions of theogony and cosmology, enlarges the debate, so that the poem is by no means restricted to his individual case. On the contrary, it addresses in general terms, within the perspective of a cosmic order established under the aegis of the gods, the question of the difference between a good life, lived according to *dikè*, and a bad life, lived under the sign of hubris. Despite having the appearance of an ethical treatise, however, Hesiod's poem goes considerably further. For he is the first to address the question that interests us most after cosmogony and theogony (the birth of the world,

[*]As has been shown magisterially by Jean-Pierre Vernant, upon whom I rely for the essence of my interpretation of these three myths.

the birth of the gods): namely, the birth of humanity as we know it today. The fundamental issue, for us mortals, is to comprehend why we are here, and what we are in fact capable of in this world—divine and ordered, certainly, but where our mortal span (contrary to the gods) offers us but little time, with which we must do the best we can.

I will begin by briefly recounting the myth of the five ages or races, after which we shall dwell at greater length on the magnificent stories of Prometheus and Pandora, before attempting to assess what wisdom these fundamental narratives possess for mortals.

The myth of the golden age and the five "races" of man

In the beginning, therefore, is the age of gold, a time of the greatest possible happiness, because men are still living in a state of perfect mutual understanding with the gods. At this epoch, all are still faithful to *dikè*, and all men are just. Which is to say they shun this troublesome hubris that consists in asking for more than one's share and thereby misunderstanding at once who one is, as an individual, and what is the order of the world. At this epoch, according to Hesiod, men dispose of three wonderful privileges that all of us would surely wish to enjoy today. *Firstly*, they do not need to work, nor exercise a profession, nor gain a living. Nature is at this time so generous that she gives freely (as in the Garden of Eden, that parallel paradise lost of biblical myth) everything necessary for an easeful existence: the most delicious fruits, fatted flocks and herds on demand, freshwater springs and welcoming rivers, a clement and unchanging climate. In short, enough to eat and drink and clothe oneself so as to enjoy life without any worries. *Secondly*, these

forebears know neither suffering nor illness nor old age, so they live sheltered from those ills that haunt ordinary mortal existence, from the misfortunes that strike all of us at some point, often unremittingly. *Finally*, although they are mortal, after all, they could be said to die "as little as possible," without pain or anguish—"as if overtaken by sleep," so Hesiod tells us. If they are "scarcely mortal," it is simply that they have no fear of a death that comes as in the blink of an eye, without fuss. So that these first humans are very close to the gods, with whom, moreover, they share their everyday life.

When this race comes to an end one day by disappearing—"covered up by the earth," in Hesiod's phrase—these men do not die entirely. They become what the Greeks called "daimons." We must be careful to dissociate this word from the negative connotations that subsequently accrued to it in the Christian tradition, and that we take for granted today: on the contrary, the meaning here is of just and protective spirits—comparable to guardian angels, if one wishes to continue a parallel with Christian tradition—able to distinguish *dikè* from hubris, good from evil, measure from immoderation. On account of their remarkable powers of discernment, Zeus charges them with the signal privilege of bestowing riches according to the good or evil actions of men. Moreover, suggesting that after their death this race of men continues in some sort to live—and even to live well—is the fact that once transformed into daimons, they remain *on earth, among the living, rather than below it* (in the underworld, where the wicked are punished by the gods).*

*Hesiod also refers to this age of gold as the age of Cronus, which may seem strange, given the famous war between Zeus and the Titans. But we must understand that, according to Hesiod, Cronus—despite his subsequent infamy—was the first ruler, the first master of the cosmos, before being vanquished by Zeus and cast into the pit of Tartarus. Moreover, as Hesiod subsequently tells us, Zeus will even end by forgiving his father and rehabilitating him.

Next comes the age of silver, ruled by a puerile and malicious tribe, followed by the age of bronze, equally detestable, peopled by terrifying and bloodthirsty creatures, followed by the age of heroes—warriors like their forefathers, but valorous and noble, who end their days on the Isle of the Blessed Ones, where life is indistinguishable from the golden age. I will leave the description of these ages[*] to one side, so as to

[*]Here is a summary: The race of silver, likewise created directly from the hands of the Olympian gods, does not grow old. However, their extended youth possesses an entirely other significance to what we might suppose: for the first hundred years, the progeny of the silver age are like small children. In other words, rather than full-fledged adults—like the men of the golden age—they are infantile beings who, as soon as they reach maturity, live for a very brief time because the most extreme forms of hubris guide their actions and lead them straight to their deaths: not only are they unspeakably violent toward each other, but they also refuse to honor the gods or to offer up sacrifices. Exasperated by their lack of *dikè*, their willful ignorance of the proper hierarchy of beings, Zeus decides to extinguish them. One might say that this race is fashioned entirely in the image of bad divinities: like Typhon or like the Titans when they made war on Olympus, these men are not on the side of constructing a just and harmonious cosmic order. On the contrary, they despise the thought and labor toward its destruction—which is why Zeus is constrained to get rid of them—as opposed to the denizens of the golden age, who act out a well-regulated and well-governed order under the aegis of the Olympians, and who therefore exist in perfect harmony with the gods. When the inhabitants of the silver age perish, by the will of Zeus, they, too, become "daimons," but in this case are consigned to the underworld, belowground, like the bad and "chaotic" divinities. This is their punishment. Third is the race of bronze: beings of a lesser breed than their predecessors since their entire existence is reduced to one dimension only, given over to the sheer and unadulterated violence of war. They know nothing except to fight with one another, and their brutality is unsurpassed. Their strength is terrifying, their weapons are of bronze, and they even inhabit houses of bronze: their world knows of nothing warm or comfortable. Their habitations are fashioned in their own image: hard, metallic, cold, empty. If the first race was a reflection of good divinities favorable to the establishment of a cosmos, and the second race corresponded to dark and chaotic divinities, the third corresponds to the giants: like the latter, moreover, the bronze race is vowed to anonymous death, which for the Greeks was the most frightful death of all, which reigns over the dark depths of the earth and from whose clutches no one ever escapes. From fighting with one another incessantly, the men of bronze end by annihilating their race, so Zeus has no need even to act in order to rid the cosmos of them. The fourth race, the race of heroes, is also devoted to war—with the profound difference that, unlike the men of bronze, they wage war in the name of *dikè*, of justice and honor, and not with the *hubris* that characterizes violence for its own sake. Achilles, Heracles, Theseus, Odysseus, and Jason: these are the exemplars of the heroic age, whose glorious and courageous deeds have made them cel-

concentrate upon the last age, the age of iron, which is the epoch of now, of our own mortal existence. And here Hesiod's description becomes overtly apocalyptic, so to speak. This epoch is manifestly the worst of all. In the age of iron, men ceaselessly labor and suffer hardship: there is not a single pleasure that is not immediately followed by pain; there is no good that is not mirrored, like the reverse of a coin, by some ill. Not only do men grow old very rapidly, but they also must work incessantly for their livelihood. And here we are still at the beginning of this era of iron, with worse to come. Why is this? Quite simply because humanity now lives in a state of hubris, of out-and-out immoderation that is not restricted—as in the age of bronze—to the brutality of war, but that contaminates every dimension of human existence. Possessed by jealousy, envy, and violence, humanity respects neither friendship, nor promises, nor justice under whatever form—to such a degree that the last of the gods to inhabit the earth and coexist with mankind are likely at any moment to leave definitively and return to Olympus. Here we are at the antipodes of the golden age, where men lived in a community of friendship with the gods, without working, without suffering, and (almost) without dying. The men of the present age of decadence are heading for catastrophe: if they persevere in their ways, as Hesiod believes (to judge from the quarrel with his brother), there will no longer even

ebrated for all time—rather than rendered anonymous, like the men of bronze. They, too, are soldiers, clearly, but above all they are men of honor, careful to respect the gods and mindful of finding their proper place in the order of the cosmos. This is why these heroes, who are also termed "demigods" by Hesiod, resemble somewhat the inhabitants of the golden age, in that they never truly die. The most valorous, when they have served their time, are settled by Zeus at the ends of the earth, in the Isle of the Blessed Ones, where, under the aegis of Cronus (now liberated and pardoned by Zeus), they live on as in the golden age, without labor, without cares, without illness or pain, in a land whose abundance provides all that is needed for a happy and easeful existence.

be a good side to the coin, only bad sides, and, at the end of it all, death without remedy. Wherein we see the final destructive ravages of an existence given over to hubris, in conflict with the cosmic order and—which is the same thing—in contempt of the gods.

This myth raised and still raises many questions. It has given rise to a bewildering diversity of interpretations. But one question seems to emerge from the rest, as self-evident: How and why did humanity pass from the age of gold to the age of iron? Why this decline, this dereliction by the gods? Or, to adopt a quite different biblical perspective (though apt enough in this context), how to explain this "fall" from a "paradise" that is henceforward "lost"? And these, precisely, are the questions to which the twin myths of Prometheus and Pandora respond quite overtly. Here again, let us be guided by the two poems of Hesiod, *Theogony* and *Works and Days*, before touching on some later and different versions of the same myths, notably those of a philosopher, Plato, and a tragedian, Aeschylus.

The "crime" of Prometheus and the banishment to earth of Pandora, first woman and "greatest misfortune" of mankind

When we read Hesiod's poem closely, it becomes clear that the myths of Prometheus and Pandora exist to explain the reasons for this passage from an age of gold to one of iron: eliding the three intervening ages, they set out to show how humanity has passed from one extreme to another. Of course, this transition seems catastrophic at first sight. And yet it speaks of us, and of our peculiar destiny, as entirely unique in a universe of gods and elements. And it is in terms of this destiny that we must pose the question of human

existence, the question of what course we must seek and, if possible, find in this world. In other words, it is impossible to ponder the question of wisdom for mortals without taking account of their unique situation, however disastrous it may seem initially, within the surrounding cosmos.

But first I must say a few words about the character who plays the central role in our story, namely Prometheus. He is usually presented as one of the Titans. The truth is slightly different since he does not belong to the generation of Cronus. In reality, he is merely a son of Titans: more precisely, one of the children of Iapetus (a brother of Cronus) and Clymene, the ravishing sea-nymph "of the beautiful ankles"—in other words, one of the numerous daughters of the eldest of the Titans, Oceanus. In Greek, the name Prometheus is eloquently meaningful: "the one who thinks ahead," who in other words is crafty, intelligent, in the sense that one says of a chess player that he is always a "step ahead" of his adversary. Prometheus has three brothers, for each of whom things will end badly—no doubt because in the aftermath of the war of Zeus against the Titans, the children of the latter are not exactly in favor with the regime. Firstly Atlas, who will be condemned by Zeus to carry the world by means of his "indefatigable" shoulders; then Menoetius, whom the master of Olympus soon strikes down with a lightning bolt because he finds him arrogant, and overflowing with hubris, and far too rash not to be dangerous; lastly Epimetheus. The name Epimetheus also possesses significance, exactly the inverse of Prometheus. Roughly, in Greek *pro* means "before" and *epi* means "after": Epimetheus is he who understands "afterward," who acts without thinking and is always a step behind, the familiar simpleton afflicted by *esprit d'escalier*, otherwise known as a plodding mind. He will be the principal instrument of Zeus's vengeance against Prometheus and

against mankind—a vengeance that, precisely, will translate men from the age of gold to the age of iron. But let us not get ahead of ourselves.

When the scene opens, we are on a vast plain where men are still living in perfect harmony with the gods: the plain of Mecone. In the words of Hesiod, there they live, "protected, remote from ills, without harsh toil and the grievous sicknesses that are deadly to men"—easily recognized as a description of the golden age. These are still the best of times. On this particular day, for reasons not offered by Hesiod, Zeus decides to "settle all disagreements between men and gods." In truth, this is business as usual for the ongoing construction of the cosmos. Just as Zeus has divided the world appropriately with his peers, the other gods, assigning to each his just share and giving "to each his own," as Roman law would later express it, by the same token he must now decide what portion of the universe is allocated to humans: in other words, what is to be the mortal lot. For now is their moment. And, as part of this plan, in order to determine fairly what in future will belong to gods on the one hand and to mortals on the other, Zeus asks Prometheus to sacrifice an ox, and to share it out fairly, so that this apportioning will in a sense serve as a model for their future relations.

The stakes are clearly huge, and Prometheus, thinking he is doing well in his self-appointed purpose of aiding mankind—with whom, it is said, he always sided against Olympian interests, perhaps because he himself was descended from the Titans and, as such, not an automatic ally of these second-generation gods—lays a trap for Zeus: he divides the offering into two heaps, in one of which he places the better cuts of meat, such as men are pleased to eat, but wraps these in the hide of the animal. This hide is, of course, inedible, and for good measure—just to make sure

that this first heap will look repugnant and have no chance of
being chosen by Zeus as the portion destined for the gods—
Prometheus places it all inside the unappetizing stomach of
the sacrificed animal. In the other heap, he places the poorest
parts, the ox's white bones, carefully cleaned and therefore
quite inedible as far as men are concerned, and slides them
delicately beneath a fine layer of shining and very appetiz-
ing fat! We should remember at this point that Zeus—who
after all swallowed his wife, Metis, who was herself cunning
incarnate, and is, moreover, the most intelligent of all the
gods—cannot possibly be duped by this ploy of Prometheus.
He sees him coming, so to speak, and, enraged at the idea of
being played for a fool, pretends to fall into the trap—while
already planning and savoring the dreadful vengeance that
he will visit on Prometheus and, by extension, on the whole
race of mortals whom Prometheus thinks he is so craftily
providing for. Zeus therefore selects the heap of poor cuts,
the white bones wrapped in appetizing fat, and leaves the
good meat for the humans.

Let us note in passing* that it does not cost Zeus very much
to leave the good meat for the humans, and for one excel-
lent reason: the gods on Olympus do not eat meat! They
consume ambrosia and nectar, the only nourishment suit-
able for Immortals. This is an important point, and one that
already announces one entire dimension of the misfortunes
that await mankind when, through the fault of Prometheus,
they leave behind the age of gold: only those who are going
to die need to eat food, such as bread and meat, in order to
restore their strength. The gods nourish themselves for plea-
sure, for amusement, and because their dishes are delicious;

*As does Jean-Pierre Vernant, and to such lucid effect, in *The Universe, the Gods,
and Men*.

men feed themselves through necessity, primarily, so as to avoid dying even sooner than will otherwise and inevitably occur, one day or another. To keep the meat for the humans and give the bones to the gods: this is in effect to confirm that the former are mortals, soon exhausted by labor, always in quest of food, in the absence of which they fail, suffer, fall ill, and die, in short order—all of which is, of course, unknown territory as far as gods are concerned.

So Prometheus has attempted to deceive Zeus in favor of mankind, or so he thinks, and Zeus is furious. To punish them all, he withholds fire, which is a gift of the gods, by means of which men warm themselves and—above all—roast the foods that keep them alive. Cooking is, for the Greeks, one of the signs of man's humanity, and what separates him decisively from both gods and animals: the gods have no need of food, and the animals on the other hand eat their food raw. And it is this identity that is lost to man as soon as Zeus withdraws fire. What is more, as a second punishment, "Zeus hid everything," as Hesiod informs us somewhat enigmatically. What this means in effect is that, whereas in the golden age the produce of the earth was offered up in plain view and at all seasons to the appetite of men, henceforth seeds will be hidden in the earth and man must labor and sow in order to germinate the wheat, then reap it, grind it, and bake it in order to make bread. It is therefore—and the point is crucial—with the onset of work, a tedious activity if ever there was one, that the fall from paradise properly begins.

This is where Prometheus commits a second act of larceny, a second crime of lèse-majesté: he quite simply steals fire and brings it back to earth again! This time, the fury of Zeus overflows, and his unleashed anger knows no bounds. He, too, will devise a ruse, and what a ruse, to punish

these mortals whom Prometheus would protect. He orders Hephaestus to fashion, at a moment's notice, using water and clay, the figure of a young girl "who will be pleasing in form," a woman with whom these idiot humans will all fall abjectly in love! A whole pleiad of gods contribute a talent here, a grace or charm there: Athena teaches her to weave; Aphrodite bestows absolute beauty, along with the gift of arousing such desire "as causes painful yearning" and provokes "cares which leave you broken." Put differently, Pandora (for it is of her that we speak) will be seduction incarnate. Hermes—go-between, god of oratory and merchants, a sly one, himself a seducer and a bit of a trickster—gives Pandora "the mind of a dog and deceitful ways," which is to say that she will always ask for "more than enough" (Hesiod again), signified by "the mind of a dog." She will be insatiable, on all levels: food, money, gifts. She always wants more. And more sexually, of course, where her appetite is likewise without limit. Potentially, at least, her orgasms never end—whereas the men, no matter how they try, are very soon spent. As for her "underhand ways," these signify that she will seduce anyone, since all arguments, all ruses, all the most tantalizing untruths are but grist to her mill. To complete this charming tableau, Athena also makes her a present of beautiful adornments, Hephaestus fashions a diadem of matchless refinement, and other divinities add their share: the Graces, the Hours (daughters of Zeus and Themis), and again the goddess of persuasion herself all contribute gifts, so that in the end, as Zeus tells himself with a bitter laugh, the unfortunate humans will be absolutely powerless to avoid this trap, this "calamity for the men who live by bread," this bionic woman, sublime but in reality to be dreaded, who will "rejoice their hearts" to the point that the simpletons "will cherish their own undoing."

We should note here the resemblances between the ruse of Prometheus and the answering ruse of Zeus. They correspond at every point: as always in a harmonious cosmos, the punishment must match the crime. Has Prometheus tried to deceive Zeus by playing on appearances (hiding the inedible bones under the crisp fat and, conversely, dissimulating the good beef in the revolting stomach cavity of the ox)? What of it! Zeus, too, will play at illusions: his gift has all the external trappings of a promised land, but at bottom she is the queen of bitches and is anything but a gift for whoever is at the receiving end!

Moreover, this ravishing and unstoppable young beauty has a name, Pandora, which is at once eloquent and wholly deceptive. In Greek it means "she who possesses all the gifts," because, as Hesiod says, "all the gods on Olympus had given her something"—unless, as others suggest, the name means "she who has been given to men by all of the gods." Both interpretations are apt: Pandora possesses outwardly all possible and all imaginable virtues in terms of seduction (if not in terms of morals, which is another matter entirely . . .). At the same time, she has decidedly been sent down to men from the gods in concert—who are determined to punish them.

So Zeus brings this sublime creature to life, then asks Hermes to conduct her to Epimetheus, the poor simpleton who acts first and thinks afterward, when it is too late and the damage is done. Prometheus had, however, warned his brother on no account to ever accept any gift from the gods of Olympus, for he knew full well that they would try to avenge themselves on him, and through him on mankind. But of course Epimetheus walks right into the trap, falling madly in love with Pandora. Not only will she now give birth to other women who will similarly and in every sense

spell ruin for men, but in addition she will open a strange
"jar" (soon to be known in mythology as "Pandora's box"),
in which Zeus has taken care to place all the ills, all the mis-
fortunes, and all the sufferings that will thereafter rain down
on mankind. Only hope itself will remain shut up in the
bottom of this fateful container! This can be interpreted in
two ways. Either we may assume that humans will not even
be allowed the means to cling onto the life raft of hope since
the latter commodity remains in the box. Or we can inter-
pret it as follows, which seems to me more apt: namely that
hope will indeed persist, but is by no means to be thought of
as a blessing conceded by Zeus. Don't deceive yourselves, in
other words: hope, for the Greeks, is not a gift. It is rather a
calamity, a negative striving, for to hope is to remain always
in a state of want, to want what we do not have, and, con-
sequently, to remain in some sense unsatisfied and unhappy.
When we hope to get better, this means that we are ill; when
we hope to be rich, this means we are poor; so hope itself is
more of an evil than a good.

Whatever the case, here is how Hesiod describes the
episode in *Works and Days*. I quote it at length, since it shows
clearly the links that connect these three myths (I offer a few
comments in italics):

> Epimetheus gave no thought to what Prometheus had told
> him, never to accept a gift from Olympian Zeus but to send
> it back lest some affliction befall mortal men: but he accepted
> the gift, and afterwards, when the evil thing was already his,
> he understood [*as always, Epimetheus understands things after
> the fact, when it is too late*]. For formerly the tribes of men
> on earth lived remote from ills, without harsh toil and the
> grievous sicknesses that are deadly to mortals [*the myth of the
> golden age, to be shattered when Pandora appears on the scene*];
> those who must die soon grow old in misery. . . . But the

woman unstopped the jar with her hands and let it all out, bringing sorrow and mischief to mankind [*the jar that will soon become known infamously as "Pandora's box"—Hesiod does not tell us where it comes from, or how; what is certain is that Zeus is responsible for filling it with its detestable contents*]. Only Hope remained inside, secure in its dwelling, beneath the lip of the jar, and did not fly out, because the lid fell back in time by the providence of aegis-bearing Zeus [*"aegis," from the Greek* aigos *meaning "goat" and referring to the famous shield made from the hide of the goat Amalthea, which had suckled Zeus in his infancy and was said to be impervious to arrows*]. But for the rest, countless troubles roam amongst men [*Zeus having placed in the jar all possible and imaginable ills with which to punish humans: sicknesses of every sort, pains of every kind, fear, old age, death . . .*]; for the earth is full of evils and the sea is likewise full. Sicknesses visit men by day, and others by night, uninvited, bringing ill to mortals; for resourceful Zeus deprived these ills of voice [*they befall us without our being able either to foresee or prevent them*]. Thus there is no way to escape the purpose of Zeus [*namely, to punish mortal men*].

And this is the reason why, because of Pandora, or rather *by means of* Pandora, we were cast out of the golden age.

In addition to this terrible punishment—which seems to target Prometheus only indirectly since it does not affect him personally but rather affects those whom he sought to defend and protect, namely humans—there is another punishment that does indeed affect the son of Iapetus directly: he is to be chained by strict and painful bonds to the top of a mountain, and Zeus unleashes a gigantic eagle against him, who each day devours his liver. For Prometheus's liver is (of course) immortal and is restored each night, only for the agonizing torture to begin afresh each day. . . . Later, much later, Prometheus will finally be freed by Heracles. In this subsequent version of the myth, long after Hesiod, Zeus has sworn by the river Styx—an oath that cannot under

any circumstances be retracted—never to free Prometheus from his rock. But Zeus is proud of the exploits of his son Heracles and does not wish to disavow him. At the same time, he has no wish to renege entirely on his oath, so he accepts that Prometheus should be freed, but on condition that the latter forever wear a small piece of this same rock attached to a ring! It is said that this little accommodation with the heavens is the origin of one of our most everyday adornments: the ring set with a precious stone. . . .

But let us return to our humans, and their new reality, as set out so mercilessly in the myth of Pandora. It contains at least three lessons that we should try to understand if we are fully to appreciate what happens next.

Three philosophical lessons, drawn from the myth of Prometheus and Pandora

Firstly, if Pandora is truly the first woman, as Hesiod insists, this means that during the golden age, before the famous division of the ox performed by Prometheus at Mecone, men lived by definition without women. There was certainly a feminine principle at work in the world, and notably a whole bevy of feminine divinities, but the race of mortals was exclusively male. This implies, logically, that they were born not of the union of man and woman but solely by the will of the gods and according to means chosen by the gods (no doubt sprung directly from the earth, as other myths invite us to believe). This point is crucial, for it is this birth from the union of man and woman that will make mortals truly mortal. Remember that, in the golden age, humans do not truly die or, more accurately, they die as minimally as possible: they slowly fade away, in their sleep, without anguish or suffering and with never a thought of dying. Moreover,

after their demise they remain in some sense alive since they turn into "daimons," those guardian spirits charged with dispensing wealth to men according to individual merit. Henceforward, however, with the appearance of Pandora, mortals are wholly and entirely mortal, and for a reason that has true philosophical depth: it is because the dimension of *time*, as we know it, along with its cortege of ills—aging, illness, death—has finally arrived on the scene. You will recall how Uranus, and Cronus in his wake, were averse to letting their children see the light of day: Uranus barricaded them in the womb of their mother, Gaia, whereas Cronus devoured each one outright until Zeus's mother, Rhea, hoaxed him and made him swallow a decoy—a stone wrapped in swaddling clothes instead of her actual son. The real reason for this savage urge to prevent their children from being born is twofold: not only to prevent an eventual conflict in the course of which the ruling king might lose his power and be usurped by his own issue but also, and more profoundly, to block the operations of time and change, and consequently that form of death symbolized by the succession of generations. A stable and ordered cosmos: that is the ideal of every sensible sovereign, but giving birth and succession always implies, more or less, the ruin of this beautiful idea of fixity. Now, henceforth, the idea of descendance becomes firmly established—by which we also see that children come to occupy a somewhat ambiguous position, to say the least: we love them, of course, but they also symbolize our demise—in which respect the Greeks seem less sentimental, and perhaps less simplistic, not to say less simpleminded than we have become today. . . .

Next, as in the Bible, the banishment from a golden age is accompanied by a truly ruinous calamity: namely labor. Henceforth, in effect, men must earn their bread by the

sweat of their brow, and for two reasons. Firstly, as I have
already mentioned, because Zeus has "hidden everything,"
has buried in the earth the fruits by which men exist, no-
tably the cereals with which we make bread, so that these
must now be cultivated if we are to feed ourselves. And then
there is also the ravishing Pandora to be contended with, and
along with her, as the *Theogony* insists, "the whole race and
tribe of women, scourge of mortals":

> They dwell with their husbands but are no fit partners for
> accursed poverty [*to speak plainly, they are never supportive in
> misfortune*], but only in time of plenty. As in thatched hives
> the bees feed the drones, whose nature is to do mischief,
> and while they busy themselves all day and every day until
> sundown laying the white honeycomb, the drones stay inside
> in the sheltered cells and pile the toil of others into their own
> bellies.

Not exactly a feminist point of view, I agree, but the
epoch in which Hesiod lived was not our own. Be that as it
may, things are finished as far as the beautiful golden age is
concerned, in which men feasted with the gods each day and
saw to their needs in all innocence, without ever bending
to the necessity of hard labor. But worst of all, if one may
say so, is that women are clearly a mixed rather than an
unadulterated evil.

The alternative would be too simple, and this is the third
lesson imparted by the myth: human life is tragic, in this
specific sense that there is no good without evil. Man, as Zeus
intended by his joyless laughter, is now entirely outplayed,
caught in a trap with no possible escape. If he refuses to marry
so as to avoid his patrimony being devoured by drones (i.e.,
by women, who always want more), he will unquestionably
accumulate more wealth. But to what end? On whose behalf
will he go to all this trouble? And when he dies without

children, without heirs, his accumulated riches will end up in the hands of some distant connection for whom he has no use! He will die a second time, so to speak, because, deprived of heirs, nothing will survive of him. Mortality squared! No, he must therefore marry if he wants heirs, but here the trap is sprung once again: there is the added consideration that his children may be worthless, the worst of all misfortunes for a father! To sum up, in either case the good is inevitably accompanied by an equal or greater ill.

Of course, Hesiod's text seems inveterately misogynist— and so it is read today in most universities. Today, Hesiod would surely be proscribed and forbidden to teach on campus. But we should also understand that times have changed, that our age is not that of Hesiod, and that, beyond their shock value, we must see his propositions above all in their connection to the question of human mortality. For clearly the supreme misfortune to befall men in the age of iron is that they no longer melt away as formerly in the good old days of gold. When we substitute being born of the earth (in a manner decided and regulated by the gods) to being born of a sexual union, the new life given by woman has as its counterpart a new death, preceded by suffering, labor, illness, and all the ills associated with aging, none of which were known to the denizens of the age of gold.

From which once again arises the critical question that underlies the entire structure of myth as we see it taking form in Hesiod: What is a good life for mortals? Contrary to the major monotheist religions, Greek mythology does not promise us eternal life or paradise. It merely attempts, like its godchild philosophy, to be lucid about the human condition that is ours. What is to be done other than try to live in harmony with the cosmic order or, if we are bent on avoiding anonymity in death, try to become famous through

glorious deeds? Along with Odysseus, we must convince ourselves that this life can be preferable even to immortality.

But let us at this point get to the end of the story, as it was imagined, or at least as it was formulated, after Hesiod.

The reasons for our banishment from the golden age: the Prometheus myth as told by Plato and Aeschylus

I am sure you must have asked yourselves the following question: Why after all must humans be punished for a crime they have not committed? There has been hubris on the part of Prometheus, clearly, since he has dared to defy the gods and to deceive them by hiding the good cuts of beef under a revolting exterior and giving the bad cuts an appetizing aspect. But why are men to be blamed for this business? And why should humans be put in their place so remorselessly by Zeus, given they had nothing to do with this deception and have done nothing wrong?

Although contemporary mythographers are in the habit of doing so, I have some scruples about proceeding as if naturally from a tale told by Hesiod in the seventh century BC to a work written in quite another context, three centuries later, namely the pages devoted to the myth of Prometheus in Plato's dialogue *Protagoras*, named after one of the greatest of the Sophist philosophers. This shift involves not only a different epoch—and three centuries, which is hardly a negligible consideration—but also a change of register: from myth to philosophy. However, despite these reservations, the philosophical outlook of Plato, albeit quite different from that of Hesiod, does offer a perspective on his poems that is both illuminating and plausible. According to Plato, Prometheus did not simply steal fire from Hephaestus; he also

stole the arts and sciences from Athena, exposing mortals to the risk of one day or another thinking themselves the equal of the gods. In which event, humanity would without any doubt be sinning through hubris! It is therefore possible that this, in effect, is what was already at stake on the plain of Mecone, at the moment the sacrificial ox was being divided. . . .

According to Protagoras, then—at least as dramatized in Plato's dialogue—the disagreement between men and gods can only be fully understood if we take into account the whole story, going back to a time before men existed, when in effect there were only gods on earth.

One fine day, the gods decide, for a reason Protagoras does not specify (perhaps they were bored, all by themselves?) to create a race of mortals, which is to say animals and men. So they set about it enthusiastically and create, by means of earth and fire, "and various mixtures of both elements," little statuettes in various forms. Before bringing them to life, they ask Epimetheus and Prometheus to divide the various attributes between these creatures accordingly. Epimetheus begs his brother to let him do the distribution himself, and first he sets about allocating to those animal species deprived of reason. How does he proceed? Epimetheus is not as stupid as he might seem, and his distribution of qualities is even very adept: he constructs a "cosmos," a perfectly balanced and viable system of life, arranging things so that each species has its chance of survival against the others. For example, with the small animals such as sparrows or rabbits, he gives to the one wings to fly away from their predators, and to the other (for the same reason) speed in running and burrows in which they can take cover from danger. Here is how Protagoras describes the labors of Epimetheus:

In his allotment of qualities he took care to equalise the odds, and in everything he devised he took precautions so that no species should be eradicated by another. When he had sufficiently provided means of escape from mutual destruction, he contrived their comfort against the variations in season sent by Zeus, clothing them with thick hair or hard carapaces sufficient to ward off the winter's cold, but effective also against heat; and he planned that when they went to sleep, the same coverings should serve as proper and natural bedclothes. He shod each species, too, some with hooves, others with hard and bloodless claws. Next he ordained different sorts of food for them—to some the grass of the earth, to others the fruit of trees, to others roots; some he allowed to gain their nourishment by devouring other animals, and these he made less fertile, while he bestowed abundant fertility on their victims, and so preserved their species.

In short, Epimetheus conceived and put into effect what ecologists would today call a perfectly balanced and self-regulating "biosphere" or "ecosystem"—what the Greeks called quite simply a cosmos, a harmonious whole, just and viable, in which each species can survive alongside and even in coexistence with the others. This confirms that nature—at least in mythology—is indeed an admirable arrangement. In which case you will perhaps ask why Epimetheus deserves to be treated as a simpleton who always understands everything too late?

Here is Protagoras's answer:

But, as everyone knows, this Epimetheus was not an especially well-advised individual, and before he realized it he had used up all the available attributes on brute beasts deprived of reason, and was left with the human race, quite unprovided for, and did not know what to do with them. While he was puzzling over this, Prometheus came to inspect

the work. He found the animals well provided for, in all respects, but man naked, unshod, with no natural covering for sleep, and unarmed. . . . Prometheus, therefore, at a loss to provide whatever means of protecting man, stole from Hephaestus and Athena *the mechanical arts*, together with fire (for without fire these skills could neither have been acquired or employed), and bestowed them on man as his gift.

Here we see how Prometheus has committed a double crime, which will incur a double punishment—namely sanctions against himself, in the form of the terrifying eagle that daily devours his liver, but also against mankind, to whom Zeus will send Pandora and, along with her, all the ills thereafter associated with the fallen human condition. So in what, exactly, does this double crime consist?

Firstly, Prometheus has behaved like a thief: without any permission he enters the workshop shared by Hephaestus and Athena to steal fire from the former and the mechanical arts from the latter, which is already highly punishable. In so doing, however, Prometheus—again without the permission of Zeus—endows men with an entirely new power, *a quasi-divine power of creation*, which we can be certain (without following Plato's commentary on other aspects of the myth that need not concern us here) will one day or another lead humans, tempted as they are to commit hubris, to take themselves for gods. For as Protagoras points out, thanks to these gifts of Prometheus that are, properly speaking, divine, men are henceforth the only animals capable of making artificial, "technical" objects: shoes, skins, clothes, produce drawn from the earth, etc. *In other words, like the gods, they, too, truly become creators.* What is more, they are the only creatures to be able to articulate sounds in such a way as to give sense to them; the only creatures to invent language, which again brings them considerably closer to

the gods. Admittedly, as these gifts come directly from the Olympians, from whom Prometheus has stolen them, humans will by the same token be the only creatures to know that gods exist, and to construct altars to them and honor them. Despite which, given that they never stop behaving badly toward one another, to the point that they are in constant danger of destroying themselves as a species—contrary to animals, who from the outset form a balanced and viable system of checks and balances—humans are permanently threatened by hubris! *What Prometheus has just confected, therefore, is a species that is prodigiously dangerous and worrying for the cosmos as a whole, and he has done so without the consent of Zeus. So now we can more easily understand the anger of Zeus, and why he regards the deceptions of Prometheus as disgraceful and reckless, and why likewise he intends not only to punish this child of Titan but mankind in general, in order (precisely) to put men in their place and discourage them once and for all from yielding to the temptations of hubris.* This is what is truly at stake in this myth: to ensure that mortals, despite the gifts made by Prometheus, do not take themselves for gods.

IT IS TO THIS same conclusion that a consideration of the play about Prometheus by the great tragedian Aeschylus fundamentally leads us, nearly two centuries before Plato dramatized the myth through the voice of Protagoras.

In effect, in *Prometheus Bound* we learn from the outset that Zeus already distrusts mortals, from the moment he divides the world and organizes the cosmos, after seizing power from his father Cronus. Here again, let us read Aeschylus's own words so as to habituate ourselves to hearing how the Greeks expressed these matters, five centuries before our common era:

"No sooner was he seated on his high, paternal throne [*the throne of Cronus, whom Zeus has just overturned with the aid of the Cyclopes and the Hecatoncheires*] than to the various Gods he allotted privileges, and parceled out his empire [*which is when the real business of creating a cosmic order begins*]. But of miserable men he took no account; rather it was his wish to wipe out man and rear another race: and no one contravened these designs but I, Prometheus. I alone had the audacity, and saved mankind from stark destruction and the road to Hades [*in other words, to hell, often named after the god who rules over it*]. For which reason I am bowed under the weight of these grievous pains, a pitiful spectacle for all to see [*referring, of course, to the chains that bind him and to the eagle that devours his liver*]. For having shown pity to man, I am judged unworthy of pity in return . . ."

No doubt this is so, but once again the question presents itself: Why? A little further on in the play, Prometheus boasts of all the benefits he has brought to mankind. When we read the list, as in Plato, we understand precisely why Zeus would not look kindly on this species that risks—rather as ecologists fear today—being henceforth the one species on earth capable, merely as a function of the technology it wields, of carrying immoderation to the point of threatening the cosmic order itself:

"But listen to my tale of mortal's sufferings—how at first they were as children, and I gave them sense, and endowed them with reason. I say this not in contempt of men, but to show the gifts with which I showered them. First of all, they had eyes but they saw to no avail, they had ears but they did not understand: like phantoms huddled in dreams, they wandered in confusion the length of their days, knowing neither timber-work nor brick-built dwellings basking in the light—but dug holes for themselves, like swarming ants in the burrows of their unsunned caves. They had no foresight

of winter's cold, nor of the springtime decked with flowers, nor yet of summer's heat with melting fruits, but managed everything without judgement. Until I invented for them the difficult art of telling the rising of the stars from their setting. Likewise, I devised for them that most beautiful of all inventions, the science of numbers, and the art of combining letters with which to retain the memory of all things, which made it possible to cultivate the arts. And it was I that first yoked unmanaged beasts to serve the collar and the pack-saddle, and take upon themselves, to man's relief, the heaviest labour of his hands: and I harnessed horses and made them docile to the rein, to be an image of wealth and luxury. Who else but I contrived the mariner's cloth-winged vessels that roam the seas? Such are the manifold inventions that I perfected for mankind, yet have myself no means to rid me of my present suffering."

Prometheus is extremely generous, but he quite misses the point of the difficulty that preoccupies Zeus—a problem that resurfaces (once again) in contemporary ecology—and it is no coincidence that the image of Prometheus is omnipresent in this latter context. In the eyes of Zeus, Prometheus's boast sounds like the most incriminating confession of guilt, and what the son of Iapetus the Titan puts forward in his defense is, from the perspective of the Olympians, the most terrible of self-indictments. What Greek mythology dramatizes here, with clairvoyance and profundity, is the definition (entirely modern, moreover)* of a species whose freedom and creativity are fundamentally at odds with both nature and cosmos. Promethean man is already the man of science, capable of ceaselessly creating and inventing, manufacturing machines and devices likely one day to emancipate himself from all the

*It resurfaces initially at the outset of fifteenth-century humanism, in Pico della Mirandola, then in Rousseau, then in Kant, and even in Sartre.

laws of nature. This is, precisely, what Prometheus bestows on men when he steals the "spirit of the arts," which is to say the capacity to deploy and even to devise all sorts of inventions. Agriculture, arithmetic, language, astronomy—all of which will serve man as means to step outside his human condition, to elevate himself arrogantly above the other creatures, and thus to disturb the cosmic order that Zeus has so painfully and so recently succeeding in implementing! In short, contrary to the other living species—whose lives were set in motion by Epimetheus as a perfectly self-regulating and immutable system, at all points unlike what will come to characterize mankind, as soon as men are equipped with arts and sciences—the human species is alone among mortal creatures capable of hubris, the only species capable of defying the gods and disturbing, even destroying, nature itself. And it is obvious that Zeus can only look upon this development with a jaundiced if not an evil eye, to judge by the punishments he metes out to Prometheus and mankind alike.

From here it takes but a short step to arrive at the notion of eradicating humanity completely, a threshold that certain mythological accounts do not hesitate to cross.

The flood, and the ark of Deucalion and Pyrrha, according to Ovid: destruction and rebirth of humanity

One fact is henceforth clearly established: the tendency for hubris to become engrained once humanity is armed with new powers of creativity allied to the sciences and scientific prowess, all of which Prometheus has stolen from the gods. Hubris threatens constantly to embroil mortals in vice and lead them to commit more and more crimes against a just order. Several ancient mythographers follow a description

of the golden age (these are more or less corrupt versions
of Hesiod) with a more celebrated episode: that of the del-
uge or flood with which Zeus decided to destroy human-
ity in its current form, in order to start afresh—exactly as
in the Bible—with two righteous individuals, a man and a
woman: namely Deucalion, son of Prometheus, and Pyrrha,
the daughter of Epimetheus and Pandora. Both are described
as simple and upright souls, who live just lives according to
dikè, remote from the hubris that characterizes the rest of a
humanity foundering in decadence.* The first poet to give a
detailed and complete account of the deluge—prior to which
there are only scattered allusions, insufficient to make a co-
herent narrative—was Ovid. At the start of *Metamorphoses*
he offers a plausible version of the myth and links the deluge
to a particular event that might be seen as occurring in the
present epoch, namely the age of iron, and that is a direct
consequence of the moral dereliction to which humanity has
been reduced in this period. The episode concerns Lycaon, a
Greek king who tries to deceive Zeus in the most abomina-
ble manner. Ovid sets the stage by evoking the existence of
a race, during or after the age of iron (the chronology is not
clear), fashioned by Gaia from the blood of the giants slain
by Zeus—in order that some trace of her former offspring
might remain. She gives these beings a "human face," but
they bear the indelible trace of their origins and are essen-
tially characterized by violence, the taste for slaughter, and
contempt for the gods.

*This episode appears nowhere in Hesiod, and the problem, of course, is decid-
ing at which stage this famous flood is supposed to have occurred. Relying on
later sources—probably *The Library* of Apollodorus—some mythographers sim-
ply placed the destruction of a corrupt humanity in the age of bronze. It should,
however, be clear that, within the perspective opened by Hesiod, this hypothesis
makes no sense, since men of the bronze age are characterized primarily by their
natural impulse to self-destruct through unremitting warfare with one another,
so Zeus has no need whatsoever to intervene in order to rid the cosmos of them.

Let us pause for a moment at this account of the deluge, and imagine ourselves transported to the age of iron or, even worse, to the epoch of those born from the blood of the giants—in other words, a time of rampant hubris. Zeus, who has been told that humans are behaving rather badly, comes to make a tour of inspection on earth, to see for himself how far humanity has fallen. And what does he find? That the situation is far worse than he had been told! Everywhere assassins and thieves are in control, men who despise the order of things established by the god. So as to make his own observations, incognito, and avoid falsifying the results by being recognized, Zeus takes human form and wanders up and down on the earth. Thus he arrives in Arcadia, which is ruled by a tyrant named Lycaon (Greek for "the wolf"). Zeus gives a sign to the common folk of the region that a god has arrived. Impressed, they begin to pray to him. But Lycaon bursts into laughter. And in keeping with a pattern that we shall often encounter, and which recalls the episode of Tantalus, Lycaon decides to challenge Zeus, to see if he is truly a god, as he claims, or on the contrary a mere mortal.

Lycaon decides to murder Zeus while he is sleeping, but before putting this grievous plan into effect, he cuts the throat of an unfortunate prisoner who had been sent by the king of a people called the Molossians as a hostage and then dismembers him. Some parts he boils, and others he roasts, with the bright idea of serving it all up to Zeus for his supper! A fatal error, because—witness Tantalus—Zeus has seen and understood everything in advance. His thunderbolt speaks, and the palace of Lycaon falls around the tyrant's head. He manages to escape, but Zeus changes him into a wolf—the same Lycaon, still as wicked, with the same eyes shining with bloodlust, but now turned against his new fellow creatures, toward which he becomes the most ferocious of

predators. . . . Here is how Ovid describes the scene, near the beginning of *Metamorphoses*—from which I quote, so that once again you may see the style and brilliance with which these myths were communicated to contemporaries. Here Zeus is speaking in the first person, from Mount Olympus, where he has called an extraordinary assembly of all the gods. It is they whom he addresses, to share his experiences, to inform them that he is ready to destroy the human race, and to give them the reasons for his decision. As always, my own comments are in brackets:

> "During that night, while I was heavy with sleep, he planned to kill me by an unexpected and murderous attack; such was the experiment he adopted in order to test the truth [*in other words, to discover if Zeus is a god or otherwise*]. And not content with this, he took a hostage who had been sent by the Molossian people, cut his throat, boiled some parts of him that were still warm with life, to make them more tender, and others he roasted over the fire. But no sooner had he placed these before me on the table than I, with my avenging thunderbolt, brought the house down upon his head. . . . Seized with terror, he flees to safety, and, gaining the silent fields, howls aloud, attempting in vain to speak words. His mouth of itself gathers the foam of his rage, and with his accustomed lust for blood he turns against the sheep, delighting still in slaughter. . . . His garments change to shaggy hair, his arms become legs. He turns into a wolf, yet retains some traces of his former shape. The same gray hair, the same fierce aspect, the same gleaming eyes, the same picture of bestial savagery. I have so far struck one house, but more than one deserves to perish! For wherever the earth extends, there menaces the same furious Erinye [*one of the goddesses of vengeance—indicating that there are crimes to be punished everywhere*]. You would think it a universal conspiracy of criminals. Let us not drag our heels. Let them all pay the penalties they have so richly deserved. This is my decision and it is irrevocable."

And the punishment, as you have guessed, is the flood. Zeus initially thinks of destroying humanity by means of his favored weapon, the thunderbolt, as used against Lycaon. But then he reconsiders: the scale of destruction required is so great—no less than the entire earth needs to be rid of a corrupt humanity—that the bonfire required would risk setting fire to the whole universe and burning Olympus itself. So it is with water that Zeus will implement his will, and by water that the human race will perish. Zeus takes care to shut down those winds, such as the mistral, that chase the clouds away and bring dry weather and warmth. On the other hand, he unleashes—like hounds—the humid vapors, heavy with dark clouds, swollen with the rain that now begins to fall in thick, heavy drops. For good measure, he asks Poseidon (Neptune) to strike the ground with his trident so that the rivers leap from their beds and the ocean waves are unleashed from their moorings. Soon the entire earth is covered in water. Ovid notes that seals with shapeless bodies replace goats in the meadows; dolphins are to be seen amid the trees; wolves are found swimming side by side with sheep and tawny lions, whose only thought now is to save their skins. . . . The daughters of Nereus, one of the sea gods, are amazed to discover entire cities still intact beneath the waters. . . . In short, men and beasts, this whole small world of mortal creatures, ends by being swallowed. Even the birds die: exhausted from flying above the limitless waters, they allow themselves to drop and be swallowed up. And those who avoid the waters, by one means or other, are sooner or later brought down by hunger—since clearly there is no more food.

The whole world is dead . . . except for two beings, two humans whom Zeus has taken pains to spare. Here, again, we are very close to the biblical story. For at the moment when

Zeus announces his decision to destroy the human race in its entirety, the assembly of gods is in effect divided. Some go along with Zeus and even whip up the fever to exterminate. But others on the contrary point out that an earth without mortals is likely to be a very boring and empty place: Are they to let this marvelous microcosm be roamed by wild beasts alone? And then, who will look after the altars? Who will make sacrifices and honor the gods if there are no men left to attend to these chores? The truth of the matter—though it is I who make this point, which is only implicit in Ovid—is that without mankind, the entire cosmos in effect is given over to death, to lifelessness.

And here once more we touch on one of the most profound themes of Greek myth: *if the cosmic order were perfect, if it were indeed characterized by a faultless and immutable equilibrium, time would simply come to a stop, which is to say all life, all movement, all history. And even for the gods there would be nothing more to do or see. From which it is clear that primordial chaos, and the forces that it periodically causes to erupt, cannot and should not disappear completely. And humanity—with all its vices and its generations succeeding one another indefinitely as a consequence of Pandora, whose legacy is that men are now "truly" mortal—is likewise paradoxically indispensable to life. It is a magnificent paradox, which we might rephrase thus: there is no life without death, no history without succession, no order without disorder, no cosmos without a minimum of chaos.* This is why, faced with the objections raised by several of the gods, Zeus agrees to spare two humans, in order that humanity might replenish itself. But which two humans? They have to be two exceptional beings so that this species can at least begin again from a sane and solid basis. Exceptionally, this does not mean that they should be persons of consequence. On the contrary, the pair in question are two simple but honest souls, pure of heart,

who live far from hubris and according to the precepts of *dikè*, honoring their gods and respecting the order of things. Who are they? Their names are Deucalion and Pyrrha. As I have said, the former is a son of Prometheus. Hesiod at no point tells us the name of his mother, nor does Ovid, but Aeschylus suggests that she may be a daughter of Oceanus, an Oceanid therefore, by the name of Hesione. As for Pyrrha, she is the daughter of Epimetheus and Pandora. In a sense, then, these are humans from the age of iron, and this is business as usual for the continuity of the species. But it is also a restarting from zero, from a man and woman who, as far as the entirety of this new future is concerned, which is to say our present humanity, *may be considered as the first man and the first woman.*

How are they to repeople the earth? In a manner that is extremely curious and recalls primitive ritual rather than anything associated with Pandora—which is just as well, if things are to get off on an improved footing. Alone, frightened, lost in a gigantic and deserted universe, Deucalion and Pyrrha, having constructed (like Noah) a very solid ark, after nine days of uninterrupted deluge, come to rest on the heights of Mount Parnassus, which has been carefully preserved from inundation by the will of Zeus. There the couple encounters some charming nymphs, known as the Corycian nymphs because they inhabit a grotto, the Corycian cave, in the side of Mount Parnassus, just above Delphi. Deucalion and Pyrrha then make their way to the sanctuary of Themis, the goddess of justice, to whom they address their prayers and their pleas: asking how to survive after the cataclysm and, above all, how to restore a lost humanity. Themis takes pity on them, and here is how she responds (as always, with the oracles—at first hearing—somewhat enigmatically):

"Leave the temple, cover your faces, remove the girdle of your garments, and cast over your shoulders without looking the bones of your grandmother."

It has to be said that these instructions seem strange, and our two unhappy humans are very confused. What exactly does the goddess mean? They reflect and finally they understand: to cover your face and remove the girdle of your garments is to adopt the ritual appearance of priests when they offer sacrifice to the gods. It is a sign of humility, of respect—the opposite of the hubris that led humanity into catastrophe. As for the bones of their grandmother, clearly this does not mean—as Deucalion and Pyrrha fear initially— that they must go and profane some cemetery or other! The grandmother in question is, of course, Gaia, the earth—or, to be more precise, the great-grandmother of Deucalion and Pyrrha, mother of Iapetus, who was himself the father of Prometheus and Epimetheus, who are in turn the fathers of our two survivors. And the bones of Gaia are, quite simply, the stones on the ground. The oracle's pronouncement just required a little thought. Completely awed, and still fearing that they have misunderstood, Deucalion and Pyrrha nevertheless pick up some stones and cast them over their shoulders. What happens next is a miracle! The stones begin to soften. Mixing with the earth, they become flesh; veins appear on their surfaces, which in turn fill up with blood. Those thrown by Pyrrha become women, and those thrown by Deucalion become men, all of whom bear the mark of their origin: the new humanity will be a race inured to work, like the stone from which they have sprung, inured to a life of fatigue, hard as rock!

This leaves the animals, which all have likewise perished in the deluge. Happily, under the sun's heat, the waterlogged

earth warms up and in this tepid mud, "as in the womb of a mother" (Ovid), animals commence slowly to be born, emerging into the light and coming to life, innumerable species, not only the old familiar species but also some quite new varieties.

The world is on the march again. Life resumes its course once more, and the cosmic order surmounts both of the evils by which it was menaced: chaos, on the one hand, which was always on the brink of resurgence, given a humanity immersed in hubris, and on the other hand deadly boredom and stultification, were mortal creatures to have vanished entirely from the face of the earth. And here we realize that only now is the cosmogony, the construction of a cosmos, well and truly complete.

It is also at this point, therefore, that the crucial question—where mythology and philosophy join hands—can finally be framed in all its amplitude: What is it that constitutes a good life for these mortals? And it is only with the figure of Odysseus that we begin to address this question in detail. It is not enough for us to place ourselves in the position of the gods, which we have done hitherto, adopting a theogonic perspective. After all, what concerns us at bottom is how we should relate as humans to this grand conceptual edifice. Let us assume, for argument, that we subscribe to the Greek vision of the world, that we believe the universe is a harmonious and regulated whole, and that we—finite creatures—are destined irremediably to die: in these circumstances, what are the conditions, the principles, of a good life? Besides, these hypotheses are somewhat less rebarbative for us, today, insofar as they possess some contemporary currency: when everything is weighed, it is quite possible that the universe is in effect an ordered whole, as the ancient Greeks believed. Contemporary science inclines on various counts

in this direction. Each day, the discoveries of biology or in physics lead us closer to thinking that there are indeed self-regulating ecosystems, that the universe is ordered, that species are evolving in the direction of increased adaptation, and so on. As to mortality, helped on by the secularization or disenchantment of the world, in the democratized West (at least) we are collectively ever more inclined to think that the idea of immortality promised by religion is doubtful. The idea, therefore, that wisdom may consist in accepting the hypothesis of a cosmic order on whose stage human beings appear but briefly seems more relevant than ever before. This is also why the voyage of Odysseus, involving an unmistakable transition from the perspective of the gods to that of simple mortals, and describing how one individual can and must find his place in the cosmos so as to arrive at the good life, speaks so vibrantly to us today.

Let us try better to understand the why and wherefore of this: it involves the whole question of a wisdom for mortals, which is well worth our pursuit.

The Wisdom of Odysseus

—or, The Reconquest of a Lost Harmony

I WILL NOW SPEAK of the celebrated voyage of Odysseus, which Homer describes in the *Odyssey*, and which takes ten long years in the aftermath of the terrible Trojan War. If we take account of the fact that the conflict itself separated our hero from his own people for ten years, that makes twenty years or more that Odysseus is not "in his rightful place," near his loved ones, where he ought to be. Nor did Odysseus want this war in the first place. He does everything in his power to avoid taking part in it, and only when forced to do so does he leave his homeland, Ithaca, the city of which he is king—leaves his little son, Telemachus; his father, Laertes; and his wife, Penelope. It is morally imperative for him to do so, of course, but no less painful for all of that: despite his deepest wish to remain at home, with his people, Odysseus must gird himself and honor his obligations toward Menelaus, the Spartan king whose wife, the beautiful Helen, has been abducted by the young Trojan prince Paris. Odysseus's life is shattered or, in the Greek sense, "catastrophied," overturned: he is forcibly removed from his natural place, from the place that belongs to him but also to which he belongs, forcibly separated from those who surround him and who form his human world. And he has but one wish, which is to return

home as soon as possible, to find his place again in the order that war has overturned. However, for several reasons the voyage back will be extremely painful and difficult, full of pitfalls and almost insurmountable trials—which explains the extent and duration of the journey that our hero will have to accomplish. Besides, these events unfold in a nonnaturalistic atmosphere, in a world of marvels that is not our human world—a universe peopled by divine or demoniacal beings, benign or maleficent, but who at any rate no longer exist in ordinary life, and who therefore symbolize the constant possibility for Odysseus of never being able to return to his initial state, of never finding his way back to an authentic human existence.

I. Context: the meaning of the voyage and the wisdom of Odysseus, from Troy to Ithaca, or from chaos to cosmos

It would be easy to recount the different stages of the voyage, one by one, without addressing their significance. They are sufficiently gripping and entertaining to be read for their own sake. But this would be a missed opportunity; we would lose so much, and to so little purpose. Firstly, because there have been dozens of retellings, not least for children, of the travails of Odysseus. Secondly and above all, because the adventures of the king of Ithaca do not assume their true contours and depth until placed in the perspective of what we have been exploring in these pages: the emergence, with a full-fledged theogony and cosmogony, of what might be termed a cosmic wisdom, a new and compelling definition of the good life for us mortals, a "secular spirituality" of which Odysseus is perhaps the very first representative in

The Wisdom of Odysseus 169

the history of Western thought. If the good life, for those
who will die, is a life lived in harmony with the cosmic
order, Odysseus is the archetype of the authentic individual,
the wise man who knows both what he wants and where
he is going. This is why, even if it holds up the story for a
moment, I would like to offer some suggestions that will
allow us to get the true sense of this Homeric epic and to
grasp its philosophical profundity.

First main theme: toward the good life and a wisdom for mortals—a voyage, like the theogony itself, from chaos to cosmos

In the first place, we should note that it all begins with a series
of ruptures, or fractures: a succession of upheavals that must
be confronted and resolved. As with the *Theogony*, the story
starts with chaos and ends in cosmos. And this initial chaos
takes many different forms.* Firstly, and most obviously,

*Before the outbreak of the Trojan War—even before the goddess of discord,
Eris, arrives to spoil the marriage feast of Thetis and Peleus and set in motion
the beginnings of the conflict (namely the love of Paris and Helen)—a baleful
destiny is already shaping itself for the Greeks: the curse of the House of Atreus.
This curse is itself the subject of a protracted history, passed from generation to
generation over the course of centuries. . . . It all begins with Tantalus, who has
defied the gods, for which he suffers appalling torment in the underworld: not
only is he forever dying of hunger and thirst, but an enormous and precariously
balanced rock is suspended just above his head, threatening at every moment
to fall and crush him—just to remind him that he is but a finite mortal who
thought he could measure himself against the gods. But the gods are not content
with this punishment, and it is his entire lineage—itself hardly respectful of the
Immortals, to say the least—that must expiate his crimes. The children of his
daughter, Niobe, will be massacred by the twin archers Artemis and Apollo on
account of her disrespect toward their mother, Leto. His son Pelops will have
two sons, Atreus and Thyestes, who will detest each other—to the point that
Atreus will kill his brother's children, boil them, and serve them up to him for
dinner. . . . Atreus himself will have two children, Menelaus and Agamemnon,
who will command the Greeks during the Trojan War. But on Agamemnon's
return, his wife, Clytemnestra—infuriated by his having sacrificed their
daughter Iphigenia—has begun an affair with Aegisthus, and he is murdered
by the couple. Orestes, his son, will avenge his father in turn by murdering his

there is the Trojan War itself, all of which occurs under the sign of Eris (going back to the precipitating episode of the "apple of discord," described at the beginning of this book). The conflict is terrible, and thousands of young people lose their lives in warfare of an unimaginable cruelty: not only is it bloodthirsty and brutal, but it also represents an unprec-edented upheaval for soldiers who are sent far from home, far from all civil society, all happiness, and plunged into a universe that no longer has anything to do with the good life, lived in harmony with others and with nature.

Once the war is won by the Greeks, thanks largely to the cunning of Odysseus and his infamous wooden horse, events are prolonged for a second act of utter chaos: the sacking of Troy. This goes beyond all moderation, almost beyond all understanding—besmirched by the most mindless hubris. The Greek soldiers, who have lost ten years of their lives in conditions so atrocious that they will certainly never recover from the experience, have become worse than beasts. When they enter the sacked town, they take pleasure in massacring, torturing, raping, and smashing all that is beautiful and even all that is held sacred. Ajax, one of the most valorous of the Greek warriors, will go so far as to rape Cassandra, the daughter of King Priam, sister of Paris, within the temple dedicated to Athena. The goddess does not appreciate this— still less on account of Cassandra's gentleness. Cassandra, it is true, is afflicted by a sinister misfortune bestowed on her by Apollo. The god of music fell in love with her and, to gain her favor, offered her an extraordinary gift: the power to foretell the future. Cassandra accepts his suit, but at the last moment refuses to yield to the god's advances . . . which in

mother and Aegisthus. Orestes will be judged and finally acquitted, which will put an end to this terrible curse upon the lineage of Atreus, which provided the subject for numerous Greek tragedies. . . .

turn angers Apollo. To avenge himself, he condemns her to a terrible fate: that henceforth she will continue to be able to foretell the future—for a gift can never be recalled—with the corollary that no one will ever believe her! It is thus that Cassandra pleads in vain with her father not to allow the Trojan horse into the city, for no one listens to her. . . .

That is no reason to rape her, however, and least of all in the temple of Athena. And the behavior of the Greeks is all of this order—such that the Olympians, even those who have been supporting the Greeks against the Trojans, such as Athena herself, are appalled by this new chaos in human affairs, heaped so pointlessly upon the chaos that is war: true nobility consists in showing oneself worthy and magnanimous not only in adversity but also in victory—and in the event the Greeks have behaved in a manner that is to be deplored. Put bluntly, they have conducted themselves like swine. Confronted with this great tide of hubris, Zeus must resort to harsh measures: he unleashes tempests upon the Greek fleet when they decide to turn toward home after the pillage of Troy has finally run its course. For good measure, and to put a halt to their gallop, he sows discord between their generals, notably between their two most powerful kings, the brothers Agamemnon (who has commanded the Greek armies for the whole of the conflict) and Menelaus, king of Sparta and cuckolded husband, discarded by the beautiful Helen in favor of Paris. . . . So here we have at least five different varieties of chaos accumulating and piled one on top of another: the apple of discord, the war, the sack of Troy, the tempests, the squabbling of the generals—the latter two already directly responsible for the initial difficulties of Odysseus in trying to return home.

But there is much worse to come for Odysseus: as we shall see in a moment, he will in the course of his voyage earn

the undying hatred of Poseidon on account of blinding one of the latter's sons, a Cyclops named Polyphemus. Under the circumstances Odysseus could hardly do otherwise: the Cyclops is a terrifying monster decked out with a single eye in the middle of his forehead, who has started devouring the companions of Odysseus. Blinding him is the only means of escape. On the other hand, Poseidon has to stick up for his children, however ill mannered, and he will never find it in himself to pardon Odysseus: henceforth, and at every opportunity, he does whatever lies in his power to make life difficult for Odysseus and prevent him from returning to Ithaca. His power is considerable, moreover, and the tribulations of Odysseus will testify to it. . . .

Finally, the last manifestation of chaos, which Homer evokes at the outset of his story and which Odysseus will have to confront at its very end, is by no means the least: the young men of his beloved homeland, Ithaca, have in his absence created the most unimaginable disorder within his palace. Convinced that Odysseus has long been dead, they decide to take his place, not only in charge of the island kingdom itself but also at the side of his wife—who tries at all costs to remain faithful to her husband. They are called the Suitors, or Pretenders, since they pretend both to the throne of Ithaca and to the hand of Penelope. Not unlike the Greeks during the siege of Troy, the Suitors likewise behave like swine: every evening they carouse in her palace, to her despair and that of her son, Telemachus, who is still too young to turn them out unaided, but who lives in a state of fury and indignation from morning to night. The Suitors drink and eat whatever they find, whatever they are capable of consuming, without restraint, making themselves entirely at home. They slowly exhaust all the wealth accumulated by Odysseus for his family. When they are in their cups

they sing and dance as if possessed and then sleep with the serving women. They even make improper advances to Penelope—in short, they are intolerable, and the household of Odysseus, what the Greeks would call his *oikos*, his natural place, itself passes from order to chaos.

While Odysseus reigned, his household resembled a small cosmos—a microcosm—a small harmonious world in the image of the universal order established by Zeus. And now, ever since his departure, all is turned upside down. If we wish to pursue the analogy, we could say that the Suitors conduct themselves like "mini-Typhons" within the state. The primary purpose of his voyage, for Odysseus, is to reach Ithaca in order to restore his world to its proper place, to reinstate his *oikos*, his house, as itself a cosmos—at the heart of which our hero is well and truly "divine." Moreover, he is often spoken of as "divine Odysseus." Zeus himself asserts at the start of Homer's poem that Odysseus is the wisest of all humans since his destiny is to behave on this earth as does the ruler of the gods on a universal scale. Although mortal, he is a just epitome of Zeus, as Ithaca is a miniature world, and the whole purpose of his exhausting return, if not of his entire existence, is to see justice—harmony, in other words—triumph over the odds, whether by cunning or by force. Zeus cannot remain indifferent to this project, which reminds him of his own trajectory. And whenever necessary, he will assist Odysseus in this journey back to the final and fateful confrontation with those embodiments of chaos and disharmony, the hubristic Suitors. . . .

Second main theme: two pitfalls, to forego being a man (the temptation of immortality) or forego the world (forget Ithaca and abandon the voyage)

We have now established where Odysseus is coming from and where he is heading: from chaos toward cosmos—on his own terms, naturally, which are human but which reflect the larger scheme. It is a journey into wisdom, a painful path, tortuous in the extreme, but whose purpose at least is perfectly clear: to achieve the good life while accepting the mortal condition that is every human lot. Odysseus, as I have said, wishes not only to find his own people again but also, equally, to put his *polis* (his city) back in order, for it is only in the midst of others that a man is truly himself. Isolated and uprooted, cut off from his world, he is as nothing. This is what Odysseus himself says, quite clearly, when he addresses the good king of the Phaeacians, the wise Alcinous (as we shall see shortly), whose harmonious and peaceful island government he so admires:

> "Nothing is better than when deep joy holds sway throughout the realm and banqueters up and down the palace sit in ranks, enthralled to hear the bard [*custom dictated that a poet or storyteller, called an* aoidos, *sing his stories accompanied by a cithara, rather like the medieval troubadours*], and before them all, the tables heaped with bread and meats; and, drawing wine from the crater [*the vessel in which wine was placed before being mixed with water*] the steward makes his rounds and keeps the winecups flowing. This, to my mind, is the best that life can afford. . . . Nothing is as sweet as a man's own country, his own kin, even though he's settled in some luxurious house, in a foreign land and far from those who bore him."

The good life is the life lived among one's own people, in one's own land, but this definition should not be understood in its flattened contemporary sense of "patriotic" or "nationalist." It is not the famous modern formula of *"Travail, Famille, Patrie"* ("Work, Family, Homeland," coined by Maréchal Pétain) that Odysseus has in mind, as if he were thinking ahead of his time. What underpins his vision of the world derives from cosmology, not political ideology: the successful life, for a mortal, is a life adjusted to the surrounding order, of which family and *polis* are simply the most tangible expression. In the tuning of a particular life within the larger orchestra of this world, there are an infinity of individual considerations to be negotiated, nearly all of which Odysseus will explore: one needs time to understand others, sometimes to struggle against them or to learn how to love them; time to civilize oneself, to discover other ways of life, other cultures, other landscapes; time to know the inmost depths of the human heart under its least obvious aspects; time to test one's own limits in the face of adversity. In short, one does not learn to live harmoniously without undergoing myriad experiences, which, in the case of Odysseus, will occupy a large proportion of his life. But beyond its almost initiatory role in human terms, beyond even its cosmological aspect, this conception of the good life also possesses a properly metaphysical dimension. It is profoundly tied to a certain conception of death itself.

For the Greeks, what defines death is loss of identity. The defunct are first and foremost "nameless," even "faceless." All those who leave life behind become "anonymous"; they lose their individuality; they cease to be persons. When Odysseus is obliged, during the course of his voyage, to descend into the underworld where those who are no longer alive pass their time, he is gripped by a gnawing and terrible anguish.

He observes with horror the numbers who dwell in Hades. And what anguishes him above all else is the indistinct mass of these shades, none of whom he can identify. What terrifies him is the noise they make: a confused murmur, a hubbub, a sort of muted rumbling beneath which he can no longer distinguish an individual voice or even words that make any sense. It is this depersonalization that characterizes the dead, in the eyes of the Greeks, and the good life must mean— insofar as possible and for as long as possible—the absolute antithesis of this infernal blankness.

Now the identity of an individual is defined by three crucial conditions. Firstly, membership in a harmonious community, a cosmos. Once again, man is only man in the midst of other men; in exile, he is no longer anything at all, which is why banishment from the *polis* counted for the Greeks as a death sentence, the supreme punishment that could be inflicted upon criminals. But there is a second condition: memory, or recollection, without which we do not know who we are. A man must know where he comes from in order to know who he is and where he is going: the oblivion of forgetting is, in this respect, the worst form of depersonalization to be experienced in this life. It is a *petite mort* at the heart of life, and the amnesiac is the most unfortunate creature on earth. Thirdly, an individual must (by definition) accept the universal human condition, which means, when all is said and done, mortality itself: not to accept death is to live in hubris, in a state of immoderation and of pride bordering on insanity. Whoever refuses death takes himself for what he is not—a god, an Immortal—just as the madman takes himself for Caesar or Napoleon. . . .

Odysseus accepts his mortal condition by rejecting the offer of Calypso. And he retains everything in his memory,

and he has but one fixed idea: to reclaim his place in the world and put his house in order, in which respect he is the model and archetype of archaic wisdom.

But it is within this same perspective that we must understand the pitfalls that Odysseus will encounter en route. It is not simply a question (as in a thriller or a Western) of challenges devised to test and bring to the fore the courage, strength, or intelligence of the hero. Here we have trials that are infinitely more searching, endowed with a significance both menacing and precise. If the destiny of Odysseus, as Zeus states explicitly at the outset of the poem, is to return home, to restore order in the *polis* and thereby find his rightful place again among his own people, then the obstacles placed in his way by Poseidon are by no means chosen at random. They are well and truly devised to lead him astray from his path and his destiny, to make him lose all understanding of his existence, to block him from achieving the good life. The traps strewn in his path are just as philosophically charged as is the end in view, as the voyage itself. For in order to divert Odysseus from his destiny, there are only two options if we renounce killing him off at the outset, as Poseidon must: either to induce in him the oblivion of forgetting or to tempt him with the blandishments of immortality.* Both of which prevent a man from being a man. If Odysseus forgets who he is, he will also forget where he is going and will never achieve the good life. But if he accepts the offer of Calypso, if he succumbs to the temptations of immortality, he will just as equally cease to be a man. Not only because he would become a de facto god but also because the condition of this "apotheosis," this translation into divinity, would be

*An aspect of the poem that Jean-Pierre Vernant in particular has richly explored.

exile itself: he would have to renounce forever being with his loved ones, in his rightful place, so that his very selfhood would be lost.

This is the paradox that informs the entire trajectory of our hero and gives its meaning to the epic as a whole: that by accepting immortality Odysseus would in effect become indistinguishable from one of the dead! He would no longer be Odysseus, husband of Penelope, king of Ithaca, son of Laertes. . . . He would be an anonymous exile, one of the nameless ones, vowed for eternity to be no longer himself—which for the Greeks affords as good a definition of hell as any. In conclusion, immortality is for the gods, not for men, and not what we should be energetically searching for in this life.

This, then, is what menaces Odysseus for the whole of his voyage: the risk of losing those two constitutive poles of the successful life, his belonging to the world and his belonging to humanity, his being part at once of a cosmos and of a microcosm. Odysseus will be menaced ceaselessly with forgetting: on the island of the Lotus-Eaters, whose food makes his men lose their memories; or when they pass close to the Sirens, the lure of whose singing makes them lose their minds; or when they are in danger of being transformed into swine by the goddess Circe; or when Odysseus succumbs to the charms of Calypso, described by Homer at the start of the poem as "coaxing him with her beguiling talk, so that he forgets Ithaca," whereas he "longs only to see the hearthsmoke rise heavenwards from his own island . . ." It is additionally in the shape of a deadly but entirely human sleepiness that Odysseus will be menaced by forgetting—and these losses of consciousness will allow his men to make fateful errors (as we shall see) in respect to Aeolus, god of the winds, and Helios, god of the sun. Forgetting, in all its forms,

is the temptation to abandon the attempt to return home, which in turn for Odysseus means renouncing his place in the scheme of things. And the other menace is equally grave: to give in to the desire for immortality, which for Odysseus would mean losing his humanity.

This is why it is absurd to try to locate the stages of his voyage on any actual map. This has never been feasible, and with good reason (which might have spared those who have wasted so much time in the conviction that it is a literal journey). The world through which Odysseus moves is not our actual world. Of course, the author of the *Odyssey*, whoever he was (it is not known whether Homer in fact composed this work, or even if there were several authors, nor does it matter for our purposes), blended the real and the imaginary so that some of the names correspond to very real places. Sometimes we can identify a particular island, or city, or mountain, etc. But the deeper purpose of this world through which our hero moves has little to do with geography. It is an imaginary realm, if not a philosophical realm, peopled with beings who are neither quite men nor entirely gods—the Phaeacians, the Cyclopes, Calypso, Circe, the Lotus-Eaters—all of whom are bizarre, out-of-this-world (in German one would say *weltfremd*), supernatural. The attempt to map the voyage of Odysseus is absurd, meaningless. It entirely misses the point: namely that Odysseus is, for a period of time—the time of his voyage—*outside* of the cosmos. He has a foot in two worlds, so to speak, and it is his choice, employing all the courage and cunning and tenacity of which he is capable, to become truly a man once more and reenter the real world.

The ultimate menace that weighs upon him, which explains the uncanny aspect of his voyage and of the beings he encounters, is quite simply the twin possibility of ceasing to be authentically human and of no longer fitting into the

world, the cosmos. This is what is at stake (rather than the difficulties of navigation or mere map reading . . .). Odysseus will steer clear of these twin reefs, and Tiresias, the sooth-sayer whom he encounters in the underworld, tells him so, albeit in somewhat equivocal terms: firstly, that he will reach home, after dreadful trials, and secondly that he will die in old age, unlike Achilles. . . . In short, Odysseus will recover his manhood and his world: mortality and the reality of men, on the one hand, and on the other hand, Ithaca and the reality of a corner of the cosmos to which he can and must restore order. Ordinary reality, and the good life for mortals, at the very last. . . .

We shall now see how this is achieved, and at what cost.

II. The voyage of Odysseus: eleven steps toward mortal wisdom

We can distinguish eleven stages or episodes in the journey that leads Odysseus from Troy to Ithaca, from war to peace. But in Homer's work, the *Odyssey*, these are not presented "in the right order," according to the actual chronology fol-lowed by Odysseus; rather they are presented in flashback, as we would say today. In the cinema this refers to a "retracing of steps": roughly, a transition to an earlier event or scene that interrupts the chronological development and explains how we arrived at the present moment. To be specific, the *Odyssey* opens at the point where Odysseus is prisoner of Calypso—which was also the starting point of this book—and where Zeus sends Hermes to command the nymph to release the hero. This is when she offers him immortality and eternal youth—and he refuses this seemingly irresistible but in reality lethal proposition. It is also during this episode

that we momentarily glimpse the Suitors in Ithaca, a far cry from Calypso and Odysseus, despoiling the palace of Odysseus and trying to rob him of both his place and his wife. But by this point, even if the voyage is by no means over, many things have already happened.

Firstly, we learn that Odysseus does finally leave the island of Calypso after lingering there for a long time—perhaps seven years, perhaps more, perhaps less. For on this island time no longer has any meaning: it is located out of the known world, and obeys rules that are not those of ordinary reality. But Calypso cannot hold out against Zeus. She must obey and allow Odysseus to leave. She does so with death in her soul, for she truly loves him and knows that henceforward she will be alone. But she does so finally with good grace nonetheless. She gives him the means to construct a raft: an axe, good tools, strong ropes, wood. Then she offers him water and wine and provisions for his journey. Odysseus believes that now he might finally be able to reach home. But he is prematurely forgetting the hatred that Poseidon still bears toward him for blinding his son, the Cyclops Polyphemus, which occurred before Odysseus came to Calypso's island. From on high, Poseidon notices Odysseus sailing through the "fish-filled seas," as Homer always refers to them . . . and he is filled with a terrible rage. He realizes that his colleagues, the gods on Olympus, have taken advantage of his absence—he had gone off to feast with his friends the Ethiopians on the other side of the world—to agree in council to allow Odysseus finally to return home, whereas Poseidon has all along been doing his level best to prevent this from happening. He cannot openly flout the other gods, or at least not the will of Zeus—otherwise he would surely have killed Odysseus by now. But he can nonetheless stick his oar in (so to speak) and considerably

lengthen the homeward journey by laying a series of traps along the way, as he has been doing from the start.

It is by now seventeen days since Odysseus left the island of Calypso, seventeen days and nights of navigating as best he can on his small raft, at which point Poseidon unleashes the most fearful of all tempests. The waves are gigantic, the wind demented. Naturally, the tree trunks patiently lashed together with ropes by Odysseus begin to break up, for a raft is not made to resist such a storm. At the last, our hero finds himself perched astride a wooden beam, and after two days of this ordeal, without sleeping or eating, in the cold and the salt water, he is convinced that he will inevitably drown. It is at this point that Ino, a sea goddess, comes to his assistance: she offers him a white veil and tells him to cast off the remains of his clothes, to wear this veil and swim for it—without fear, for he will come to no harm. Odysseus hesitates, asking himself—as you would in his place—is this not another ruse, another of Poseidon's tricks to destroy him. On the other hand, as he really has no other alternative, he takes the plunge. He must either drown or trust himself to the waves.

It was the right thing to do. Without too much trouble he finally reaches dry land: a magnificent island inhabited by a people, the Phaeacians, whose king, Alcinous, and queen, Arete, are profoundly good and welcoming people. In needs to be added that, during this entire episode, Athena is watching over Odysseus and making sure that he comes through unscathed. Alcinous and Arete have a daughter, the ravishing Nausicaa, fifteen or sixteen years old. She finds Odysseus, who is in a terrible state of disarray and exhaustion. His hair all matted, his face swollen, streaked with brine and filth, he looks more like a scarecrow than a hero. But Athena still watches over events. She dispels

Nausicaa's fears and makes her see Odysseus as he is "in truth," despite appearances. Nausicaa has him washed, decently clothed, and anointed with olive oil, all of which makes him recognizably human. . . . Then she leads him to her parents' palace, where he is received as a friend. Alcinous grasps immediately that he is dealing with no ordinary mortal. He even offers Odysseus the hand of his daughter, Nausicaa, which Odysseus declines graciously, telling them the simple truth: his wife, Penelope, his city, and his son await him. But here again, the temptation is great and the trap of forgetting very nearly springs shut. . . .

Odysseus is presented with magnificent gifts, games are organized, grandiose dinners, a magnificent feast in the course of which an *aoidos*, the bard or troubadour without whom no Greek celebration is worthy of the name, retells (what else?) the late story of the Trojan War. Odysseus can no longer contain himself. His tears flow—unperceived at first, for he hides them well—but Alcinous sees them and cannot help but ask the reason. It is now that Odysseus reveals his true identity: that he is in reality Odysseus, hero of the Trojan War, whose exploits the bard has just been singing. Naturally the entire assembly holds its breath. The unfortunate bard falls silent, as he must when faced with such competition. And Odysseus is asked to continue the story in his own words: Who better placed than he to narrate his own adventures?

It is here that the famous flashback begins, the retracing of steps that will allow us to fill in the gaps and to understand what really happened between the end of the Trojan War and the arrival on Calypso's island (we know what occurred afterward, but we know nothing of what preceded Calypso). Odysseus sets about telling the whole story, before the king, the queen, and their guests—all of whom are fascinated to

learn what will follow. He begins by recalling the sequence of events, the primal scene, so to speak: the Trojan War has just ended; the dreadful pillage is over and done with, on account of which the Olympians are angry with the Greeks; Zeus sends a tempest and sows discord among their generals, as I described earlier. So the homeward journey of Odysseus starts off under very poor auspices. All the more so since immediately or soon after his departure he drops anchor with his companions in a hostile region, the land of the Cicones, a warrior race with whom any truce seems impossible. It is warfare all over again. Odysseus and his men plunder the city—just as they plundered Troy—and massacre their new enemies with a vengeance, apparently sparing only one man and his family: a certain Maron, a priest of Apollo. By way of thanks, Maron offers Odysseus several goatskins of delicious wine, quite out of the ordinary, at once delicate and strong, which will later prove very useful . . . but let us not anticipate. For the moment, Odysseus and his soldiers set to feasting on the beach. This is the well-earned rest of plunderers, but hardly prudent under the circumstances. The few Cicones who have escaped with their lives have gone inland for reinforcements; they come back in the dead of night and descend like eagles upon the Greeks, massacring in their turn a goodly number. The survivors take flight as quickly as they can. They reach their boats and hasten to leave this country, which decidedly has brought them little good, apart from the wine of Maron. We are back in the archaic epoque of conflict and chaos.

Nevertheless, up until this point all is, so to speak, normal and believable: we are dealing with a real city (Troy), a real country (that of the Cicones), real boats, all too real humans— violent but nonetheless "eaters of bread," meaning Odysseus and his companions. . . . There is chaos everywhere, certainly,

but nothing as yet has crossed into the uncanny. With the next stage of his voyage, Odysseus will leave behind the real world and enter an imaginary one, where he will confront obstacles that are no longer quite human, nor even natural, but properly speaking "supernatural": whose meaning can no longer be accommodated in terms of geography, nor of politics or military strategy, but operates rather at the level of myth and philosophy. . . .

Odysseus and his companions have just put out to sea once more, in Homer's words, "sick at heart, glad to have escaped death, though we had lost our dear comrades . . ." For the same reasons as before, Zeus is not best pleased by what has occurred: the Greeks seem to pile one pillage upon another, one disorder upon another, and this must stop. He unleashes once more a terrifying tempest. The sails of the ships break up, such is the force of the wind. The men must resort to rowing (the Greek boats used both means of propulsion). Day and night, Odysseus and his men pull at the oars with all their might . . . until once more they reach a stretch of land. There, overcome with fatigue, they remain on the sand for two days and two nights, unable to do more than sleep and try as best they can to recover their strength. Then, on the third day, they set off again, but the waves, the currents, and the wind, which has picked up again, drive them off course. They no longer know where they are. They are quite lost, with no means of finding their bearings, and for good reason: Zeus has led them into the waters at the edge of this world, which gives us some clue as to the nature of the island on which, after ten days, exhausted once more, they finally land.

It is an island whose inhabitants are indeed strange. They do not eat bread or meat, like ordinary mortals; rather they live off one dish, one flower: the lotus. They are for this

reason named the Lotophagi, which in Greek simply means
"lotus-eaters." You will find no entry for this flower in any
dictionary. It is an imaginary or fabulous plant, a species of
date that possesses one remarkable property: whoever tastes
of it immediately loses his memory. Completely. He be-
comes perfectly amnesiac, remembers absolutely nothing at
all. Neither where he comes from, nor what he is doing here,
nor (even less so) where he is going. He is content with his
condition, and that is all there is to be said. He has all that he
needs. Of course, there is a complete contrast between this
flower, as delicate as it is delicious, and the terrible menace
it represents for Odysseus. If ever he has the misfortune to
taste even a small amount, a sprig, his destiny will be turned
upside down; he will no longer have any wish to return
home, will no longer retain even the notion of home, and
any possibility of attaining the good life will slip through
his fingers once and for all. Besides, three of his companions
have already tasted this herb, with calamitous results. They
are more or less beyond recall. They walk around with a
perpetually inane smile on their faces, like simpletons. They
are entirely happy to be living finally in the present tense
and have no interest in hearing about any voyage home. As
Odysseus nicely puts it:

> "And any crewmen who ate of the honey of the lotus, lost
> all desire to bring back word or return home; their only
> wish to linger there and remain among the Lotus-Eaters,
> gorging on the lotus, all memory of their homeward way
> dissolved forever. . . . But I brought these men by force to the
> ships, weeping though they were, and clapped them in irons,
> forcing them beneath the rowing benches and lashing them
> fast in the hollow of the ships; and I commanded the rest of
> my faithful companions to embark with no delay, so none
> could eat of the lotus and forget the voyage home."

These Lotus-Eaters are no doubt charming and gentle people, like their flower, but Odysseus is all too aware of his narrow escape, and that the worst dangers are not necessarily those that come in menacing shape: they can equally assume a seductive appearance and be as soft as honey. So he takes to the sea again, relieved to have got away so lightly. The next stage of his journey will, however, involve a less concealed and more overtly horrible trial. After several days of rowing, Odysseus and his companions reach their next island, the land of the "one-eyed," also known as the Cyclopes.

Here, too, as with the Lotus-Eaters, he encounters beings like no others, albeit a great deal more unpleasant. Neither men nor gods, they are simply unclassifiable. Here is how Odysseus describes them in the account he gives to Alcinous and Arete:

> "Thence we came to the land of the Cyclops, a race of overweening and lawless brutes, who, trusting entirely to the everlasting gods, plant nothing with their own hands nor plough the soil; but the earth teems for them without sowing or ploughing: barley, wheat, and vineyards bearing rich clusters of grapes which the rain of Zeus ripens. They have neither assemblies for council, nor appointed laws, but dwell separately on the peaks of lofty mountains, in hollow caves, and each is a law unto himself, ruling his wives and children, and they have nothing to do with each other."

Plainly, these people, like the Lotus-Eaters, are not really human. The proof? They do not cultivate the soil and they have no laws. Not that they are therefore gods, but we learn in passing that they are protected by the gods and, to all appearances, very well protected, since they do not need to toil in order to live. . . . In effect, we are in the intermediate world—between mortal and immortal—which will characterize the whole of Odysseus's voyage once he leaves human

reality behind, after his bloody encounters with the Cicones. This island of the "one-eyed" abounds with the fruits of the earth. The companions of Odysseus go hunting and come back with an abundance of provisions, with which they fill the holds of their ships. Everyone gets ready to set sail except Odysseus, who has an unquenchable curiosity about other lives. He is not merely cunning but also intelligent—interested by everything, constantly enriching himself and enlarging his intellectual horizons with new knowledge and experience. He thus addresses his companions:

> "The rest of you stay here, my faithful comrades; but I with my own ship and crew will go and make trial of these men, to learn what they are—whether they are cruel, savage, and lawless, or whether they love strangers and fear the gods."

As this makes clear, the expedition that he now embarks upon is exclusively concerned with knowledge—and here we see another facet of Greek wisdom. An imbecile would not know how to find the good life, and if the final end is indeed to find one's place in the cosmic order, this fulfillment will not occur without a journey that offers the individual the means to enlarge and enrich his vision of the world and his understanding of the beings that populate it. This healthy curiosity is not, however, without its dangers, as Odysseus's encounter with the one-eyed Polyphemus will unhappily demonstrate. With twelve handpicked members of his crew, Odysseus visits the neighboring island. Here he discovers a high cavern, roofed over with laurel: it is both the home of a Cyclops and the shed where his flock of goats and sheep shelter with him at night:

> "Here an individual of monstrous size had made his home, who shepherded his flocks alone, and mingled not with

others, but lived apart, set in his own lawless ways. For he was fashioned like a wondrous monster; not like a man that lives by bread, but like a wooded peak, a man-mountain which rears head and shoulders over the world."

Polyphemus, in effect, is a man as tall as a mountain. With his one eye in the middle of his forehead and his Titanesque strength, he is quite simply terrifying, and Odysseus begins to wonder whether his curiosity has not finally got the better of him . . . but he wishes to satisfy it nonetheless. Seeing that Polyphemus is not at home and that his cave is empty—the Cyclops is out grazing his sheep in the neighboring fields— Odysseus and his companions enter the lair of the monster. One more point to note: Odysseus has taken care to bring with him the dozen goatskins of excellent wine given to him by Maron, Apollo's priest, as a present for Odysseus's bounty in sparing him and his family. The cave of the Cyclops groans with provisions: the racks are full of delicious cheeses; the pens are full to bursting with lambs and kids, with metal churns overflowing with milk, with earthenware jars. . . . Odysseus's companions have but one idea in their heads: to help themselves to all these victuals and get out of there with all due haste and without further questions. But Odysseus wants to know more about these strange creatures. He will not leave the cave without having seen Polyphemus—to his own deep misfortune and, above all, that of his companions who will lose their lives there in atrocious circumstances. For Polyphemus is well and truly a monster.

Odysseus and his friends settle in and wait. As night falls, they kindle a large fire and warm themselves while eating some cheeses to pass the time. When he finally returns home and comes upon this scene, Polyphemus begins by breaking all the rules of hospitality. For the Greeks—at least for those "who eat bread and fear the gods" like true mortals—custom

demands that you begin by offering strangers something to eat and drink before asking them anything about themselves. But Polyphemus begins by subjecting them to an interrogation: he wants to know their names, who they are, where they have come from. Odysseus senses that the encounter is not going well. Instead of replying, he asks for hospitality, reminding Polyphemus, in passing and with an air of veiled threat, of the reverence due to the gods. The Cyclops bursts out laughing: he has absolutely no use for the gods, not even for Zeus himself, the god of strangers. The Cyclops and his like are, so he says, stronger than the gods. As if to make his meaning clear, he now seizes two of Odysseus's crew by their legs and dashes them to the earth, head first. Before their brains have emptied into the ground, he has torn them to pieces, limb from limb, and made his supper of them . . . after which he stretches out and calmly falls asleep.

Sickened, racked by grief and by a sentiment of guilt— for it is his curiosity that has led to the death of his companions—at first Odysseus thinks of killing Polyphemus with his sword. Then he thinks the better of it: the Cyclops, who is of unimaginable strength, has blocked the entrance to the cave with an enormous boulder, and even with their combined force, Odysseus and his friends would be incapable of moving it by so much as an inch. Even if he managed to kill the Cyclops, he would remain forever trapped in his lair. He must therefore find an alternative solution. An atrocious night is spent waiting for an equally terrifying day. And so it proves. For his breakfast Polyphemus devours two more of Odysseus's companions, following the same bloodthirsty procedure. Then he contentedly goes out with his sheep, carefully closing the entrance to the grotto with an enormous boulder. Impossible to escape. Odysseus reflects and comes up with a plan. Noticing a great beam of wood lying near

one of the sheep pens, a sort of massive club of olive wood, as huge as one of the masts of Odysseus's ship, he and his men take hold of it. They hew it, and with their swords they sharpen it at one end, like a giant pencil. Once this stake is well honed, they plunge it into the fire, to harden it as far as possible in the blaze. . . .

Polyphemus finally returns and, as is his custom, sacrifices two more members of Odysseus's crew for his supper. Then Odysseus, following his plan, offers him some wine, namely the delicious but very strong nectar given to him by Maron, which as I said would someday prove useful. The Cyclops, who has never tasted better, drains three or four well-filled craters, one after the other, with the result that he is now properly drunk. He asks Odysseus to tell him his name, promising that if he replies, the Cyclops will make him a sumptuous gift. Odysseus immediately answers with a made-up name, which is the third and last part of his stratagem: that he is called "No One" (*outis*, a word that in Greek inevitably evokes *metis*, or cunning, to which it is very close). The Cyclops replies, cynically, that his great gift to "No One" will be to eat him the last of all his comrades, since he has been gracious enough to tell his name. And with a great burst of laughter, he stretches out and immediately falls into a drunken sleep, to work off the wine and the human flesh that he has just consumed. . . .

Odysseus and his companions thrust the stake back into the fire to heat up. It is by now as hard as bronze and as sharp as a lance. The wood begins to glow; it is time to act. Helped by his men, Odysseus seizes hold of his new weapon and plunges it into the monster's eye while at the same time whirling it around. The scene turns to horror: the Cyclops's blood spurts out and bubbles; his eyelashes burn and turn to ashes; he roars deafeningly. He tears out the stake and

searches desperately for the culprits, to exterminate them . . .
but to no avail, for he is now completely blind, and you
may imagine how well the others have shrunk themselves,
silently burrowing into the most concealed corners of the
cave. However he tries, Polyphemus cannot lay hands on
any of them. So he pushes back his boulder and opens his
door to cry for help. He bellows with all his might. His
Cyclopes neighbors rush to his aid and ask him what has
happened: Was he wounded by cunning or by force? And by
whom? Polyphemus replies that of course he was wounded
by cunning . . . namely by "No One," which he thinks is the
name of Odysseus. The others take him at his word. They do
not understand. "If you were wounded by no one," they tell
him, "then there is nothing we can do for you. You'll have
to manage as best you can!" And off they go.

Abandoned by everyone, Polyphemus stations himself at
the entrance to his grotto, determined to let no one (precisely
so) leave, and to avenge himself on them all in the most
brutal manner. But Odysseus has thought of everything. He
has braided some ropes and has yoked together the rams,
three at a time. The men slide beneath, and cling firmly onto
their underbellies, and by this means leave the cave without
drawing the attention of the giant. . . . Everyone escapes, and
they rush as fast as possible toward their ship, which waits at
the foot of the mountain.

Odysseus, however, does not wish the matter to rest there.
He cannot help himself from shouting his hatred at Polyphe-
mus: if he does not reveal himself, the punishment will not
be fully accomplished. The Cyclops must learn by whom he
has been vanquished. So Odysseus, while running to safety,
turns and yells in the direction of Polyphemus: "Know this,
you poor imbecile: that it is I, Odysseus, and not 'No One'
who has punished you as you deserve by blinding you."

This is an error on the part of Odysseus. He should not have
yielded to this insidious form of hubris that goes by the name
of boastfulness. He would have done better to remain silent,
to leave without a murmur, as his companions, moreover,
beseeched him to do. But we have to concede that Odysseus
cherishes his identity, which, after all, is at stake at every
moment of the voyage home. Polyphemus now breaks off
the peak of a high mountain and hurls it in the direction of
the voice that he has just heard. . . . The boat is very nearly
destroyed. What is worse, he prays to his father, Poseidon,
begging him to punish in turn the impudent one who has
dared to attack one of the latter's sons. He does so in these
terms—which I quote here because they outline clearly the
obstacles that now lie in wait for Odysseus:

> "Hear me, Poseidon, earth-enfolder [*Poseidon is god of the
> sea, but reigns equally over the earth because all the rivers belong to
> him, and because he can also unleash earthquakes with his trident*],
> and god of the sea-blue mane, Poseidon, hear me! If I am
> indeed your son and you claim to be my father: grant that
> Odysseus may never reach home, this sacker of cities, this son
> of Laertes, who lives in Ithaca! But if he is destined to see his
> people once again, and reach his high house and his native
> land, may he get there only after many sorrows, after losing
> all his comrades, alone in a stranger's ship, and let him find a
> world of pain at home."

And such, in effect, is the destiny that awaits Odysseus. He
will reach home, certainly, but only after enduring a thousand
misfortunes. All of his companions will meet their deaths,
without exception. His ship will be wrecked and it will be
on a boat borrowed from the Phaeacians that he will arrive
back in Ithaca, only to find the most complete disorder (here,
too, the prayer of Polyphemus will be answered). . . . The
formulaic phrase is by now the norm: Odysseus and his men

take to the sea once more, "sick at heart, glad to have escaped from death, though lamenting their lost comrades . . ."

I will summarize briefly the four subsequent stages of the voyage.

Odysseus arrives on the island of Aeolus, god of the winds, who makes him welcome. A benevolent host, he even offers him the most precious of possible gifts: a leather skin, closely sealed, containing all the winds that are unfavorable to Odysseus's voyage. He has only to let himself be carried by those winds now gusting above the waters: they are gentle and are blowing in the right direction, so he is quite certain to arrive safe and sound in Ithaca. Things could not be better. Odysseus thanks him with tears in his eyes and sets off again, holding on tightly at all times to his magnificent gift. But his sailors, who are not very bright, convince themselves that the bag contains treasure that Odysseus wants to keep for himself. Eaten away by curiosity, they take advantage of a moment's inattention on the part of the hero—Odysseus has been overtaken by sleep—and they open the bag, just when the coast of Ithaca has come into view. Disaster! The adverse winds are released, and the ship is driven helplessly off course, heading out for the open sea once more. Odysseus is mad with rage, and above all desperate with disappointment. He is angry at himself; he should never have allowed himself to fall asleep and drop his guard, for sleep is a form of forgetting, of oneself and of the world—momentary, no doubt, but sufficient for everything to turn to ashes once again. However much he beseeches Aeolus, when the ship is driven back to his island, the god of winds will not listen to another word: if Odysseus has such rotten luck, this is most certainly because a more powerful god than Aeolus is angry with him, against which one can do nothing. . . .

So Odysseus and his men are off course once more,

completely lost. As chance would have it, at the end of six exhausting days, they reach new land, that of the Laestrygonians. At this stage of his voyage, Odysseus is still at the head of a proper fleet, numbering several vessels, which moor alongside one another in a sheltered cove forming a natural harbor, where all seems perfectly calm. Cautious as ever, Odysseus decides nonetheless to moor his boat slightly apart, in a creek, attached to the rocks by strong ropes. He sends three men to reconnoiter the ground. Approaching a village they see a young girl, in effect a giantess, who has come to draw water at a well. Although very young, she is as tall as a full-grown plane tree. She is the daughter of the king of this region, Antiphates the Laestrygonian, and she offers to lead the men to her father's dwelling. There, the unfortunate men meet her parents, two monstrous beings as tall as mountains. Antiphates wastes no time on social niceties. He seizes one of the mariners and subjects him to the same fate meted out by Polyphemus to the other friends of Odysseus: he smashes his skull on the ground and devours him whole. These people, as Homer says laconically, are no "breakers of bread." In short, they are not humans at all but monsters, from whom all humans must flee urgently. But it is already too late. The other giants in the village overlooking the port have run to the scene, and they, too, are demanding their share of flesh. Seizing huge boulders, they hurl them down at the ships, crushing the men, breaking the masts and the hulls. The carnage is appalling. All of the ships are destroyed in a matter of moments and their sailors devoured on the spot. Odysseus barely escapes, together with his boat and a few other survivors. Seeing the dreadful spectacle, he cuts the ropes with one stroke of his sword and heads for open sea as fast as possible, once more "sick at heart, glad to have escaped from death, though he has lost his dear comrades . . ."

More days at sea, and another island appears on the horizon. Odysseus still cannot get his bearings, but they need provisions, water and food. The decision is taken to land. For two days and nights, Odysseus and his sailors, overcome by exhaustion, slowly regain their strength. They stay on the beach, without visiting the interior of the island. On the third day, Odysseus's curiosity gets the better of him: he sends two sailors on reconnaissance. Smoke can be seen rising from a distant chimney. Approaching the house, they see lions and wolves along the path, moving about in a natural state of freedom. At first they are terrified and keep their hands on their swords to anticipate attack, but nothing of the kind occurs. Besides, these normally wild animals have an expression—a look, one might say—that is extremely strange: both profound and imploring, almost human. As gentle as small dogs, they come up and rub themselves against the legs of the mariners, who cannot believe their eyes but continue along the path and begin to hear a voice, unworldly, seductive, coming from the house.

It is the voice of Circe, the enchantress, aunt of Medea (another enchantress, whom we shall encounter later on in other contexts). Circe is a little bored all alone on her island. She is grateful for the company of these new visitors, and would like above all to detain them at her leisure. She invites the sailors to sit down and offers them refreshments. They start to feel unwell. It is the effect of a magic potion, which immediately transforms anyone who drinks it into animals. One tap of the magic wand and the friends of Odysseus are changed into pigs. Circe gently leads them toward the pigsty, where she will give them water and acorns fit for their kind. They are in every respects proper pigs, except that inside they remain humans. Their minds are unaffected, and they are frozen with horror to see themselves reduced to this new

The Wisdom of Odysseus

he will set about freeing them

he will set about freeing them.

condition. Now they suddenly understand the reason for the tameness of the lions and wolves who crossed their path earlier: these, too, were clearly humans whom Circe has transformed into animals for company.

Fortunately, one of the sailors, Eurylochus, had sensed a trap in the making and refused to drink the concoction offered to him by Circe. He escapes and runs as fast as his legs will carry him back to Odysseus, to whom he describes everything he has seen. Odysseus takes up his lance and his sword, and sets off to liberate his companions. It is courageous, of course, but in truth he has no idea of how he will set about freeing them. As always, when a difficulty becomes insurmountable, Olympus rouses itself and comes to the rescue. Hermes intervenes on the orders of Zeus. He offers Odysseus an antidote, a little herb that, if taken immediately, will inure him to the spell of Circe. Hermes gives him some advice, moreover: when he sees Circe, he must drink her potion. Nothing will happen to him, at which point Circe will understand who he is. He must rise up, threaten her with his sword as if he means to kill her. She will in turn release his companions, restore their humanity, but in exchange she will invite Odysseus to share her bed. He must accept, but on one condition: that she swears by the river Styx not to do him or his men any further harm.

Everything unfolds as promised, but because Circe is so beautiful—a goddess of sorts, like Calypso—Odysseus is rather taken by her. In consideration of which, he remains in her arms for a full year, loving, eating, drinking, sleeping. . . . and with each new day the same scenario repeats itself. What he is once again being stalked by, of course, is the temptation to forget. Circe does everything in her power to make him stop thinking, above all to stop thinking about Penelope and Ithaca, so that he will stay with her in her warm

bed. Once again, Odysseus comes within a hairbreadth of catastrophe—an imperceptible, beguiling catastrophe, certainly, but nonetheless calamitous. And for once, it is his sailors who come to the rescue. They start to grow impatient, even mutinous, not having a Circe to spend their nights with . . . so they go in a delegation to Odysseus and demand that he get back on the road.

Against all expectations, Circe takes this rather well. After all, you cannot keep a lover by force, and if Odysseus wants at all costs to go home, he had better get going! Which is more or less what she tells him herself. Odysseus supervises preparations for departure, but he still does not know where he is, and has not the slightest idea of how to go about setting a course for home. Circe will help him, but the instructions she offers make him shudder: he must find the entrance to Hades, the kingdom of the dead, and present himself to Tiresias, most celebrated of all soothsayers. Tiresias alone can tell Odysseus what is in store for him for the rest of his voyage, and how to find his bearings. . . . It is an understatement to say that Odysseus lacks enthusiasm for the sinister prospect opened up by Circe. But there is nothing else for it and he must set his course.

It is at this point that the famous descent of Odysseus into the underworld takes place, usually referred to as the *Nekyia* ("a voyage to the realm of death"). I will not go back over the dread that takes possession of Odysseus at the sight of this population of shades, who create a permanent hubbub, at once confused and sinister. Once again, what characterizes the dead—and what terrifies the hero—is their loss of individuality. To restore them to a little life, so that they take on color and begin to speak, there is but one means: to sacrifice a ram and get them to swallow a beaker of the warm blood. It is by this means that Odysseus succeeds in having a

conversation with Tiresias, then with his mother, Anticlea, whom he tries in vain to embrace: as soon as he folds her in his arms, he presses against a void. The dead are but shades who no longer possess any reality. It is here, too, in Hades, that Achilles makes his dreadful admission, which reduces the myth of warrior heroism to ashes: that he would prefer a thousand times to be the living slave of the humblest peasant rather than the most glorious hero in the kingdom of the dead. As I have said, Odysseus learns from Tiresias that he will ultimately reach home, but only after seeing all of his companions perish and losing his ship. The end of the voyage is assured, but the journey promises to go very badly, all on account of Poseidon, who is determined still to avenge the blinding of his son. . . .

The episodes that follow are so well known, and so often retold that there is no need to do more than summarize them here. Odysseus and his companions first encounter the Sirens, those bird-women (and not mermaids, as is often thought) whose song is as deadly as it is seductive: its charm drawing sailors irresistibly toward the reefs on which they will be shipwrecked. Their appearance is intensely alluring, but they are fearsome, as shown by the fact that they are surrounded by rocks scattered with whitened bones and rotting flesh. One detail in particular holds our attention: to protect his sailors, Odysseus stops their ears with wax. By this means, they do not risk yielding to the sulfurous attractions of these bird-women. But Odysseus, on the other hand (as with his encounters with Polyphemus or Circe), wants to hear it for himself, at whatever cost: his will to know and to experience is still intact. And so he has himself lashed to the mast with ropes, and gives orders to his men to tighten his bonds if he has the mad notion of letting himself be drawn any closer. Naturally, the song of the Sirens can hardly be said to leave

him indifferent. After only a few moments of listening to it, he would give anything and everything to join them, but this time his men are wise to his ways. As promised, they tighten the bonds that tie him to the mast and their ship sails past without mishap. Odysseus is henceforth the only man to survive hearing the song of the Sirens, and will remain so for as long as he lives, just as he is the one of the rare mortals to visit Hades in this life and tell the tale, before one day returning there for a second and last time.

After another visit to Circe, who supplements the predictions of Tiresias and gives him some additional advice, Odysseus takes to the sea once more. There ensues the episode of the wandering rocks, which destroy any ships that venture between them, and are all the more dangerous on account of the two terrifying beings who hide in their midst: Charybdis is a female monster whose mouth is so vast and voracious that she swallows whatever comes within her vicinity, causing a permanent giant whirlpool. She can be avoided, certainly, by keeping to the open sea, but in this case hapless sailors draw close to Scylla, another female monster, whose hideous body is topped by six horrifying dog's heads. From this duo we derive the common expression: to be caught between Scylla and Charybdis. Six of Odysseus's sailors are snatched by the head and come to an unpalatable end in the jaws of Scylla. The predictions of Tiresias are beginning to be fulfilled, and Odysseus realizes that he will indeed quite probably return alone to his fold.

He now lands, to regain his strength, on the island of Helios, god of the sun. It is populated by magnificent oxen. But these are sacred animals, belonging to Helios, and are absolutely forbidden to touch. Their number indeed possesses cosmic value, equaling as it does the days of the year. And, as Helios is all-seeing, it would be foolish indeed to misbehave

in this place. Circe has given them provisions, after all—what more can they need! But a south wind prevents them from hoisting sail for more than a month. Short of food, the sailors can restrain themselves no longer. One evening when Odysseus has fallen asleep and his men are on night watch—sleep once again symbolizing the temptations of oblivion—they commit the unforgivable: they roast a magnificent cow. And then another, making a true feast of it. Awakened by the scent of smoke, Odysseus rushes to the scene. Too late, he arrives merely to see the disaster unfold. He orders everyone into the boats, but of course Zeus always punishes the guilty. He unleashes once again a dreadful tempest. All of Odysseus's friends drown. He alone survives, clinging to a spar of wood. He drifts until he reaches the island of Calypso, the ravishing nymph who will hold him prisoner for many long years.

The circle is therefore complete: we find ourselves back at the starting point of the whole narrative. Odysseus will end by leaving Calypso and touch land among the Phaeacians, in the castaway condition we have already described, from where he will finally set sail for Ithaca, with Athena on hand to aid him until the very last: to massacre the Suitors, be reunited with his son and wife and father, and restore order to his *oikos*: his house, his kingdom. . . . Once Odysseus arrives among the Phaeacians, we leave behind those episodes of the voyage that most concern us.

Two final remarks, by way of conclusion, to underline the philosophical reach of this initiatory voyage: firstly, concerning the "nostalgia," supposed or real, of Homer's writing; secondly, concerning the seduction or charm that Odysseus exerts over his entourage, over those he encounters on his travels, and notably over women.

Is it correct to speak of "nostalgia"?
And if so, in what sense?

Is it appropriate, as is often remarked of the *Odyssey*, to speak of "nostalgia" to characterize what motivates Odysseus? At first sight, we might be tempted to say yes. The word itself sounds Greek, formed as it is from *nostos*—which derives from *nesthai*, "to return home," a verb that in turn borrows from the proper name Nestor, "he who comes victoriously home"—and from *algos*, "suffering." Nostalgia is, therefore, the painful longing to return. And is it not this, precisely, that drives Odysseus? A fanatical but constantly thwarted will to get back to his original point of departure, to "return"—or, to adopt the terms of the German Romantics (masters par excellence of nostalgia), to be *bei sich selbst*: to be close to himself?

It would be better to proceed with caution, however, and not let ourselves be carried away by a magic formula, firstly because the term "nostalgia" does not belong to the vocabulary of the ancient Greeks. It is nowhere to be found in the *Odyssey*, nor for that matter in any classical text. And for good reason. It was only coined belatedly, in 1678, by a Swiss doctor by the name of Harder, to translate a term destined to acquire a growing importance over the centuries and notably so in the twentieth: namely *Heimweh*, whose equivalent in contemporary English is "homesickness" (the expression only appears in the nineteenth century, but already in the eighteenth century it was possible to speak in French of *mal du pays*: sickness for home).

If we leave the foothills of philology and history for the more elevated air of philosophy, we can discern in effect three different forms of nostalgia, among which Milan Kundera's fine novel *Ignorance*—whose subject is nostalgia—

does not always distinguish. There is, first of all, a purely sentimental nostalgia, which regrets all past happiness, of whatever variety: the family nest, childhood holidays, defunct affairs. . . . We all feel this at some point or other. Then there is historico-political nostalgia, "reactionary" in the proper sense of the term, which is the driving force behind all Restorations or "returns to order," and which expresses itself most comfortably in a dead language, for example by the Latin tag *laudator temporis acti*, itself the title of a very good anthology by the philosopher Lucien Jerphagnon, and which means quite simply: "We were better off before"—in the days of Atlantis, or before modern civilization, before industrialization, before cities became too big, before pollution, before capitalism, and so forth. It was already in this spirit that, in nineteenth-century Germany or Switzerland, the Romantic movement constructed ready-made antique ruins at the bottom of its gardens rather than up-to-date geometrical avenues à la Versailles. By this means they attempted to evoke the idea of former days, in which humans were better off, or quite simply better, than today: nobler, loftier, freer, bolder, more educated, etc. Finally, even if the term is inexact, or at any rate anachronistic, there is the nostalgia of the Greeks, of Odysseus, which is above all else a cosmological anguish, and is encapsulated within a formula I have borrowed for the occasion from Aristotle: *phusis archè kinéséos*, or "nature is the principle of movement." Which is to say that we are by nature moved, as in the *Odyssey*, to return to the place from which we have been displaced: namely Ithaca, the purpose of the voyage being, for the hero, to rediscover his lost harmony with the cosmic order.

It is not love that moves Odysseus. He has never set eyes on Telemachus, and has largely forgotten Penelope, whom he constantly betrays, moreover, whenever the opportunity

presents itself. Even less is he driven by an interest in restoring a prior political reality: if he wants to restore order to his household, it is not to reverse some decline or other that has been set in motion by a revolution or by some modernizing vision of the world. No, what propels Odysseus, fundamentally, is the desire to return home, to live in harmony with the universe, a harmony worth more to him even than the immortality promised by Calypso. Put differently, if Odysseus embraces his mortal condition, it is not as a worst case but, on the contrary, in order to live a fuller life. As I have said before, the choice of immortality he was offered would have depersonalized him by severing him from others, from the world, and, finally, from himself. For he is not cut out to be a lover of Calypso—someone who betrays his own kin, forgets his homeland, is content to live wherever, in the middle of nowhere, with a woman he does not truly love. . . . No, none of this is Odysseus! And to be truly himself, he must accept death, not with resignation but, on the contrary, as a driving force: it is what pushes him at all costs to find his point of origin again. This is how the wise man must negotiate with the cosmic settlement that, hitherto, we had considered only from the point of view of the gods. And Odysseus is the earliest embodiment of a wisdom for mortals, of that secular spirituality that Greek myth was to bequeath, indirectly, to Western philosophy. And it must be admitted that this wisdom, which Odysseus was without doubt the first hero in literature to embody consummately, still exerts a powerful attraction.

"Enlarged thought," or the
seductions of Odysseus

As everyone knows, Odysseus is cunning. And, as we have also established, he is strong, resourceful, courageous. All of which is impressive enough. But there is more: Odysseus is a "real" man, as we say in sentimental novels: neither immortal nor forgetful of his place in the world—wise, experienced, and, for these reasons, wholly seductive. He is also, as I have said, naturally curious: "Many were the men whose cities he saw and whose mind he learned . . ." He likes to understand, to know, to discover—countries, cultures, beings different from himself. From the very opening lines of the poem, we learn that he is not only "the man of many devices," not merely "the sacker of Troy." He possesses to the highest degree what Kant was to call "enlarged thought": curiosity about others, a constant will to broaden his horizon, which is what will get him into trouble on Calypso's island, or with Polyphemus, but which is what makes him finally a true human, a man whom no woman can resist, because he is many-faceted and because he has a thousand stories to tell.

One day, a Brazilian journalist asked me a question that immediately struck me by its strangeness. As I was speaking of this "enlarged thought"—of Odysseus and, as it happens, of Victor Hugo—she asked me point-blank: Why, after all, is it so important to "enlarge" one's thought? She gestured toward the nearby beach, at Copacabana, which was full of young people, carefree and fit, tanned and happy to be living their lives as in an innocent and endless game: Why wake them from their pleasant distractions? And, above all, even were I able to come up with an adequate answer, how would I convince them to leave their beach and their games, to

immerse themselves in Homer or enlarge their horizon by displacing themselves, if only intellectually? I immediately thought of the response that might have been given by Odysseus, or by Hugo: no woman can live for very long with a blue-eyed boy who knows nothing, who has nothing to say. If he is very young and very handsome, she can enjoy putting him in her bed, as do the nymphs who surround the companions of Odysseus. But faced with a goddess such as Circe or Calypso, with a strong-minded wife like Penelope, this youthful paragon is no match. This is why Odysseus triumphs over the Suitors—those young, gilded, and doubtless fit and tanned Pretenders. He does so not merely by cunning and strength (which are after all the dowry of the gods) but through the seductive force of the honed and accomplished man: a force that comes from within, from his voyages and tribulations, from what he has made of it all— and not from the gods or anywhere else. Odysseus might have remained eternally young, handsome, and strong. Let us not forget that it was in full possession of the facts, after looking death in the face, that he chose to age as a mortal, because, on balance, such a fate, however calamitous in itself, is the condition for acceding to a humanity that alone can make a man truly singular and, by this token, irresistible.

The fact remains that the choice of Odysseus, even if it is the wisest choice, is also intensely courageous. Not all of us are capable of this, and, as is clear from the trials to which he is subjected at every turn of his voyage, wisdom does not come automatically. Whence, undoubtedly, the temptations of hubris, the tendency to immoderation and pride that makes us all believe that we can elevate ourselves to the ranks of the gods without in any way deserving it. And, as we shall see in a moment, in the world of the Greeks, this flaw is never forgiven. . . .

4

Hubris: The Cosmos Menaced by a Return to Chaos

—or, How the Absence of Wisdom
Spoils the Existence of Mortals

I HAVE ALREADY HAD occasion to mention how, on the pediment of the temple at Delphi—one of the most celebrated monuments raised to the glory of Apollo—proverbs were engraved in the stone, enshrining fundamental tenets of Greek wisdom. Two of which, at least, remain celebrated to this day: "Know Thyself!" which appears prominently, along with its corollary, apparently more enigmatic, but in effect meaning the same thing, "Nothing to Excess!" As I have also mentioned, in passing, the sense of these messages has become obscured with the passage of time, and today their true meaning is often misinterpreted. We have a modern tendency to "psychologize" myth, to interpret the lessons of archaic wisdom with a modern slant, in the light of psychoanalytic schemas. This is, quite simply, a gross error. The famous "Know Thyself," in particular—adopted by one of the founding fathers of philosophy, Socrates,* as

*In Socrates already, this formula (which has no "psychological" dimension whatsoever) takes on a slightly different meaning to what it originally had in archaic Greek culture: it becomes linked to a very particular concept of truth that Plato pursues, in its multiple and profound consequences, a doctrine according to which we formerly knew the truth but have forgotten it, such that knowledge now arrives in a third stage as a form of "anamnesia," an "unforget-

the governing motto of his thought—is often construed to mean that we must at all costs "find" ourselves or, in analytic jargon, "bring to light our unconscious if we are to make any progress in this life, without fearing the return of what is repressed." In the Greek world, the injunction "Know Thyself" has nothing to do with this modern mantra. And it is important to restore its authentic and original meaning, not for reasons of pedantry but because it furnishes (as we shall see) a precious and vital thread, indispensable even, if we are to understand a whole group of important myths that I shall now describe.

At its origin, in archaic Greek culture, this injunction possessed an obvious significance, even for the humblest citizens: we must stay in our allotted place, not get "above ourselves"—as is still said today in rural societies to describe someone proud, arrogant, someone who takes himself for what he is not. Moreover, another modern locution corresponds perfectly to what we are trying to restore to view and equally employs a spatial metaphor: to "put someone in their place"—referring to when we "teach someone a lesson," when we "take someone down a peg or two." This expression, like "Nothing to Excess," commands us to discover our limits, within the cosmic order, so as to guard against hubris, against this vanity or immoderation

ting" or "re-membering" of something that was within us without our having knowledge of it. It is in terms of this concept of truth, as a "re-cognition," that Socrates answered the famous Sophist paradox that he who seeks the truth can never find it: in effect, if he is looking for it, this means that he does not already have it. He would need, in order to tell a true opinion from the false opinions that are everywhere to be found, a criterion . . . which is itself a truth criterion! He would need therefore, in this slightly specialized sense, already to possess the true, in order to distinguish it from the false. Now this is precisely what the Platonic theory of knowledge as recollection affirms: yes, we already have the true within us! We have simply forgotten it, so all knowledge is a recognition, a recollection. And this Platonic vision of truth will run through the entire history of Western philosophy.

that defies the gods and, by doing so (since it is all one and the same), flouts the universal order. For mortal men, hubris invariably leads to disaster, and it is this sense of a catastrophe foretold that is staged in the myths that now concern us.

The original model of hubris, the primary instance of a behavior that goes beyond all measure, we have already encountered: namely the example furnished by Prometheus. This is in some sense the archetype for all those stories that bring us the edifying news of disasters caused by this one supreme flaw, in the estimation of the Greeks—but which also allow us to glimpse the temptations it arouses. For, it goes without saying, if mortals sin through hubris, it is because there is something that leads them on. . . . Prometheus is the very first to be punished on account of arrogance and pride, and mankind with him. We have already seen in what manner—by means of Pandora, the wife "who wants always more than enough"—and why: because, with the weapons given to them by Prometheus (stolen from Hephaestus and Athena), namely fire, the arts, and industry, human beings are in danger of no longer knowing their rightful place, and of taking themselves one day for the equal of the gods. Here already, for the Greeks, lies the difference between man and animals. As you will recall, when Epimetheus arranged all living creatures in their order, when he distributed the qualities and attributes that allow them to survive, we see that the creatures each have a precisely designated place in the order of things. With animals there is no possibility of hubris, for they are guided by the instinct common to their species, and there is no risk of them stepping beyond their bounds. Impossible to conceive of a rabbit or an oyster in revolt against its destiny, undertaking to steal fire or the arts from the gods! On the contrary, men are endowed with a sort of liberty, with a capacity for excess that no doubt makes them more

interesting than the animals—capable of so many detours and ruses—but capable equally of the most crazed acts of hubris.

Many centuries later, we find in contemporary humanity this same conviction that—unlike the animals, who each have a mode of being that is predefined, from which it is impossible to deviate—man is no way predetermined from the outset, that he is potentially anything and everything, that he can do and become whatever he chooses. He is par excellence the creature of possibility—as symbolized by the fact that, in the myth of Epimetheus, precisely, as distinct from the animals, he arrives, so to speak, "entirely naked" at the outset. He has neither fur like the bear or the dog, to protect himself from the cold, nor a carapace like the tortoise or the armadillo to shelter him from the rays of the sun; he is neither swift or agile at running, like the rabbit, nor armed with claws and teeth like the lion. In short, the fact that he is so unprotected at the outset means that he must devise everything for himself if he is to survive in a world as fundamentally hostile as that which succeeded the golden age. The myth implies, even if it does not say so explicitly, a power of invention, a certain *freedom*, if by this is meant that man is not imprisoned inside a role prescribed in advance by Epimetheus, as is the case with the animals. Now, it is precisely this liberty that is at the root of all hubris, for without it, man could not step outside his place, nor deviate from the role allotted to him. He could not make mistakes, and it is indeed the history of these mistakes—and the obligation, on the part of the gods, to put man "back in his place"—that the great myths of hubris will relate.

The human individual is thus defined, above all else, as he who can go too far. He can be wise or foolish. He has the choice. An infinity variety of lives awaits him: nothing

says at the outset that he should be a doctor or a carpenter, a mason or a philosopher, a hero or a slave. It is up to him, at least partly, to decide the matter—and it is, moreover, this breadth of choice that often turns youth into a crucial moment. Crucial but difficult. And it is also this freedom that exposes man to the risk of defying the gods, to the point of even threatening the entire cosmic settlement. It is what the ecologists still reproach him with, long after the philosophers and poets first stigmatized the consequences of hubris: that humanity is the only species capable of laying waste to the earth, for it is the only species to possess such inventive and insurrectionary capabilities against nature as are able to truly disturb the universe. Once again, it is hard to imagine rabbits or oysters laying waste to the planet, or devising the means to do so. But humanity, on the other hand, at least since Prometheus bestowed upon it the sciences and the arts, is well and truly in a position to do so. Whence the threat it permanently poses to the cosmic order guaranteed by the gods.

Is this the sin of pride, in the Christian sense? Doubtless, but not exclusively so. In certain respects hubris goes much further: it is not limited to a subjective fault, a personal failing that tarnishes an individual and makes him wicked. It possesses, far beyond the simple sin of pride or concupiscence of which Christianity warns us, a quite other and cosmic aspect that I have just evoked: hubris always risks overturning the beautiful and just order of things established so painfully by Zeus in his war against the forces of chaos. And it is for this reason in particular that the gods punish hubris: quite simply, they are trying to preserve universal harmony against the madness of men. Or, at least, as far as certain of the gods are concerned. Which is why Greek mythology abounds in stories that recount dreadful punishments, whose victims are

those who have the audacity to defy the precepts of wisdom the gods have imparted. It is not merely an affair of obedience, as in conventional Christian discourse, but of respect and concern for this world.[*]

A final remark before getting to the heart of the matter, to the stories themselves. Doubtless because the original audience was immediately able to grasp their true significance, these narratives of hubris sometimes follow on from one another a little drily, without literary embellishment. As if what takes place is self-evident, and any reader or auditor would perceive the meaning immediately, without needing it to be underlined. In each myth the scenario is the same: a mortal, sometimes a monster or even a minor divinity, thinks himself (or herself, or itself) powerful enough to step outside his allotted role and measure himself against Olympus; each time the transgressor is put back in his place with unswerving brutality, with a maximally deterrent effect upon all those who might be stupid enough to want to risk making a similar mistake. Unswerving, because it is the cosmos that is reasserting its rights, through the instrument of divine punishment. The resulting narratives, at least in the written form in which they have reached us, are often therefore quite skeletal. They confine themselves to a fairly basic framework: a hubristic revolt against the cosmic order is described, followed by crushing retribution—all presented in their chemically pure state, so to speak, without any ornament. Such is the case with the myths of Ixion, Salmoneus, Phaeton, Otus and Ephialtes, Niobe, Bellerophon, Cassiopeia, and so many others. By way of illustration—and because some of these myths are celebrated, and it is good for us to be familiar

*There is, of course, in the major religions a concern for the world and its well-being, but sin is almost invariably presented as a matter of "personal" fault.

with them—I have offered the basic outline of these stories in a footnote and, where appropriate, the source texts in which the myths are to be found.*But we must also bear in mind that amateur or professional storytellers (of an evening,

*Ixion. At his marriage to Dia, the daughter of Deioneus, Ixion promises his father-in-law that he will offer her magnificent gifts. Under this pretext, he leads him into a garden in which he has dug a deep ditch full of burning coals—and into which he dispatches his father-in-law. A crime so appalling that no one will agree to its purification . . . except Zeus, who takes pity on Ixion and decides to give him a second chance. Invited to Olympus, Ixion can think of nothing better, by way of gratitude toward his benefactor and savior, than to try and seduce Hera, who in turn complains to her husband. Zeus, so as to be clear in his own mind, creates a cloud in the shape of Hera. Ixion falls into the trap and makes love to the cloud, thinking that it is the goddess herself. This is finally too much for Zeus, who expedites him by thunderbolt to the underworld, where Ixion is attached by serpents for all eternity to a wheel of fire, ceaselessly turning in Tartarus. . . .

Salmoneus. Here is Apollodorus's account, and a good example of his dryness and compression:

> Salmoneus lived in Thessaly at first, but later went to Elis and founded a city state there. A man of great *hubris*, he wanted to put himself on a level with Zeus and suffered punishment for his impiety. For he claimed that he himself was Zeus, and depriving the god of his sacrifices, he ordered that they should be offered to himself instead. And he dragged dried animal skins and bronze kettles behind his chariot, saying that he was making thunder; and he hurled flaming torches into the sky, saying that he was making lightning. Zeus struck him down with a thunderbolt, and destroyed the city that he had founded, with all its inhabitants.

End of story!

Phaeton. The story of Phaeton is told notably by Ovid in his *Metamorphoses*, with profuse detail. But despite the best efforts of the poet, the story retains a disarming simplicity. Phaeton is the suspected son of Helios, god of the sun. He boasts of this, but his friends refuse to believe him. So he asks his mother to intercede for him, so that he may meet his father, whom he asks (out of vanity) to prove that he is indeed his father. Helios promises to grant him any wish. So Phaeton asks to be allowed to drive the chariot of the sun for one entire day, from east to west, from sunrise to sunset. Helios is apprehensive, for he knows just how difficult it is to control this chariot, and how the prospect represents a potential danger for the entire cosmic order. The inevitable happens: the divine horses run away with the headstrong Phaeton and gallop too close to the earth. Crops are scorched, rivers run dry, and animals are charred as he skims recklessly across the ground. Faced with a dire situation, Zeus as always intervenes with extreme prejudice, striking the miscreant with lightning and turning him into the constellation Auriga (the Charioteer).

Otus and Ephialtes. Here is Homer's account, in the *Odyssey*, of the brief lives of these two giants:

around the hearth) would embellish and add their tuppence worth, breathing new life and emotion by the addition of details, or spinning out events—as did the Greek tragedians

Godlike Otus and far-famed Ephialtes—men whom the earth, the giver of grain, reared as the tallest, and most beautiful of her sons, after the famous Orion. At nine years of age they were nine cubits in breadth and in height nine fathoms. And they threatened to raise the din of furious war against the immortals in Olympus. They would have piled Mount Ossa on Olympus, and Mount Pelion, with its waving forests, on Ossa, so that heaven might be scaled. And this they would have accomplished, had they reached the age of manhood; but the son of Zeus, whom fair-haired Leto bore [namely Apollo], slew them both before the down covered their chins with a full growth of beard.

Niobe. Niobe is the daughter of Tantalus, and the sister of Pelops. Like her father, she is very prone to hubris, and at a ceremony in honor of Leto, goddess of motherhood, she boasts that she is worthier than Leto (mother of the twins—and divine archers—Apollo and Artemis) to be a recipient of the sacrifices offered to these Olympian divinities. She demands that henceforth a cult should be initiated in her own honor, asserting that she is far more fertile than the goddess, with six sons and six daughters (some say she has ten sons and ten daughters, which is beside the point). Leto does not take this insult lightly and asks her twins to settle the matter. Apollo and Artemis do so gladly: their arrows transpierce all twelve children of Niobe. They die before her eyes in atrocious agonies. Zeus transforms Niobe into a rock, down which it is said that her tears continue to fall. . . .

Bellerophon. Grandson of Sisyphus, Bellerophon is at the start a sympathetic and courageous young man. But like his grandfather he ends in the clutches of hubris, for which he will likewise pay dearly. After killing the tyrant of Corinth, Bellerophon finds asylum with Proetus, king of Tyrins, and becomes his friend. Unfortunately, the queen falls in love with him. He rejects her advances, so she accuses him falsely, in front of her husband, of trying to seduce her. Stupidly, Proetus believes his wife but refuses to kill Bellerophon himself. So he sends him to his father-in-law, the king of Lycia, with the request that he dispatch Bellerophon instead. But the Lycian, seeing the honest face of the latter, is equally reluctant to kill him. He decides to set the young hero an impossible task, in the course of which he will assuredly lose his life: he demands that Bellerophon kill the Chimera. To accomplish that he must first tame Pegasus, the winged horse that sprang from the blood of Medusa after Perseus cut off her head. Athena helps Bellerophon, however, and he succeeds in killing the Chimera . . . but success goes to his head, and he starts to "believe in himself," whereas in reality he owes everything to the gods. He now feels that because of his victory over the Chimera he deserves to fly to Mount Olympus, the realm of the gods, and become immortal. His presumption angers Zeus, who sends a gadfly to sting the horse, causing Bellerophon to fall all the way back to earth, with fatal consequences. . . .

Cassiopeia. She will be punished for boasting that she and her daughter are even more beautiful than the Nereids, daughters of Nereus the sea god. . . .

in their evidently grander fashion, choosing to bestow their letters of nobility on certain of these myths.

Very fortunately for us, other narratives revolving around this same theme of hubris have survived in versions that are fully developed and probe more deeply from a literary and philosophical point of view. They constitute entire dramas, accompanied by rich and profound lessons in wisdom, both comedic and tragic; these, too, have often been enriched with accretions of new material over the course of time. We have already seen a case in point, in the myth of Midas. I will describe several others that are both worthy of close attention and often poorly understood, buried as they frequently are (without our modern mythographers even being aware of the fact) under a carapace of Christian morality, or bourgeois rectitude, or even contemporary psychology, all of which dilute their original savor and significance. It is important to reinsert them into the cosmological and philosophical contexts that are truly theirs, and with which we are becoming properly acquainted in these pages. All the more so since the richest of these myths directly concern the question of the relations between mortals and what unavoidably awaits them—namely, of course, death itself.

I. Tales of hubris: the case of those who "cheat death," Asclepius (Aesculapius) and Sisyphus

Within the category of stories addressing the tribulations to which mortals expose themselves by transgressing through immoderation, those myths that deal with the attempt to escape or "cheat" death—involving figures like Sisyphus or Asclepius, who try to outwit mortality by arts or by cunning—occupy a special place and demand close atten-

tion. Not only is the literary merit of these myths generally
superior, but their cosmic aspect and their subsequent history
are also of signal importance. Once again, as with Midas, we
are dealing with a group of individuals who are not merely
wrapped up in their own arrogance, as if their personal fail-
ings alone were in play, but whose behavior in effect men-
aces the universal order. Let us begin with the founder of
medicine, Asclepius (Aesculapius for the Romans). Some
versions of the myth diverge widely, which suggests we
should pay attention to those among which there is close
agreement. I shall follow, for the most part, the accounts of
Pindar and Apollodorus; excepting a few details, without
fundamental significance, they complement each other suf-
ficiently for us to assume that they derive from a common
source or tradition.

Asclepius as original model for the
Frankenstein myth: the doctor who
brings the dead back to life

The life of little Asclepius begins in a singularly violent man-
ner. He is one of the sons of Apollo, who was, of course, not
merely the god of music but also of medicine. Apollo has
fallen in love, as is not uncommon with the gods, with a rav-
ishing mortal by the name of Coronis. You will have noted,
in passing, that the gods are especially susceptible to mortal
women. Not that women are more beautiful than goddesses.
On the contrary, the beauty of the latter is infinitely superior
to that of humans, whoever they be, but the gods are sus-
ceptible precisely to the imperfections of mortality—to the
fact that mortal beauty is so ephemeral, so transient. Para-
doxically, it is what gives women their irresistible charm,
something precious and infinitely touching, a fragility never

encountered among the Immortals . . . and which makes gods fall in love with them. Which is why Apollo is besotted with Coronis.

Whether he has seduced her or forced her, we do not know. The fact remains that nothing can resist a god, and so he succeeds in sharing the bed of his beloved. And from their passion is conceived little Asclepius. So far, so usual. But things soon start to spoil. Coronis, it seems, is not for her part in love with Apollo. She has the supreme audacity—which even her father disavows—to prefer a simple mortal, a certain Ischys, and she becomes his wife. The marriage is, as you may imagine, resented by Apollo as a downright insult: How dare his mistress have the impertinence to prefer a common mortal to a god? All the more so, since Apollo passes for the handsomest of the Olympians. . . .

How does Apollo find out that he has been deceived, not to say cuckolded? Here the accounts diverge. According to some, it is thanks to his famous art of divination that he discovers what has been going on. But according to Apollodorus, Apollo sends a crow (in Greek, *corone*, a name with a strong resemblance to that of his beloved) to keep an eye on the lovely Coronis. Unfortunately, the bird reports back what he saw: Ischys and Coronis making love with unabashed enthusiasm. Distracted with jealousy, Apollo starts by punishing the messenger, turning the crow entirely black (according to the myth, crows and ravens were originally as white as doves prior to this regrettable episode). The case has its application even today: we often bear a grudge toward the bringers of bad news, however unfairly, even when the latter are quite innocent of involvement. In the first place, because we cannot help ourselves from suspecting a secret complicity, on their part, with the ill that has befallen us. And after all, without this bird of ill omen Apollo would have continued

happily, or at least untroubled—for no one ever breathes a word of what they know, where love is concerned, and what we do not know does not harm us. . . . Woe betide those who are the first to peddle bad news! They are never forgiven.

Be that as it may, Apollo is clearly not satisfied with chastising the unfortunate crow. He takes his bow and arrows—and you may recall that, of all the gods, it is he and his twin sister, Artemis, who are the most accomplished archers—and transfixes both Ischys and Coronis, who promptly expire in the most dreadful agony. But Apollo now remembers that his lover is pregnant by him and is carrying his infant. According to Greek funerary rites, the corpse must be burned after the vigil over the body, and silver coins placed over the eyes or on the tongue of the deceased, to pay the boatman Charon, who ferries them across the river Acheron to the underworld. It is only at this moment, when Coronis has been placed on the funeral pyre and the flames are licking her body, that Apollo comes to his senses. He quickly snatches the infant from the womb of Coronis—according to some versions it is Hermes to whom this thankless task is entrusted—and hands the child over to the greatest educator of all time: the centaur Cheiron, a son of Cronus and first cousin to Zeus, a sage among sages who has already raised the likes of Achilles, hero of the Trojan War, and Jason, who leads the expedition of the Argonauts to find the Golden Fleece. In short, Cheiron is the gold standard in matters of education. He is even said to have taught Apollo medicine. At any rate, it is Cheiron who will raise Asclepius, destined as he is to become the father of this art and, according to legend, the greatest healer of all time.

You will notice already—and this is important for an understanding of what happens next—that there is a similarity between the origins of Asclepius and of Dionysus:

each is snatched from his mother's womb after the latter has died, consumed (in both cases) by fire. Which is to say that Asclepius, if not twice-born, as is the case with Dionysus (who as a fetus is sewn into the thigh of Zeus until the time comes for him to be properly born), is nonetheless saved in extremis. From the outset, his existence is placed under the sign of rebirth or renaissance: the quasi-miraculous victory of life over death.

And it is indeed this that will mark the art of Asclepius as healer. Not only does he become an incomparable surgeon, but also, in the image of a god (rather than a man), he will become in the deepest sense of the word a savior of men. He is said to have received from Athena a gift that will enable him to realize the secret dream of all doctors: that of resuscitating the dead. It is the goddess Athena who, together with Hermes, has helped Perseus to combat Medusa, the dreadful and terrifying Gorgon, who instantly petrified (literally, turned to stone) all who looked into her eyes. Perseus cut off the head of Medusa, from whose neck—as she breathed her last—sprang Pegasus, the winged horse, while at the same time two liquids flowed from her open veins. From the first vein there streamed a virulent poison that could kill any mortal within seconds; from the other vein streamed, on the contrary, a miraculous remedy that possesses, quite simply, the power to bring the dead back to life. Armed with this precious viaticum, Asclepius sets about healing the living— but also the recently dead—in large numbers. To the point that Hades, who reigns over the kingdom of the dead, complains to Zeus when he sees his intake of clients decline at an alarming rate. As in the case of Prometheus, who stole fire and the arts from Athena, Zeus begins to be uneasy at the possibility of mortals achieving parity with the gods: What is the difference between the two, in effect, if the former can

now provide for themselves the means to achieve the immortality so precious to the latter? And if they are allowed to do so, the entire cosmic order will be shaken to its first principles—starting with the cardinal distinction between mortals and Immortals.

We are in the presence of the original version of a myth that I have already touched on, that of Frankenstein. Like Dr. Frankenstein, Asclepius has succeeded—with the help of Athena, it is true, who here plays an intermediary role analogous to that of Prometheus—in making himself master of life and death. He is, so to speak, the equal of a god: a supreme arrogance in the eyes of a Christian, of course, for whom power over life is the sole prerogative of a supreme being—but equally a case of absolute hubris as far as the Greeks are concerned, insofar as it is not merely the gods who are threatened, and the respect and obedience that are their due, but also well and truly the universal order of things. Let us try to imagine what would become of life on earth if people stopped dying. Soon there would no longer be room to house and feed everyone. Worse still, the functioning of the family would be turned upside down: children would attain the same seniority as parents, the meaning of different generations would be confounded, and all would end in confusion. . . .

Worried by this same prospect, Zeus (as always) takes extreme measures: he simply eradicates Asclepius with a thunderbolt. Pindar tells us, whether justly or otherwise, that Asclepius was in effect mercenary, driven by the lure of gain, amassing a great fortune by bringing back the dead. But this is off the point. What matters is that Zeus decides when enough is enough, and sounds the call for a return to order. As always, he intervenes to secure the continuity of the cosmos, for this is clearly what is at stake above all in

the story of Asclepius cheating death. Apollo, who loves his son, as is clear from the care he has taken over his education (by confiding him to Cheiron), is distracted with grief and rage when he learns what Zeus has done. Apollodorus tells us that, to avenge himself, he kills all of the Cyclopes who—as we recall—had forged the thunderbolt for Zeus, to help him win the struggle against the Titans and establish order. Other accounts claim that it is not the Cyclopes whom Apollo puts to death, since they are immortal, but rather their children. . . . Whatever the case, Zeus is not best pleased by Apollo's repeated rebellions and decides to imprison him in Tartarus, just as he dealt with the Titans. But Leto, mother of the divine twins Apollo and Artemis, intervenes. She implores Zeus to show clemency, and Zeus commutes the sentence to a year of enslavement: Apollo, too, has sinned by hubris, by pride and arrogance. He must therefore relearn the humility and respect due to the ruler of the gods. To which end, nothing could be better than a whole year spent minding the herd of a simple mortal by the name of Admetus, to whom as it happens Apollo will in due course render a considerable service. . . .

Nonetheless, Zeus—who owes it to himself to act justly on all occasions—wants to pay tribute to the skills of Asclepius: after all, the latter sought only to alleviate the lot of mortal men; he has not committed a great fault, at least not intentionally. So Zeus decides to immortalize him by transforming him into a constellation, that of Ophiuchus, which means "serpent bearer." In this sense, Asclepius succeeds in realizing for himself what he can no longer achieve for others. He undergoes what the Greeks called an "apotheosis"—a term that, literally, means a divinization, or transformation into a god (*apo* = "toward," *theos* = "god"). This is why he is not merely considered the founder of medicine but well

and truly the god of healers. Even today, Asclepius is usually represented with a serpent in his hand—and his scepter, consisting of a serpent coiled around a staff, or "caduceus," still serves as the symbol of those who practice the difficult art of medicine.

Why a serpent, you might ask, and what is the story of this famous caduceus that can still be seen on the windshields of medical vehicles and, with small variations, in the storefronts of pharmacies? It is worth a digression to clear up some of the confusion that has surrounded this symbol.

In effect, there are in Greek myth two different kinds of caducei, only one of which relates to medicine, although they have become confused with each other over the course of time.

The word "caduceus" derives from the Greek *kerukeion*, signifying "herald's wand or staff," not as pertaining to a hero who wins battles and performs exploits but as designating the herald who announces news, like Hermes, messenger of the gods. The first caduceus is indeed the emblem of the god Hermes, and consists of two serpents entwined around a staff, itself topped by a pair of miniature wings. The myths diverge at this point. According to some, Apollo exchanges his golden scepter with Hermes for a flute, which the latter supposedly invented after inventing the lyre. According to others, Hermes, seeing one day two serpents in combat (or making love?), separates them by throwing a staff (the magic wand of Apollo?) between the two reptiles, which then coil themselves around it, to which Hermes adds his trademark wings, which allow him to travel the world at high speed. Strangely, it is this same caduceus of Hermes that in the United States to this day so often serves as an emblem of medicine. In reality, however, it has no connection to the art in question. This caduceus has been confused with another, that of Asclepius,

probably because ancient medicine (and modern medicine likewise) is a "hermetic" art that uses learned words and obscure jargon, and, above all, because the earliest faculties of medicine were close to being secret societies. An understandable error, therefore, but an error all the same.

The other caduceus, which truly symbolized medicine, belongs not to Hermes but to Asclepius. Here, too, the accounts are both obscure and contradictory. There are two principal and competing lines of transmission. According to the first, Asclepius, while a pupil of Cheiron, who teaches him healing (as instructed to do so by Apollo), has a strange experience: coming across a serpent on his path he kills it . . . and is then amazed to see another serpent come to the aid of the first, bearing in its mouth a small herb that it makes the other swallow, and that brings the dead serpent back to life. It is from this moment that Asclepius is said to have discovered his vocation for resurrecting the dead. According to the second version of the story, Asclepius takes the serpent as the symbol of his art for a much simpler reason: because this creature seems to begin a new life when it sloughs off its old skin. It is enough to take a walk in the rocky terrain of Greece to see these abandoned snake skins more or less everywhere. To conclude from this that the dead creature comes back to life is but a small step, and one that Asclepius supposedly takes. As you can see, the two versions are fundamentally one: in both cases, the serpent signifies rebirth, the hope of a second life. This is why, when he strikes down Asclepius, Zeus transforms him into the constellation of Ophiuchus, the serpent bearer, which is a way of making Asclepius immortal. European physicians adopted the caduceus of Asclepius as the emblem of their art, to which was added a mirror, to symbolize the prudence necessary for the proper exercise of their calling.

A third caduceus was subsequently devised, as used by pharmacists. In truth, this is but a variant of the caduceus of Asclepius. It, too, consists of a serpent coiled around a staff, with the difference that in this case the head of the creature surmounts a cup into which it spits its venom. This is the cup of Hygieia, one of the daughters of Asclepius (from which we derive the word "hygiene") and sister of Panacea (universal remedy); the venom deposited in the cup symbolizes the ingredients of medicine, whose secrets are known only to pharmacists—the word "pharmacy" connoting both poison and remedy.

By way of conclusion: the great Greek physician Hippocrates claimed to inherit the mantle of Asclepius and to be his direct descendant. Even today, all doctors before they begin to practice must swear an oath of good conduct, referred to as the Hippocratic Oath. . . . Unfortunately they are not always able to restore to life those we would wish to see again. But at least now they know that, when a mortal takes himself for a god and claims mastery over life and death, a higher power will intervene to put him in his place. As is demonstrated by the tale of another death deceiver, the wily Sisyphus.

The two stratagems of Sisyphus

The case of Sisyphus seems at first sight quite different from that of Asclepius. Firstly, Sisyphus acts on his own account: he does not try to save others but only to save himself; secondly he does not resort to science but to deception. However, in both cases we are dealing with an extreme form of hubris, in that both Sisyphus and Asclepius potentially endanger the established order. Here again I will follow the account given by Apollodorus, supplementing it in one or two

places with that of Pherecydes of Athens, a mythographer of the fifth century BC.

The punishment meted out to Sisyphus in Hades is familiar and has attracted considerable commentary: after his death he is condemned by Zeus to roll a great boulder to the top of a high hill, from which, each time, it immediately rolls down—so that he must keep starting over again, interminably, without his intolerable task ever coming to an end. Moreover, we do not know precisely what motivates this dreadful punishment. The great French writer, Albert Camus, devoted a whole book to this myth, which in his eyes encapsulates the absurdity of human existence. But in Greek myth, as we shall see, the story possesses a quite other meaning, not remotely connected with the real or supposed absurdity of human lives.

The story proper begins when Sisyphus plays a very low trick on Zeus. We need to know that this hero is, rather like Odysseus, a man of a thousand ruses. Some even claim that Sisyphus was in reality the true father of Odysseus: the day of the marriage of Laertes to the ravishing Anticlea (mother of Odysseus—of this we are certain), Sisyphus supposedly managed, by trickery, to take the place of the bridegroom in the marital bed and enjoy Anticlea ahead of Laertes——the product of this illicit encounter being Odysseus. Reputations shape reactions: true or false, the anecdote suggests fairly well the type—morally disreputable, and ready at every turn to deceive his neighbor.

Even when the neighbor in question is Zeus. As it happens, the latter, as is his wont, has abducted a ravishing young beauty: Aegina, daughter of Asopus, a river god and secondary divinity. The latter, torn between anxiety and fury, searches feverishly for his beloved daughter: he can see that she has disappeared, but does not know that it is Zeus

who is responsible. To complete the picture, it needs to be added that Sisyphus is the founder of one of the most famous Greek cities: Corinth. And for his city he needs water, as do all mayors in all ages. So he proposes a bargain to Asopus: "If you cause a clear spring to gush forth, for my city, I will tell you who carried off your daughter." The deal is struck, and Sisyphus now commits the unmitigated folly of informing against Zeus—who is far from pleased.

To begin with, Zeus makes the river Asopus retreat into its source by means of his favorite weapon, the thunderbolt. Ever afterward, it is claimed, the river, whose banks were charred, still bears large lumps of coal. . . . What is certain is that Zeus is unimpressed by the anger of the girl's father, and carries her off to a deserted island. Their amorous union even produces a little boy, Aeacus, who gets bored all by himself, for the island is deserted, so Zeus transforms the ants into inhabitants to keep him company. He now turns his attention to the business of punishing Sisyphus according to his just deserts, of which there are two versions, a short one and a long one. According to the first, Zeus simply strikes down Sisyphus with his bolt and sends him after death to Hades, where he is condemned for all eternity to his celebrated punishment.

The longer version, as reported by Pherecydes, is rather more interesting. Sisyphus remains undisturbed, in possession of his magnificent palace in the city of Corinth, watching the waters that have been set flowing by Asopus. So Zeus now sends death—the divinity known as Thanatos—to conduct him to the underworld. But Sisyphus has more than one trick up his sleeve. He sees Thanatos coming from afar and lies in wait for him, with one of those traps that are his specialty. Thanatos walks right into it: Sisyphus hurls himself upon him, ties him up with sturdy ropes, and conceals him

in a closet somewhere in his immense palace. As with the myth of Asclepius, the world now begins to go off the rails. With Thanatos imprisoned, no one can die. Hades, wealthiest of all the gods, stops accumulating wealth: he no longer has his quota of the dead, and if Zeus does not do something to restore order, the planet earth will become so cluttered as to make life impossible. It is Ares, god of war, who decides to act. You may guess why: If nobody dies any longer, what is the point of war? Ares finds Thanatos, frees him, and delivers into his hands the unfortunate Sisyphus, who is now well and truly forced to descend to Hades . . . at which point you might think that the game is up for Sisyphus. But wrongly so: he has one more trick up his sleeve.

Before dying and forsaking his palace for the realm of Hades, Sisyphus makes a very strange request of his wife: "Above all, please grant this wish, and do not accord me any burial or such funeral honors as every good wife is obliged to perform on the day her husband dies. . . . Do not ask why, I will explain later." And Merope, his charming wife, does as her husband says: she does not watch over his corpse; she carries out none of the rites that would normally be performed. So that, as soon as he arrives in the depths of the underworld, Sisyphus makes straight for Hades himself and complains bitterly about having such a bad wife, and no burial rites. Profoundly shocked by such a lack of propriety, Hades allows Sisyphus to return home to the upper world, to chastise his unworthy spouse as he sees fit, on condition of course that he promises to come back directly afterward. As you may imagine, Sisyphus goes home and promptly forgets his promise about returning to the underworld. On the contrary, he gives grateful thanks to his wife, proceeds to give her numerous children over the years, and ends his days dying quietly in old age. Only then is he obliged to return

underground, where he is forced to interminably roll his great boulder: a torment that Hades imposes so as not to be duped a second time. As for the meaning of the torture itself, it relates directly (as always) to the crime. For mortals, life is a perpetual beginning, not an open road without end. And whoever tries to push back these limits—as dispensed by the cosmic order—will learn to his cost that, once arrived at its term, the process must begin again from zero: life is a state of constant renewal. In other words, and to restate the lesson of Odysseus, no individual can escape the essential finiteness of his human condition.

II. Foiled resurrections, successful resurrections: Orpheus, Demeter, and the Eleusinian Mysteries

With Orpheus and Demeter, properly speaking, we are no longer dealing with stories of hubris. Nevertheless, I will speak of them here because their extraordinary adventures are in one essential respect related to the theme touched on in the myths of Sisyphus and Asclepius: in effect, the question of escaping death—or at least that of returning from the underworld to the light of day. As we shall see, this journey, impossible for mortals (there is as far as I know only one exception in the whole of Greek mythology*), is not easy even

*Namely, the story of Alcestis, a young woman who volunteers to die in place of her husband, Admetus—and whose sacrifice so moves Persephone, the wife of Hades, that she chooses to allow Alcestis to return to earthly life. Heracles, Orpheus, and Odysseus do, of course, also return from their time in the underworld, but they are there as members of the living rather than the dead. There is also the case of Semele, mother of Dionysus, who dies in childbirth but is then rescued from the underworld by her son before being herself deified in turn. But Semele is already the daughter of a goddess, Harmonia, and as mother of an Olympian she is herself destined to become divine: her case is therefore less desperate from the outset than that of Alcestis. . . .

for those gods who, albeit immortal, find themselves imprisoned in the kingdom of the dead. And this theme of resurrection bears upon the nature of the cosmic order within which gods and mortals cohabit, for it is in the nature of things that men die, from which none can escape without provoking a disorder that, in the end, would overturn the course of the universe. We must therefore accept death, in whose shadow we must nonetheless seek the good life.

Orpheus in the underworld—or why death is stronger than love

Let us begin with Orpheus, whose story is one of the rare myths to have influenced the Christian religion, perhaps because it is built around a question that will be of central concern to the Gospels: that of the unavoidable and insoluble contradiction between love and death,* a contradiction that provokes in mortal men the notion of resurrection followed by an ardent yearning for resurrection. Who among us would not wish, with every fiber of our being, to bring back those whom we have loved passionately or devotedly? It is thus that, in the Gospels, Jesus begins to weep when he learns of the death of his friend Lazarus: although divine, he experiences, like you or me, the infinite pain caused by the death of a loved one. And, of course, Christ is well placed to know—it being one of the cornerstones of Chris-

*One more point to make before going further: Although very ancient, the myth of Orpheus in the underworld is found neither in Homer nor in Hesiod. Clearly it was in circulation as early as the sixth century BC, but it was above all the Romans of the first century, Virgil and Ovid, who have left us the most detailed and coherent versions of the story. Essentially it is these that I follow here, even if at various points it has been necessary to consult older Greek sources for completeness—notably *Alcestis* by Euripides and the works of Apollonius of Rhodes, Diodorus and even Plato. As always, *The Library* of Apollodorus has been a precious resource.

tian belief—that, in his words, "love is stronger than death."
Which he goes on to prove by restoring life to his friend,
who has been dead long enough (as the Gospel makes clear)
for his flesh to have already started decomposing. But what
matter since love triumphs over everything, and the miracle
of resurrection must be accomplished. . . .

But with the myth of Orpheus we are in the world of
the Greeks, not the Christians, and such resurrection seems
entirely beyond the reach of mortals. When the unfortunate
Orpheus loses his wife, who dies before his eyes, stung by a
poisonous snake, he is properly inconsolable. But let us not
anticipate, until we are clear as to whom we are dealing with
here.

Orpheus is first and foremost a musician. According to
the Greeks he is the greatest musician of all time, superior
even to Apollo, who, moreover, finds his playing so excep-
tional that he is said to have made Orpheus a present of the
famous lyre invented by his little brother Hermes. The lyre
is an instrument with seven strings, and Orpheus, deciding
that this is not quite enough to create perfect harmonies,
adds two supplementary strings . . . which in turn "tunes"
his instrument to the number of the Muses: the nine god-
desses, daughters of Zeus, who are held to have invented the
principal arts and to inspire all artists. To which it should be
added that Calliope, queen of the Muses, is none other than
the mother of Orpheus. Music can therefore be said to run
in the family. It is said that when he sings to the accompa-
niment of his instrument, wild beasts, lions and tigers, fall
silent and become as gentle as lambs; fish leap from the water
to the cadence of his divine lyre; and the rocks themselves,
which, as is well known, have hearts of stone, are moved to
weep. . . . In short, the music of Orpheus has magical prop-
erties, and with nine strings to augment the harmony of his

song, nothing can resist him. When he joins the expedition of the Argonauts, led by Jason, who set sail in search of the Golden Fleece on a boat constructed by Argos (whence their name), it is Orpheus who saves them from the Sirens, those bird-women whose singing tempts unfortunate mariners to shipwreck. . . . Orpheus is the only being in the world who can outperform their baleful song.

But let us return to the story of what will draw Orpheus to the underworld.

Orpheus has fallen in love with Eurydice, a nymph of matchless beauty who, according to some sources, is even a daughter of Apollo. Her beauty aside, this is a story of true love, and Orpheus cannot exist without her. Deprived of her presence, life no longer has any meaning for him. According to Virgil, who retells their story at length in the *Georgics*, one day as she is walking along a riverbank Eurydice is pursued by the violent advances of one Aristaeus. She starts running to escape him, and looking behind her now and then, to see if he is catching up, she fails to see a poisonous snake ahead of her, on whom she places her delicate foot. Death is more or less instantaneous, and Orpheus is inconsolable—nothing can stop his weeping—to the point that he resolves to attempt the impossible: to go and seek her himself in the underworld, where he will endeavor to convince Hades and Persephone, his queen, to allow him to return to the upper world with his beloved.

The descriptions in Virgil and Ovid of Orpheus's passage through the underworld are vividly realized. Even to this day the story inspires painters, musicians, and writers. Orpheus must first find the entrance to the underworld, which is by no means straightforward. He succeeds, orienting himself by a source that springs from the earth at the place where one of the four infernal rivers flows out of the depths. He must

cross or keep close to all four. First there is Acheron, the
river that all those who die must cross before they can enter
Hades. It is here that the frightful Charon, a repulsive and
grimy old boatman, demands an obol to ferry the dead souls
from one shore to the other—which is why, as we have seen,
the Ancients placed coins on the eyelids or in the mouths of
the dead, so they could pay the ferryman, without which
they must spend a hundred years wandering the shore to
await their turn. . . . Thereafter, Orpheus must navigate the
Cocytus, a glacial river along which are swept great blocks
of ice; then the terrifying Phlegethon, a huge torrent of fire
and molten lava; and finally the Styx, upon whose waters the
gods swear their oaths.

But this fearful landscape is peopled with beings who
are even more appalling. There are, first and foremost, the
throngs of the dead, those pitiable phantoms, without any
identifying features, unrecognizable, who harass the visi-
tor unceasingly. Worse still, if possible, Orpheus encoun-
ters infernal monsters: Cerberus, the dreadful three-headed
hound; centaurs and Hundred-Handed Ones; abominable
Hydras, whose hissing is enough to freeze the blood; Har-
pies, who torment whomever they meet; Chimeras and
Cyclopes and . . . In brief, the descent to the underworld
surpasses in horror whatever can be imagined by the human
mind. For the sake of Eurydice, Orpheus is prepared to en-
dure it all. Nothing can stop him. Besides, he sings for the
entire length of his appalling voyage, accompanied by his
lyre—and in these depths, as elsewhere, his music produces
the same results. Under the spell of his song, even those
being tortured recover a little and enjoy (if not happiness,
in such a place) a little respite: Tantalus ceases momentarily
to feel hungry and thirsty; the wheel of Ixion stops turn-
ing; the rock of Sisyphus stops rolling downhill. Cerberus

himself lies down as biddably as a lapdog, and would almost allow himself to be stroked. . . . The Furies stop their vile work for a moment, and the tumult that usually resounds through this infernal place subsides. The rulers of the underworld, Hades and Persephone, themselves fall under the spell. They listen to Orpheus attentively, even favorably. His courage impresses them, and his love for Eurydice—so true, so unquestionable—fascinates these two deities famed for being ordinarily so impervious to the least human emotion.

It is Persephone, it seems, who is the first to let herself be persuaded. Orpheus may return to life and light with his Eurydice . . . but on one condition: that she follows him in silence and, above all—above all—that he does not turn around to look at her before they have entirely left the underworld. Orpheus, mad with joy, accepts. He leads Eurydice, who follows him meekly, as agreed, a few steps behind. But without any explanation as to why he does so—Virgil speculates that Orpheus is overcome by a sort of lunacy, a sudden gust of love that can wait no longer; Ovid inclines to suggest a gnawing anguish that makes him doubt the promise of the gods—Orpheus for whatever reason commits an irreparable error: unable to help himself, he looks over his shoulder at Eurydice—and this time the gods are inflexible. Eurydice must remain forever in the kingdom of the dead. There is nothing more to be done, nothing further to discuss, and the unfortunate girl dies a second time, definitively and without appeal.

As you may imagine, Orpheus is once more inconsolable. In despair, he returns home and shuts himself in his house. He refuses to see other women: What is the use? He is a man who can only love once, and her name is Eurydice. He will never love again. But according to the Latin poets, Orpheus thereby offends all the women of his city. They

do not understand how a man of such charms, whose song is so seductive, can possibly be so neglectful of them. All the more so since, if we believe some sources, not only does Orpheus turn away from the fairer sex but he also interests himself henceforth exclusively in young men. He even entices to his home the husbands of the region, with whom he shares his new passion for young boys. This is the last straw, and more than these women can endure. According to this version of the myth, Orpheus is literally torn to pieces by the jealous spouses: arming themselves with sticks, stones, and various agricultural tools left in the fields by laborers, the women hurl themselves upon him, then throw his dismembered limbs and severed head into the nearest river, which carries everything out to sea. Thus do the head and the discarded lyre of Orpheus float on the current until they reach the island of Lesbos, whose inhabitants erect a tomb for him. According to some mythographers, the lyre of Orpheus is transformed (by Zeus) into a constellation, and his soul transported to the Elysian Fields, which is roughly a Greek equivalent for paradise, or more accurately, a return of sorts to the age of gold.

This detail is not without significance since it allows us better to understand how and why the myth of Orpheus was to give rise to a cult, or even a religion, aptly named Orphism. Orphic theology claimed to take its inspiration from the secrets that Orpheus discovered in the course of his voyage, and that permitted him, despite his grievous fate on earth, to find salvation ultimately in the blessed realm of the gods. . . . As we shall see, here is a feature that links the story of Orpheus with that of Demeter, as I am about to relate, and equally with what are referred to as the Eleusinian Mysteries, named after the city in which Demeter established her temple and her cult.

But first we must ask ourselves, again, as to the exact meaning of this combat of Orpheus against death. In particular, how are we to understand the strange prescription by Persephone that Orpheus should not look behind him? Stranger still, how can Orpheus have been fool enough to turn around when he had all but reached his goal and after so many painful tribulations? Strangely, none of the texts devoted to this myth offer any plausible explanation. Virgil puts everything down to love: blind and impatient love. But even were this to explain the error as such, it throws no light on the restraining order imposed by the gods: Why, in effect, must the backward glance of Orpheus be fatal for the two lovers?

Many different answers have been given to this question, and it would be long and tedious to repeat them all here, especially since none of them strikes me as very convincing. Commentators have often grafted a Christian perspective onto the myth, explaining that Orpheus turns around because he doubts the divine word, and he who loses his faith is lost because only faith can save us, and so forth. I think that, in the end, we should rather keep the details of the story in our sights: the contradiction between love and death as insurmountable by mortals, despite all the hopes placed in the attempt by Orpheus. If Orpheus loses Eurydice a second time by *turning around*, and if she is under strict instructions to remain *behind* him, and on no account to pass *in front*, and if the gods have imposed these conditions in the full knowledge that they will not be obeyed (otherwise why impose them?), it is simply because by looking backward Orpheus will finally understand that what is behind is indeed behind, that the past is past, that time is irreversible, and that every mortal must accept (as Odysseus did when faced with Calypso) the human condition that is his: that of a species that,

like the rock of Sisyphus, sees its term unroll between this point of departure and that point of arrival, and which none can alter, not by so much as a single jot.

Our birth and our death are not ours, and Time, for us mortals, is quite irreversible. The irremediable is our common fate, and ill fortune does not negotiate terms: in the best of cases, it remains sufficiently tacit and slumbering to allow us to follow the natural course of our lives, rather than diverting it, so that we must start again from a point that is somewhere behind us. As so often, despite the proximity to Christianity in the way the paradox is formulated—that love wants at all costs to prove itself stronger than death— the Greek attitude proceeds inversely: death always wins out against love, and it is in our interest to recognize this from the outset if we wish to attain the wisdom that alone permits us to accede to a good life. Nothing can change this primary fact, which is the most solid pillar of the cosmic order—around which the difference between mortals and Immortals, between men and gods, revolves. As for those mysteries that the Orphic priests claimed to reveal to their flock, I fear that these must forever remain (as always in such cases) where they were at the outset . . . neither more nor less than mysteries.

This leads me directly to the mysteries of Eleusis, which is to say the myth of Demeter, goddess of harvests and of seasons. We shall see how the fact of being immortal changes everything: for the fortunate gods, unlike the unfortunate mortals, it is always possible to leave Hades, even if the latter is determined to keep you by his side. . . .

Demeter—or how return from the underworld is possible if you are immortal . . .

Although it brings us back once more to the underworld, the story of Demeter and her daughter, Persephone, does so on quite different terms to that of Orpheus.* Here the protagonists are immortal gods, not simple mortals trying desperately to escape the clutches of death, which is to say that their relation to the underworld is not the same. Nevertheless, this myth also establishes—albeit in a different mode—a causal link between the realm of Hades and the order of the world above. It is with this myth, moreover, that the Greeks explained to themselves a fundamental aspect of the organization of the cosmos, namely the fact of the seasons: the end of autumn and winter, when everything dies, followed by the arrival of spring and summer, when everything comes back to life and blossoms once more. A process that is directly linked to the descent into the underworld of Persephone, daughter of Demeter, which I shall now recount.

Demeter is herself the daughter of Cronus and Rhea; she is consequently the sister of Zeus, but equally of Hades. As the goddess of seasons and of harvests, it is she who makes the wheat grow, which is why the Romans named her Ceres, whence derives the word "cereals"—with which of course men make bread and many other products besides. It is likewise Demeter, moreover, who first teaches men the art of cultivating the earth: namely agriculture. She is an immensely powerful goddess since she bestows life—upon

*The myth is described in the Homeric Hymns, a collection of poems that were for a long time attributed to Homer himself but whose true authorship is unknown. This is essentially the text I follow here, as it is not only one of the most ancient but also the richest and most interesting.

plants, at least, and vegetables and fruits, flowers and trees—
and who can equally, when she wishes, take life back: ar-
range things so that nothing grows in the fields and orchards.
Insofar as human life, as distinct from that of the gods, de-
pends on food as such, Demeter possesses from the outset an
especially powerful link to mortality and survival.

Now, Demeter has a daughter, by her brother Zeus, to
whom she gives the name Persephone—who is also some-
times named Cora, which in Greek signifies "young girl,"
and to whom the Romans will give yet another name,
Proserpine. In the archaic age it is common, among gods,
for brothers and sisters to have children together—after all,
in the beginning there was not much choice: like the Ti-
tans, the Olympians were obliged to make do with one an-
other since there was no one else with whom to procreate.
So, Demeter has a daughter who is a goddess and whom
she deeply loves. She is, if anything, besotted by her child.
To which we should add that Persephone is by all accounts
lovely beyond compare. Like all goddesses, she is of course
endowed with perfect beauty, added to which she embod-
ies everything that is suggested by a young girl in blossom:
fresh, innocent, gentle—and desirable. While her mother
wanders the world surveying the harvests and keeping watch
over the grain, Persephone plays in a meadow with a group
of nymphs, gathering flowers to make a bouquet. But Zeus
has other plans for her, which he has made sure not to men-
tion to his sister Demeter: that he intends their daughter,
Persephone, to marry the richest of all the Immortals, Hades,
ruler of the underworld—also known as Plouton, meaning
"wealthy one," which will in turn provide the Roman name
Pluto. He reigns over the dead, which is to say over the most
numerous group of mortals, since the dead greatly outnum-
ber the living. If we estimate the wealth of a king by the

number of his subjects, then inevitably the master of the underworld must be the wealthiest sovereign in the universe.

To attain his ends, Zeus has asked Gaia, his grandmother, to create a magical flower, unlike any other, and more to be admired than any other, from whose single stem there grow a hundred dazzling sprays, whose perfume is so intoxicating that the whole sky smiles approval. Those who see it, whether mortal or immortal, fall instantly under its charm. Naturally, Persephone, playing in her meadow, makes straight for this miraculous flower, which of itself would make the most beautiful of bouquets. But as she is about to gather it the earth opens (which proves that Gaia is indeed closely involved in the plot), and the ruler of the underworld surges upward on his chariot of gold—for he is extremely wealthy!—drawn by four immortal horses. He seizes Persephone in his all-powerful arms and carries her off. She in turn utters a terrible scream, of such shrillness as to resound throughout the cosmos, a shriek made all the more heartrending in that it is fueled by despair at ever seeing her mother again. For she adores her mother reciprocally and as equally as she is herself loved. There are in the universe only three individuals who hear this shriek: Hecate, a deity whose attributes are somewhat mysterious but who often shows herself to be clement toward those in pain; Helios, the sun god who sees everything and from whom nothing escapes; and of course Demeter herself, who is seized with terror at hearing the terrified shriek of her daughter.

For nine days and nights, Demeter wanders the earth, from east to west, from sunrise to sunset, searching for her beloved child. At night she carries immense torches to light her way. For nine days and nights she touches neither food nor water, does not wash or change her garb; she is stunned with grief. No one, either among the mortals or the gods, is willing to

tell her the truth, and no one comes to her aid—except for the kindly Hecate, who brings her to see Helios, the sun god who witnessed everything. And this latter, sympathizing with her grief, resolves to tell her the truth: Persephone has been well and truly abducted by her uncle Hades, the prince of shades. Of course, Demeter immediately grasps that this operation cannot have taken place without the consent or even complicity of their brother Zeus. By way of retaliation, Demeter immediately withdraws from Olympus. She refuses to sit any longer among the assembly of gods and comes down to earth to live among mortals. She casts off her immortal beauty and, as in a fairy tale, takes on the disguise of an old woman, ugly and poor. Then she goes to the city of Eleusis, where, by a well, where they have come to draw fresh water, she meets the four daughters of the king of this city, a certain Celeus. They start to converse, and Demeter, who continues to conceal her identity, tells them that she is looking for employment, hopefully as a nurse. This is a happy coincidence, for the four girls do indeed have an infant brother: they run back to ask their mother, Metanira, if she will hire this old woman as a nanny. The deal is soon concluded, and Demeter finds herself in the palace of King Celeus. Here she becomes friendly with Metanira, the queen, and a woman of their company, Iambe, who notices the sadness etched on the countenance of Demeter and undertakes to distract her. She tells her jokes and funny stories, by means of which she manages to cheer Demeter up a little, making her smile and even laugh!—which has not happened to her for many a day. She regains a little of her zest for life, enough at least for her to take an interest in the little boy who is henceforth her charge.

Now occurs an episode that is not without interest, for it, too, is linked to the theme of death that runs through the

entire myth. Finding herself in the role of a mother once again, Demeter decides to immortalize this child who has been entrusted to her—in other words to bestow on him the greatest gift a god can offer a human. She rubs him all over with ambrosia, which enables him to escape his mortal confines, as a result of which the little boy grows at an extraordinary rate, to the considerable surprise of his parents, for he seems to eat nothing. Immortals are content with nectar and ambrosia, never touching the bread or meat with which humans nourish themselves, and this small boy is already almost a god. Each night, Demeter plunges him into the sacred fire that she takes care to light in the chimney. The flames contribute their share to making mortals immortal, stripping them of their mortal flesh. But the boy's worried mother, Metanira, conceals herself behind the door to spy on Demeter and discover what she is up to each night. When she sees the goddess plunge her son into the fire, she begins to scream. She has cause to regret it, for Demeter drops the child to the ground and he instantly becomes mortal again. In symbolic terms, Demeter is once more stripped of her maternal role. Her second motherhood has, so to speak, been thwarted. She reassumes her immortal appearance, recovering instantly all of her beauty and brilliance. She reveals her true identity to Metanira and her daughters and gives them to understand the scale of the error perpetrated by Metanira, without whose ill-advised intervention her son would have joined the ranks of the immortal gods. Now it is too late, so much the worse for him and for them. Then Demeter orders that the people of Eleusis erect a temple worthy of her and create a cult so that she can, when she sees fit, reveal to them the mysteries (of life and death) to which she holds the key. From which is born the famous cult surrounding what are called the Eleusinian Mysteries. The adepts of this new

religion, linked to the memory of Demeter, hoped, by pen-
etrating the mysteries of life and death, to gain salvation and
achieve immortality. In which respect, as you see, the myth
of Demeter joins that of Orpheus, which also inspired a cult
(Orphism) linked to the hope of penetrating the secrets of
eternal life, thanks to the teaching of those who have de-
scended into Hades. . . .

But let us return to Demeter. Deprived of a child for
the second time, her attitude hardens, even to the point
of menace. She decides that the joke has gone on for long
enough, and it is time her daughter was restored to her. And
she will do whatever it takes to achieve this. And as she,
too, possesses the secrets of life and death, or at least those
that govern the vegetable world—which are directly and
exclusively her privilege—she decides that nothing more
will grow or flower on earth for as long as Zeus refuses to
give back what is hers. No sooner said than done: everything
organic on earth wilts and dies, and soon the cosmos as a
whole is threatened, the heavenly spheres included.

Here is how the Homeric "Hymn to Demeter"—our
archaic source for the myth—describes what ensues:

> So Demeter made a most terrible and cruel year for human
> beings on the nourishing earth. The ground did not send
> up seed, for rich-crowned Demeter kept it hidden. Many
> times the oxen dragged the curved plough across the fields
> in vain, and many times the white barley fell upon the earth
> fruitlessly. So she would have destroyed utterly the mortal
> race of human beings, starving them to death, and deprived
> those who live on Olympus of the glorious honour of gifts
> and sacrifices, if Zeus had not taken note and reflected upon
> it in his heart. . . .

As always, when the cosmic order is truly endangered—
ever since the original ruling by which Zeus divided and

organized the world—it falls to him to propose an equable solution, one that is just and lasting for all the parties concerned. We may note in passing how the existence of mortals is justified in this poem: the possible extinction of humanity is not presented as a catastrophe in itself, but rather as a source of frustration for the gods. In other words, men exist above all for the sake of the gods, to entertain them and to pay tribute to them. Without organic life, and the dimension of history that humans introduce into the cosmic order, the latter would be fixed forever, immutable for all eternity, and as a result deathly boring. . . .

Be that as it may, Zeus dispatches the Olympians to intervene with Demeter, one by one, and try to persuade her to arrest the unfolding catastrophe. But without success. Demeter remains stonily indifferent: until such time as her daughter is restored to her nothing will grow again on earth—until all life disappears, if necessary—which naturally dismays the gods. Once again, without mankind to distract them, to honor them and make handsome sacrifices to them, the Immortals will themselves die . . . of boredom. Without life—which is to say without history, without time itself, as symbolized by the birth and death of mortal men, the succession of the generations—the cosmos will be entirely devoid of interest. Zeus therefore sends in his ultimate weapon, Hermes, as he did when he needed to convince Calypso to release Odysseus. Everyone obeys Hermes, because everyone knows that he is the personal messenger of Zeus and speaks in his name. Hermes notifies Hades that he must release Persephone back to the world of light and to her mother. Let us note in passing that, apart from the episode of the abduction itself, where Hades must have used force, he has shown himself extremely attentive to Persephone. He is doing everything in his power to be loving and gentle with her.

Hades must obey the orders of Zeus. It is futile to try in any way to shirk the command, or even to think of using force to do so. On the other hand, a little cunning never hurt anyone: surreptitiously, looking quite unconcerned, and just as she is leaving with Hermes, Hades offers Persephone a few pomegranate seeds, a delicious fruit that she tastes quite thoughtlessly. What she is unaware of is that these few ill-starred seeds will bind her forever after to Hades, for it means that she has consumed something that comes from the world below, and through this nourishment, however modest, she is linked irrevocably and forever after to the underworld.

Zeus now must find a fair solution: one that reflects both his decision to give his daughter to Hades and the equal claim of the mother to keep her daughter by her side in the world of light. He must, so to speak, meet both claims halfway if he is to reestablish a just order. Here is how, according to the Homeric Hymn:

> Then loud-thundering, all-seeing Zeus sent a messenger to them—Rhea with her lovely hair—to bring Demeter in her dark-blue cloak back to the tribe of gods; and he promised to give her honours, whatever she chose among the immortal gods, confirming with a nod that her daughter would live in the kingdom of dusk and darkness for a third part of the circling year, but for the other two parts she would live with her mother and the other immortals. So he spoke. And the goddess did not disobey the message of Zeus.

In effect, there is no disobeying the messages of Zeus. But most important of all, the solution possesses profound significance in terms of justice. As we can see, it weaves together two "cosmic" themes, each crucially important: on the one hand that of life and death, on the other that of seasonal divisions. When Persephone is with Hades, among

the dead, for a third of the year, nothing more can grow on earth: neither flowers, nor leaves, nor fruit nor vegetables. This is winter, with its glacial cold that hems in men and animals alike. Death reigns over the vegetable world, mirroring what occurs below when Persephone is prisoner in the kingdom of shades. And when she returns to the light, to rejoin her mother, it is spring, then summer, until the beautiful season of autumn: everything is once more in flower, everything grows, and life takes the lead again.

The division of the world, of the entire cosmic order, is hereby guaranteed: death and life alternate in a rhythm that corresponds to reality above and below ground. No life without death, no death without life. Put differently, just as a stable cosmos needs the rhythm of generations played out by mortal lives—without which the ensuing immobility, without life or motion, albeit stable, would be indistinguishable from death itself—so, too, there is no perfect cosmos without the succession of seasons, the alternation of winter and spring, death and rebirth. The same goes for Apollo and Dionysus: the one requires the other. A rich and living universe needs both stability and vitality, order and excess, reason and madness. *It needs humans so that the animate world of gods and mortals alike can participate in the movement of history; it needs seasons so that the inanimate world of nature can also experience the living principle of change and diversity.* This is the deeper meaning of the Demeter myth, which does not strictly belong with the other stories of hubris examined earlier. However, I wish to make the connection to those myths because the Demeter myth likewise shows that cosmic disorder must ensue when an injustice between the gods takes center stage (Hades behaves unjustly). And, as before, it is Zeus who must intervene to put an end to the anomaly, by a cosmic rul-

ing that in turn establishes a new order: during the season of Persephone's absence, nothing grows; during that of her return, all is reborn. Thus does life proceed on this earth of mortal men, in whose absence the gods themselves would end by perishing. . . .

5

Dikè *and Cosmos*

The Hero's First Mission, to Guarantee Cosmic Order Against the Return of Chaos

I HAVE ALREADY SUGGESTED how heroism—the quest for great deeds that might earn eternal glory for those who accomplish them—occupies a central place in the mental universe of the Greeks. It means defeating the very finitude that defines human life through glorious actions and thereby gaining a particular sort of eternity. And it is through what is written about him that the permanence of the hero is assured: if he succeeds in becoming the subject of a myth, of a legend that mythographers and historians record thereafter in black and white, so to speak, the hero will survive the fate of ordinary mortals, whose memory is effaced completely by death. The hero will be remembered for a long time, perhaps forever. He will retain his singularity, which death strips from ordinary mortals and renders them entirely anonymous. The shades that haunt the kingdom of Hades are without names or faces. They have lost all individuality. To remain forever a person, if only in the memory of others, requires merit: glory is not obtained easily. It can be acquired in the conduct of war, as with Achilles, the most valorous of all Greeks. Or through acts of courage, cunning, and intelligence, as with Odysseus, who manages to survive the

innumerable pitfalls laid for him by Poseidon in the course of his voyage. But greater still is the glory attaching to the hero who has fought in the service of a divine mission, in the name of justice, or *dikè*, in order to defend the cosmic order against the archaic forces of chaos, whose resurgence is an ever-present threat. It is of this species of heroism that I will now speak, by considering the greatest heroes of mythology: Heracles, Theseus, Perseus, and Jason. As we shall see, their cosmic adventures are well worth a detour.

I. Heracles: how a demigod carries out the task allotted to him by Zeus, eliminating the monstrous beings that threaten the harmony of the world

The legend of Heracles—who will become Hercules for the Romans—is one of the earliest in Greek mythology. Homer and Hesiod already speak of him, which indicates that the story was certainly well established by the seventh or eighth centuries BC. Heracles is also by far the most celebrated of Greek heroes—for his legendary strength, his unfailing courage, his fabulous exploits, and his sense of justice, or *dikè*. Many thousands of pages have been devoted to him, likewise innumerable paintings, statues, poems, stories, and films. From antiquity onward, all mythographers, poets, tragedians, and even philosophers have presented or represented, each after their fashion, the exploits of his life . . . to the point that the events that mark the course of his story are all, without exception, subject to the widest possible range of versions and variations. Not a single exploit of this hero, not a moment of his existence, including even the origin of his name, has not been subject to multiple interpretations—as if the Greek

imagination is almost boundlessly enabled and enlarged by contemplation of this story.

This is why we must not trust to accounts that tell the life of Heracles as a stable and linear sequence of events: a single narrative the elements of which are generally accepted. To do so is to court deception. There are only three aspects of the myth upon which the many different versions seem to agree, and then only approximately so: the birth of Heracles, his celebrated "twelve labors," and his death, followed by his "apotheosis," or deification, his passage from mortal man to immortal god. It is these three episodes that I would like to recount, as clearly as possible, but without eliding the variations between different versions and in each case indicating the sources I have chosen to follow. I will select what seem to me to be the most suggestive and profound versions of the story—in other words, those that seem to have contributed to a common culture within the Greek world. For it is this that matters most, if we wish to understand how the legend of Heracles was able on several fronts to provide a model of wisdom that philosophy, and particularly Stoicism, would subsequently adapt for its own purposes, endowing it with a rational dimension.

The birth of Heracles and the origin of his name

A poem written probably in the sixth century BC, and long attributed to Hesiod, contains the earliest detailed description of the fabulous story of the birth of Heracles. The poem is simply titled "The Shield" because it is mostly devoted to describing this item in the warrior's equipment of the hero. From the opening lines, we learn by what means—

somewhat devious, it has to be said—Zeus managed to seduce the ravishing nymph Alcmena, a mortal who was married to a certain Amphitryon, before fathering Heracles upon her. The child was to be a "demigod," in the specific sense employed by the Greeks: the son of an immortal father and mortal mother. Above all, the poem gives us an important insight into the intentions of Zeus. Just for once, it was not simply a case of diverting himself by making love to a pretty girl—as Hesiod is at pains to make clear:

> The father of men and gods was forming another scheme in his heart: to beget one who would defend against destruction both gods and men.

"Defend against destruction"—such is the principal role of our hero. But against what kind of danger? And why would Zeus need a deputy, like a sheriff in a Western? In effect, with Heracles it is more of a lieutenant that Zeus creates, someone able to "take the place" on earth of the ruler of the gods, and to assist him down here in his struggle against the continual resurgence of the forces of chaos—the distant legacy of the original Titans. It is with this struggle, of course, that the legend of Heracles will be centrally concerned. You will no doubt be wondering about the reality of these forces. Is it not simplistic to speak, like a latter-day politician, of "the forces of evil," on the one hand, and on the other hand the forces for good (by which is meant, as it happens, one's very own party)? In truth, we are very far from this caricature. For we must understand that in this archaic period, clearly legendary, when gods are not yet quite separated off from mortals—the proof of which is that they still sleep with them and have children by them—we are still very close to the origins of things: close to the primordial chaos and the great "titanic" combats that led to the construction of the

cosmos. Zeus has only recently conquered Typhon, the last monster to threaten the order of the world, and on earth mini-Typhons resurface continually, here or there, threatening to seize power, and continually need putting in their place. Which, given their strength and the terror they inspire in ordinary mortals, is far from easy. . . .

Hence, precisely, the essential task that Zeus entrusts to Heracles, whose role is to continue in this sublunary world the work achieved by Zeus elsewhere, and on another scale, involving the cosmos as a whole. The entire existence of Heracles will be dedicated to struggling in the name of *dikè*—a just order—against injustice, against magical and baleful entities, often sprung directly from Typhon himself, who in however many guises always embodies the possibility of a resurgent disorder. But an important clarification is needed here. It would be a category error to understand the word "disorder" in its modern sense, usually drawn from law enforcement, as when we speak of "the forces of order" to indicate the police or "offences against public order" to indicate a street demonstration. What we are speaking of in the present context is an "order" understood in a cosmological sense. It is the harmony of all things that is otherwise in doubt, and the forces of disorder are not street demonstrators but magical beings, often engendered by aberrant deities, whose behavior menaces the organization of the universe and universal justice as instigated by Zeus at the time of his famous division of kingdoms. As a corollary, we must understand the preservation of order as even less a business of simple policing than a weighing of mortal man's purpose on this earth. For if the good life consists in finding our place in the universe and, on the model of Odysseus, at all costs finding our way back to the right place, then a great deal must depend on this order itself being intact and enduring. In the

absence of that, the meaning of human life as such collapses and, with it, all possibility of a search for wisdom.

This is why Stoic philosophy, which represents the summit of Greek thought, saw in the figure of Heracles a tutelary spirit, a sort of godparent. The underlying idea that informs Stoicism is that the world, the cosmos, is divine in the sense of being harmonious, beautiful, just, and good.* According to which nothing is better appointed than the natural order, and our mortal mission on earth is to preserve it, find our place in it, and adjust ourselves to it. It is within this perspective that the founders of Stoicism thought of Heracles as their precursor. Cleanthes, one of the very first scholarchs or directors of the Stoic school, preferred to be described as a "second Heracles"; Epictetus, at several points in his writings, maintains that Heracles is a god living on earth, one of those beings responsible for the elaboration and preservation of the divine order of the world. The philosophical consequences of the adventures of Heracles are therefore considerable, in which case there is nothing surprising about his exploits provoking such imaginative richness of interpretation and giving rise to such a variety of accounts. This is why I shall try to give some idea of their extraordinary diversity, even if this sometimes makes my narrative itself a little less straightforward and linear.

But let us return for a moment to the beginning of the story, to the famous stratagem employed by Zeus to conceive Heracles. For this setting, described several times by Homer, is far from merely anecdotal. It possesses numerous and important consequences for the future career of the hero.

Alcmena, the mortal woman who will become Heracles's mother, has just married Amphitryon. They are first cousins.

*For a more complete presentation of this wisdom, see *A Brief History of Thought*.

Their fathers are brothers, and sons of another famous Greek hero, Perseus. Perseus is therefore the great-grandfather of Heracles, and was in his own right a famous slayer of monsters, having triumphed over the terrible Gorgon Medusa in the course of a series of adventures to which we shall return again shortly. Now it so happens that the brothers of Alcmena have been killed in a war against tribes who were referred to at the time as the Taphians and the Teleboans. Let us leave the details to one side: Alcmena loves Amphitryon, her husband and cousin, but she has forbidden him her bed until such time as he has avenged her brothers, which is why Amphitryon goes off to wage war against these famous Taphians and Teleboans. All the while, Zeus is observing events from the heights of Olympus. He sees Amphitryon conducting himself admirably as a warrior in combat, achieving victory and getting ready to return home to tell his wife of his exploits. As a result of which, Amphitryon has high hopes of finally sharing his wife's bed. It is at this moment that Zeus has his brain wave about Heracles. He disguises himself as Amphitryon. Quite simply, he becomes the latter's indistinguishable double and enters the home of Alcmena as if he were her returning husband. He even has the nerve to boast to her of his exploits, as if it were he (rather than Amphitryon) who had accomplished them. According to some versions, he even goes so far as to offer Alcmena jewels and other trophies snatched for her from the enemy. Grateful for what has been accomplished on her behalf—the avenging of her brothers—and seduced by a husband so manifestly courageous, Alcmena agrees to share her bed with him, or rather with Zeus, who without more ado impregnates her, the issue of which will be little Heracles.

This setting for the myth gives rise in the literature to an impressive number of different versions, but the

basic framework remains more or less the same, and is as I have described. We should also add that when the true Amphitryon returns home he also sleeps with his wife and gives her a child, Iphicles, who will become the twin brother of Heracles, although having a different father.

Some versions claim that Zeus slows or stretches time itself so that his own night with Alcmena lasts three times longer than a normal night—no doubt to take advantage of his opportunity since Alcmena is, as I have said, ravishingly beautiful, but also to delay the return of Amphitryon. Other versions frequently relate the astonishment of the returning husband when he realizes that she already knows about all of his exploits before he tells them, and is even (which completely confounds him) already in possession of the trophies he brought back for her . . . but which he has not yet had the chance to offer her! These details of the story do not properly matter. What does count is that Heracles will be born, and out of wedlock rather than born of Hera, the legitimate wife of Zeus—and that Hera will become mad with rage when she discovers that Alcmena is pregnant by her husband.

You will have noticed perhaps that the two names—Hera and Heracles—resemble each other closely, or rather that one is a contraction of the other, and there is indeed a link between them. Etymologically, Heracles means "glory of Hera," and this part of the myth also needs explication as a vital link between the principal adventures of the hero.

In the beginning, and on this point all the sources agree, Heracles was called Alcides, meaning "son of Alcaeus," in memory of his grandfather, whose name means "the strong one." However, as with all aspects of the life of Heracles, different versions variously explain the reason for the change of name. Basically, two alternative explanations are usually

offered—as if these events concerned an actual historical in-
dividual, whereas we are, of course, dealing with an entirely
mythical and legendary being, one who never existed. This
in turn suggests that the Greeks attended closely to these
stories and took them very seriously—if not literally, at the
least for their significance as wisdom literature. The earliest
explanation of the name can be ascribed to the poet Pindar,[*]
who claims that Hera herself baptized our hero, but for a
fairly inverted reason: since she is eaten away by jealousy,
and rancorous at being deceived yet again by Zeus, she con-
ceives an abiding hatred for the new offspring. It is Hera who
will devise the celebrated twelve labors, hoping to dispose
of Heracles as quickly as possible by sending him to combat
monsters against whom no human being has ever managed
to prevail. Now it so happens that Heracles succeeds, not
only victoriously but crowned with glory of an unprece-
dented kind. What is more, the demigod and the goddess
will end by being reconciled, after the death of Heracles,
when he is transformed into a true god and welcomed to
Olympus. So it is thanks to Hera, so to speak, that Heracles
will become renowned throughout the world—not only be-
cause his glory is entirely dedicated to Hera but also because,
however paradoxically, he owes it all to her. Whence his
name: *Hera-kleos*, "glory of Hera."

We find, notably in Apollodorus, a slightly different
explanation for the origin of the name, but one that
nevertheless coincides with Pindar. Even before starting
on his famous labors, Heracles has occasion to perform a
considerable service to Creon, the king of Thebes who had
succeeded another equally celebrated figure of mythology,
Oedipus. In exchange, or at least as a sign of recognition,

[*]Or at least Pindar seems to have been the first to relate it.

Creon offers Heracles the hand of his daughter Megara in marriage. Heracles marries her and has three children. They live together happily, it seems, until out of jealousy Hera casts a spell on Heracles to drive him out of his mind, and violently so. The spell works, and overcome by a terrible frenzy, a momentary fit of madness for which he is no way responsible, Heracles throws his three children on the fire and, for good measure, kills two of his nephews, children of his "twin half brother," Iphicles. Returning to his senses, he sees the horror of what he has done and condemns himself to exile. He arrives in a neighboring town, in order to be "purified" there, as is the custom: by means of a ceremony, a priest or god could, in effect "cleanse" a perpetrator of his fault when a grave crime such as murder has been committed—rather as Midas washes himself in the source of the river Pactolus. Once the ritual has been accomplished, Heracles travels to Delphi to consult the oracle, and (according to Apollodorus) it is the oracle or Pythian priestess who gives him the premonitory name of Heracles—"glory of Hera"—commanding him to place himself in the service of the goddess in order to accomplish the twelve labors, which represent the impossible tasks she will impose on him through the intermediary of his cousin, the frightful taskmaster Eurystheus (about whom more in a moment). The oracle adds that Heracles, after accomplishing these tasks, will become immortal—not only glorified but actually transformed into a god.

Whatever the case, these two versions are not as remote from each other as they might seem. In both cases, in effect, Heracles works for the glory of Hera, and her glory insists upon his accomplishing the impossible tasks that she imposes out of jealousy, to avenge herself on his very existence, which bears permanent witness to the infidelity of Zeus.

Two final remarks, before coming to the earliest exploits of Heracles, which precede the twelve labors and which he accomplishes quasi-miraculously while still an infant.

Firstly and anecdotally, but nonetheless suggestive about the interlocking of all these stories, you will note that Heracles, strange as it may seem, is both the great-grandson and the younger brother of his great-grandfather Perseus! In effect, albeit several generations apart, they both share the same father, namely Zeus: immortality makes possible for gods what is inconceivable for humans. Symbolically, it also makes a connection between two separate myths and, as in the game of happy families, links individuals with similar attributes, in this case Perseus and Heracles: both are destroyers of monsters, and both carry on—in their different ways, of course—the work of their father.

My second remark concerns the "Herculean" origins of the Milky Way.* As always, there are several ways of recounting this famous legend concerning the earliest months in the life of our hero. One of these, which seems to stand out as the most dominant, serves to remind us that to become an Immortal—which is the destiny of Heracles, as confirmed to him by the oracle at Delphi—one must swallow the food of the gods, particularly ambrosia. Moreover, in Greek the word "ambrosia" simply means "nonmortal": *a-(m)-brotoi*. It is with this in view that Hermes is charged by Zeus to place the infant Heracles at the breast of Hera while she sleeps. However, on waking during this operation, Hera is seized with horror to find herself suckling this infant who reminds her now and forever of the infidelity of Zeus. She pushes it

*This legend appears very early on in fragmentary form, but more developed versions of it are to be found in Pausanias, Diodorus, and Hyginus.

away violently, and drops of her milk spurt across the sky to form the Milky Way. Diodorus tells a slightly different version: Heracles was placed at the breast of Hera by Athena, but already too strong, he suckled a little too vigorously, at which point she tore him from her breast, thereby giving birth to the Milky Way. These variations have the same outcome: the birth of the celebrated starry highway. I mention them here simply to give an idea of how differently, from antiquity onward, the same mythological stories are set out, according to epoch, author, and region. Nonetheless, from this diversity arises, in broad terms at least, a common and coherent culture that the mythographers transmit to the philosophers—rather as, in our own tradition, fairy tales develop variations from a common ground. After all, between the story of Cinderella as told by Grimm and the same story as told by Perrault, there are more than incidental differences, yet the framework remains fundamentally the same.

Let us consider now the exploits that punctuate the earliest years of our hero, well before he accomplishes the twelve labors for the glory of Hera that will make him famous for all eternity.

The first exploits of a demigod

These are generally agreed as numbering five. Here they are, reduced to essentials.[*]

There is in the first place the famous story of the two serpents, which serves at once to show the divine origin of Heracles (which explains his extraordinary infant precocity)

[*]I follow the narrative established by Apollodorus, which seems to reflect the broadest "consensus."

and to establish the significance of his mission on earth: to
eliminate evil forces, in particular those that suggested to
the Greek imagination the legacy of Typhon. Here is how
Apollodorus describes the episode and, in doing so, offers
both of the most familiar versions—which proves in passing
that ancient mythographers were already aware of the
importance of variants between these legends, as bringing
different perspectives to the same story, enabling the audience
better to understand their meaning and significance:

> When Heracles was eight months old, Hera, wanting to
> destroy the infant, sent two huge serpents to his bed. Alcmene
> cried out for Amphitryon to help, but Heracles leapt up and
> killed the serpents by strangling them, one in each hand.
> However, Pherecydes says it was Amphitryon who placed the
> serpents in the bed, because he wanted to know which of
> the children was his own; and seeing that Iphicles fled while
> Heracles stood his ground, he realized that Iphicles was his
> child. . . .

What is clear from both versions, once again, is that the
infant is already launched on his career as a hero. Archaic
paintings depict the scene in epic terms, moreover: we see
Heracles, still an infant, grasping in each hand a serpent that
he throttles. . . . One has to admit that, for a child of eight
months, it betokens superhuman force.

The next two exploits focus upon an episode concerning
a lion.

Once upon a time, in the region around Thebes, birthplace
of Heracles, a terrifying lion is decimating the flocks of
Amphitryon, the human father of Heracles, but also those
of one Thespius, a neighbor and friend of the family. I have
omitted to mention that Amphitryon is also an extremely
decent man, in every sense: both courageous and kindly.
He has accepted, as was usual at this time, the bad news of

the divine paternity of his wife's child: after all, Alcmena did not knowingly betray him, and the decisions of the all-powerful Zeus, whatever they might involve, are final and sacred. This is why Amphitryon raises little Heracles as his son. And the latter returns his affections. Seeing the flocks of his earthly father and Thespius being decimated by this lion, Heracles, who is by now eighteen years of age and possessed of prodigious stature and strength, does not hesitate: he fetches his weapons and sets off in pursuit of the lion. So as to be closer to the whereabouts of his prey, he presents himself at the home of Thespius, who is only too happy to offer him hospitality. For fifty days Heracles tracks the lion tirelessly. Every evening he returns to the house of Thespius—who manages each night to slip one of his many daughters into Heracles's bed. A little fatigued by his daily hikes into the mountains, Heracles does not pay too much attention: he thinks that each night he is sleeping with the same girl. He makes this mistake fifty times—which is convenient for Thespius, since this is exactly the number of nights that Heracles spends in his house, being the time it takes him to find and ultimately slay the lion in the course of a dreadful combat. And from these fifty nocturnal unions fifty sons will be born!

This already adds up to three exploits: killing a serpent at eight months of age, slaying a lion at eighteen years of age—and, at the same age, fathering fifty sons in fifty nights!

The two other exploits of the young Heracles are not quite exploits, in the positive sense. They bear witness rather to the dark side of Heracles, his Titanesque aspect: not merely powerful but also unrestrainedly violent. This is an important point, and it applies to all gods, and all heroes, and—in its chemically pure state, so to speak—is embodied by Dionysus: there is no struggle for order without brutality,

no combat on behalf of the cosmos without brute violence. The sudden madness of Heracles is but one example of this, as is his bloodlust: his capacity to kill and kill again, without fear, but also without shame or restraint.

On his way home from pursuing the lion, Heracles encounters messengers from the king of Boeotia, one Erginus, who, after achieving victory in his war against the city of Thebes, has required that for the next twenty years the inhabitants pay an annual tribute of one hundred cattle as war reparations. Unfortunately for him, Heracles was born in Thebes and naturally thinks the tribute is unjust. As is his wont, he does not waste words: he catches hold of the messengers by the scruff of the neck and, by way of discussion, cuts off their noses, ears, and hands. Then he makes a necklace of the body parts, hangs it around their necks, and sends them all bloodied back to Erginus, with instructions that this is the only tribute the Thebans intend ever to pay him! As you may imagine, Erginus is not overjoyed. He assembles his troops and goes to war against the Thebans once more. Except that this time the latter have Heracles on their side, who makes short work of the entire army of Erginus. Unfortunately, Amphitryon is killed in battle. But this is also the moment at which, by way of thanks, Creon, king of Thebes, offers Heracles his daughter Megara's hand in marriage, of which we have already spoken. . . .

This fourth exploit gives us pause. Of course, there is no doubt that Heracles has acted in the name of justice in defending his city and his king. But we see also a terrible violence at work, if not outright bloodlust: all of his life will be marked by these repeated murders and acts of slaughter.

As for the last of the early "exploits," it is even more worrying, confirming as it does this dark side of his nature. During his childhood, Heracles receives a thorough

education. Amphitryon shows him how to drive a chariot. Castor, the illustrious brother of Pollux, teaches him the handling of arms, and a variety of excellent soldiers teach him archery, hand-to-hand combat, and the other arts of war. . . . As for what might be termed the "humanities," however, Heracles does not exactly have a gift for arts and letters. He has a music teacher, Linus, who is none other than the brother of Orpheus, the greatest musician of all time. But one day, when Linus reprimands him a little too harshly, the little Heracles loses his temper and in short order he strikes and kills the unfortunate tutor with a well-directed blow from his zither! Heracles is brought to justice, but pleading self-defense—Linus, exasperated by his playing, had smacked him—he is finally acquitted. Heracles is very strong, perhaps too strong. In a certain sense, might is always right, and he possesses courage enough for any trial. But he is not tenderhearted, and he is no poet. . . . What he is most certainly is a soldier of Zeus, as he will prove in spectacular fashion when it comes to the twelve labors imposed on him by Hera.

The twelve labors

A few words, first, about the exact origin, significance, and number of these famous labors, which constitute without doubt the most celebrated story in the whole of Greek mythology.

In the first place, we are told that in order to assure herself of her power over Heracles and impose these tasks on him, in the course of which she firmly expects him to be killed, Hera herself resorts to a stratagem that matches those of her husband. The latter, who sees that the birth of his son is imminent, declares somewhat hastily before the assembly of the

gods that the first descendant of Perseus to see the light of day will become king of Mycenae, one of the most important cities of the Peloponnese, which according to legend was founded by none other than Perseus. In saying this, Zeus is obviously thinking of Heracles, for whom he foresees a royal destiny. But Hera takes him at his word. In her jealousy she delays the delivery of Alcmena, and at the same time brings forward the birth of a certain Eurystheus—a first cousin of Heracles—who is also a descendant of Perseus. Eurystheus is born at seven months, whereas Heracles stays in his mother's womb for ten months, so his cousin beats him to the finish line and is set to become king of Mycenae. According to custom, Heracles now owes Eurystheus obeisance, and Hera makes of the latter her military arm: it is Eurystheus who will assign his labors to Heracles, and who will send him off each time to the four corners of the world to confront the worst perils, in the hope that he will succumb to one or another of them. Eurystheus is always described in the legends as a feeble individual, a poor wimp of no importance, quite the opposite of his cousin. He fills the role of a miserable coward perfectly.

Secondly, the "cosmic" significance of the labors of Heracles is attested as much by the equipment he uses in his combats as by the missions that the ignoble Eurystheus assigns to him for each labor. As the majority of mythographers insist, it is the gods themselves—and not any old gods but the Olympians—who furnish Heracles with his arms. According to Apollodorus, it is Athena who is his first benefactor; Hermes who teaches him archery and provides him with the necessaries, not just his bow but also his quiver and arrows; while Hephaestus for his part goes to the expense of a sumptuous present: a golden breastplate that he has forged himself with all the skill for which he is renowned. For good measure, Athena once more adds a magnificent cloak, and

our hero finds himself thus fully equipped for his future adventures. This is no trivial matter: it signifies that Heracles is, manifestly, a representative of the gods on earth. Quite obviously, his mission is divinely ordained or—the same thing as far as the Greek mind is concerned—is of cosmic importance: not only is his father Zeus behind and beside him but also the whole of Olympus.[*]

As for the missions to which he will be assigned, we shall see that they belong almost without exception to a realm beyond the normal, to a world that is properly speaking supernatural—which suggests, once again, that the combat waged by Heracles is directed first and foremost against forces of destruction that are themselves far from ordinary but variously represent the resurgence of Chaos, of the Titans, indeed of Typhon himself. In short, the archaic forces that Zeus himself was obliged to thwart. . . .

As to there being twelve labors, finally, it was only in the first century BC that the figure twelve became the established number, agreed upon by all mythographers. In archaic Greece, the number of labors varied. In Apollodorus, there are at the start only ten labors, but Eurystheus—who is as bad a player as he is a loser—discounts two of these, namely the slaying of the Lernaean hydra and the cleansing of the Augean stables, on the grounds that Heracles is assisted or paid in kind for these exploits. As a result, Eurystheus adds two further labors, which still brings us to a total of twelve, a number that was never disputed thereafter.

Let us now get to the heart of the matter.[†]

[*]Having said this, one final small detail concerning his equipment: Heracles himself makes his favorite weapon, the one that he is so frequently depicted wielding on Greek figure vases, namely the famous club made out of olive wood, with which he will massacre so many monsters.

[†]With the exception of a few details, and to avoid getting lost among the variant versions, I follow the accounts in Diodorus—who is the earliest historian (first

First of all—and this, together with the cleansing of the Augean stables, is without doubt the most familiar of the labors—there is the famous combat between Heracles and the lion of Nemea, a village in the surroundings of Argos. Eurystheus, the puppet of Hera and by this time king of Mycenae, has asked his illustrious cousin to bring him back the skin of the lion. What merits attention above all in this story is the nature of the beast Heracles has to tackle. Naturally, the creature is terrifying. It has been ravaging the region known as Argolis, decimating its flocks, and also devouring any humans it encounters in its path. But there is more. Its essential characteristic is that this animal is not in effect an animal at all. It is no ordinary lion that Heracles must confront but truly a monster, whose parents are in no sense lions. Its father is none other than Typhon himself, and its mother, according to some, is Echidna, the terrifying half-woman, half-serpent who serves Typhon for a wife. The point is crucial, testifying vividly to the real nature of Heraclean combat, which has nothing to do with the ordinary pursuit of an animal, however savage and dangerous. Heracles is a Zeus in miniature: if the latter has confronted Typhon, it is now the turn of the former to confront Typhon's progeny. What proves the monstrous and supernatural aspect of the Nemean lion is its skin—which Eurystheus so much covets. The hide possesses a remarkable attribute, possessed by no mortal animal: nothing can pierce it, neither arrow, nor sword, nor dagger, no matter how sharpened and pointed the blade might be. And this renders the monster all the more formidable, for it is invulnerable to being hunted. . . .

Despite all his talent for archery, Heracles must therefore

century BC) to offer an overall narrative, coherent and complete, of all twelve labors—and in Apollodorus, which is largely consistent (even if the order of the labors is not always the same in both authors).

renounce his usual arms: arrows will rebound off this animal's hide, and sword strokes will slide off its body like water off a duck's back. So Heracles must draw on his own deepest resources: his strength and courage, which are both supranatural and quasi-divine. This lion inhabits a cave that has two entrances joined by a long corridor. Our hero blocks up one of the entrances with an enormous boulder and advances headlong into the other. When the lion hurls itself upon him, Heracles seizes it by the throat and squeezes so hard and for so long that the lion is finally suffocated, at which point Heracles drags it by its tail out of the cave, where he manages to flay the creature and make a sort of cloak from its hide to serve as armor, while from its head he makes himself a helmet.

When Eurystheus sees Heracles returning victorious in this outfit he nearly faints. He is rooted to the spot with terror, for if Heracles is capable of dispatching the Nemean lion, it is clear that Eurystheus must be warier than before. Paralyzed with fear, this cardboard king forbids Heracles ever again to enter the city. Henceforth, the returning Heracles—assuming he manages to return again (let us not forget the hopes of getting rid of him for good one day)—must deposit his trophies at the foot of the ramparts, beyond the city gates. Apollodorus even specifies that, in the grip of fear, Eurystheus orders the construction of a sort of huge bronze jar, which is then placed underground, in which he plans to hide should events take a turn for the worse.[*]

For the time being, if he is to get rid of Heracles, Eurystheus must come up with a second trial, even more fearful than the first. So he now requires Heracles to go and slay a

[*]Eurystheus will end up being killed in the course of a war against the Athenians. It was said that after his death his head was brought to Alcmena, the mother of Heracles—who scratched out its eyes.

hydra that inhabits the region of Lerna. Here again, there is nothing natural about this hydra. In effect, what we refer to today by the name "hydra" is a small and harmless fresh-water polyp, a centimeter and a half long, rather like a sea anemone and endowed with a dozen stinging tentacles that grow back when they are cut. Nothing to worry about. But the Lernaean hydra has little in common with anything to be encountered in the "natural" order. It is truly a gigantic monster, armed with nine heads that grow back as soon as they are chopped off—except that two heads reappear for every one that is severed! This creature likewise terror-izes and lays waste to the countryside, killing anything that comes in range, whether human or animal. Hesiod in the *Theogony* gives us some precious information about the crea-ture. Firstly, as with the Nemean lion, we are dealing with a monster born of the embraces of Typhon and Echidna: here again, the link with the labors of Zeus is clear. Secondly, it is Hera who in her anger has been responsible for causing the creature to be raised so as to unleash it one day against Heracles.

Here is how Apollodorus describes the victory of Heracles over the hydra:

> As a second labour, Eurystheus ordered Heracles to kill the Lernaean hydra; this creature had grown up in the swamp of Lerna, and was used to making incursions into the plain, destroying the cattle and the countryside. This hydra had a body of enormous size, with nine heads, of which eight were mortal, but the one in the centre immortal. So climbing onto a chariot driven by Iolaus [*his nephew*], Heracles made his way to Lerna. Halting his horses there, he discovered the hydra on a hill by the springs of Amymone, where it had its lair. By hurling flaming brands at it, he forced it to emerge, and as it came out, he seized it and held it fast. But it twined itself round one of his legs, and clung to him. Nor could he effect

anything by striking the hydra's heads off with his club, for as soon as one was struck off, two grew up in its place; and a huge crab came to its assistance by biting Heracles on the foot. So he killed the crab, and in his turn summoned assistance by calling Iolaus, who set fire to part of the neighbouring forest, and using brands from it, burned out the roots of the hydra's heads to stop them regrowing. And when, by this means, he had prevailed over the sprouting heads, he cut off the immortal head, buried it, and placed a heavy rock over it by the road that leads from Lerna to Elaeus. As for the body of the hydra, he slit it open and dipped his arrows in its gall. Eurystheus declared, however, that this labour should not be counted among the ten, because Heracles had not overcome the hydra on his own, but only with the help of Iolaus.

After these two exploits, which, despite the dishonesty of Eurystheus, earn him a considerable reputation throughout Greece, Heracles dispatches or at least gets the better of a series of monsters disguised as animals. I will not recount all of these stories, whose pattern is identical and which, moreover, are easily encountered elsewhere. There is the Ceryneian hind, the wild boar of Erymanthus, the Stymphalian birds, the Cretan bull, the mares of Diomedes, Cerberus (the selfsame hound of Hades, who guards the entrance to the underworld, with three heads and a serpent's tail), and so forth. What is worth noting in all these accounts is not so much the events as such, which are in each case the same (a monstrous beast terrorizes a whole region, and Heracles invariably overcomes it), but rather the supernatural and malevolent aspect of the creatures that he confronts. Aside from the wild boar of Erymanthus, which is merely possessed of exceptional strength and an aggression never encountered in nature (and which is, moreover, scarcely mentioned in earlier sources compiled before the fifth century)—these monsters are both maleficent and magical:

the hind is gigantic, with golden antlers; the feathers of the birds are of bronze and as sharp as razors; as for the bull, different classical mythographers sometimes identify it with the one sent from the sea by Poseidon to enable Minos to become king of Crete, sometimes with the bull that carried off Europa (the lovely nymph after whom Zeus lusted), sometimes with the bull with whom Minos's wife Pasiphae fell in love, or sometimes even with the bull of Marathon. In all of these cases, supernatural creatures are involved, whose parents are neither cows nor bulls, as happens in nature, but gods who divert themselves by consorting with mortals. The mares of Diomedes are worse still: these are horses that have been cast under a spell and eat human flesh—which no horse in the natural order of things could acquire a taste for since they are all herbivores. Nor can Cerberus be said to belong to the sublunary world. There is nothing monstrous as such about the cattle of Geryon, but their owner—whom Heracles must confront in order to steal the cattle—is the son of Poseidon and the terrifying Medusa. As for Geryon's dog, Orthrus, who guards the herd and whom naturally Heracles must also slay, here is yet another monster who has nothing in common with an actual dog, given that he has two heads and is likewise—the theme linking Heracles to the labors of Zeus pervades these stories—the offspring of Typhon and Echidna.

In other words, the forces against which Heracles struggles are well and truly out of this world, not to say supernatural, and are the corollary of those Zeus himself had to confront before the division of the world and the definitive creation of the cosmos. Divine does not necessarily mean a force for good: there are evil gods, like Chaos, like the Titans, like Typhon. Besides, the Lernaean hydra, one of whose heads is immortal, is overpowered in exactly the same

manner employed by Zeus to overcome Typhon: just as Zeus succeeds in neutralizing Typhon not by killing him—which is impossible—but by burying him beneath Mount Etna, so likewise it is by placing a permanent boulder over its nonmortal head that Heracles succeeds in ridding the cosmos of the hydra. Let us add that Hera is sometimes mentioned explicitly as the one who, if not exactly creating this or that "animal," is nonetheless arranging matters so that it will cross the path of the hero whom she still wants dead at all costs.

The Nemean lion, the Lernaean hydra, the wild boar of Erymanthus, the Ceryneian hind, the Stymphalian birds, the Cerberean hound, the Cretan bull, the mares of Diomedes, the cattle of Geryon guarded by the frightful Orthrus . . . we have already counted nine labors.

THE THREE REMAINING, OF which I have not yet spoken—the belt worn by the Amazon queen Hippolyta, the golden apples of the Hesperides, the stables of Augeas—have a different aspect altogether. Here it is no longer a question of overcoming monsters disguised as noxious animals but, more straightforwardly, of accomplishing a task reputed to be impossible. Here, more so than in the other exploits, the notion of the "labor" finds its deeper application: what is at issue first and foremost is a dangerous and impossible mission, certainly, but one in which the monstrous is neither the primary nor the only factor. We leave behind the familiar scenario of a victorious struggle against a malevolent being that is, more or less, a descendant of Typhon.

Nonetheless the violent forces of chaos remain ever present, in the background. This is certainly the case with the Amazons, those uncompromising warriors whose right breasts are removed in childhood so as not to compromise their subsequent mastery of the bow and the javelin. For his

labor involving the Amazons, it is not so much Eurystheus who imposes a new chore upon Heracles as his daughter Admete, who throws a tantrum: she absolutely must have the famously magnificent belt of Hippolyta, the Amazon queen. Now it so happens that this belt was given to Hippolyta by Ares himself, the god of war, so one might suppose it would prove difficult for Heracles to wrest it from its owner. However, against all expectations, when he arrives in embassy before the queen (after many adventures that I shall not repeat here), she quite willingly makes him a gift of the ornament. But Hera will have none of it. She now takes on the appearance of an Amazon—for the gods can metamorphose themselves at will—and spreads the rumor among the other Amazons that Heracles has come in enmity, to abduct their queen, which is of course quite false. Immediately a fierce battle breaks out between Heracles's followers and the Amazons, in the course of which Hippolyta is killed by Heracles.

As for the famous golden apples of the Hesperides—one of which, as you will recall, was thrown by Eris on the marriage table of Thetis and Peleus—here again we are dealing with a magical fruit, such as is not encountered in the natural order. These very particular apples are of gold, and grow as such on their tree, for good reason: the tree was the wedding gift offered by Gaia to Hera on the day of her marriage to Zeus. The queen of the gods thought them so beautiful that she planted the tree in a garden situated on the confines of the actual world, on Mount Atlas, the mountain that is also itself a god: the famous Titan named Atlas, brother of Epimetheus and of Prometheus, on whose shoulders the world rests. Hera is forever fearful that someone will come and steal her apples. She has therefore placed two sorts of guardian at the entrance to the garden. There are first of all three nymphs, called the Hesperides—"daughters of Hes-

peris," who is herself the daughter of Hesperus, the evening star. These divinities, moreover, have names that evoke the colors of sunset: Aegle ("dazzling light"), Erytheia ("the red one"), Arethusa ("of the setting sun"). . . . But as Hera was not quite certain of her nymphs, she added a second guardian: an immortal dragon who is, of course, yet another of the offspring of Typhon and Echidna, standing as ever in the path of Heracles. It is during this expedition in search of the golden apples that Heracles will liberate Prometheus from his chains by killing with his bow and arrow the famous eagle—likewise a son of Typhon and Echidna—that devours the liver of Prometheus.

Interestingly, it is not by force but through cunning that Heracles succeeds in stealing the apples of Hera—proof that he is well and truly the son of Zeus. Having been freed by Heracles, Prometheus is only too happy to show him what he has been seeking for more than a year: the exact location of the famous garden of the Hesperides. This is easily done since it is where Prometheus's brother Atlas resides. Prometheus advises Heracles not to steal the apples himself—this would be an unpardonable act of theft—but to send Atlas in his stead. When he encounters Atlas, Heracles therefore proposes a deal: he offers to hold the world on his shoulders, in place of Atlas, while the latter goes and fetches the apples. Atlas accepts, and by the time he returns he has begun to feel somewhat relieved of his burden, and is starting to realize how agreeable life would be without it and how tired he is of straining to keep heaven and earth apart for all eternity. Which is understandable. So he tells Heracles that, on reflection, he will go off and deliver the apples to Eurystheus himself. We should bear in mind that, during this time, Heracles has been bearing the weight of the heavenly vault on his shoulders, and must at all costs find a way of handing it back

to Atlas. Quite casually, and without attracting suspicion, he agrees to what Atlas proposes. He merely adds that, if Atlas will be so kind as to take back his burden for a moment, Heracles will grab hold of a small cushion to put behind his head so that he is more comfortable. Atlas is strong but also slow-witted: he falls into the trap and takes the world back on his shoulders, whereupon Heracles takes his leave and returns to Eurystheus with the apples, leaving poor Atlas to his unenviable lot.

The end of the story is quite revealing: when he holds the apples in his hand, Eurystheus scarcely glances at them but hands them straight back to Heracles, which proves—if proof were still needed—that the object of these exploits is to kill the hero straightforwardly, and that what Heracles reaps from his labors is of no intrinsic interest. Moreover, it is strictly forbidden for anyone to steal these apples, which must absolutely remain in their cosmic garden. Heracles now gives them to Athena, who puts them back as quickly as possible, so that the order of things is undisturbed. . . .

I have kept the story of the Augean stables until last (although Apollodorus places it as the fifth of the labors) because this exploit does not resemble the others. No monster is involved, no offspring of Typhon and Echidna, no other supernatural beings . . . and yet the struggle between order and disorder is no less omnipresent.

First, through the figure of Augeas himself, who is king of a region named Elis (in the western Peloponnese) and who also turns out to be a king of injustice as well as of disorder. He possesses immense herds of cattle given to him by his father: Helios, the sun god. But since taking over, Augeas has never bothered to clean out his stables. And they are now mired in scarcely imaginable squalor, which threatens to pollute the entire region. The manure is never carted

away, and is piled high over the neighboring lands, so as to render them barren. What we are dealing here with here is a major disorder, a natural catastrophe on a considerable scale. Heracles refrains from telling Augeas that he has been sent to clean up the mess. In effect, he wants to be paid for this labor, which he now understands has been imposed on him not—in this instance—so as to put an end to him (the hero's existence is not threatened, after all) but to humiliate him, to reduce him to the level of a slave who must dirty his hands in this mire. So Heracles wants to be paid—and he demands, according to Apollodorus, a tenth of Augeas's cattle if he manages to clean out all of the stables in a single day. To which Augeas agrees, not because he is a lover of cleanliness and would like to tidy up the region but because he takes Heracles for a fool and does not credit any of his promises. He is merely curious to see what will happen. Let us add here that, in addition to being paid, Heracles has no intention of getting his hands dirty. He is no slave but a demigod, the son of Zeus. Here again, cunning will be added to strength. Before setting to work, Heracles makes a large breach in the principal wall of the cattle yard containing the stables, and then a second breach in the opposing wall. Next, he digs a wide trench between two rivers flowing nearby, the Alpheus and the Peneus, and diverts the surging waters into the front of the stable yards and out the rear, flushing all the filth along with it. So within a few hours the stables are as clean as a new pin!

However, as I said, Augeas is not only a filth merchant but also a liar: when he discovers that Heracles has been sent by Eurystheus, he refuses to pay him, although the former has fulfilled his side of the bargain. And by way of justification he comes up with an elaborate argument: he claims that since Heracles was obliged to perform this labor in the

first place, he does not need to be paid for it. In effect, Augeas would not have paid even if Heracles had owned up to the origin of the chore as a labor imposed upon him. The argument is so specious that Augeas is obliged to lie to the tribunal that is now summoned in order to settle the dispute: he perjures himself, swearing that he promised Heracles no reward whatsoever. But he is out of luck: his own son, who had been witness to the deal, testifies against his father and comes to the defense of Heracles. A poor loser, Augeas does not wait for the sentence before ordering both his son and Heracles off his lands. For which he will in due course reap the whirlwind. Heracles never forgets, and the next time he encounters Augeas he kills him. For the present, Heracles can return victorious to his cousin, who must now renounce any further trials, since they have all proved useless, at least in terms of fulfilling their sinister purpose. . . .

The adventures that follow the twelve labors are innumerable. The accounts that have come down to us are so varied, and so contradictory, that it would be absurd to try to recount them as if they formed a linear story and a coherent biography of Heracles. It seems preferable to skip directly to what the majority of mythographers do agree upon: the third and last marriage of Heracles (to Dejanira), his last moments, and his apotheosis.

Death and resurrection: the "apotheosis" of Heracles

As far as the end of Heracles's life is concerned, the earliest and most detailed source is furnished by the tragedy of Sophocles titled *Trachiniae*, or *The Women of Trachis*, named after the city that brings together, with tragic consequences, Dejanira, the last wife of Heracles, and Iole, his last mistress.

Although very involved, the succession of events that leads to the appalling death of Heracles is more or less coherent—and the accounts of it given by later mythographers such as Diodorus, Apollodorus, or Hyginus remain largely consistent. If we keep to the central framework, it can be divided into six principal acts.

First act: under circumstances that we will leave to one side, Heracles meets Dejanira, in the village of Calydon. He falls in love and naturally wishes to marry her. But she has a suitor, a certain Achelous. The latter is both a god and a river, rather as Atlas is both mountain and Titan. Achelous possesses, moreover, a strange characteristic, no doubt deriving from his fluidity: he is able to metamorphose into different beings, each as difficult to combat as the other. Sometimes he retains his primary form, that of a river, but sometimes he transforms himself into a bull or a dragon. Heracles must combat all of these if he is to walk off with Dejanira. It is when Achelous assumes the form of a bull that Heracles snatches victory, by tearing off one of his horns. Achelous must recover it at all costs, so he declares himself beaten and asks Heracles please to return his horn. One of the numerous variants of the myth relates that, in exchange, Achelous gives Heracles the famous horn of the she-goat Amalthea, who nursed Zeus when he was an infant (concealed in the cave made by his grandmother, Gaia, to prevent his father, Cronus, from swallowing him). The horn of Amalthea is referred to as the "horn of plenty" because it has the magical property of providing its owner with everything he desires in the way of nourishment. . . . It is also worth recalling, in passing, that the impenetrable skin of this goat also served to make the aegis (from *aix*, "goat"), the famous shield of Athena. . . .

But let us return to our story. After his victory over Ache-

lous, Heracles remains for a while in Calydon with his new conquest, Dejanira, whom he plans to marry. Unfortunately, in the course of a dinner given by Oeneus, the king of this city, Heracles inadvertently kills—"without meaning to," as children say—one of the servants, who just happens to be related to the king. Decidedly, Heracles is too strong to remain in the world of mortals, where he is beginning to do more harm than good. We can already intuit, from this episode, that it is perhaps time for him to return to another world, a divine world, more adapted to his stature. Since the death was an accident, Heracles is pardoned by Oeneus. However, he is not exactly pleased with himself: he feels culpable and, with his stern sense of justice, decides to apply the harsh penalty of exile to himself. He therefore leaves Calydon, with Dejanira, and makes his way to a different city, Trachis, where he now plans to reside.

On the way—third act—he comes to a river, the Evenus, which he must cross. Here there is a ferryman, a centaur by the name of Nessus—half man, half horse—who makes travelers pay to cross the river on his makeshift craft. Heracles crosses the river on his own and entrusts Dejanira to the ferryman. The latter can think of nothing better than to try and rape her during the crossing. Dejanira starts to scream; Heracles hears her cries and takes out his bow and arrows. With a single arrow—their tips are poisoned, as you will recall, Heracles having dipped them in the venomous blood of the Lernaean hydra—he pierces the heart of Nessus. In his dying moments, Nessus, in the hope of avenging himself after his death, tells Dejanira a cock-and-bull story, managing to persuade her that by collecting some of his blood she can make a love potion that will bring back Heracles should he ever cease to love her. Dejanira believes Nessus: no doubt she thinks that nobody in the throes of death has any interest

in telling a lie. In which respect she will be proved quite wrong. . . .

Fourth act: Heracles and Dejanira finally reach Trachis, where the hero installs his wife in the palace of Ceyx, king of this city, who is both a friend and a relation (a nephew of Heracles's mortal father Amphitryon). Unable to stay still, Heracles immediately goes off in pursuit of new adventures, and in the course of various combats or wars he kills more evildoers and plunders a goodly number of cities. I will pass over the details. Let us merely add that in the course of one of these customary raids—at this epoch, all wars (not least the Trojan War) usually ended with the ritual sacking of the defeated city—he abducts the ravishing Iole, whom it seems he has decided to take as his mistress. He has her conducted to Trachis, along with other captives, where she will lodge in the palace of Ceyx—together with Dejanira. Heracles plans to return a little later. On his way home he intends to spend time on the heights of the Cenean promontory, to make sacrifices to Zeus. As he leaves, he conveys a message to Dejanira—through the messenger who is conducting Iole and the other captives—to send him a new cloak so that he can make the ritual sacrifices with clean garments, worthy of the act of purification he intends to accomplish.

As soon as she sees Iole, Dejanira recognizes the threat: this young woman is decidedly too beautiful. Sophocles, in the *Trachiniae*, describes the moment so that we see how, in a flash, Dejanira grasps that her husband is slipping away from her. Then she remembers Nessus and his love potion. She finds it and smears it carefully on the shirt the messenger must take to Heracles. Her hope is to bring him back, to make him fall in love with her again, as Nessus promised would happen. But it is a trap, of course: the potion is

indeed magical, but only in the sense of killing—in the most atrocious manner—whoever should wear it. Heracles puts on the shirt. As soon as it is warmed by contact with his body it starts to burn him. He tries, of course, to remove it, but it sticks horribly to his skin. When it is taken off, strips of charred flesh come off with the fabric. The pain is dreadful, and there is no way of saving whoever is caught in its web. An oracle had, moreover, warned Heracles that he would only die at the hands of someone who is already dead, and he now understands that this someone is none other than Nessus, the centaur whom he killed with his poisoned arrow.

So Heracles now begs one of his sons to make a massive funeral pyre for him so that he may die through the purificatory fire. His horrified son refuses, but a servant accepts the command, in exchange for which Heracles gives him his bow and arrows. He mounts the pyre. The servant lights the brazier . . . and thus does Heracles end his career on earth. He must die, like all mortals, but his story does not end here. According to Apollodorus, who expresses the view most widely held by the various mythographers, a cloud descends from the sky, drapes itself delicately around the burning body of Heracles, and carries him up slowly to the heavens. Here, on Olympus, he will be transformed into a god. And here, too, Hera will forgive him, finally, and their reconciliation will take place. His apotheosis—*apo-théos*: transformation into a god—is the reward for his ceaseless struggle, in effect divinely inspired, against the forces of chaos.

II. Theseus—or how to continue the work of Heracles in the struggle against the surviving forces of chaos

Theseus is a cousin, an admirer of, and a successor to Heracles. He, too, is a fabulous slayer of monsters. Moreover, his early exploits are explicitly presented by the majority of mythographers as a direct continuation of the labors of Heracles, when the latter is briefly indisposed due to his condemnation to slavery by the queen Omphale. . . . We might say that, in a manner comparable to Heracles in the Peloponnese and the region of Argos, known as Argolis, Theseus is the greatest hero of all time in what is referred to as Attica, in other words the region around Athens. Theseus, like Heracles, is exclusively a figure of legend: he never existed. However, as with Heracles, we know of his adventures through "biographies" that depict and relate his life as if he were an actual historical personage* who lived a generation before the Trojan War—which is supposedly proven by the fact that two of his sons were said to have taken part in that conflict. Theseus would therefore be a contemporary of Heracles, albeit younger, and according to several legends they even had occasion to meet each other. Unfortunately—or perhaps fortunately: the contradictions are part of the charm and interest of these myths—these

*The earliest account, at least among those that have come down to us, is that of the Greek poet Bacchylides (fifth century BC), which was happily rediscovered in the nineteenth century, when the British Museum made the chance acquisition of two rolls of papyrus containing twenty or so poems in a state of perfect preservation. Among these were what are termed "dithyrambs," namely odes dedicated to the glory of the god Dionysus, which were sung in the great open-air amphitheaters during the poetry competitions to which the Greeks of this epoch were devoted. Among these recovered dithyrambs is a narrative relating five of the earliest exploits of Theseus. As far as the rest of his career is concerned, we must rely once more on Apollodorus, as well as the accounts found in two other authors: Plutarch (first century AD) and Diodorus Siculus (first century BC).

legendary biographies diverge freely, and the divergences begin with the birth of Theseus.

According to some accounts, notably that of Plutarch—who, albeit late, is the single most important source on our hero—Theseus is the son of Aethra, a princess and daughter of Pittheus, king of Troezen. His father is Aegeus, king of Athens and ruler of the whole of Attica. Theseus is therefore of high birth. According to this version, it is said that Aegeus failed to have children with any of his various wives, so he decided to make the voyage to Delphi to consult the Pythian priestess, famous oracle of Apollo. Her words, sibylline as ever (in other words, more or less incomprehensible), were that he should not open his wineskin before returning home to Athens. Here, according to Plutarch, are her exact words:

> *"Loose not the wine-skin's foot, great prince,*
> *Until to Athens thou art come again."*

I will take advantage of this moment to say a few words about "sibylline words" and the original meaning of the term "sibylline." Sibyl was quite simply one of the Pythian priestesses, charged with delivering the oracles of Apollo. As she was held in great esteem, it was decided after her death to transform her name into a common noun, and to refer to any oracular priestess who succeeded her at Delphi or elsewhere as "a sibyl." Now these oracles all shared one characteristic: they always spoke equivocally, in an ambiguous manner, whose meaning was never immediately apparent but on the contrary difficult for mortals to interpret. Whence the use of "sibylline" to designate all utterance that is unclear or ambiguous.

Aegeus, understanding little of what is uttered by the Pythian priestess, decides on his way home to visit his friend

Pittheus, king of Troezen, to ask his counsel. This latter has no trouble in interpreting the words of the oracle, namely that he must get Aegeus drunk and put his daughter Aethra in his bed if Aegeus is to produce a child. This behavior, especially on the part of a father, must seem bizarre: we have difficulty imagining a parent deliberately getting his guest drunk so that he will sleep with the daughter of the house. We would sooner take steps to prevent such a scenario! But at the epoch in question, such matters were regarded rather differently: in the eyes of Pittheus, his compatriot the king of Athens was an excellent catch for his daughter. A child by Aegeus would be an honor for the family and would offer the chance, if not the certainty, of having a grandchild out of the ordinary. It is by such means, at any rate, that Theseus first sees the light of day. According to other sources (Bacchylides and, so it seems, Apollodorus), while Theseus was certainly the child of Aethra—the mother is never in doubt in such cases—the real father was not Aegeus but Poseidon himself, who slipped into Aethra's bed the same night as Aegeus did! An even higher birth for Theseus since the father is in this case a deity.

Whichever the case, it matters little. What is certain is that Theseus is from the start cut out to be a hero, if we are to judge by his prestigious antecedents—as did the aristocratic society of the time. However, for the whole of his childhood, he remains ignorant as to his father. In effect, his mother refuses to reveal to him his true identity. In any case, when a god sleeps with a mortal, her husband (or consort) is generally persuaded not to take offense. He must raise or arrange for the child to be raised as if it were his own. Aegeus, the morning after this night during which he gets drunk and sleeps with Aethra, tells himself that if ever he should have a son, if would be good that, when he is old enough, he should

be able to know his father. To this end, he hides a sword and a pair of sandals beneath a great rock—almost impossible to move—and before returning to Athens, he tells the young princess that if by chance she has a son by him, she should wait until he is old enough to reveal to him this hiding place and the true identity of his father. Then, and only then, will he be strong enough to remove the rock and find the gifts left for him, at which point he should be sent to Athens with these tokens to present himself to his father. In the meantime Aethra and Pittheus raise little Theseus with the greatest of care.

You will perhaps be wondering why Aegeus does not prefer to bring Aethra and his future son with him. Is he a bad father, who cares nothing for the child he engenders on his travels? Not in the least. The truth is quite other, and we must not judge by appearances. In effect, Aegeus desires only one thing in this life, which, moreover, is why he made the journey to Delphi to consult the oracle: namely, to have a son. But he wants this son to reach man's estate before making himself known and being acknowledged in turn; otherwise he will risk being killed by his cousins, the sons of Pallas, the brother of Aegeus. The reason for this is immediately clear: everyone in Athens knows that Acgeus is childless. In view of this, his nephews (the sons of Pallas) confidently tell themselves that it is they who will inherit the throne of Athens. And you may be sure that, if they happen to learn that Aegeus has a son, they will undoubtedly try to get rid of him to prevent his depriving them of what they now regard as rightfully theirs, namely the succession to the throne. And as there are no less than fifty of them and they are quite unscrupulous, the child will have no chance of surviving. This is why Aegeus instructs Aethra to keep silent, and to refrain from revealing to Theseus his origins

until he is grown-up and strong enough to remove the rock, and likewise to wield the sword that is hidden beneath it.

Theseus grows rapidly . . . and sturdily. By the time he is sixteen he is as strong as an adult, and stronger than all the men of the region. He has the strength of Heracles, in effect, and is described as having modeled himself on Heracles from childhood, to whom, moreover, he is distantly related. Aethra decides it is time to reveal to him the double secret that she has been keeping for so long: firstly, that his father (or at any rate the father who counts most for him on this earth, his mortal father) is Aegeus, king of Athens; secondly, that he has left something for his son, hidden beneath a heavy rock—to which she now leads Theseus, to see if he is yet strong enough to displace it. As you may imagine, it takes Theseus mere seconds to get the better of this rock, which he removes as if it weighs nothing. He seizes the sword, puts on the sandals, and tells his mother that he is setting off immediately to find his father in Athens. Here again, you may well ask what is the point of these wretched sandals: we can all understand why a father would leave a fine weapon for his son, both to arm himself and as symbol of his rite of passage into adulthood. But why leave an object as banal and without significance as a pair of sandals, when clearly his mother and grandfather will already have furnished him with whatever he needs in the way of footwear? But the sandals have a precise significance: they indicate that Theseus must make the voyage from his birthplace Troezen to Athens on foot and not by boat. And why should this be so important an element in the myth?

Because, as you will remember, the life of Theseus is more than ever menaced by the wicked sons of Pallas, who would inevitably usurp him. Aethra and Pittheus are, moreover, extremely anxious on his behalf. They exhort him at all costs

to avoid traveling to Athens by foot: it is far too dangerous. Not only is it menaced by the sons of Pallas, but the region is also infested with brigands, and even by actual monsters, since Heracles is at this point reduced to slavery and cannot acquit himself properly in his role of monster-slayer. The monsters that haunt the road to Athens are more violent and merciless than mere bandits—demoniacal creatures that it would be unwise for an inexperienced young man to try to confront. Such at least is the voice of wisdom, or of prudence. On the other hand, there are the sandals, indisputably, which his father must have left for him for good reason. If Aegeus has hidden the sandals, it is so that Theseus will use them; it is therefore clear that he must go to Athens on foot, and if monsters block his way they will meet their match, since Theseus is by now almost as strong as Heracles and endowed with a formidable sword.

Considered more symbolically, what is involved is an initiatory voyage, in the course of which Theseus will discover his true vocation: that of a hero, exceptional not merely by his strength and courage but also by his capacity to rid the world, even the cosmos, of the intolerable disorder created by monstrous forces. There are two possible outcomes: either Theseus will fail, or he will succeed. If he fails, it will be because he was not cut out after all to be a hero. If he succeeds, he will become, like his cousin Heracles, one of the great successors to the work undertaken by Zeus when he overwhelmed the Titans and triumphed over Typhon: a man, certainly, but a man-god by virtue of his contribution—after the manner of a god—to the harmonizing of the universe and the victory of the cosmos against the forces of chaos.

As to the forces of chaos, Theseus will certainly encounter more than his fair share of these. During the course of his journey to Athens, he will cross the path of six living

abominations—beings that, moreover, terrorize the entire isthmus of Corinth. As in the labors of Heracles, nearly all of these monsters have a redoubtable or bizarre ancestry, and all of them are possessed of characteristics beyond our common understanding. They are all dangerous and fearful to a degree.

We begin with Periphetes, who according to Apollodorus (whom I generally follow here)* is the first to be encountered by young Theseus, on the outskirts of Epidaurus. Periphetes is truly an unpleasant piece of work. Said to be the son of Hephaestus, the lame god and the only Olympian without beauty, he has short crooked legs like his father. As these are also enfeebled, Periphetes always pretends to be leaning on a staff—in effect an iron club or bludgeon—so that travelers will feel pity and approach him to offer help. As does Theseus, politely. In return for which, by way of thanks, the hideous Periphetes raises his massive bludgeon to kill Theseus. But the latter is quicker and defter, and runs him through with his sword. Then Theseus takes possession of the bludgeon, from which it is said that he will never again be parted. . . .

Second act: Theseus continues on his way and encounters the contemptible bandit Sinis, also known as Pityokamptes—in Greek, "bender of pines," for reasons that will become clear. Sinis is a giant of unimaginable strength, in the proper sense inhuman—out of all human proportion—which is in itself a sign of monstrosity. According to Apollodorus, he is the son of a certain Polypemon, but it was sometimes claimed—no doubt so as to explain his monstrosity and strength—that he is of divine ancestry, as a son of Poseidon. In order to understand the atrocious little game played by Sinis, we must

*This episode is the only one of the six that does not figure in the dithyramb of Bacchylides.

refer back to archaic iconography, to the painted images, notably on vases, that depict the scene and which are often more explicit than written texts. Sinis hijacks travelers who have the misfortune to pass within range. He asks them to help him bend two neighboring pine trees that grow close together. At the point where the tops of the trees are held farthest back, Sinis attaches his victim's legs and arms to each of the two treetops and then lets go so that the traveler is literally torn apart when the trees are released and revert violently to their upright positions. At which Sinis sniggers, this being his favorite pastime. Until the day that Theseus crosses his path. Our hero pretends to enter into the game, but instead of letting himself be attached, he ties the feet of the monster to the two trees, so that when they straighten it is Sinis who is torn in half, suffering the same fate that he gleefully inflicted on so many others.

Third act, and even worse: the wild boar of Crommyon, or rather the wild sow, for it surely concerns a female boar. This sow is quite out of the ordinary and has nothing in common with others of her breed, past or present. She is the daughter of Typhon and Echidna, herself the daughter of Tartarus and mother of (among others) Cerberus, the hound of hell. Echidna is a monster with the face of a woman, whose body ends not with legs but with a serpent's tail . . . so, as you can see, the monstrosity of this boar runs in the family. And murder is likewise her pastime: she terrorizes the region, killing whoever comes within range . . . until Theseus rids the earth of her with his sword strokes.

Theseus encounters the fourth monster outside the city of Megara. This one wears a human face: he is named Sciron, and once again, divine ancestry is sometimes claimed for him, some sources even suggesting that he is (another) son of Poseidon. Others insist that he is the son of Pelops,

himself the offspring of the celebrated Tantalus, who was condemned to an eternity of hunger in the underworld. Whatever the case, this is clearly an inhuman figure who has staked out his territory along the high coast road that follows the sea, near a promontory aptly called the "cliffs of Sciron." Here he patiently waits for travelers and compels them to wash his feet. He always carries his basin in hand, but when the unfortunate travelers bow down to carry out the chore inflicted upon them, Sciron hurls them into the deep, where they become the prey of a huge sea turtle, itself monstrous, and are devoured alive. . . . Again, Theseus has the measure of all this. On certain vase images, he is depicted as seizing the basin of Sciron, banging him on the head with it, and dispatching him to join his turtle in the waters below.

Theseus resumes his perilous path. As is to be expected, he comes upon another veritable pestilence. This time the encounter occurs outside Eleusis, the city of Demeter and her mysteries. A strange figure blocks Theseus's way—a certain Cercyon, who once again is not quite human, said to be yet another son of Poseidon or perhaps of Hephaestus, like the dreadful Periphetes. Whatever the case, he is endowed with superhuman strength and his pastime is to do evil for evil's sake. He stops travelers and compels them to wrestle with him. And because of his divine origins and his strength, he wins every time, after which he kills his adversary. When he stops Theseus he is certain of the outcome, pitted against a youth of sixteen years. He will make short work of him. Except that Theseus is an uncommon youth, and quick as a panther. He seizes Cercyon by his leg and arm, lifts him up on high, and dashes him to the ground with all his strength. The monster has met his match: he falls with a force to match his size . . . and dies instantly.

As in all good stories, the worst is kept for the end. Namely,

the encounter with a certain Procrustes (whose other names are Damastes or Polypemon)—a word that in this context signifies "one who hammers." Here again, some accounts endow him with a nonhuman origin: Hyginus, notably, makes Procrustes a son of Poseidon—to whom, as we have seen, a host of unsavory offspring are attributed. Procrustes possesses two guest beds, one short and the other long, in his house, situated along this same road leading from Troezen to Athens. Politely, and with a casual air, Procrustes offers his hospitality to passersby who come within range. But he always takes care to offer the long bed to those who are short, and the short bed to those who are tall, so that the first are all at sea, whereas the second stick out at both ends. As soon as they are asleep, their dreadful host attaches them firmly . . . and proceeds to top and tail those who are too long, while hammering the limbs of those who are too short until the victims are stretched to match the dimensions of the bed. Here again, Theseus is not fooled. He has anticipated the maneuvers of his host, whom he has distrusted from the outset. Grabbing hold of him, Theseus subjects him to the torture ordinarily reserved for his victims. . . .

When he finally arrives in Athens, safe and sound, Theseus is already preceded by a considerable reputation as a slayer of monsters. Everyone acclaims him, showing profound gratitude for his having cleared the route of these demoniacal beings dedicated to gratuitous evildoing, and whom nobody has hitherto been able to confront. Only Heracles can be compared to this new hero. Theseus now goes to find his father, Aegeus, king of Athens. But two obstacles still stand in his path. There are firstly the sons of Pallas, his first cousins and sons of his uncle, who want to kill him so as to prevent him from inheriting the throne in their place. Secondly, and possibly even more to be feared, there is the enchantress

Medea, who has become the wife of Aegeus. Medea, despite her personal charms—which include her absolute beauty—is a terrifying being. For one thing she is the niece of another necromancer, Circe, who transformed the companions of Odysseus into pigs. But she is also the daughter of Aietes, king of Colchis, possessor of the Golden Fleece, which has been claimed by Jason, of whom we shall hear more later. In this other myth, Medea has killed her own brother without hesitation and cut him into pieces, to help her lover Jason to flee from Colchis with the fleece, which gives some idea of who Medea is and what she is capable of. Moreover, on the day that Jason ends by abandoning her, after she has borne him two children, she will stab them to death purely to avenge her rage against him.

She knows, of course, that Theseus is the son of Aegeus, and she is aware that with all his heroic attributes he is bound to make trouble for her. So she starts putting ideas into Aegeus's head. She explains to him that this Theseus is dangerous, that they must rid themselves of him. We should remember that, at this point, Aegeus has no idea yet that Theseus is his son: he knows of him only through his reputation as a slayer of bandits and monsters. Like most husbands, he allows himself to be persuaded by his wife and, according to Apollodorus, tries initially to get rid of the hero by sending him off to confront a dreadful bull, the man-killing bull of Marathon, who is sowing terror throughout that city. Of course, Theseus returns victorious after having annihilated the beast. On the advice of Medea, Aegeus now tries to poison Theseus, still unaware that the latter is his son. The enchantress has prepared poisoned wine, one of her specialties. Aegeus gives a feast in his palace, to which he invites Theseus. He hands him a cup of poison, but just when Theseus takes it and raises it to his lips, Aegeus notices that Theseus

is wearing the royal sword at his side, the same that Aegeus himself had placed under the rock as a token of recognition. He looks down at the young man's feet and also recognizes the sandals. With the back of his hand he sweeps away the poisoned cup, and the vile liquid spills onto the ground. He embraces his son, with tears in his eyes. Theseus is saved, and Aegeus immediately has the dreadful Medea chased out of his kingdom. As for the sons of Pallas, let us merely add that, at the appointed time, after his father's death, Theseus will have no trouble in exterminating them, one by one, to the very last of the fifty, so that the way is finally clear for him to become the new king of Athens.

But even here we are not quite done. There is one more trial, the most terrible of all, that awaits Theseus on the path of his accession to the throne. He must encounter a monster compared to which all that has gone before is as child's play: namely the Minotaur, half man, half bull, which King Minos has confined in the Labyrinth specially constructed for this purpose by the most famous architect of the epoch, Daedalus. And in this case the outcome is far from guaranteed in advance: no one has ever triumphed over the monster who lurks in the celebrated Labyrinth, just as no one who has entered this evil garden has ever found his way out.

To understand what ensues, we must return to the origins and the unusual story of this creature.

Theseus confronts the Minotaur in the Labyrinth constructed by Daedalus

The myth of the bull goes far back in time. Let us begin with the figure of Minos. This king of Crete is hardly a sympathetic character. He is said to be one of the numerous sons of Zeus, engendered when Zeus transformed himself—

into a bull, no less—so as to abduct Europa, a beautiful young girl with whom he had fallen in love. I will note in passing, to indicate the interweaving of these stories, that Europa is the sister of Cadmus, who, as we have seen, helped Zeus to vanquish Typhon and to whom the ruler of the gods had given the hand of Harmonia in marriage, one of the daughters of Aphrodite and Ares.

But to return to our story. In order to seduce Europa without being seen by his wife, Hera, Zeus has assumed the appearance of a magnificent bull, a creature of immaculate whiteness and endowed with horns like a crescent moon. Even when disguised as an animal, Zeus remains magnificent. Europa meanwhile is playing on the beach with a group of other young girls. She is the only one, it is said, who does not run away from this apparition. The bull approaches her. She is frightened, of course, but the creature seems so gentle, so lacking in ferocity—and we may well imagine Zeus doing everything in his power to make himself agreeable—that she begins to stroke it. He makes cow eyes at her. He kneels before her, as cute as can be. She cannot resist. She climbs on his back . . . and in an instant he gets up and carries her off at top speed toward the waves, and across to Crete, where he assumes human form and in short order gives the lovely creature three children: Minos, Sarpedon, and Rhadamanthus.

The one who interests us here is Minos. According to Apollodorus—whom I follow once more for the essentials of the story—Minos is responsible for writing the laws for Crete, the land of his birth and over which he wishes to become king. He marries a young woman, Pasiphae, also of high birth since she is said to be one of the daughters of Helios, god of the sun. He has several children by her, and two of their daughters will also become celebrated,

Ariadne and Phaedra—of whom we shall have occasion to speak later on. On the death of the king of Crete, who is without issue, Minos decides to take his vacant place and claims to all who will listen to him that he has the support of the gods. The proof? The people have only to ask, and Minos will request Poseidon to send down an offering, as a sign of his legitimacy: a magnificent bull floating upon the waves of the sea. In effect, to obtain the favors of the god of the sea, Minos has already sacrificed several animals, and above all has promised that if ever Poseidon accedes to Minos's request—namely, on the day in question, to send an enormous bull out of the sea—Minos will immediately sacrifice the animal to him. As we know, the gods love nothing more than sacrifices. They adore the worship of mortals, the cults and the honors, but also the delicious odors wafting upward from the succulent legs of a bull roasting over the charcoals. . . . So Poseidon does as Minos requests, and before the astounded eyes of the people of Crete, gathered for the occasion, a magnificent bull slowly rises out of the waves!

No sooner is the miracle accomplished than Minos is elected king. The people can refuse nothing to one who is manifestly in such favor with the gods. However, as I have already suggested, Minos is not exactly what we would call a nice guy. Among other faults, he does not keep his word. And he now finds Poseidon's bull so beautiful and so powerfully built that he makes up his mind to keep it as a breeder for his own herds instead of sacrificing it to the god as promised—a grave error of judgment, and one that clearly verges on hubris. No one makes a mockery of Poseidon: the god is incensed to a rare degree and decides to punish this brazen mortal.

Here is how Apollodorus describes what happens next:

Angry at him for not sacrificing the bull, Poseidon turned the animal savage, and contrived that Pasiphae [*wife of Minos*] should conceive a passion for it. Becoming infatuated with the bull, she enlisted the help of Daedalus, an architect who had been exiled from Athens for murder. The latter constructed a wooden cow, mounted it on wheels, hollowed it out on the inside, sewed around it the hide from a cow which he had earlier skinned, and placing in the meadow where the bull habitually grazed, he made Pasiphae climb inside. The bull came up to it and had intercourse with it, as if it were a genuine cow. As a result, Pasiphae gave birth to Asterius, who was called the Minotaur. He had the face of a bull, but the rest of his body was human; and Minos, in compliance with certain oracles, enclosed him and guarded him in the Labyrinth. This Labyrinth, which Daedalus constructed, was a chamber from whose tangled windings none could ever find their way out.

Let us dwell for a moment on this passage.

First of all, the vengeance of Poseidon. Let us agree that it is fairly twisted. He decides, quite simply, to make a cuckold of Minos, and not just by any means but by the very bull that Minos should have sacrificed to Poseidon! As always, the punishment fits the crime: Minos has cheated the god with a bull; he will in turn be cheated by a bull. Poseidon casts a spell on Minos's wife, Pasiphae, so that she falls in love with the bull and gives birth to the Minotaur—literally, "the bull of Minos," who despite the name is anything but the father. . . .

Let us now turn to the role of this strange and inspired individual, Daedalus. Apollodorus tells us in passing that Daedalus was exiled from Athens for a crime. What crime? The answer reveals him to be another fairly unsympathetic type, albeit of matchless intelligence. Daedalus is not merely an architect but what we could call today an "inventor." He

is part crackpot, part Leonardo da Vinci. You can present him with any problem and he will find the solution: ask him to invent any machine, and he will come up with an instant prototype. Nothing is too complex for him, and he is diabolically ingenious. However, he has many faults. In particular, he is jealous. He cannot bear the thought of anyone else being more intelligent. He has his workshop in Athens, and one day he takes on an apprentice, his young nephew Talus—according to Diodorus Siculus, who describes the episode in detail (Apollodorus merely alludes to it). As it happens, this Talus is very gifted. Incredibly talented, in fact, and even risks outmastering his master when he invents, quite by himself and unaided, the potter's wheel—that wonderfully useful mechanism on which vases, bowls, plates, jars, and so forth are fashioned from clay. And likewise, for good measure, he invents the metal saw. . . . Daedalus is mortally envious, which in turn makes him nasty, to the point that, in a sudden access of hatred, he kills his nephew (according to Apollodorus, by hurling him from the top of the Acropolis, one of the highest points in Athens). Daedalus is convoked by a famous council named the Areopagus, because in earlier times it had tried Ares, god of war, for murder. This prestigious assembly finds Daedalus guilty and condemns him to exile.

To us, today, this sentence may seem lightweight: merely to be exiled from one's city for such an abominable crime seems like a meager punishment. But at the time it was considered to be worse even than the death penalty—and this is consistent with the Greek worldview that emerges from everything I have been saying about these myths since the outset. If the good life—witness the story of Odysseus—consists in living in accord with one's "natural place" in the scheme of things instituted by Zeus, then to be banished

from this place is indeed to be condemned in perpetuity to an existence of misery. The proof once again is Odysseus— who rejects Calypso's offer of a gilded exile when, in order to keep him by her side, she proposes immortal youth. . . .

Daedalus is therefore banished from Athens and knows for certain that henceforth he is one of the damned, doomed forever to the prison of nostalgia. He leaves for Crete, where, among his kind, he goes back to work, in the service of Minos, who has welcomed him into his house. And, as we have seen, he does not hesitate to undermine his new master by constructing the wooden cow in which Pasiphae hides in order to couple with Poseidon's bull. And, as we shall see in a moment, Daedalus will trick Minos again by helping Theseus to find a way out of the Labyrinth that he himself conceived and executed to contain the Minotaur. But let us not get ahead of ourselves. For the moment, we know simply that Minos has been cruelly cuckolded by Poseidon by proxy. And he has plenty of other worries. One of his sons, Androgeus, has gone to Athens to take part in a great festival named the Panathenaea: a competition rather like the Olympic Games, in which young people from different regions were invited to pit themselves against one another in various events: javelin, discus throwing, racing, horse racing, wrestling, etc. In the course of which, for one reason or another—variously explained—Androgeus is killed. According to Diodorus, Aegeus has him killed because he has befriended the sons of Pallas and therefore represents a menace. Apollodorus tells us that Aegeus sends Androgeus to fight the bull of Marathon, and he is killed in the attempt. What is clear is that the son of Minos meets his death while staying in Athens, and the father holds Aegeus responsible, rightly or wrongly. Minos consequently declares war on Athens, and there follows, according to Diodorus (Apollodorus is silent on this point), a

period of drought that threatens the very existence of Athens. Aegeus solicits Apollo for guidance, and the god replies that, to break the deadlock, Athens must submit to the conditions imposed by Minos.

As I have said already, Minos is not an especially sympathetic figure. In return for calling off the siege of Athens, he demands to be sent a yearly tribute of seven young men and seven young women, to be introduced into the Labyrinth, where they are devoured by the Minotaur. These unfortunates do everything in their power to escape the clutches of the monster, but it is impossible to find any way out of his lair, and one by one they are massacred. In some sources, Theseus is drawn by lot to be one of the next consignment of victims. But according to the majority of versions, with his usual courage he naturally offers himself as a volunteer. Whatever the case, Theseus finds himself embarked on a boat bringing fourteen youths to Crete, where a terrifying fate awaits them. The sources are unanimous as to what ensues. Here is one of the oldest accounts, that of Pherecydes (mid-sixth century BC, and the main source for most subsequent accounts), which serves as the matrix for the majority of mythographers:

> And when he came to Crete, Ariadne, daughter of Minos, being amorously disposed towards him, gave Theseus a clue [*a ball of thread*], which she had received from Daedalus, the architect, and told him to fasten one end to the bolt of the door, on entering, letting it trail behind him as he proceeded, until it was played out. And that when he discovered the sleeping Minotaur in the innermost part of the Labyrinth and killed him, to sacrifice to Poseidon the hairs of its head, then to make his way back again by rewinding the thread. . . . After killing the Minotaur, Theseus embarked with Ariadne and likewise the young men and women, who had yet to be handed over to the Minotaur. After which, he sailed out

unobserved under cover of night. He put in at the island of Naxos, disembarked and slept on the beach. Athena appeared before him and commanded him to leave Ariadne and set sail for Athens. There and then he got up and complied. Then Aphrodite appeared before the inconsolable Ariadne, exhorting her to take courage: she would be the wife of Dionysus and become celebrated. Then the god himself appeared before her and gave her a crown of gold, which subsequently the gods changed into a constellation to please Dionysus.

Here again, a few words of commentary.

Firstly, once again, as with Pasiphae, Daedalus does not hesitate in betraying Minos, who is nevertheless his king and protector. As soon as Ariadne asks for the means of helping Theseus, with whom she has fallen in love at first sight, Daedalus has no scruple in providing her with a stratagem for bailing out her lover: by means of the ball of thread, Theseus can retrace his steps and thereby become the first mortal ever to find a way out of the cursed Labyrinth (whence the expression "Ariadne's thread," still used to designate the main theme of a complicated story). In exchange for this service rendered, Theseus promises Ariadne that if he manages to kill the Minotaur, he will take her away with him and marry her. Theseus succeeds, of course. He enters the Labyrinth and beats the Minotaur to death with his bare fists.

You will note, too, that, contrary to other mythographers, who suggest that Theseus "forgot" Ariadne on the island where they disembark, Pherecydes (followed by Apollodorus) tells us that nothing of the sort took place. Theseus is not an ungrateful hero by nature. He is even in love with Ariadne. But he simply obeys the command of Athena and defers to a god whom it would be pointless to try and resist: namely Dionysus. I prefer this version of the tale, for it tallies

more closely with what we know of Theseus: a courageous and loyal figure, who obeys the gods and who it is hard to imagine conducting himself so churlishly toward a woman who has just saved his life. It is with a heavy heart, therefore, deprived of her in whom he already saw his future wife, that he returns to Athens.

This also explains the subsequent drama leading to the death of his father. In effect, as he was leaving Athens for Crete, to combat the Minotaur, Theseus took his place in a boat that displayed black sails. Before he leaves, Aegeus gives his son a set of white sails, with a plea: that if he comes back alive, having triumphed over the monster, on no account to forget to take down the black sails and hoist white sails in their place. By which means his old father will be reassured, from a distance, and at the earliest possible opportunity: the lookout, who continually watches for approaching ships, will inform him that the sails are white, that his son is saved. But Theseus, heavyhearted at the loss of Ariadne, quite forgets to change the sails. Aegeus, in despair, hurls himself from the high rock that overlooks the port, into what is forever after called the Aegean Sea. . . .

The death of Minos and the myth of Icarus, son of Daedalus

A few final words about Daedalus and Minos before we return to the further adventures of Theseus. Firstly, concerning Daedalus: on learning of the death of the Minotaur and the flight of the young Athenians, and realizing, moreover, that his daughter Ariadne has also vanished, Minos is enraged and wants to avenge himself at whatever cost. He is left in no doubt: only Daedalus could have helped Ariadne and Theseus to discover a way out of the Labyrinth; only

Daedalus is clever enough to have devised a means of escape for them. No longer able to hand his architect over to the Minotaur, he nonetheless incarcerates Daedalus and his son Icarus in the Labyrinth, swearing never to release them from this dreadful confinement. But he is not counting on the genius of Daedalus, which knows no obstacles. One might think that, having created this convoluted garden, Daedalus must be able to find his own way out of it. Not so. Without his blueprint, Daedalus has as little idea as anyone else of where to begin. He must come up with another of those solutions for which he is renowned. So of course our inventor devises a contraption. With wax and feathers, he constructs two magnificent pairs of wings, a pair for himself and a pair for his son. Father and son take to the skies, floating serenely free of their prison.

Before taking off, Daedalus lectures his son carefully: above all, he says, do not fly too close to the sun, or the wax will melt and your wings will come unstuck; and do not fly too close to the sea, or the humidity will unseal the feathers from the wax and you also risk falling out of the sky. Icarus says yes to his father, but once he is up in the sky he loses all sense of proportion. In other words, he gives in to hubris. Carried away (in every sense) by his new powers, he takes himself for a bird, perhaps even for a god. He forgets his father's warnings. He cannot resist climbing the skies, as high as he can reach. But the sun is shining powerfully and the wax holding Icarus's wings together begins to melt. Suddenly they fall off and drop into the sea—followed promptly by Icarus, who drowns beneath the gaze of his father, who can do nothing except grieve the death of his child. Since then—as with the Aegean—this sea is named after the fallen one: the Icarian Sea.

On learning of the escape of Daedalus, Minos is once

again furious, all patience at an end. He will do everything in his power to find the man who has so repeatedly and so conscientiously betrayed him: who has been responsible for the infidelity of his wife, for the flight of his daughter, for the death of his monster. Daedalus, meanwhile, has escaped unharmed and taken refuge in Sicily, at Camicos. Minos pursues him wherever he goes, determined to do so as far as the confines of the world if necessary. In order to flush out the traitor, Minos has devised an invention of his own: wherever he goes he brings with him a small seashell, a convoluted spiral, and he publicly offers a large sum of money to whoever can pass a thread through the interior of what is in effect a miniature Labyrinth. Minos is convinced that Daedalus alone is clever enough to find the solution, and equally convinced that, vain as he is, the inventor will not be able to resist coming forward, to demonstrate how he can solve any enigma.

That is indeed what happens. In Sicily, Daedalus is lodging with a certain Cocalus. One day Minos visits this house, by chance, and shows the host his little puzzle. Cocalus is quite sure that he can come up with the solution. He asks Minos to come back the next day, and in the interval, he of course asks his friend Daedalus to solve it for him—which Daedalus does not fail to do. He catches a little ant, attaches a thread to one of its legs, then releases the ant into the shell, after piercing a hole in the crown. The ant soon leaves the shell via the hole, pulling the thread behind itself. When Cocalus brings him the solution, Minos is in no doubt: Daedalus must be living here. He instantly demands that the latter be handed over for punishment. Cocalus gives the appearance of complying and invites Minos to dine. But before dinner he proposes a nice bath for the guest . . . which has been filled with scalding hot water by his daughters. An atrocious death for a singularly

unsympathetic figure. Legend has it that Minos subsequently became one of the judges of the dead, alongside his brother Rhadamanthus, in the kingdom of Hades. . . .

Later adventures: Hippolyta, Phaedra, and the death of Theseus

After the death of his father, Theseus becomes the new king of Athens. As we have seen, he disposes of the sons of Pallas, and with no further obstacles to overcome or monsters to subdue, he exercises his power with unexampled justice. He even comes to be regarded as one of the principal founders of Athenian democracy, one of the first to occupy himself with the weakest and the poorest in society. But let us be clear: it is almost impossible to relate his final adventures coherently, given the profusion of anecdotes and the divergence of sources. If we follow the life of Theseus as narrated by Plutarch, our hero engages in another war, against the Amazons, in which he combats these celebrated warriors alongside Heracles. He then engages in a further war, against the centaurs, this time alongside his closest friend, Pirithous, after which (like Odysseus) he descends to the underworld to try and carry off Persephone—an attempt that apparently ends in bitter defeat. He then carries out another abduction, of the beautiful Helen, then aged only twelve, and goes on to experience further adventures still. . . .

But in the course of this extraordinary life there is one further episode that merits our particular attention: the marriage of Theseus to Phaedra and his quarrel with Hippolyta.

During the war against the Amazons, the victorious Theseus carries off their queen, or at least one of their leaders, whom he brings back to Athens. They have a son, Hippolytus, whom he loves devotedly. A little later, however, he marries

Phaedra, sister of Ariadne and one of the daughters of Minos.
It is a love match, but also a token of reconciliation with
the family of his old adversary, long since removed from
the scene. Theseus loves Phaedra, but the latter, although
she reveres her husband and has strong feelings for him,
nevertheless falls passionately in love with . . . Hippolytus,
his son. Hippolytus refuses the advances of his stepmother,
for two reasons. Firstly, he has no time for women. His
only enthusiasms are hunting and war games. Whatever is
feminine fills him with horror. Besides, he has deep regard
for his father, and nothing in the world would persuade him
to betray Theseus by sleeping with the latter's wife. Phaedra
takes it very badly that this young man should refuse her
advances. Moreover, she begins to fear that he will denounce
her to his father. Anticipating such a turn of events, she takes
the offensive. One day, when she knows that Hippolytus is in
the vicinity, she breaks down the door of his chamber, tears
her clothes, then begins to scream and pretend that the young
man has tried to violate her. Hippolytus is overwhelmed with
horror. He tries to defend himself to his father, but as so
often, Theseus defers to his womenfolk, and with a broken
heart he banishes his son from the house. And in his anger
he commits the fatal error of entreating Poseidon—the god
who is also Theseus's father—to cause Hippolytus to die. The
young man is already on his way. He flees the parental home
as fast as possible, on his chariot, drawn by his thoroughbred
horses. At a point where the road runs along the sea, Poseidon
causes a bull to rise out of the waves (for the second time in
our story). Startled, the horses panic and leave the road, and
the chariot is smashed into a thousand pieces. Hippolytus is
killed. Phaedra cannot bear the pain—she ends by confessing
the truth to Theseus and then hangs herself.

The tragedy has inspired a host of playwrights, and the

story—one of the saddest in classic mythology—remains
unforgettable. Theseus is henceforth only a shadow of
himself. For various reasons, which I shall not relate here,
he is no longer capable of ruling Athens and abdicates the
throne in order to take refuge with some distant cousin, a
certain Lycomedes. According to some accounts, Lycomedes
murders Theseus, for obscure reasons, perhaps jealousy or for
fear that the latter will ask him for some land. According to
others, Theseus dies a natural death, from an accident while
hiking in the mountains of the island. Whatever the case, his
end is relatively modest and miserable. As so often in heroic
narratives, the end is far from grandiose and seems unworthy
of the hero: because he dies as a man, like other men, and
because death is always pointless. Later on, however, the
Athenians open the tomb of Theseus, repatriate his remains,
and initiate a cult for him, such as is normally reserved for
the gods themselves. . . .

III. Perseus—or the cosmos
relieved of the Gorgon Medusa

With Perseus, we are again dealing with one of those Greek
heroes sustained by a sense of justice and the desire to purge
from the natural world all entities likely to destroy the beau-
tiful cosmic order instigated by Zeus. The earliest coherent
account of the adventures of Perseus derives from Phere-
cydes, followed fairly closely, it seems, by Apollodorus—and
it is upon this template that the other mythographers tended
to embroider their variants. My account relies for the most
part on this original version of the myth.

There were once two royal twin brothers, named Acrisius
and Proetus, of whom it was said that they got on so badly

that they quarreled already inside their mother's womb! To avoid quarrelling as adults they resolved to share power. Proetus became king of a city named Tyrins, and Acrisius, who interests us most here, reigned over the beautiful city of Argos—not to be confounded with the three other mythological figures named Argus, who bear the same name: first there is Odysseus's dog, Argos, in the *Odyssey*; then there is the giant with a hundred eyes who is slain by Hermes when Hera sends him to guard Io (the lovely nymph transformed into a cow by Zeus), and whose eyes are said to have been subsequently printed on the tail of Hera's sacred bird, the peacock; finally there is Argos the naval architect, who constructs the boat on which Jason and the Argonauts sailed. . . .

But let us return to Acrisius, king of the city named Argos. He has a ravishing daughter, Danae—but no son, and at this remote epoch a king's duty was to provide a son to take his place on the throne. Acrisius therefore travels to Delphi, as was customary, to consult the oracle and discover if, one day, he will have an heir. And, as was also the custom, the oracle replies obliquely, telling him merely that he will have a grandson and that when he grows up this grandson will kill him. Acrisius is filled with dismay, and even terrified: the oracle at Delphi is never mistaken, and what he has just heard from the horse's mouth, so to speak, spells his death sentence. There is no preventing fate—despite which humans cannot stop themselves from trying every alternative. Although he loves his daughter, Acrisius makes up his mind to incarcerate her, together with a female companion, a maidservant, in a sort of bronze chamber that he orders to be constructed underground, in the cellars of the palace courtyard. In effect, this prison derives from the archaic burial tombs constructed at Mycenae, in the depths of the earth, from which doors of

gilded metal were later recovered. Acrisius merely asks his architect to leave a small vent in the ceiling so that a little air can circulate, so that Danae does not die of asphyxia. . . . When the chamber is finished, he shuts his daughter in with her maidservant and feels a little less anguished.

But Acrisius has not anticipated the watchful concupiscence of Zeus, who, having spotted Danae from the heights of Mount Olympus, has decided—as is his habit—that he must have her at all costs. To achieve this, he transforms himself into a fine golden rain, which falls from the sky and finds its way delicately through the openwork grille at the top of her chamber. This golden shower descends onto Danae's lap, and from this contact alone is born a son, Perseus—unless perhaps things happened differently, and Zeus assumed a human form once inside the chamber, the better to make love with Danae. Whichever the case, the end result is little Perseus. He grows very happily, inside their golden cage, until one day Acrisius's attention is caught by the sound of a child's babbling. Gripped by fear, he has the chamber opened and discovers to his horror the reality: despite all of his precautions he well and truly has a grandson, and the oracle has begun to fulfill itself, slowly but surely. What is to be done? Acrisius starts by killing the unfortunate maidservant, who is not remotely involved with what has occurred, but whom he imagines to be an accomplice in this fateful birth. He himself cuts her throat, on the private altar inside his palace dedicated to Zeus, hoping thereby to obtain the protection of the ruler of the gods. . . . Then he interrogates his daughter: How has she managed to produce this child? Who is the father? Danae tells it as it is: Zeus is the father, and he came down from the sky disguised as a golden rain, etc., etc. "Really! And do you take me for a complete fool?" thunders the king. He has a point. Put yourself in

his place for a moment: he cannot be expected to believe a word of this story, and he thinks his daughter is telling him brazen nonsense. But he cannot subject her to the same fate as her servant. Nor can he touch Perseus: they are, after all, his daughter and grandson, and the Furies, who always avenge murder within the family, would be sure to come after him. . . .

So Acrisius calls upon a resourceful carpenter and has him construct a large chest, sturdy enough to be seaworthy— into which Acrisius places his daughter and grandson. The lid is secured, and they are set adrift! Mother and son are abandoned to their own devices, and to wherever the currents may take them. In ages to come, painters and poets will frequently and variously depict the scene. We are told that Danae is a resourceful and fearless mother: in appalling circumstances, she manages wonderfully to look after her small son. The chest eventually and inevitably reaches land: an island, as it happens, the isle of Seriphos, where the two castaways are taken in by a fisherman by the name of Dictys. He is a good man, a man of real generosity. He treats Danae with the respect due to a princess, and he raises little Perseus as if he were his own son. But Dictys has a brother, Polydectes, who has rather less refinement or respect. Polydectes is king of Seriphos, and he falls in love with Danae as soon as he sets eyes upon her. In fact, he would give everything to possess her. The only problem is that Danae is not interested. Besides, Perseus has grown up and is now a young man. He watches out for his mother and cannot easily be disposed of. But Polydectes has an idea, no doubt intending to distract the attention of Perseus or set a trap for him—we do not know for certain. At any rate, the idea is to get Perseus out of the way, and Polydectes announces with great publicity that he will hold a festival to which all the young men of the

island are invited. He will then pretend that he is to marry a young woman, Hippodamia, who is passionate about horses. As is the custom, all the young men of the island must offer gifts. Each of them therefore brings a horse, the handsomest he can find, to please their king. But Perseus cannot afford a gift and turns up empty-handed. To compensate, or perhaps in a show of bravura, he says that he will endeavor to bring Polydectes whatever else he desires—if necessary even the head of Medusa, the dreadful Gorgon. Perhaps he says this to show off, but also because he already senses in himself the destiny of a hero. The various accounts are not too clear on this point.

Whichever the case, Polydectes obviously takes Perseus at his word, all too happy at this excellent opportunity to rid himself definitively of this troublemaker. No one, in effect, has ever confronted the Gorgon and returned alive. The way will now be clear for Polydectes to wed (or take by force) Danae.

I have already spoken of the three Gorgons and their monstrous, terrifying aspect. I will now describe them in more detail. They are sisters, and according to some sources, notably Apollodorus, they were once beautiful but had the effrontery to claim they were more beautiful even than Athena. This sort of hubris, as we know, is never forgiven. To avenge herself—or, more accurately, to put them in their place—Athena literally disfigures them. She gives them each bulging eyes, and a horrible swollen tongue like a pig or a sheep that sticks out permanently, together with tusks like a wild boar, so that now they all wear the same fixed and frightful snarl. Their arms and hands are turned into bronze, and golden wings sprout from their backs. But worst of all, their protruding eyes are of a piercing intensity that instantly transforms whatever meets their gaze (all living things,

whether animals, plants, or men) . . . to stone. Here we encounter an exact analogue—in more extreme form—of the famous golden touch of Midas: in both cases, the magical or necromantic gift that can transform the organic into the inorganic, the living into mineral or metal, represents a direct threat to the entire cosmic order. Ultimately beings endowed with such powers could destroy the works of Zeus, if they are intent on doing so, or allowed to do so. It is therefore vital for the well-being of the cosmos, whenever the case arises, to put them in their place. Of the three Gorgons, one is mortal—Medusa—but the other two are immortal. It is high time to dispose of the disposable mortal, at least, and it is Perseus who takes it upon himself to do so.

The problem is that the unfortunate youth has spoken a little too rashly, and has not the slightest idea how to proceed. To begin with, he would need to know where Medusa lurks, of which he clearly has not the vaguest notion. It is said that the Gorgons, who are magical and mysterious creatures, do not even inhabit our earth but reside somewhere at the margins of the universe. But where, exactly? No one seems to know, least of all Perseus. Secondly, even if he finds them, how will Perseus kill Medusa without being himself transformed into stone for the rest of time? Bear in mind that Medusa flies like a bird, that her staring eyes swivel constantly in all directions at lightning speed, and that it will take merely a single glance for the whole story to be over for Perseus. Suffice to say that the challenge is not easy to meet, and it might have been better for him to offer Polydectes a horse like everyone else. . . . But he is a hero and, lest we forget, he is no less than a son of Zeus—like Heracles. And as proof that his work on this earth is indeed divine, Hermes and Athena—the most powerful Olympians, and the closest to Zeus—come to his assistance.

The first hurdle for Perseus is to pay a visit to those known as the Graeae, three sisters who also happen to be siblings of the Gorgons themselves. They share the same parents, equally shocking in appearance—two huge marine monsters, Phorcys and Ceto. The Graeae are responsible for guarding the route that leads to the Gorgons, and if they are perhaps unclear as to where the latter reside, at the least they are acquainted with some nymphs who do have this information. If Perseus manages to make the Graeae speak, he can then find these nymphs (the second obstacle on his journey). But the Graeae are not exactly cooperative. They, too, after their fashion, are monsters, and are far from trustworthy: they have a reputation for devouring young men when the fancy takes them. Moreover, all these divinities, whether the immortal Gorgons or their monstrous parents or their frightful sisters, belong to a pre-Olympian universe: they are creatures of chaos rather than cosmos, spawned from the archaic original forces that must always be feared, and that a hero must know how to subdue if he is to escape destruction.

As proof of this, the Graeae are endowed with two scarifying attributes. The first is that they are born old. They have neither youth, nor childhood, nor infancy. From birth these are old women with wrinkled skin, aged sorceresses from the start. Their second characteristic is that they have but one eye and one tooth to share among them! Imagine the scene: they are constantly passing one another the eye and the tooth, which revolve in a perpetual and infernal circle, so that, a little like Argos, the hundred-eyed monster, although they have only one organ of sight, it is permanently on watch because the three of them are never asleep at the same time. And their one tooth is permanently at the ready, to chomp and sever and tear whoever comes too close.

Jean-Pierre Vernant compares the passage of the eye to

that of the ball in the game of pass-the-slipper. The image is excellent, but the story makes me think rather of the three-card shuffle. Three cards are placed facedown on the table. The dealer, a sort of conjuror, keeps switching the position of the cards—so rapidly as to make it increasingly difficult to follow the track of the ace or chosen card. You pick the wrong card and you lose your money. Something similar happens to Perseus with the Graeae. He must seize the eye or the tooth at the exact moment when it is being passed from one old crone to the other. It seems impossible to do—they are so alert and so quick—but Perseus is a hero, and as one might expect, he succeeds at this first exploit. Quick as lightning, he manages to snatch both the eye and the tooth so that the three old crones are terrified and begin to scream: they are immortal, yes, but deprived of the eye and tooth their existence will be hellish. As to what happens next, let us call a spade a spade. Perseus exerts blackmail. It is not very pretty, but he has no other option: if they tell him where to find the nymphs who know the whereabouts of the Gorgons, he will give them back their property; if not, they will pass the rest of eternity blind and starving. The offer is brutally simple. Although they grumble, the old women comply. They show him the road to the nymphs whom they are meant to be protecting. As good as his word, Perseus gives back the eye and the tooth . . . and hurries on his way.

Unlike the three sorceresses, the nymphs are as welcoming as they are beautiful. They have no problem with showing him the way to the Gorgons. What is more, they press priceless gifts upon him, each endowed with magical powers without which Perseus truly has no hope of succeeding in his mission. Firstly, they give him the same winged sandals as worn by Hermes, which allow him to fly through the air with the greatest speed, as fast or faster than a bird. Then

they give him the famous helmet of Hades, a dog-skin cap
that allows the wearer to become invisible—which will per-
mit Perseus to escape pursuit by the two immortal Gorgons
when they seek to avenge their mortal sister. Finally, they
present him with a shoulder bag, of the kind used by hunters
to carry dead game, into which Perseus must place and care-
fully seal the head of Medusa after he has severed it. For the
eyes of the Gorgon—even after death—will continue for all
eternity to petrify whatever they see: it is prudent, therefore,
if not essential, to keep them well hidden. To these three
gifts Hermes himself adds a fourth: a knife or small billhook
like the one Cronus used to cut off the genitalia of his father
Uranus—in other words an instrument that is as magical as
the rest, so hard and so resistant that it severs whatever comes
in contact with its blade.

Armed with these accessories, Perseus resumes his journey
and eventually reaches the land of the Gorgons. Here again,
the task is far from easy, and he will need the help of Athena.
How in effect can he sever the head of the petrifying Medusa
without meeting her gaze? To do his job, he must inevitably
look at what he is doing—which will mean instant death.
Happily, Athena has thought of everything and has brought
her famous shield. Polished and gleaming, it will serve as a
mirror. She positions herself behind Medusa, who is sleep-
ing, while Perseus creeps up on her, as silent as a cat. He sees
the reflection of Medusa's head in the shield: even should she
look at him, there is no danger since it is merely an image
rather than the reality. Nothing could be simpler, now, than
to cut off the fearful head and slip it into his game bag. But
the two other Gorgons have woken up. They utter the most
abominable screams, those cries that, as you will recall, give
Athena the idea of the flute, which in turn she fatefully
passes on to the unfortunate Marsyas after being mocked

for her flute-playing cheeks by Hera and Aphrodite (all of which indicates, once again, how interwoven all these stories are . . .). Instantly, Perseus dons the helmet of Hades and becomes invisible; likewise, the sandals of Hermes, which enable him to make an instant escape. However they stare, wide-eyed, spreading their golden wings and looking this way and that, Perseus is nowhere to be seen, and he disappears, without mishap, as rapid as the wind. . . .

On his way back to Seriphos, where he will rejoin his mother, Danae, and deliver the head of Medusa to Polydectes, Theseus is high up in the air when he spies, down below, the woman who will become his wife: the beautiful Andromeda. She is in what might justly be called a difficult situation.

As Perseus passes overhead, Andromeda is lying chained to the side of a cliff, overhanging the sea, at whose base a sea monster watches her eagerly. It turns out that Andromeda's mother, Cassiopeia, wife of Cepheus (king of Ethiopia), has had the unhappy notion—as did Medusa, in respect to Athena—of defying some far from trifling divinities: namely the Nereids, daughters of Nereus, one of most ancient gods of the sea, prior even to Poseidon. Cassiopeia has openly insulted the Nereids, claiming to surpass them all in terms of beauty—which, as we know, is to flagrantly commit the sin of hubris. . . . The Nereids are enraged, as is their comrade Poseidon, by this foolish claim. To punish her insolence, he sends a flood as well as a sea monster, who proceeds to terrorize the entire region. To appease Poseidon there is only one solution: to offer up the king's daughter, the lovely Andromeda, as prey, which her father, Cepheus, has just resolved to do, with death in his heart. This is why Andromeda is tied to the rock and awaiting her dreadful fate, which will occur just as soon as the sea monster makes up its mind to seize her. Perseus does not hesitate, but promises Cepheus that he will

rescue her. He merely asks, in exchange, that Cepheus agree to give him the rescued girl as his wife. The oaths are sworn. With his billhook, his winged sandals, and his invisibility cap, Perseus has no trouble in slaying the beast, rescuing the girl, and returning her safely to solid ground. Everyone is delighted, with the exception of a certain Phineus, her uncle, who had been promised Andromeda in marriage beforehand. He plots against Perseus, but when the latter learns of this he removes the Gorgon's head from his bag, and Phineus is instantly turned to stone.

Here is the end of the history of Perseus. I will let Apollodorus tell it, in his own entirely laconic manner (with a few comments in italics):

> When he arrived back at Seriphos, Perseus found that his mother and Dictys had sought refuge at the altars, on account of the violence of Polydectes. So he entered the palace, where Polydectes had assembled his friends, and with averted eyes [*so as not to be petrified himself*] he showed them all the Gorgon's head; and all who beheld it [*including Polydectes, of course*] were immediately turned to stone, each in the exact position he happened at that moment to have assumed [*imagine the scene: some are drinking wine, others are looking astonished at the entrance of Perseus, Polydectes himself probably full of curiosity and apprehension, and so forth*]. Then, after making Dictys king of Seriphos, Perseus restored the sandals, shoulder bag and cap to Hermes, and the Gorgon's head he gave to Athena. Hermes returned the aforesaid objects to the nymphs and Athena fixed the Gorgon's head to the centre of her shield [*remember that she is also the goddess of war, and that with the head of Medusa she can literally "petrify" with fear all her enemies . . .*].

A final and inevitable coda: the oracle must now be fulfilled, and Acrisius punished for his wickedness and egotism. Accompanied by Andromeda, now his wife, and by his mother, Danae, Perseus decides to return to Argos.

As a good prince, he has forgiven his grandfather: he has no wish to punish him, for he understands that basically Acrisius did what he did out of fear that the oracle might be fulfilled. Perseus wishes to pardon him. But Acrisius learns that Perseus is on his way home and is terrified by the prophecies of the oracle. He immediately takes flight to a neighboring city, Larissa, where he demands protection from the ruler of this city, Teutamides. As it happens, the latter is holding an athletic contest: one of those tournaments that the Greeks of the time were so keen on organizing, in which young men measure up to one another in all kinds of competitions. Acrisius is invited by his friend the king to enjoy the spectacle. At the same time, learning that these games are being held so near to Argos, which is on his route, Perseus cannot resist the pleasure of competing. He excels at throwing the discus. As ill luck would have it, the first discus he throws strikes Acrisius on the foot, killing him instantly.

Let us not inquire as to how a discus that strikes your foot can kill you instantly. It is irrelevant. What counts is that justice is accomplished, and that destiny—which is but another word for cosmic order—has reasserted itself. Order is restored, and Perseus can live out the rest of his life in tranquility, between his mother and his wife, surrounded by the children with which she will not fail to provide him. At his death, Zeus, his father, will make a signal gesture of commemoration for a mortal: to reward his courage and his contribution to the upholding of cosmic order, Perseus is inscribed for eternity in the heavenly vault, in the form of a constellation that was said to describe the contours of his human face. . . .

IV. Another combat in the name
of *dikè*: Jason, the Golden Fleece, and
the marvelous voyage of the Argonauts

With Jason, we leave behind the category of heroic monster-slayers. He will, of course, encounter some of these on his voyage—a fire-spitting bull, fearsome warriors who spring directly from the earth, Harpies, a dragon, and so forth—whom he, too, as a hero must overcome. But this is not the heart of his story, as it is with Heracles, Theseus, or even Perseus. Jason exists above all to redress an injustice perpetrated by a villainous king, Pelias, a sin against the gods as much as against his own kind. And to put things back in place, to restore a just order, faced with the misdeeds of this evil, baleful sovereign, Jason must go in search of a mythical object, the Golden Fleece, about which I shall say a few preliminary words, by way of introduction to the adventures that follow.

What then is this Golden Fleece? Its story—at least in the most usual version, found in Apollodorus—begins with the account of a king, Athamas, who ruled over Boeotia, the farming region from which Hesiod originated. Athamas has just married a young woman, Nephele, with whom he has two children, a boy named Phrixus and a daughter, Helle. But soon afterward he remarries, this time to Ino, daughter of Cadmus, king of Thebes and husband of Harmonia (herself the daughter of Ares and Aphrodite). Much later, Ino will become a sea goddess, but for the moment she is a simple mortal—and a jealous one at that: she cannot endure the children of Athamas and Nephele, to the point that she thinks up a terrible stratagem to remove them from the scene. As I have said, Boeotia is a region of small farmers, whom citizens of the capital affect to despise because they

seem uncultivated, unsophisticated. Besides, even today "Boeotian" is sometimes used to indicate someone a little naive or rough around the edges. Ino therefore has little difficulty in coming up with a cock-and-bull story that persuades all the women of the region that they must secretly roast the wheat grain over a fire, so as to kill the seed before it is sown by their menfolk.

The following year, the earth fails to produce its crop, and nothing grows. Deeply concerned, Athamas—who is, of course, ignorant of his new wife's scheming—sends envoys to Delphi to consult the famous oracle. But Ino, still pulling strings, persuades the envoys to tell Athamas that, according to the oracle, the earth will become fertile again and the supposed anger of the gods be appeased only if he sacrifices to Zeus his children, Phrixus and Helle. Athamas is horrified and resists, but the credulous farmers believe the oracle and threaten to revolt against their king: from all quarters they clamor for his children to be sacrificed. Athamas is compelled to give way, and with a heavy heart, he leads the unfortunate victims to the place of sacrifice. But at this point Nephele, their mother, intervenes, with the help of Zeus—who is not best pleased by Ino's machinations, and who sends his faithful messenger Hermes to the assistance of Phrixus and Helle. The assistance takes the form of a ram, which Hermes gives to Nephele. This is no ordinary ram since, instead of the wool that is sported by all the other rams in the world, it bears a magnificent fur—a golden "fleece," in effect—and is, moreover, winged. Instantly Nephele places her children on its back and the creature takes to the skies, toward a less hostile region, namely the land of the Colchians. Alas, while they are flying, little Helle falls into the sea and drowns: the sea where she dies is called the "Hellespont"—known today as the Dardanelles Strait, separating Europe and Asia.

Her brother, Phrixus, for his part reaches their destination unharmed. There he is given a kind welcome by Aietes, king of Colchis. In gratitude, Phrixus sacrifices the ram. A more satisfying variant of this story tells that the ram itself asks to be sacrificed so as to shed its mortal form and return to the divine world of the gods. Whatever the case, Phrixus gives the Golden Fleece to Aietes, which some say will protect the region—and that, on the contrary, evil will befall him if he allows it to be taken away or captured. Aietes has the fleece nailed to an oak, in front of which he posts a terrifying dragon, which never sleeps, to guard it night and day. . . .

And this is the fleece that Jason must fetch. On whose behalf? And why? To answer these questions, we need to return to Jason's childhood. Here again, our source for the most part is Apollodorus, which needs to be complemented here and there by another work of fundamental relevance: that of a poet who lived in the third century BC, Apollonius of Rhodes, to whom we owe a lengthy work, Homeric in form, about Jason's expedition to Colchis, titled the *Argonautica*.

The story begins in the manner of a fairy tale. There was once a man named Aeson, who was half brother to the king of the city of Iolcos, the famous Pelias—who, as I have said, was a very wicked man. . . . The throne of Iolcos ought by rights to have passed to Aeson, and then to his son Jason. But Pelias has seized it by force, and illegitimately. Jason firmly intends one day to assert his father's rights and, when the time comes, his own rights, against this unjust uncle, in order to recover the throne that is rightfully theirs.

I should add at the outset, so that you will more clearly grasp the villainy of the usurper, that Pelias ends by murdering his half brother, to be certain of not being divested of the throne. To be sure, he does not do the deed himself, but

the effect is perhaps worse: Aeson learns that Pelias intends to have him assassinated, and he takes the initiative, asking permission to do the job himself, by committing suicide. Pelias accepts, all too happy not to get his hands dirty, and thus does the unhappy father of Jason meet his end. To be on the safe side Pelias goes on to eliminate Jason's mother, as well as his little brother. . . . The least one can say about Pelias is that he is thorough.

But it is also said that Pelias behaves unjustly not merely toward fellow mortals: he has also offended several of the Olympian gods, notably Hera, by killing a woman in the very temple of the goddess. What is more, he absolutely refuses to honor Hera and forbids her cult to be practiced in his city, requiring that all sacrifices be reserved for his own father, Poseidon (who has decidedly spawned an impressive number of monsters and louts from his successive liaisons with mortals!). This is why the Olympians decide finally to send Jason to Colchis, not merely on the pretext of fetching the Golden Fleece but also to bring back Medea—the enchantress who is the daughter of Aietes, king of Colchis, and the niece of Circe—so that she can punish Pelias by appropriate means when she returns to Colchis . . . and we shall see how she does so, to atrocious effect, at the end of the story. This interpretation of the purpose of Jason's voyage was already offered by Hesiod, whose *Theogony* refers to Pelias as *hybristès*—someone driven far astray by hubris— and describes him as "that overbearing, outrageous and presumptuous doer of violence" and specifies in passing that the gods are the instigators of Jason's voyage, whose principal aim is indeed to bring back Medea. For Hesiod, it is "by the will of the gods" that Medea will be taken from her father, Aietes (with her consent, it should be added, since she falls madly in love with Jason—helped perhaps, as some

mythographers suggest, by the efforts of Aphrodite, who sends little Eros to pierce her heart at the moment she first sets eyes on our hero).

Be that as it may, this Pelias is an odious figure who lives in and through hubris—injustice toward his own people as much as toward the gods—and it is Medea (acting through Jason, since it is he who brings her back from Colchis) who will mete out justice in return. But let us not anticipate. The adventure is only beginning, and it will prove no easy matter either to find the Golden Fleece or to steal Medea from her lord and master Aietes, the powerful ruler of Colchis.

Let us return to Jason.

If he has the makings of a hero, it is not merely on account of his birth. There is also his education, as entrusted to the celebrated Cheiron, of whom we have already spoken, one of the sons of Cronus and reputed to be the greatest teacher of all time. Cheiron is a centaur, the wisest and most learned of his kind, and he teaches Jason not only medicine, as he taught Asclepius, but also the arts and sciences, as well as the handling of arms—in which he also instructed Achilles. The young Jason grows up with his parents in the country, outside the city of Iolcos. One fine day he is told that his uncle Pelias is about to offer a great sacrifice by the sea in honor (as always) of Poseidon, and has invited Jason to take part in it. In truth, Pelias has not especially invited Jason, whom he does not know and on whom he has never set eyes, since Aeson mistrusts his half brother and has carefully hidden his son, to protect him from possible assassination. Rather, Pelias has extended a group invitation to all the young men of the region, and it is in this context that Jason goes to the city, desirous to have some explanation finally from his usurper uncle. In order to understand what follows, we also need to know that the oracle at Delphi, consulted one day

by Pelias about the future of his regime, has told him—incomprehensibly, as ever—to avoid like a plague "the man who wears but one sandal." Pelias can make no sense of these words, but on this day he is destined to understand them.

In effect, on his way to the city of Iolcos, Jason has to cross a river. And on the riverbank, beside the water, he encounters a woman who also wishes to cross, but is too old to manage on her own and needs assistance. Jason, who is both well brought-up and already very strong, takes the old woman on his shoulders and begins to ford the stream. His feet search this way and that for some purchase on the pebbles carried along by the current. Sinking into the mud of the riverbed and losing his foothold, Jason finally reaches the other side nonetheless, without mishap. The old woman, as you may perhaps have guessed, is none other than Hera, queen of the gods, who has come down in disguise to see for herself how our young hero is shaping up—and whether he has what it takes to set off on the fearful adventures required to bring back Medea, who in turn will chastise Hera's mortal enemy. It would seem that Hera is entirely satisfied by this first contact with her future protégé. And, as you have no doubt also guessed, Jason has emerged from the river wearing only one of his sandals! And when Pelias catches sight of a young man arriving with only one sandal, he suddenly remembers the half-forgotten words of the oracle. He questions Jason, asks him who he is, what he wants, what he is doing here, and so forth. He now understands that he has to deal with his own nephew.

If we follow Apollodorus, it is now that Pelias asks Jason, in front of all the young men assembled for the sacrifice, what he would do, in Pelias's place, were he told by the oracle that a young man wanted to depose him and take his kingdom. Inspired by Hera, and without knowing quite what he is

322 THE WISDOM OF THE MYTHS

saying, Jason replies: "I would send him off to fetch the Golden Fleece." Pelias, no doubt even more taken aback than Jason, is delighted by the response: to bring back the Golden Fleece is an impossibility, he thinks to himself; the voyage to find it is already insanely dangerous; as for taking the fleece away from Aietes, king of Colchis, this is not to be thought of. Besides, it is guarded by a dragon, and dreadful ordeals would need to be undergone before wresting it from him. In short, Pelias is certain that Jason has committed the gravest of errors: this young imbecile has just offered the surest means for disposing of himself definitively. Pelias takes Jason at his word, of course, and the whole assembly can now testify to the fact that the young man has undertaken to go and fetch the Golden Fleece himself. He has no alternative but to take up the challenge.

To reach Colchis, Jason will need—before all else, and above all else—a good boat and a brave if not outstanding crew, which is what Jason now sets out to recruit. For the boat he summons the assistance of Argos, son of Phrixus, who arrived as a boy in Colchis astride the sacred ram, fleeing the sacrifice ordained by his father Athamas. Argos is by now an excellent naval architect; however—just to make sure—he will be aided by Athena. The goddess advises him on the construction of the ship; as a final touch she herself adds to the bow a wooden figurehead that has the power of speech and can, if necessary, give navigational aid. As for the crew, it consists of beings who are quite out of the ordinary. They are hereafter called Argonauts, which in Greek means "sailors of the *Argo*"—*Argo* being the name of the ship, in honor of its builder. Among the Argonauts—of whom there are fifty, it being a fifty-oared vessel—are several famous heroes, including Heracles, Theseus, Orpheus, the twins Castor and Pollux, and Atalanta—the fastest woman alive at

running and the only female presence on board. And there
are other remarkable individuals present, less famous per-
haps but whose talents are every bit as necessary as those
of their more celebrated peers: Euphemus, who can walk
on water; Periclymenus, who can take any physical form
he chooses; Lynceus, who can see through walls; and the
two sons of Boreas, god of the wind, who can fly like birds,
which will allow them to chase away the Harpies when nec-
essary. And so forth. It is with these exceptional companions
that Jason makes his preparations to sail. And likewise it is
with the divine aid of Hera and Athena—itself by no means
negligible—that he sets out on a long and dangerous voyage.

The latter will unfold in three distinct stages. There is
firstly the voyage to Colchis, where the fleece is to be found.
Once there, trials have to be undergone in order to possess
the fleece—for King Aietes is not at all willing to part with
it. Thirdly comes the return voyage, which will also be full
of pitfalls.

But let us begin with the voyage out. The voyage of the
Argonauts begins in an extraordinary fashion. Their first
port of call is Lemnos, which has one peculiarity: it is an
island of women. There are no men to be found, not a
single man, which evidently strikes our mariners as strange.
Why this absence? By dint of questioning the inhabitants,
the Argonauts learn the reason, which is both surprising
and unsettling. The Lemnian women had formerly failed
to honor Aphrodite. The goddess, vexed, decided to teach
them a lesson and afflicted them with an evil smell, which
immediately repelled their husbands and generally put off
any man who came near them. A curious affliction! As a
result of this, their husbands took women captive from the
neighboring land of Thrace and promptly bedded them
instead. The abandoned wives took this in poor spirit and

retaliated by murdering their menfolk. And since this time they have been alone. So they naturally welcome the Argonauts with a good deal of enthusiasm. According to some reports, the Argonauts are only allowed to disembark on condition that they promise to sleep with the islanders.

Either the evil smell has by now abated, or the Argonauts are made of stronger stuff, but they seem to comply with the request without difficulty, given that Jason engenders two sons by the Lemnian queen, Hypsipyle, which in itself suggests that our heroes spend some time on this island, perhaps a little over two years. What do they do during this interval? According to Pindar, they give themselves over to all sorts of athletic games, combats, competitions: in other words, the period on the island serves as preparation for the difficulties ahead, which they will soon encounter on their voyage.

Their trials begin with the second phase of the journey—once again, under unusual and even inauspicious circumstances. The Argonauts have finally set sail once more. They next come to port in the land of the Doliones, a people ruled by a king named Cyzicus. He is a good man, well disposed, who greets our Argonauts warmly and humanely. They soon become the best of friends. They eat together, feast together, exchange gifts, until finally it is time to leave. They say their good-byes, sadly and effusively. The *Argo* puts out to sea. Unfortunately, during the night a strong offshore wind whips up, which drives the boat inexorably back upon the coast from which they have just sailed. There is nothing to be done about it. During the night, the *Argo* is forced to land once more among the Doliones. But it is pitch dark, and Cyzicus for his part takes them for invading pirates from a neighboring island. He rouses his soldiers and falls upon the enemy—who are none other than the Argonauts, their new

best friends. The latter, equally unable to see in the dark-
ness, are just as convinced that they are under attack by pi-
rates. The two sides fight to the death, and when day comes
and the sun lights up the field of battle, the scene is one of
horror. The ground is strewn with dead and wounded, and
Jason realizes their terrible blunder: he has killed his friend,
King Cyzicus, and the gentle Doliones are decimated. The
fury of combat gives way to sobbing and cries of despair.
They bury the dead and tend the wounded, but nothing is
healed. Nothing can give any meaning to this senseless epi-
sode, which serves as a terrible warning: during this voyage,
the Argonauts must henceforth distrust all appearances and
must remain as alert as possible at all times. But the lesson has
come at a price. . . .

The voyage continues, despite everything, with various
other stopovers, until they reach the land of the Bebryces,
which is under the rule of a certain Amycus. He is anything
but a friend, and here at least the Argonauts are in no danger
of being deceived by appearances. The son of an embrace
between a nymph and Poseidon (whose progeny we would
all be happier to manage without), Amycus is endowed with
colossal strength, and his favorite pastime is boxing. Except
that for Amycus this is neither a sport nor a game: it is a fight
to the death, and nothing makes him happier than to kill the
unfortunates who have been unable to escape his challenges,
from which he invariably emerges victorious. Except on this
occasion he faces Pollux, whom the Argonauts have delegated
to deal with this problem. And Pollux is no ordinary mortal.
Like Heracles and Perseus, he is one of the numerous sons of
Zeus, twin brother of Castor (one of the Dioscuri), and his
father's son when it comes to combat. Amycus learns this to
his cost: Pollux kills him by a blow to the elbow (let us not
ask how a blow to the elbow can kill a man: there are quirks

and strangenesses in Greek myth that we must accept at face value . . .). This episode, moreover, gives a foretaste of what lies in wait for our heroes: even if it is not the essential point of the story, in their quest for the Golden Fleece they must expect to show themselves capable, like all Greek heroes, of confronting assorted monsters and surmounting trials that threaten their lives.

The next stage is no doubt the strangest of all, and aspects of it are frankly comedic. After leaving the land of the Bebryces—having slaughtered an impressive number of their warriors, who were foolish enough to try and avenge their dead king—the Argonauts next drop anchor in a deserted spot. Or rather, not entirely deserted. They encounter someone who will be of particular use to them, a diviner who is greatly reputed for unraveling the future. His name is Phineus, a former king of Thrace who is now blind. According to some accounts he was blinded by Zeus for forewarning humans of the future, knowledge of which is supposedly reserved for the gods. For good measure, Helios (the sun god) sent the Harpies after him, that terrifying and remorseless duo of female creatures with wings. When the Argonauts encounter Phineus he is skeletal, as if he were literally dying of hunger. Having learned that this diviner is a trustworthy soul, they urge him to foretell their route: what lies in wait for them, what trials they must confront and how to surmount them. Phineus whispers that he would advise them happily, but that he is too hungry, that he cannot foretell anything on such an empty stomach.

At first the Argonauts do not understand: "But you must eat," they tell him. "We shall prepare a feast for you." Immediately they set to laying a table, full of delicious and appetizing dishes, which they place before the old diviner. But they are about to witness the terrible curse that has been laid upon

him. No sooner is the food on the table than the Harpies literally fall upon it: in a moment they have devoured almost everything or carried it off in their claws. Even so, there remains a little food on the table. The Argonauts encourage Phineus to at least take advantage of these few leftovers. But then these foul bird-women drop enormous piles of excrement from the skies onto the table, which soil and spread their stench over the remaining dishes, rendering them quite inedible! A black comedy, of sorts, though not for Phineus, who suffers this appalling fate, comparable only to the unending torments of Tantalus at the hands of the gods.

Happily for Phineus, there are exceptionally gifted individuals among the valiant crew of the *Argo*—in particular, the two sons of Boreas, god of the wind, who are able to fly like birds. As soon as they see what game the Harpies are playing, they instantly take off after them in hot pursuit. After a while one of the Harpies drops exhausted into the river Tigris, named thereafter the Harpys in memory of this demon. A little later, the second also drops with exhaustion. The spirits of the wind now make them promise on pain of death not to persecute the unfortunate diviner any further. Phineus will finally be able to eat in peace. More important, as far as our heroes are concerned, he will be able to speak. What he tells them is far from reassuring: to arrive at Colchis they will have to negotiate—if they are able—some strange blue-colored rocks. These are known as the Clashing Rocks because, as soon as anything passes between them, they immediately collide together and crush their hapless prey. A thick mist surrounds them, which terrifies mariners and prevents them from seeing the danger before them, and when the rocks come together the clash is tremendous and terrifying. Phineus gives the Argonauts advice that will save their lives: they must release a dove

between these reefs before entering between them. If they see the dove pass safely through, this means that the rocks are closing, but not quickly enough to crush it, and that they will shortly open again—at which precise moment the *Argo*, with the mariners pulling hard on the oars, has a chance of getting safely through.

After hearing this advice the Argonauts put out to sea, and as they approach the rocks, Jason gives the order to do exactly as Phineus has suggested. The mariners release a dove from the prow. The bird makes straight between the rocks and manages to pass through with only the tip of her tail, or "rectrix," being snipped off as they clash together. It is the closest of shaves. The *Argo* waits a few moments until the rocks draw apart again; then it shoots forward and, in turn, disappears into the passage that has just opened between the rocks. Not for long, however. As soon as the prow enters the passage, the rocks begin to close again. The men row with all their might; the oars strike the water in rapid cadence, with unimaginable force. And, sure enough, the boat, like the bird, manages to get through. And like the bird, the mariners leave behind the tip of the vessel's poop—in effect the rear portion of the rudder is shorn off. But this can be repaired, and the *Argo* continues on its way, this time without misadventure.

After one or two further stops, the *Argo* finally enters the port city of Colchis, where King Aietes is in residence.

Jason at the court of King Aietes: the conquest of the Golden Fleece

Their troubles are far from over, however. The Argonauts must now take hold of the fleece. Besides, Jason is an upright young man, not a thief. He starts by going to see the king and

politely asking him if he will kindly hand over the famous fleece of gold. No doubt so as to avoid immediate hostilities, Aietes does not say no. But there are certain conditions to be fulfilled. And as you may imagine, these conditions are in fact fearful trials, challenges that Jason must accept, in the course of which King Aietes naturally expects him to lose his life—which will allow Aietes to get rid of this absurd young man and retain his precious treasure into the bargain. Jason must now accomplish two perilous labors, in the manner of Heracles laboring for Hera.

The first consists of harnessing a pair of bulls: they must be placed under a yoke and forced to plow a field—the location of the latter to be indicated to Jason by Aietes. At first sight, there is nothing insurmountable about such a task, except that these are no ordinary bulls. In effect, they have hooves of bronze and their nostrils breathe fire, just like dragons. No one has ever succeeded in approaching them without losing his life. Aietes feels confident: he is convinced that Jason will fail, just like everyone else. But this is without counting on his own daughter Medea, who—as mentioned already—falls in love with Jason at first sight (probably under the influence of Hera). Anguished at the thought that this young man may get himself killed, she draws him aside and proposes a deal: if he agrees to take her away with him and marry her, she will show him how to harness these furious beasts. Naturally Jason accepts. Medea prepares a magic potion: he must rub his whole body, his spear, and his shield with the potion, after which he will be completely invulnerable to fire and steel alike. She tells him, besides, that to yoke the bulls he must grab them directly by the horns—which, of course, is possible only if one is protected from the flames that shoot forth from their nostrils. The next day, Jason enters the arena and, to everyone's surprise, despite the rivers of fire that issue

from these two monsters, despite the furious blows from their bronze hooves, he passes the yoke around their necks without any difficulty and calmly starts plowing, as though he were in charge of a pair of docile oxen.

But the ordeal is not yet over. The second test seems even more daunting: Jason must now sow the teeth of a dragon—which are, of course, no ordinary teeth. As soon as they fall to earth, fearsome armed men spring up from the ground, ready to kill whoever approaches them. It is not by chance that these teeth have fallen into the hands of Aietes. They have an entire history going back to the days of Cadmus, the founder of Thebes and its first king. Cadmus had decided one day to found a city on the site of a fountain guarded by a dragon. This dragon belonged to Ares, god of war. Besides, as you will recall, Cadmus had married the daughter of Ares and Aphrodite, the wife of Hephaestus (who was far from happy at being cuckolded, but that is another story . . .). In order to draw water, so vital for his city, Cadmus was obliged to kill the dragon. Athena and Ares collected the monster's teeth—knowing as they did that no sooner were these teeth sown than fully armed warriors would spring from the earth. They then distributed these uncanny seeds: half to Cadmus, so that he could populate his new city, and the other half to Aietes, king of Colchis, so that he would have the means to guard his precious Golden Fleece.

The warriors who spring from the earth are called the Spartans—*spartoi* in Greek, meaning the "sown men": those who have been placed in the ground, like seeds, in order to sprout. These sown men have a direct link to the earth (they are "autochthonous," a Greek term meaning "born of the earth"). Their proximity to the earth evokes, in the present context at least, the violence of the first gods, the children of Gaia—the earth—who existed before the Olympians and

who are still close to, and driven by, the primordial chaos. This notion will recur in connection with Sparta, a city given over entirely to war, where all the menfolk are soldiers with a rough upbringing, taciturn and laconic—Laconia being the Greek name for the region of Sparta.

So Jason sows the dragon's teeth, and these fearsome armed warriors instantly spring from the earth. But Medea comes to the rescue again and suggests a ploy—the same that had already been employed by Cadmus.* These warriors are practically indestructible, of formidable strength and skill in combat; on the other hand, they are not very smart. In fact, they are perfect cretins, brutes who can see no farther than their noses. It suffices to throw a stone into their midst, and each believing he is being attacked by his neighbor, they fall upon one another with such violence that they succeed in exterminating themselves, down to the last man, without Jason having to lift a finger. The path to the fleece is now clear—or nearly so. Were it not that the king, a poor player and a worse loser, refuses to keep his promise. Under cover of darkness, he now plans to set fire to the *Argo* and murder its crew.

Meanwhile, Jason will take by force what is being unjustly withheld from him. It only remains to dispose of the dragon guarding the Golden Fleece, hanging from its tree. Medea sends the dragon to sleep with one of her potions, and Jason has only to unhook the precious fleece before making his way back to his ship and making off.

When he discovers what his daughter Medea has dared to

*Cadmus likewise sowed the dragon's teeth and witnessed these same terrifying *spartoi* spring from the earth. He hurled a stone between them, causing them to fight among themselves like imbeciles . . . to the point that only five of them were left alive. It was these five who would serve to populate the city of Thebes—the companions of Cadmus having been decimated by the dragon guarding the celebrated fountain of Ares.

do, Aietes is furious. He mobilizes his fastest ships and sets off in pursuit of the *Argo*—at which point Medea commits a dreadful crime, one of the worst in the annals of Greek myth. She has brought her brother with her aboard the *Argo*. Seeing their father in pursuit, she does not hesitate, but murders the young boy and cuts him into pieces, which she casts overboard: a leg here, an arm there, followed by the head. . . . The bleeding limbs float on the surface, and the unhappy Aietes recognizes the evidence of his own son. Naturally he orders a halt so as to rescue these remains, in order to make a decent burial, so far as possible. As a result, he loses precious time and the *Argo* makes unstoppably for the open sea.

The difficult return of the Argonauts to Iolcos and the punishment of Pelias

Nonetheless, the ordeals of the Argonauts are by no means over. They have yet to return safely to Iolcos, the city of Pelias, to bring him the Golden Fleece as promised. And the return journey is no picnic. In effect, Zeus cannot properly allow the manner in which the Argonauts have escaped from Aietes: the slaughter of Medea's brother cannot be tolerated, and the ruler of the gods unleashes a terrible tempest against the *Argo*—a tempest that will oblige the crew to make many detours. Zeus then orders Jason and Medea to go and be purified by Circe, the magician and aunt of Medea. As a result, the voyage of Jason comes to resemble that of Odysseus: the two heroes will undergo comparable ordeals.

Firstly, they must reach the island of Aeaea, home of Circe, and obey her commands, performing all the purificatory rites for the murder committed by Medea. It is only on this condition that the *Argo* may resume its route to Iolcos. Like Odysseus, the *Argo* will have to sail past the Sirens, those

bird-women whose song is the ruin of any sailors who hear it, invariably tempting them to shipwreck. But instead of having himself lashed to the mast and blocking the ears of his crew, Jason requests Orpheus to sing; his sweet and powerful voice drowns out that of the Sirens, whose song for once is quite powerless. As with Odysseus, the route of the Argonauts also passes those terrifying monsters Charybdis and Scylla: the whirlpool that swallows everything within its reach, and the woman whose body is topped by six dog's heads. The Argonauts likewise pass the Wandering Rocks, surrounded by flame and smoke, from whose reefs few ships are fortunate to escape. Finally, like Odysseus, Jason skirts the island of Thrinacia, which contains the oxen of the sun, before coming to that of the Phaeacians, where the good king Alcinous gives them a kindly welcome. . . . And it is here that Jason weds Medea, before setting off again toward Iolcos. The *Argo* weathers another violent tempest, which Apollo calms by shooting an arrow into the sea, and then the crew attempts to land at Crete.

But on this island there reigns a fearful giant, called Talos. It is said by some that he belongs to the race of bronze, of whom Hesiod writes—that tremendous race of warriors who were invincibly clad in metal. According to other accounts, he has been constructed by Hephaestus himself and given to King Minos to guard his island. Whatever the case, Talos is terrifying. Each day he keeps watch by running around his island three times, killing whatever he encounters on his path. As soon as he sees the *Argo* approaching, he picks up great stones and hurls them in the direction of the ship. Talos has a weakness, however: he has but a single vein, which runs from his neck to his ankle. Through her drugs and her incantations, Medea succeeds in driving him completely mad—to the point that, while caught up in a sort

of demented jig, he grazes his ankle against a sharp rock, which dislodges the stopper that closes his one and only vein. The vital fluid—which takes the place of blood—seeps away through this opening, and Talos falls headlong, stone dead.

After this last ordeal, the Argonauts finally reach Iolcos without further incident.

As I said earlier, Pelias has abandoned any expectation of the Argonauts' return. Convinced that Jason is dead, he has forced Aeson to take his own life. To be sure to rid himself of anyone who might stand in his way, he has also caused the deaths of Jason's mother and little brother. When Jason arrives back in Iolcos, he hands over the Golden Fleece nonetheless. But he equally intends to dispense justice and to avenge his loved ones. As foreseen by the gods, since the outset of the voyage, it is Medea who will take charge of the punishment. She persuades the daughters of Pelias that, in order to rejuvenate their father (who is beginning to show his age), they must chop him into small pieces and boil him in a large cooking pot, promising to restore his youth with her drugs. To gain their confidence, she asks for a ram to be brought, which she cuts up and has the pieces thrown into a cauldron, ordering that it be boiled. By sleight of hand (let us not forget that Medea is a sorceress), a magnificent young lamb emerges seconds later from the stew. The daughters of Pelias are immediately convinced. They run off in search of their father, to subject him to the same fate as the ram . . . with the difference that Pelias will remain forever in a state of boiled morsels! In other words, he meets his death, well and truly, and both Jason and Hera are avenged through the services of Medea.

For ten long years, Jason and Medea live happily together. They have two children. Later, unhappily forsaken by Jason, who remarries, Medea will kill her children to avenge

herself. She then sends her husband's new wife a tunic steeped in poison, of the same sort as killed Heracles. Then she leaves for Athens, where she will marry Aegeus, ruler of that city and father of Theseus, whose adventures we have already described. As for Jason, unlike Medea he is a mere mortal who must sooner or later leave this world. It is said that, one day, as he snoozed beneath the remains of his old ship, the *Argo*, the speaking figurehead that Athena had fixed to the prow finally fell off and crushed him so that he died instantly. Thus did the boat and her captain end their long journey together.

You may perhaps be surprised that the ultimate end of these heroes is not always very dignified, that it does not really accord with their exploits. This is because heroes are, for the most part, mere mortals. They must die like everyone else, one day or another, and all deaths are as one in their pointlessness. At the same time, heroes are recognized, honored, and admired after their deaths. It is no consolation, but there is a kind of logic to it, a form of intelligible proportion.

Up to this point, if I may summarize somewhat roughly what we have seen since the voyage of Odysseus (at the outset of our journey), everything unfolds, in a certain sense, quite "logically." The trajectory of Odysseus is, of course, full of pitfalls, but in the end he reaches his destination, his island, where he restores order and harmony, and where he lives out many subsequent years among his own people. . . . If we consider the figures driven by hubris, likewise, their stories also prove to be perfectly rational: they commit a fault, even a crime, and the cosmos, as embodied by the gods, puts the situation to rights and restores justice, no doubt brutally but nonetheless according to an intelligible design. As for the monster-slaying heroes, even if they end their days like ev-

eryone else, public opinion elevates them at least to the status
of a cult, or else they are deified or packed off to the Elysian
Fields, as in the case of Heracles. . . .

There remains a lurking question, however, which seems,
on the surface at least, to break with the norms we have seen
at work thus far. Put simply, how are we to understand the
misfortunes that befall poor humans who have done noth-
ing wrong, nor anything remotely out of the ordinary? Who
have neither defied the gods through hubris, nor sought
out unusual adventures, nor shown extraordinary courage
in going after malevolent and magical entities? How do we
explain all these calamities that swoop down on us, without
our being able to do anything in response: children with
birth defects; early deaths that take away our loved ones;
scourges that devastate our crops and provoke famines; cy-
clones; and other catastrophes that wipe out at a stroke so
many innocent lives? Here is a mystery to which the stories
we have so far encountered do not supply a key. The myth
of Oedipus, on the other hand, together with all that fol-
lows for his descendants, and in particular for his daughter
Antigone, may permit us to glimpse an answer to this most
enigmatic question of all. . . .

The Misfortunes of Oedipus and of His Daughter Antigone

—or, Why Mortals Are So Often "Punished" Without Having Sinned

THERE CAN BE NO doubt: humans do not always deserve the calamities that overtake them and devastate their lives. Natural catastrophes, tragic accidents, and mortal illnesses affect the honest and the wicked without discrimination. They do not choose whom they afflict, and unless we sink to the lowest levels of obscurantist superstition, misfortune cannot and should not be interpreted as divine punishment. This being so, the question cannot be avoided: In a world supposedly ruled by justice and harmony, in a universe at the heart of which the gods are omnipresent and decide everything, what sense do we make of such flagrant injustice? What meaning can we give to the scandal of human misfortune, in those instances where it seems peculiarly senseless? Even if it possesses numerous other dimensions—other "harmonies"—the myth of Oedipus first and foremost addresses this fundamental question. The study of it therefore seems an indispensable complement to the preceding chapters of this book: it clarifies the significance and above all defines the limits of this celebrated cosmic harmony that occupies the center of the Greek vision of the world—or such

as will be handed on to philosophy by ancient theogony and mythology.

The life of Oedipus turns to nightmare—despite the fact that, in the language of children, even if he has acted badly he has not done so "on purpose." Here is a man of exceptional intelligence, with a courage and sense of justice out of the ordinary. Far from being rewarded accordingly, not only does his existence become a hell, but despite all his clear-sightedness, he is at the mercy of events and blind forces that overtake him and that he never begins to comprehend—at least until death puts an end to his unspeakable sufferings. How can such a perversion of justice be possible? How are we to interpret a fate that is as tragic as it is unwarranted, without concluding that the world—far from being a harmonious whole—is but a catalogue of horrors ordained by wicked deities who play with mortals as do children who amuse themselves by tearing the wings off flies or squashing ants? To attempt to answer this question, which inevitably raises itself at some point in any consideration of Greek cosmology, I shall begin by taking a closer look at the story of Oedipus and his daughter Antigone. Secondly, we shall try to understand its deeper significance—and in doing so we shall complete the vision of the world that the other Greek myths have allowed us to progressively construct.

I should point out immediately, before going any further, the general principle that once the cosmos has been disrupted, it is impossible for order to be restored without involving a great deal of (what one might call) collateral damage. This is why, for example, when a father commits an atrocious crime, it is sometimes succeeding generations that pay the penalty, not because—strictly speaking—they are responsible or guilty but because order cannot be reestablished all at once. Of course, no one is accountable for the actions of his

parents, but it remains true nonetheless that a child is bound by the deeds of a parent, and that the manner in which our parents have lived can have considerable repercussions for our own lives—whether we wish it or not, and whether we are aware of it or not. If parents have sinned gravely through hubris, it is possible for the world at large to register the shock—and when the cosmos has been disrupted it cannot be repaired in short order. It takes time, and this interval is precisely the interval of human misery that embroils innocent individuals. This is why, if we are truly to understand the myth of Oedipus—rather than confine ourselves to the usual clichés of psychoanalysis or modern philosophy—we must go back to a time before Oedipus himself. For we shall find the origin of his troubles in what occurred prior to his birth.

Such a conception of the world may well seem outmoded. It may shock our modern moral sensibilities, understandably so. In effect, we have acquired the habit of considering that a punishment should never fall upon he who has done no ill: outside of totalitarian regimes, we no longer think of punishing children for the actions of their parents. However, we shall see that the unwarranted is often a reality rather than an absurdity, and there is no shortage of examples to illustrate the truth—even today—that a world *out of joint*, whether on the natural or societal level, is a world that destroys individuals who have nothing in particular with which to reproach themselves.

However, let us not get ahead of ourselves, but consider the story of the unfortunate Oedipus and his daughter Antigone—these two myths being inseparably linked.

Oedipus and Antigone:
the archetypal tragic destiny—or
how misfortune can strike blindly

As always in Greek myth, there are several versions of the story, and every stage of the life of Oedipus is subject to conflicting accounts. Nonetheless we have one principal archaic source, namely the Greek tragedies and in particular those of Sophocles: *Antigone, Oedipus Rex*, and *Oedipus at Colonus* (named after the city to which Oedipus comes after the series of catastrophes that I am about to describe). It is of course valuable to take note here and there of other versions, which sometimes afford fresh insights,* but the subsequent literature almost always defers to Sophocles when recounting and interpreting this most famous of all myths. Which is why, for the most part, we shall follow the framework of the Sophoclean story in the following pages.

A few words, first, on events preceding the birth of little Oedipus. He is a direct descendant of the celebrated Cadmus, king of Thebes, of whom we have had occasion to speak at several points already—brother of Europa, who was herself the mother of Minos, the Cretan king whom she conceived by Zeus. . . . After marrying Harmonia, the daughter of Ares and Aphrodite, Cadmus founded the city of Thebes, where the main drama of the story of Oedipus unfolds. Oedipus's father is named Laius, and his mother, Jocasta. At the point where our story begins, they have just learned from a terrifying oracle that if ever they have a son, he will

*For the archaic period—fifth century BC and earlier—we find a few precious references to the Oedipus myth in Homer, Hesiod, and Pindar. *The Phoenician Women*, by Euripides, brings a very different emphasis than Sophocles to some aspects of the story. For later accretions, we must as always consult our two "default" mythographers, Apollodorus and Hyginus, as well as referring to Pausanias and Diodorus Siculus.

kill his father and, according to certain accounts, even bring about the destruction of Thebes. As is common in such cases and at this epoch, the parents make the difficult decision to abandon the infant: to "expose" him, as was said at the time, because the child was usually secured to a tree and left to the mercy of wild animals but equally, sometimes, to the clemency of the gods. . . . Laius and Jocasta entrust the infant to one of their menservants, a shepherd, with instructions to abandon it in an appropriate place. The servant treats the unfortunate infant as one would treat a game bird or suchlike creature: he pierces its ankles and passes a cord through them so as to carry it more easily on his back, with a view to securing it subsequently to a tree, where it will be left "exposed." It is from this experience that Oedipus will draw his name, which in Greek means quite simply "swellfoot" (*oidos*, which gives us our modern medical term "oedema," meaning "swollen"; and *pous*, "foot"). On his way to the place, the servant of Laius encounters "by chance"—and the spectators of Sophoclean tragedy were well aware that this seeming chance is but another name for the will of the gods—the royal servants from another city, Corinth, whose king, named Polybus, is, as it happens, impotent and unable to produce the child he dreams of having. As the unwanted infant is so very dainty, the servants of Polybus propose taking the child with them. Why not? After all, if Laius has chosen to expose the child rather than kill it outright, this must mean he intends to give it a chance: the Corinthian servants will bring it to their master and the latter will surely wish to adopt it. And so it turns out, so that the infant is saved in extremis. . . .

Oedipus grows up in the city of Corinth, far from his birthplace in Thebes, at the royal court, whose king and queen he evidently believes to be his natural parents. Everything turns

out well for him. But one day, during a game, he gets into a quarrel with a playmate. It is a very ordinary argument, such as often occurs between boys. However, his adversary calls him a name that he will never forget and that seems dreadful to him: he calls him a bastard, suggesting that his parents are not his "real" parents, that he is merely a foundling who has been lied to all along. . . . Oedipus runs back home and questions Polybus, his supposed father; the latter, in his embarrassment, denies the charge, but too feebly for Oedipus not to retain a clouded sense, a vague suspicion of doubt as to his origins. He still wants to be clear in his own mind, so he resolves to go to Delphi and consult the famous Pythian Apollo, just as his natural parents Laius and Jocasta had formerly consulted the oracle. He demands to know who he is, where he is from, who his parents are. . . . The oracle responds, as usual, by avoiding the question: providing not information on Oedipus's past but—on the contrary—a prediction concerning his future. And the prediction is terrible: that Oedipus will kill his father and marry his mother.

From this, of course, Freud will draw the name of his famous "Oedipus complex," the infantile impulse that—according to Freud—propels boys to unconsciously desire their mothers and violently reject their fathers at some point or other in their development. However, as we shall see, even if this aspect is present in the original myth, it falls far short of providing us with a key. Whatever the case, it remains clear that Oedipus is crushed by the words of the oracle. And so as to prevent its predictions from coming true, he decides to leave Corinth forever, for he still believes that this is the home of his parents, Polybus and his queen, Periboea. By quitting this place, he will avoid any risk of killing his father or sleeping with his mother—except that Polybus and Periboea are not his biological parents, and that

in leaving Corinth the unfortunate Oedipus will inexorably and blindly achieve the reverse of what he hopes: he will draw ever nearer to carrying out the dreadful prediction of the oracle. In other words, by his very attempt to elude the oracle, he unconsciously prepares its fulfillment—a contradiction that will furnish one of the most important psychological mainsprings of Sophocles's trilogy. And, of course, in this context where everything is already anticipated by the gods—as witness the two oracles, which invariably translate divine wishes—Oedipus heads toward Thebes, the city of his true parents, Laius and Jocasta. Now it so happens, to aggravate matters, that Thebes is at this point enduring a terrible plague that is decimating its population. Here again, the spectator can only suppose, even if it is not made explicit, that this scourge has been sent by the gods for whatever reason. But let us continue: against this backdrop of catastrophe, Laius has also decided, like Oedipus, to go to Delphi and consult the oracle once more as to what might be done to save the inhabitants of his city.

We are here at the center of a tragic crux that cannot but seize the attention of the entire audience: imagine the father, convinced that his son is dead, and the son, convinced that his father is in Corinth, each making his way unwittingly toward an encounter with the other! Their destinies cross, literally as well as figuratively: the chariots of Laius and Oedipus find themselves face-to-face, at the crossroads of three routes, so narrow that each is forced to draw his team to a halt. One of them must reverse and pull up on the verge to let the other pass. But both men are proud, each being convinced that he has right of way, if not natural precedence over the other: Laius because he is king of Thebes, Oedipus because he is prince of Corinth. The situation becomes inflamed. Their servants exchange insults, and Laius seemingly

lashes out at Oedipus with his whip. They come to blows, and carried away by his anger, Oedipus kills his father, as well as the driver and retinue who accompany him. Only one of the servants escapes with his life, by running away, though not before having witnessed (and this will have importance for what follows) the entire scene. . . . And so the first part of the oracle has been fulfilled! Without Oedipus— any more than Laius—having taken the measure of what has just occurred, he has in fact murdered his father. . . .

Entirely ignorant as to his own identity, or that of his adversary, Oedipus resumes his route toward Thebes. Of course, the violent episode that has just taken place is regrettable, but the fault was on both sides, and Oedipus feels that he acted legitimately in self-defense. After all, it was not he who aimed the first blow. He ends by forgetting the whole affair and arrives in the city of his birth after a long and tortuous voyage. Apparently the plague has run its course, but a different calamity—itself equally of divine provenance, no doubt—now grips the city, whose new king (having ascended the throne after the death of Laius) is Creon, brother of Jocasta and therefore uncle of Oedipus. This new calamity has a name: the Sphinx, a female with the body of a lion and the wings of a vulture, who guards access to and terrorizes the city by requiring all the young men to answer a riddle. If they fail to do so, she devours them, and Thebes has started to become visibly deserted. . . . Here is one version (there are others, but they roughly amount to the same) of the riddle in question:

> "Which creature in the morning goes on four legs, at midday on two legs, and in the evening upon three, and yet the more legs it has, the weaker it is?"

Oedipus hears of this Sphinx and, without hesitation,

presents himself to her and asks for the deadly riddle. As soon as he hears it he knows the answer: unquestionably its subject is man himself, who in the morning of his life, while still an infant, crawls on all fours, then on two legs when he becomes adult, and finally on three legs in the evening of life, when he is weak and supported by a stick. According to an ancient prophecy, the Sphinx must die if ever a mortal succeeds in solving one of her riddles. Faced with Oedipus's answer, she casts herself from one of the highest ramparts and is crushed to death. Thebes is thereby delivered from the monster, and Oedipus enters in triumph. The city celebrates, showering him with sumptuous presents. The crowd applauds his passage, and since Queen Jocasta is a free woman—she was still a young widow when Laius was killed—her brother Creon offers Oedipus his sister's hand in marriage, by way of thanks, together with the throne of Thebes, which he now yields willingly, having occupied it merely as an interim ruler.

Thus the second of the oracle's predictions is fulfilled: still in complete ignorance of what is determining the course of his existence, Oedipus has killed his father and now wedded his mother. He provides her with four children over the course of time: two boys, Eteocles and Polynices— who will one day kill each other over the succession to the throne—and two daughters, Ismene and Antigone. For the next twenty years, however, everything will proceed calmly. Oedipus wisely administers the city of Thebes, alongside his wife, who is also his mother, and Jocasta raises their children with loving care.

Unfortunately, when the latter are just reaching adulthood, a terrible outbreak of plague begins to ravage the city once more. Nothing can put a halt to it. Worse still, if such is possible, strange accidents begin to occur and proliferate—

women give birth to stillborn or monstrous children, sudden
unexplained deaths take place—so Oedipus sends a messen-
ger once again to consult the oracle at Delphi. This latter
replies, unambiguously for once, that the scourge upon the
city will cease only when the murderer of Laius is captured
and punished. Such a crime, in effect, cannot remain un-
punished with impunity—which proves once more (in pass-
ing) that the gods have been following events closely since
the outset, as is indicated beyond any doubt by the fact that
all new developments are announced through the agency of
Apollo's direct and oracular representatives.

Oedipus still has no idea that it is he who is the guilty
one, and he intends fully to obey the oracle. He organizes
an inquiry, and on the advice of Creon he calls upon the
most celebrated soothsayer of the region, the famous Tire-
sias, whom we have already encountered several times in
other myths. Tiresias knows the whole truth, of course—
otherwise he would not be a soothsayer. But he is embar-
rassed, not to say horrified, by the secrets in his possession,
and feels an insurmountable reticence about divulging them
in public, in the presence of Oedipus, who is still in a state
of complete ignorance. The latter now becomes angry, ac-
cusing Tiresias of the murder and of conspiring with Creon
to overthrow him. In short, he makes such a racket that the
soothsayer ends by capitulating to his wishes. He pours out
the whole story to Oedipus: if Oedipus must know, it is he
himself who killed Laius, who was indeed his father, just as
the oracle predicted, and who for good measure then pro-
ceeded to marry his own mother! Jocasta, overwhelmed by
these words, protests and tries to persuade both herself and
Oedipus that the soothsayer's words are wild. To convince
him, she relates some of the details of Laius's murder at the
crossroads: it was not one man who killed Laius but a band

of brigands; it cannot therefore be Oedipus who perpetrated this act. For good measure, she reveals to him that she had another son long ago but that this child was "exposed." Oedipus is only half reassured: the description of the crossroads calls up some disturbing memories, but on the other hand everything seems so confused. . . .

At this juncture, a messenger arrives from Corinth: he announces to Jocasta and Oedipus the death of one whom Oedipus still believes to be his father, namely Polybus. The news saddens Oedipus, but at the same time relieves him: at least he has not killed his father! Except that the messenger cannot help adding an astounding detail: that Oedipus should not be too upset, after all, because Polybus was not his real father. He was exposed as a child, discovered by chance, and adopted by the rulers of Corinth. Revelation! At a stroke the entire puzzle comes together. Oedipus, to be completely clear in his own mind, summons the shepherd who years earlier had been charged with exposing the child of Laius and Jocasta. He discovers that this same shepherd was indeed the servant who accompanied Laius at the moment he was murdered—and who then escaped with his life, since which time he had taken refuge in the mountains and had sworn, to be left in peace, that the king of Thebes was killed by bandits—which, in turn, reassured Jocasta that Oedipus could not possibly be responsible. But this was a lie, and now the shepherd reveals the truth. Yes, Tiresias and the messenger from Corinth are correct: the exposed child was none other than Oedipus and it was he alone who killed Laius. Everyone present can now put two and two together and reconstitute the whole story: the dreadful oracle of Apollo is finally fulfilled, and recognized as such.

We are at the epicenter of the tragedy, and there will be no happy resolution. On the contrary, things can only get worse.

Jocasta commits suicide as soon as she knows the real story. As for Oedipus, when he finds her hanging in her chamber, he seizes the brooch from Jocasta's robe and gouges out his eyes in rage. As always, the punishment fits the "crime"—I place the word in quotation marks, for Oedipus has never in reality intended any of this to happen. Indeed, his whole tragedy is that he has *seen* nothing in advance of its coming. Despite all his intelligence, he has been *blind* from start to finish. And just as he has sinned by lack of sight, of foresight, it is by this means that he is punished. To his mental blindness there now corresponds his physical blinding. . . .

The end of his life is equally sorrowful. If again we follow the version of Sophocles—there are others, but his has become canonical—Oedipus immediately quits the throne, which is once more provisionally occupied by Creon. Oedipus flees to Colonus, where the former king and savior of Thebes, having reigned for twenty years, will now eke out a blind and miserable existence of vagrancy. His daughter Antigone, who is kindhearted and has a keen sense of family, accompanies and watches over him. He then directs his steps to Athens, ruled at this time by an excellent king, the benevolent Theseus. Along the route, near a small wood, he comes to a spot that he recognizes as the place where he must die: this grove in effect belongs to the Erinyes, or Furies, those dreadful deities born from the blood of Uranus, which soaked the ground of Gaia after the castration visited by Cronus upon his father. The Erinyes, we should here recall, were from the outset entrusted primarily with avenging all crimes within families—of which poor Oedipus has become the unwitting and unwilling world champion, so to speak. It is normal that, under such circumstances, he must end his unhappy existence in the hands of these famous "kindly ones." But the grove is sacred. The servants of the

king of Athens believe they are doing the right thing by chasing Oedipus from this ominous place. The latter asks them to send for Theseus, who, well intentioned as ever, arrives immediately at the scene. With true benevolence, he takes pity on Oedipus and accompanies him to his death: the ground opens, the Erinyes carry him off, but no one will know the exact place of his death. Theseus performs the funerary rites for Oedipus, as a token of friendship and by way of pardon for his involuntary crimes. . . .

In broad terms, this is the basic scenario and framework of the myth. It remains to add a few words about the further consequences for the children of the unhappy hero. This is dealt with in Sophocles's *Antigone*, but also in the only surviving play by Aeschylus to take the Oedipus myth for its theme (he did so in several other plays that have unfortunately been lost): *Seven Against Thebes*. Eteocles and Polynices, the two sons of Oedipus, behaved badly toward their father when they learned the details of his story. They humiliated and maltreated him, to the point that Oedipus ends by entreating the wrath of the gods against them. Successfully so: the two brothers will become their own worst enemies. To try and settle their differences, in the struggle for power that has come to the fore now that Oedipus is dead, they agree to take turns as rulers, from one year to the next: Eteocles will occupy the throne of Thebes for the first year, Polynices for the second year, Eteocles once again for the third year, and so on . . . except that once he is in power Eteocles refuses to stand down for his brother. So the latter raises an army to retake Thebes and enforce their agreement. This army has seven commanders, corresponding to the seven gates of the city that Polynices now proposes to besiege—whence the title of Aeschylus's drama: *Seven Against Thebes*.

To summarize the outcome of the play: Thebes, well pro-

tected by its ramparts, valiantly resists the assaults of the seven, and their army loses the battle decisively. The two enemy brothers face each other before the seventh gate and, in single combat, succeed in killing each other. Creon, who as a result is returned to power, decrees that the brother who defended his city, namely Eteocles, shall be buried with honors, while Polynices, who assaulted the city, shall be refused burial: the supreme humiliation. His body will be left to the dogs and the birds. And anyone who dares to flout this edict will be summarily executed!

It is at this point that the tragedy of *Antigone* begins. Although very brief, it has caused a great deal of ink to flow, innumerable commentaries. The plot is of the simplest, however: Antigone declares—if we follow the ending of Aeschylus's drama—that she must assume her responsibilities within the community that has given her life, namely her family, whatever the misfortunes that have befallen it. The private sphere must in her eyes take precedence over the laws of the city. She therefore defies the orders of her uncle, Creon, and proceeds to bury her brother Polynices. Naturally, she is arrested and condemned to death, at which point the drama of Aeschylus ends. If we continue the story according to Sophocles, we learn that Creon is initially inflexible, but under pressure from those around him he reverses his decision and decrees that Antigone—who has been thrown in prison and is awaiting execution—be released. When they come to release her, they find that she has hanged herself. To make matters worse, the wife of Creon also kills herself, leaving the old king to ponder the consequences of bad decisions. . . . Later, the sons of the seven, who are known as the Epigoni, wishing to avenge the death of their fathers, take up arms and destroy the city of Thebes.

Thus does the sinister cycle of the Theban legends come to

an end. There are innumerable interpretations of the fate of
Oedipus and the revolt of Antigone. The myth has inspired
fascination for centuries and continues to do so today, when
not a year passes without new learned contributions. In
the light of this it may seem presumptuous to risk further
commentary, albeit impossible not to do so in the present
context. It is with the greatest caution, therefore, that I
propose—instead of another modern reading—to try and
return to how the Greeks themselves may have understood
the myth, if we pay attention to what Aeschylus says when
he makes discreet but specific reference to accounts of the
original founding of the city of Thebes.

What in effect do these various myths say? First of all,
that Oedipus is quite obviously not "guilty," in the sense
implied by our modern conceptions of justice. Oedipus is
neither aware of the chain of events in which he is caught
up, nor does he cause them to happen. Equally clearly—as
is indicated by the crucial role of the oracles in this story
and, through them, that of the gods—he is the plaything of
a higher destiny that eludes him at every turn. To which we
may add—since we should not forget the minor players in
this affair—that the Thebans (or at least the common people)
are likewise innocent of any responsibility for the calamities
and other scourges that afflict them, repeatedly, down to the
final destruction of the city by the Epigoni.

The truth of the matter is that an ancient curse weighs
from the outset upon the entire line of Theban rulers—
and this curse, linked to an original transgression, cannot
end until there is a restoration of order within the reigning
family and within the city. In the end, the restoration takes
place in similar fashion to the myths of Deucalion or Noah,
through the wholesale destruction of all the protagonists.
These unfortunates can do nothing right, and herein lies their

tragedy. They are annexed by a destiny that both eludes and crushes them, whatever they do, for the curse goes back a very long time. It is primarily linked—if we return to the generation immediately preceding Oedipus—with the crime once perpetrated by his father, Laius, against the son of Pelops. We need to know that Pelops had in those days received and raised Laius as if he were one of his own family. The latter (for reasons that we shall not broach here) passes his entire childhood in this household. But one day Laius falls in love with the young Chrysippus, son of Pelops, and attempts to rape him. The horrified young man commits suicide, and Pelops, maddened by anger and grief, invokes the gods with a dreadful request: that if ever Laius should have a son, his son will slay him (as always, the reciprocity between crime and punishment), and that the city of Thebes will be destroyed. According to some mythographers, Hera and Apollo can never forgive the Thebans for having made Laius their ruler with no thought of punishing his crime.

From this point events unfold with implacable logic: Apollo, through the mouthpiece of his oracle, forewarns the wedded couple Laius and Jocasta that if ever they have a son catastrophe will rain down on them. Laius does not much care for women and prefers boys. So, according to most versions of the myth, it is under the influence of alcohol, when deeply drunk, that he makes love to Jocasta, who conceives little Oedipus.

Here is how the Chorus summarizes events, in Aeschylus's *Seven Against Thebes*:

> "I am thinking indeed of the ancient fault, so swiftly punished, but whose effect endures even to the third generation. The fault of Laius, deaf to the voice of Apollo who, from his Pythian shrine which stands at the earth's navel, warned three times that the king would save his city only if he died without sons. But yielding to senseless desire [*Laius is drunk when he*

makes love to Jocasta], he fathered his own death, a boy, namely the parricide Oedipus, who sowed his mother's sacred field, where he was nurtured, and dared to plant a bloody crop. Madness had brought the frenzied bridal pair together. And now it is as if a sea of evils pushes its swell onward and over us. As one wave sinks, the sea raises up another, three times stronger, which crashes around our city's stern. . . . For the price is high when imprecations uttered long ago are finally settled, and the ancient curse never passes away. . . ."

Further on we learn that, as part of the same remorseless process, when Polynices ("the illustrious seventh hero") is killed by his brother, this, too, is the will of Apollo, for the god had reserved the right to take charge of the seventh gate himself, where the mortal combat takes place between the two brothers: "so as to fulfil the punishment of the tribe of Oedipus for the ancient fault of Laius."

The matter could not be stated more plainly, and it would be fruitless to look for further reasons in one psychological realm or another. The remainder of the play, moreover, insists upon this point repeatedly: the descendants of Laius are all victims of a destiny that eludes them, for which they are not responsible, that enacts the will of the gods as represented by Apollo. The same goes for Antigone herself, who unswervingly expresses her decision to confront death by infringing the orders of Creon—as an individual choice, freely entered into, but occurring nonetheless in a context from which freedom is absent, where everything is constrained and predetermined by cosmic imperatives and by the gods themselves:

"Nor am I ashamed to act in defiance of the rulers of the city. We are of necessity bound to those with whom we share a common womb, born of a wretched mother and unfortunate father. Therefore, my soul willingly shares his evils [*those*

of Polynices], unwilling as these have been, and bears living witness to a brother dead. No hollow-bellied wolves will tear his flesh—let no one believe this, for though I am a woman I will myself find the means to give him burial and a grave, carrying the earth in the folds of my linen robe. With my own hands I will cover him . . ."

It is a magnificent paradox, and one which perfectly sums up the tragic dimension of this story: Antigone acts independently, of her own free will. She takes the decision herself, fully conscious of the danger she risks—and yet she does so in a context where she, too, has no control over events, in which she realizes that, in truth, she cannot act otherwise: she belongs to her family, far more than her family belongs to her. As a result, she is bound to the curse that weighs immemorially upon her, and nothing can change her course. . . .

Just as psychoanalysis has given a leading role to the unconscious, in its interpretations of this myth, so, too, feminists and antifeminists alike (for the drama of Aeschylus can be read both ways) have made much of the fact that Antigone is a woman, and as such "naturally" embodies the dictates of the heart, of the private sphere—as against the drily rational sphere of the male *polis*, of collective responsibility, and so forth. Once again, it is not impossible that these modern connotations are to some degree present in the folds of the myth. It is even probable. After all, the Greeks were no less intelligent than us, and they had their own notions of men and women, the unconscious, the role of the passions, and other themes so dear to modern psychology. But the key to the myth is certainly not to be found here, and while these perspectives are legitimate and relevant for us, they are quite different from those of the Greeks.

We have no reason to disbelieve what Aeschylus says:

this tragedy does not have to do with psychology but with cosmology and blind destiny (something quite other than the individual unconscious), which intervenes when the order of things has, for whatever reason, been turned upside down. And ever since men have existed—ever since Pandora and Epimetheus first engendered mankind—such disturbances have abounded. They are unavoidable, as we know, because they constitute the life principle itself, and the mainspring of history. If the succession of generations did not occur, everything would be transfixed for all eternity in the most perfect cosmic boredom. But the passage of generations at the same time brings with it the constant risk of tragic blunders. This is why we must in effect retrace the entire history of Thebes since its foundation by Cadmus if we are to grasp the roots of the misfortunes that strike Oedipus. I have chosen for the moment to stop at Laius and his crime against the son of Pelops. But the worm was in the fruit from the very start.

In the beginning, Cadmus wedded Harmonia, who, despite her name, was herself already the fruit of certain discord, being the daughter of Ares and Aphrodite, a rickety and forbidden pact between love and war (not least because Aphrodite was officially married to Hephaestus . . .). But there is more, much more: you will recall that Cadmus, in order to found his city, was obliged to call upon the services of the "sown men," those famous *spartoi* born of the teeth of the dragon who guarded the sacred spring of Ares. The dragon was slain by Cadmus in order to access the water so vital to the sacrifice of the cow that had led him to the spot where his city was to be founded. Now these famous "sown men," numbering five, are warriors, archaic forces close to the aboriginal Chaos, to earth itself, to the Titans, to Typhon. And here we once more encounter a central cosmological theme,

without which we can understand nothing concerning the legends—including that of Oedipus—that surround the history of Thebes. Moreover, one of these "sown men" plays a part in founding the lineage of Oedipus; he is called Echion, a name that inevitably evokes the monster Echidna, the famous half-snake, half-woman who was Typhon's mate. The fate of the descendants of Cadmus will often prove terrible in the extreme, and invariably turbulent—such as that of Pentheus, his grandson who succeeds him on the throne of Thebes and ends up being torn to pieces by the Bacchantes of Dionysus.

Without entering too much into the details of this protracted history, it is clear that the destiny that weighs upon Oedipus and Antigone goes back a very long way, and that they can do absolutely nothing about this, no more than the young Thebans who are devoured by the Sphinx or the population decimated by plague can alter their fate. That is the way of things. Calamities have always been diverted from Olympus by the gods, at least since they vanquished the Titans, since Zeus effected the original division, ordering the world according to justice so as to finally ensure a harmonious cosmos—at least on high, on Olympus. But not here, down below! On earth, there has to be a little disorder, as a by-product of time and of life itself. It is inevitable. The proof? If we wanted at all costs to banish chaos and, therefore, banish injustice, the only means of doing so would be to suppress history and the roll call of generations: in other words, to suppress human life itself. This is why, since the original division by Zeus, all misfortune is reserved for humans, and matters cannot proceed differently. In truth, some mortals seek out misfortune—they positively beg for it!—as is the case with all those who transgress through hubris. But there are others, by far the greater number, who are not in any

way responsible for what befalls them. There are misfortunes transmitted from generation to generation, like an illness, a genetic flaw—except that in this case the flaw is linked to a cosmic disturbance for which this or that ancestor may have been responsible, more or less, but which always recalls us to the fact that the threat represented by the primordial chaos can never disappear: it is consubstantial with the condition of man and the history of men. In some cases, even if this seems cruel and unjust, the gods must repair things and restore order by annihilating the entire lineage of those who have inherited the initial transgression and breach of equilibrium. This would certainly have explained, at least for the spectators of a tragedy, how and why the most atrocious evils fall upon humanity like rain. As I said at the outset of this chapter, no more than the rain chooses to soak this or that individual but falls indifferently on the good and the bad, the misfortunes that strike individual men are by no means always merited. That is the way of things, simply, about which we can do nothing, for these afflictions are an essential part of our human condition: that of mortals plunged into a life and a history that entails at every turn the possibility of an error with which we must learn to come to terms. . . .

It may strike us as a grim lesson for life, all told, and this kind of surrender to the present, to the world as it is, may seem like a counsel of despair. But we must acknowledge that in reality—if we consider more deeply, instead of clinging to our modernity—the tragic outlook, such as the myth of Oedipus distills in its purest state, almost caricaturally so, is at once full of truth and full of wisdom. I shall try to suggest briefly why this is so, and to explain why it is in our interest, even today, to ponder these lessons.

Firstly, quite simply, because it is true to the facts: human existence is indeed—sometimes, if not always—tragic, in the

sense that misfortune strikes without our being able to as-
cribe a meaning to it. And we are misguided in trying to
do everything in our power to forget this. Today, as soon as
misfortune strikes unjustly, we succumb to the modern mania
of looking for "those responsible." A river bursts its banks and
drowns some campers? The fault of course is with the mayor,
the council, the minister, all of whom are incompetent or
corrupt! A plane crashes? Quickly, we must hold an inquiry
to establish the guilty parties and put them in the stocks. . . .
Whether it is the roof of a school that collapses, a storm that
uproots trees, a tunnel that bursts into flames, we must at all
costs find a human explanation, a moral fault to be stigma-
tized imperatively. Let us speak frankly: in no other sphere
do we encounter modern folly in such undiluted form. You
will perhaps ask why I speak here of "Moderns," capitalized,
as if to indicate a category apart, a species of humanity dis-
tinct from "Ancients"? I exaggerate, of course, but in order
to isolate a way of thinking characteristic of our time, which,
on this point at least, is utterly opposed to that of the ancient
world. Humanism, which I approve and defend, has become
omnipresent as a framework of thought—so convinced are we
of being the absolute rulers of the natural order, the holders of
all power, that we have come to think of ourselves, impercep-
tibly, as controlling everything, including natural forces, ca-
tastrophes, even pointless accidents. . . . And this is a species of
delirium, in the proper sense: a denial of reality. For the truth
is quite other. Despite the gigantic powers afforded mankind
by science, it is no less the case that our destiny eludes us, and
will forever do so. Not only is chance a part of human life, not
only is contingency woven into human history, but our lives
are also composed of such variables, under conditions so com-
plex and so ramified, that the idea of having complete control
over whatever happens to us is simply grotesque!

To take an extreme but manifest example: the last world war caused fifty-three million deaths. Do we seriously believe that all of those unfortunates consisted exclusively of the "guilty," the responsible, the wicked? The truth, of course, is that misfortune strikes—as in the myth of Oedipus— without our having any part in it, and it strikes very hard, as much in the realm of politics and society, which we might imagine ourselves as controlling more effectively, as in the realm of nature. Depending on whether we are born here or there, our chances are unequal, and on a scale that often cannot be fathomed. None of this can de denied. Why under such circumstances would we not be tempted to find an explanation, as the Greeks did with the myth of Oedipus? And the notion of a world out of joint as explaining misfortunes and injustice has its own truth, to which there seem to be no very tenable objections. . . .

Above all, there is an underlying wisdom here—not Christian, it is true, and therefore strange to our way of thinking, conditioned whether we like it or not by centuries of Christianity—which merits reflection. A Christian, believing that everything is more or less willed, or at least supervised, by God, will be drawn almost inevitably to find a sense in the madness of men, an explanation that makes us in some degree responsible for what happens to us: if God is all-powerful, and if he is good, then there cannot really be any other explanation for the evils of this world. We must assume that they proceed from the wickedness of men, from their abuse of their freedoms, so that mankind is in some sense collectively responsible for the catastrophes that befall it. We are here at the outer limits of superstition, and many a dialectical ruse is required on the part of Christians who wish to avoid the trap of superstition.

The Greeks thought differently: for them it was a case of

accepting the absurdity of things as they are. A wisdom of the present tense, as it were, which invites us to "make do"—not in the form of resignation but to incite us to develop our receptive capacity, our openness to the world, to profit from life while it is there, while it is going well. This supposes a certain relationship to time that we Moderns have largely lost. Once again: I am a Modern, a "humanist," as they say, and I have even spent my life in elaborating what I would call a "postmetaphysical" or "post-Nietzschean" humanism. Be that as it may, we cannot remain insensible to the grandeur of ancient Greek thought, nor—above all—to the fact that its strong points coincide so often with our weak points. Where we believe wrongly that we can master everything, the Ancients offer us a different perspective, from which we may draw new inspiration.

What does this mean, exactly? It follows on from what I have already expounded in connection with Stoicism, in my earlier volume, *A Brief History of Thought*, and which I will resume briefly here, in the context of Greek myth. There can be no doubt that the primary conviction that mythology was to bequeath to ancient philosophy, and notably to Stoicism, was that the twin evils that weigh upon human existence—the twin brakes that curb a full realization of ourselves, such as would proceed from the victory over our fears—are nostalgia on the one hand and hopefulness on the other: attachment to our past and anxiety for our future. The past draws us ceaselessly backward, thanks to the terrible power exerted over us by what Spinoza nicely termed the "sad passions": nostalgia—when the past was happy—but culpability, remorse, and regret when it was unhappy. As a reaction to this, we take refuge in those mirages of the future that Seneca, in his *Letters to Lucilius*, already described so well. We imagine that by changing this or that—that car,

this house, these shoes, that hairstyle, the holidays, the MP3, the television, our job, or whatever else comes to mind—we shall as a result be happier. The truth is that the blandishments of the past and the mirages of the future are for the most part snares. What they take away from us ceaselessly is the present itself, and thereby prevent us from leading a full life. Moreover, they are the permanent focus of anxieties and fears—the former almost invariably surge out of the past and the latter out of the future. And there is no greater obstacle to the happy life than apprehension.

Such was the conviction, simple and profound, at the core of Greek wisdom, as disseminated notably by Stoicism.* In order to be saved, in order to accede to the wisdom achieved by the victory over our fears, we must learn to live without nostalgia for the past or needless fear for the future, which means ceasing to live permanently in dimensions of time that, moreover, have no existence (the past is no longer and the future is not yet)—and keeping to the present insofar as possible. As Seneca write in his *Letters to Lucilius*:

> We must remove ourselves from these two things: fear of the future, and the memory of ancient ills. The latter are no longer my concern, and the future is not yet my concern.

For as he goes on to say, by dint of living inside these two fictional dimensions, we quite simply end by "missing life."

But you will say perhaps that this wisdom of the present does not really hold water, and that, in any case, there is little evidence that it was so very deeply held by Oedipus—no more than by Antigone—both of whom quite obviously feel that the destiny reserved for them by the gods is outrageous and insupportable. Besides, we may imagine that the original

*See the chapter on Stoicism in my *Brief History of Thought*.

spectators of these tragedies must have felt more or less the same thing: they must surely have told themselves that this whole saga is frightful and that reality itself is not to be trusted or embraced for being willed and determined by the gods under such terms as these. Put differently, how to reconcile Greek wisdom—considered as love of the real and as reconciliation with the present moment—with the tragic impulse that goes contrary to it and encourages the thought that, even if determined by the gods for ultimately harmonious ends, the world is a thoroughly intolerable place for many of us?

With this very simple question we touch on the most deep-seated difficulties inherent to a cosmological and divine vision of the universe, to which we can, I think, provide three answers.

The first answer, and one that undoubtedly makes the best job of reconciling the wisdom of acceptance with the tragic sense of reality, roughly consists in saying the following: you must understand, poor humans, by the example of Oedipus, that your destiny is not yours, and that it can always turn out badly, taking back what has been given to you. For twenty years, while ruler of Thebes, surrounded by Jocasta and his children, Oedipus experienced glory and happiness. And then everything was taken from him. Worse still: the very underpinning of his happiness, namely the fact of having killed his father and married his mother, becomes the ground of his ultimate and complete undoing. The moral of the story: we must profit from life when it is good and not spoil things by uselessly tormenting ourselves. Knowing that, whatever happens, it will end badly, we must enjoy the present (the twenty splendid years in Thebes) and follow the famous "*carpe diem*" advice of Horace: seize each day as it comes, without asking ourselves useless questions. The sage

is one who lives in the present, not by lack of intelligence or ignorance as to what might come about, but (quite the contrary) because he knows all too well that one day or another it will all turn to ill, and that we must know how to profit from what is given to us now. This is, as it were, the minimalist version of Stoic wisdom.

The second or maximalist version necessarily goes much further. It equally invites us to embrace the real, but under all of its aspects—even when those are tragic and destructive. Under these conditions, the sage does not restrict himself to loving what is already lovable. We are all of us capable of that. Rather, the wise man is one who in all circumstances succeeds in "hoping a little less, and loving a little more," as the philosopher André Comte-Sponville expressed it to me once, in an effort to sum up the spirit of this Greek wisdom in a single phrase. And in fact this formula does perfectly express the serenity and strength of character needed to address the catastrophes that blindly confront us one day or another. As such, this is an idea that has traveled down the centuries. We see it already in the writings of the Epicureans as much as with the Stoics, and we encounter it again in Spinoza and even in Nietzsche, who also challenges us explicitly to love the world as it is—not only when it proves a pleasant enough place to be, which would be altogether too facile, but equally when, as in the case of Oedipus, it becomes intolerable:

> My formula for greatness in a human being is *amor fati*: that one wants nothing to be other than it is, not in the future, not in the past, not in all eternity. Not merely to endure that which happens out of necessity, still less to dissemble it—all idealism is untruthfulness in the face of necessity—but to *love* it . . .*

*Friedrich Nietzsche, "Why I Am So Clever," *Ecce Homo*.

In other words, which might be those of Greek wisdom in its "maximalist" version, we must not linger in the illusory dimensions of time—in the past or the future—but try, on the contrary, to inhabit the present as far as possible: to say with conviction "yes," even to the horrors of the present, with what Nietzsche calls a "Dionysian affirmation," in reference to the god of wine, of feasting and exuberance.

Much as I am drawn to follow this injunction as unreservedly as it requires, in practice I have never believed it to be remotely feasible or possible for us to say a joyful "yes" to the death of a child, or to a natural catastrophe, or to a war. And in its way, the sad end of Oedipus is sufficient proof that Greek tragedy has little to do with this vision of things, no doubt grandiose in theory but nonetheless absurd in ordinary life. Personally, I have never understood how, after the fashion of Nietzsche or Spinoza or the Stoics, one can say "yes" to whatever happens. Nor am I sure that this is desirable. What would it mean to say "yes" to Auschwitz? To reduce the question to such stark terms is crude, no doubt, in which case, let us be crude. In effect, I have never heard a remotely credible response to this question, however trivializing it may seem, from my Stoic or Nietzschean or Spinozist friends, and it is this that prevents me still from sharing their life affirmations. . . . Besides, as I have said, Oedipus himself succeeded no better than you or I in assenting to the horrors that beset him.

There remains for us to try and imagine a third way, between the minimalist version of wisdom—which strikes me as very beautiful but already very difficult to practice in the fullest spirit—and the maximalist version, which makes little sense of human reality. This third way seems to me to be latently present in Greek tragedy, almost surreptitiously so. To all appearances, Oedipus does not exactly utter a joyous

"yes" to his fate, and it would be disingenuous to claim that the spectators of this tragedy rejoiced to see the cosmos or divine order reasserting itself, however legitimately, against the ordinary mortals whom it crushes so brutally in its passage. Does this therefore mean, because he does not think or act as a good Stoic or Spinozist or Nietzschean, that Oedipus lacks wisdom? I am not so certain. For it seems to me that Oedipus leaves us with a message that is of interest other than in terms of *amor fati*. Of course, as a Greek who believes in his world and in his gods, he partly accepts his fate, as witness the fact that he punishes himself. He gouges out his eyes, quits his throne, and ends his life in miserable vagrancy. Nonetheless, by these very acts, by his very public suffering—which contains no discernible *amor fati*, or embracing of the present—he revolts, he protests, he cries out that something is wrong. His daughter Antigone goes even further and, in more extreme form, takes up the torch on his behalf. Not that either of them questions—at least not explicitly—the universe in which they find themselves plunged: on the contrary, Antigone states clearly that she belongs to her family and can do nothing about it. And yet there is a false note. These individuals are formidable: Oedipus is wise, intelligent, kindly, honest; Antigone is courageous, loyal, faithful to her ideals (which are of the highest order) . . . and yet they are crushed. This needs to be pondered further. . . .

Their sad tale teaches us first of all better to understand the human condition, better to grasp the sense in which misfortune is an integral and inevitable part of human life— and at the same time why it is always unjust, absurd, and exorbitant. It makes us understand likewise the reasons for embracing a wisdom of the present, a love of things as they are, and for abstaining as far as possible from brood-

ing over painful memories, or fantasizing radiant futures for ourselves. But beyond this initial lesson (which echoes the "minimalist" model), if Oedipus and Antigone become heroic and, in a positive sense, legendary figures—for us as, originally, for the Greeks—then this is because they testify, like no other personages, through their suffering as such, to what is singular about the human condition within the cosmic order. Here we can sense the early ferment of a humanism to come. In the same way as Prometheus, in Aeschylus's play, revolts against the gods in the name of men, the spectator of Sophoclean tragedy cannot but start thinking, however obliquely, that this world must be changed, improved, transformed—and not merely interpreted. What is certain is that there is a glitch in the scheme of things, and that it has a name: this pebble in the shoe, this ghost in the machine, is none other than man himself. When she pleads for a morality of the heart, Antigone—even if she speaks in the name of the gods—is a revolutionary, a humanist (they are the same, at bottom), who is perhaps unaware of the fact herself but forces this recognition upon the spectator. Far more than *amor fati*, a mere surrender to the way of the world, she incites us to an interrogation of things as they are. And it is this that is properly human in her character: that it is not reducible to order, not assimilable either by the gods or by the cosmos. We must wait until the birth of humanism, until the appearance of Rousseau and Kant, until the coming of the French Revolution, before this Promethean idea is fully articulated—and here the term "Promethean" takes on its fullest sense, for it was indeed Prometheus who, according to Plato, was the first to see humankind as starting from nothing but capable of achieving everything, including a rejection of the appointed order of things. Herein, to

my mind, resides the true grandeur of the double tragedy of Oedipus and Antigone: for the first time, and from deep inside the closed system of Greek cosmology, it attains to the idea of a humanity with virtually unlimited subversive potential.

CONCLUSION

Mythology and Philosophy

The Lesson of Dionysus and Secular Spirituality

I DO NOT PROPOSE to return to the Greek construction of the cosmos as it was bequeathed by mythology to the philosophical tradition. We have registered sufficiently, throughout this book, the many and complex senses in which the good life could only be found—at least if we attend to what was for a long period the essential message of Greek culture—through an existence conducted in harmony, ideally speaking, with the cosmic order of things. But with the tragedy of Oedipus, we have also begun to perceive something else: the cracks in the wall of this system, the glitches that must affect and pose problems for it, and that must at the very least strike us mortals as potentially tragic. It is with this development that I would like to conclude, pursuing some further reflections on what might generally be termed "alterity": this "Other" that opposes the cosmos and opposes harmony, and that is none other than ourselves, we mortals. For the grandeur of Greek myth does not reside solely in its manifold articulation of a universe. It derives equally from the almost desperate effort to integrate the facts, to reconcile all that exists and is other than perfectly ordered within a dominant scheme of thought that nonetheless privileges harmony above all else. It is a fact: Greek cosmology un-

derlines order and justice, accord and identity, but it is no less alert to the uneasy attraction of chaos, difference, festivity, drunkenness—in short, everything that at first sight falls within the province of folly rather than wisdom. It has often been remarked that this "dissident" aspect of Greek thought, so to speak, finds expression in a philosophical tradition parallel to that of the Platonic or Stoic mainstream, in a kind of counterculture that runs through the theories of the pre-Socratic Atomists, the Epicureans, and the Sophists—a species of "deconstruction" *avant la lettre*, one might say, which already expresses in explicit form a yearning for chaos rather than for order, for difference rather than identity, for the body rather than the soul.

If we place ourselves in this perspective, what seems truly admirable about Greek myth is that it had the extraordinary audacity to accede to this aspect of things and to take account of it, quite explicitly, by embodying it in a figure who has crossed our path already, namely Dionysus, about whom I would like to say a few things by way of conclusion. Let us acknowledge before going any further that it was a very bold move to make so disreputable a figure into an Olympian, and to integrate him so resoundingly and so confidently at the heart of the cosmological system.

For it would be an understatement to say that Dionysus is hard to come to terms with. I have mentioned before how he was born from the "thigh of Jupiter," snatched in extremis from the womb of Semele, his mother, no goddess but an ordinary mortal who caught fire—literally, was consumed in flames—at the sight of her lover in all his glory: Zeus, ruler of the gods. From the start, Dionysus is a being quite apart from all others. Firstly, he is the only Olympian to be born of a mortal woman, which already suggests that he carries within himself his share of chaos: a fundamental

otherness, a sort of flaw. What is more, there is said to be something "oriental" about him, rather than the look of a Greek "born and bred." The expression is dubious, which is why I have placed it in quotation marks, to indicate that, from a traditionally correct point of view, Dionysus has the air of being what the Greeks called a *metic*, a stranger. Worse still, since his earliest infancy he has been disguised as a girl, in a world that publicly values only men and male virtues. At the start, it was in order to escape the wrath of Hera that King Athamas—to whom Hermes entrusted the young god—inflicted this disguise upon Dionysus. Besides, several sources agree that it was Hera who had already caused his mother's conflagration, by strongly encouraging her to ask Zeus to show himself to her in his true colors—Hera knowing perfectly well that the young woman could not endure for one moment the radiance emanating from the ruler of Olympus, and that she would be consumed by it. But then Dionysus subsequently acquires a taste for feminine clothes. To avenge herself, Hera drives him insane when she discovers this disguise, and Dionysus needs to make almost superhuman efforts at self-purification in order to break free of the demented and extravagant frenzies with which the wife of Zeus populates his head. Zeus himself, to shield Dionysus from his wife's hatred, transforms him into a goat, which, it has to be said, only adds to his oddity: *not only is he born of a mortal woman; not only is he somewhat oriental, a bit feminine, and very deranged; moreover, he has a past as an animal!* It would be an understatement to say that there is nothing intrinsically Olympian about such a figure. On the contrary, there is everything to be disturbed about, when he is spotted leading his band of satyrs, Bacchantes, and sileni, with their unimaginable morals—threading their way through Greek cities dominated by virile and martial notions of a just order.

With his retinue of drunken lunatics, and their appetite for unbridled sexuality, even to the extremes of sadism, we are in the presence of hubris with compound interest! It is worth repeating that it took a singular audacity to insert this peculiar customer into the canon of the most august Olympian gods, which in turn prompts the apparently simple question: Why?

Perhaps, in order to better understand what is at stake rather than attempt an easy answer, we should review the earlier and most vivid episodes of his career*—notably the death of Pentheus, which I have already mentioned briefly. The story is worth telling in more detail since it is so illuminating about the singularity of this strange divinity.

No sooner is Dionysus born than Hera begins to pursue him with her hatred, as we have seen, just as she has pursued so many others—notably Io and Heracles—for the same jealous motives. The child is hidden in a safe place by Hermes, on the orders of Zeus, and raised in the disguise I have mentioned. When Hera discovers what has been going on, she does not merely drive Dionysus insane but also his adoptive parents, Athamas and Ino (in some versions, this also gives rise to the myth of the Golden Fleece: the children of Athamas trying to flee the madness of their father . . .). Zeus now hides little Dionysus once more, this time in a distant land called Nysa, where he is raised by nymphs—some sources claim it is from this episode that the young god takes his name, Dionysus: "god—or Zeus (*Dios*), of Nysa." . . . Whatever the case, he travels widely, and ends by curing himself of his dementia. At this point he tries to return to Thrace but is violently expelled by Lycurgus, king

*For the essentials of which I follow Apollodorus, although it is useful to complement this with reference to the Homeric Hymns and the famous *Dionysiaca* of Nonnus of Panopolis.

of this region. Like an intolerant mayor who sees gypsies appearing in the neat and tidy streets of his city, he has no wish to play host to the crazy retinue of Dionysus and has them all rounded up. Not a good idea. The young god is already endowed with fearful powers. He casts a spell on Lycurgus, who in turn loses his reason and comes to a dreadful end, torn to pieces by his subjects after cutting off one of his own legs in a frenzy. . . . After further voyages Dionysus finally returns to his birthplace, or at least to that of his mother, Semele, who is, as you will recall, the daughter of Cadmus and Harmonia, rulers and founders of Thebes. Semele has a sister Agave, who has a son named Pentheus, first cousin to Dionysus. The latter is therefore equally a grandson of Cadmus. And the father of Pentheus—importantly for our story—is one of the famous "sown men": the *spartoi* of whom we have spoken earlier. He is even the most celebrated of these *spartoi*, by the name of Echion, an authentic autochthon—born of the earth, as is indeed the case with all of these "sown men." Pentheus is therefore the exact opposite of Dionysus: not a "stranger" but a local, a product of the land. His grandfather being too old by this time to rule the city, it is Pentheus who has become the new king. Now his mother, Agave, has always made fun of her dead sister, the mother of Dionysus: she has never credited the story of Zeus and the immolation of Semele, nor the rumor of a son being born from the "thigh of Jupiter," and she puts the word about that it is all a fable, if not an imposture—which supremely displeases Dionysus for two reasons: firstly, because he does not like his mother being slandered, and secondly, because Agave in effect denies Dionysus's descent from Zeus. Both Pentheus and Agave will pay very dearly indeed for this indiscretion.

As Jean-Pierre Vernant has told this story so brilliantly, I

can do no better than let him describe at least the scene of Dionysus's arrival in Thebes:

> The city of Thebes is something of a model archaic Greek city; Dionysus comes to it in disguise. He presents himself not as the god Dionysus but as the god's priest. An itinerant figure, dressed as a woman, wearing his long hair down his back, he is the complete Eastern half-breed, with his dark eyes, his seductive looks, his smooth talk—all the features that might infuriate and raise the hackles of that "sown" man from Theban soil, Pentheus. The two are roughly the same age. Pentheus is a very young king, and this so-called priest is a very young god. Around whom there swarms a whole band of women, young and old, who are Lydians, women of the East—the East as a physical type, as a mode of being. They make a great racket in the streets of the city, they sit about and eat and sleep out in the open air. Pentheus sees all this and it sets him in a rage. What is this bunch of strays doing here? He wants to chase them out . . .*

What is so clearly captured in this description, and why I have cited it here, is the powerful contrast between Dionysus and Pentheus, the stranger or exile versus the man of the soil, the metic versus the autochthon: we can see from the outset that they must inevitably clash. But Dionysus will stage this in a sinister and deadly manner. Beneath the rage of Pentheus is concealed, as so often in such cases, an unconscious temptation. In effect, he is fascinated by all these women, by this sensuality that brims over in the streets, this liberty of expression and freedom of spirit—he who is so damnably constrained, brought up the hard way from infancy in the "spartan" manner, espousing the "virile" virtues and values of his model city. And Dionysus knows how to exploit and play on this fascination. He invites Pentheus into the

*Vernant, *The Universe, the Gods, and Men*, 143–4.

forest—slyly, it has to be said—encouraging him to join in the feasting: the famous Bacchanalia, or Dionysia, that are to take place in honor of the god. Pentheus lets himself be tempted. He climbs into a tree, to observe in secret the astounding spectacle that will no doubt unfold. All of which contradicts what he himself is and represents, but for this very reason exerts—mentally, even physically—a secret and troubling attraction. . . . The Bacchantes, the women in Dionysus's retinue (thus named in reference to Bacchus, itself one of the other names of this many-faceted god) now start to become delirious, to dance and drink and run after young animals before eating them alive, torturing them, tearing them to pieces. . . . In short, this is the Dionysiac madness in full sail, in which the most obscure passions are compounded—sexual license, of course, and drunkenness, but also sadism, ecstatic trances, jibbering ecstasy. . . . For his sins, poor Pentheus is soon spotted—Dionysus having of course arranged this. The women are now pointing him out with their fingers. Look, their new prey! They bend the tree, forcing him to come down, and Agave, his own mother, who conducts operations like a general, tears her own son to pieces, assisted by her cronies. In her frenzy she takes him for a wild animal, and now proudly returns home to show Cadmus her trophy: the bleeding head of his own grandson, mounted on a pike. . . .

Let us leave to one side the sequel of the story: the aged Cadmus is completely broken; Agave likewise, after she recovers her wits; whereas Dionysus makes a name for himself and openly asserts his power. . . . But what concerns us more is the fact that the Greeks should need to complement their cosmology—their myths and legends, so entirely dedicated to the cause of order and harmony— with this kind of episode, so indefensible and inappropriate,

so close to outright dementia. There is something strange here that forces us to query the inclusion of such a being as Dionysus within the universe of the gods. Once again, we must ask: Why?

The answer is, in effect, quite straightforward. But in the first place we must avoid making a category error: Dionysus is not, like the Titans or like Typhon, a creature of "chaos," a fanatical opponent of the cosmic settlement established by Zeus. Were this so, he would quite simply not be an Olympian. On the contrary, he would be locked up in Tartarus, like all the other archaic entities, under close watch in the entrails of Gaia. He does not therefore embody—or at least not primarily—one extreme of the two poles of chaos and cosmos, even if, as we have seen from Nietzsche's commentary on the spirit of music, there is clearly an element of the chaotic, of the Titanesque, in his constitution. In effect, he is a composite of the two, a synthesis possessing its own lucidity, for it suggests that by definition there is no harmony without discord, no Immortals without mortals, no identity without difference, no autochthons without metics, no citizens unless there are strangers. . . .

Why is this message so important that it must be embedded symbolically at the very heart of Olympus? This question is often answered by recourse to two interpretations of the figure of Dionysus, opposed but equally plausible. Besides, it is quite usual for a myth to give rise to several readings, given that they do not properly speaking have identifiable authors. As with fairy tales, we are here dealing with "generic" literary productions—creations that can be attributed to no individual in particular, hence impossible to ascribe a single easily ascribable authorial intention. Impossible to interview Homer, not merely because he is dead but also because quite probably "Homer" is a collective name that conceals

several different identities, or at least several oral traditions, where no single individual can claim responsibility for the meanings of a work. It is always therefore "outside" of the work, so to speak, that we must look in order to reconstruct its meaning—in which case alternative readings are equally possible, and more likely or inevitable than when a work can be ascribed to an "individual" author . . . which in turn makes the business of reconstruction all the more interesting. And let us equally guard against those evasions, so common in the recent past, which—on the pretext that we dealing very often with "texts," rather than with works imbued with a controlling intention—consists in seeing only "structures" without ever attempting to elicit meanings and their significance. This would most certainly be a grave error in the case of Greek myth.

So according to a first, "Nietzschean" reading of the myth (albeit vaguely so, given how far removed it is from Nietzsche's actual thought), Dionysus incarnates the festive or carnivalesque aspect of existence. He represents those moments of abandonment, rapturous and excessive, certainly, but also ludic and joyous, even to the very brink. In short, all those instants that a "liberated" view of life gladly dedicates to hedonism, to the pleasure principle, to the satisfaction of even the most furtive erotic impulses. Here we have what might be termed a "Leftist" reading of Dionysiac ritual, a remote anticipation of anarchism, the spirit of May 1968 in embryo. . . . It was, moreover, in a fairly congruent sense that Roman culture would subsequently depict Bacchus: an old drunk, no doubt, but at the same time sympathetic, addicted to the good life, full of humor and warmth, and, at the end (like his companion Silenus), a sage of sorts. "Live like a volcano" might be the motto of Dionysus—at least according to this reading of the myth.

The problem is that nothing in his existence, as reported by the myths, remotely corroborates this idealized image of Dionysus. The truth looks quite different. At no point does the life of the god of wine and feasting even conjure up carefree happiness. His birth is painful and his childhood turbulent. When he flees Lycurgus, when he travels in India or Asia, when he returns to avenge himself upon Agave and Pentheus, he lives more often in a state of fear or hatred rather than love and joyous abandon. Moreover, Dionysian festivities—if we take time to consider attentively what the founding texts tell us (the reality was no doubt rather different)—resemble a horror film rather than a joyous orgy: a scene of animals being torn to pieces, children tortured, gang rape, atrocious killings, all conducted according to a terrifying rhythmic cadence— all of which leads us to wonder if the idealized images of the Roman orgy or May 1968 or the "Summer of Love" are not completely off the point. Furthermore, as we saw in his treatment of his cousin Pentheus, Dionysus behaves as little as possible like a sympathetic hero. He charms and seduces, yes, but through hypocrisy, lies, and treachery—in short, by recourse to tricks and artifices that on closer inspection have nothing to do with what adherents of the golden age view are trying to valorize: excess and transgression within a context of joy and free love. There is plenty of transgression in Dionysus, but very little joy or love. . . .

A second and contrary interpretation, already far closer to the reality, takes its inspiration not from adulterated Nietzscheanism, but rather from Hegel. This consists in saying, in effect, that Dionysus represents the moment of "difference"*—corresponding to the idea that Time must

*What Hegel calls "being there" (*Dasein*), in his triad of "in itself" (*an sich*), "being there," and "for itself" (*für sich*).

be added to Eternity and Cosmos in order to incorporate the dimension of otherness: i.e., that which is different from those eternal fixities. To try and state the matter more baldly, without jargon: this god of delirium will henceforth embody the need to take account of all that is different from, even opposed to, the calm, eternal, and divinely ordained universe instigated and vouched for by Zeus—not divine chaos as such (which is the realm of the Titans and of Typhon, who are themselves gods and are brought under control even before the cosmos is itself properly established), but chance, confusion, contingency, heartbreak, and the other imperfections peculiar to the human condition. All of this must find expression so that—in a third stage (the first corresponding to the creation of the cosmos as such)—it may be restored within the overall harmony: whence the role of Dionysus at the heart of Olympus itself.

This interpretation is palpably closer to the truth underlying the Dionysiac legends, which insist that we take account of otherness, strangeness, disorder, and death—in effect, everything that is not divine. The only qualification (albeit essential) I would bring to this Hegelian perspective is that in the end there is no happy and successful synthesis. Yes, it was unavoidable and essential to invent Dionysus and allow him pride of place, because real life—the good life, for humans and gods alike—is cosmos and chaos combined, mortals and Immortals together. With pure cosmos, life stalls, becomes ossified; with pure chaos, everything is destroyed. The disorder of the Bacchanalia, if unchecked, ends in disaster and death; an opposing principle has to intervene and put an end to it. Reciprocally, a cosmic order without humans—without the living, who move and have their being in the temporal dimension of history—would be death by other means, a cryogenized immobility.

As in Nietzsche's characterization of the inclusiveness of the "grand style" (I speak here of the real Nietzsche, who is in no sense "Nietzschean," still less a figure of the "Left"), one must integrate the enemy within* rather than leaving it outside, which is not only dangerous but, worse still, extremely wearisome—which explains the fascination that the German philosopher experienced for the character of Dionysus, in whom he recognized himself. The opposites described in *The Birth of Tragedy*, the Apollonian and the Dionysiac, are inseparable from each other and equally essential to life: just as there is no cosmos without chaos, neither is there eternity without time, or identity without difference. . . .

Dionysus, by his very existence, reminds us continually of the origins of the world, and the abyssal darkness out of which it came into being. Whenever we need reminding, he makes us newly aware of how the cosmos was constructed out of chaos, and of how fragile is this edifice, stemming from the victory of Zeus over the Titans—all the more fragile if we forget these origins and this precariousness. This is why the carnivalesque frightens us, just as madness frightens us, because we feel undeniably how close it is to us: how it is inside us. This is fundamentally the lesson of Dionysus, or rather of his integration among the Olympians: as in Greek tragedy, we are continually being made to understand that this entire construction is, after all, made by humans and for humans, for those who are not merely members of the eternal cosmos but also plunged into a world of finitude, born in that dimension of loss and disorder of which Dionysus speaks to us at every turn.

*See the chapter on Nietzsche in my *Brief History of Thought*.

Nor is there any final reconciliation—contrary to the Hegelian model—no happy end, and it is perhaps on this point that the myth of Dionysus allows us to grasp, better than any other, the reason why all these myths still speak to us today in so intimate a manner. It is because they speak about us, and our mortality, in ways that are not remotely religious: they do so in the terms of secular spirituality, rather than of belief; in terms of human salvation, rather than faith in God. What is so moving about the voyage of Odysseus is that he does everything in his power to pull through on his own, to remain lucid, to stay in (or regain) his place, to refuse immortality and the too facile assistance of the gods. Some of them, of course, like Athena and Zeus, come to his help, while others, like Poseidon, do everything to ruin his existence. In the end, however, it is Odysseus who pulls through unassisted, advancing steadily toward the death that awaits him. Only philosophy will bear continued witness to this secular vision of reality, originating in Greek myth. Once again, I am fully aware of how illogical this claim may seem at first sight: to judge by all appearances, surely mythology is too taken up with gods, too populated with supernatural beings and occurrences, for loose talk of a "lay" or secular wisdom?

The objection is self-evident. But we must not rest with appearances. If we look deeper, as we have tried to in these pages, we find in Greek myth something quite other than religion: rather an attempt, epitomized by the figure of Dionysus, to take the full measure of human mortality, to confront the truth of this absurdity that the gods have delegated to mankind and to the sensible world, so as to rid themselves of it and preserve their cosmos for themselves. It is this sublunary world ravaged by time to which we must attempt to

give meaning, against the odds—or rather to give a whole
constellation of possible meanings in the face of its Other,
the cosmos of the immortal gods. Fundamentally, what my-
thology offers us, and what it will bequeath to philosophy
as a point of departure, is a vividly inclusive account of the
possible itineraries for us as individuals, within a universe
both ordered and beautiful, but which exceeds us at every
turn. In an age such as our own, in which religion fades day
by day—obviously I am speaking of the secular European
order, rather than continents still governed by theopolitics—
Greek myth explores a question that affects us now as never
before: namely, that of life beyond theology. As such, my-
thology can serve as a template for thinking about our con-
temporary condition.

 This is why I would insist again, by way of conclusion, on
the paradoxically secular rather than religious character—
human, and sometimes all too human—of the wisdom and
spirituality that is the legacy of Greek myth to the Western
philosophical tradition.

*Of philosophy in general as a secularization of
religion, and of Greek philosophy in particular as a
secularization of myth: the birth of a secular spirituality*

I have had occasion elsewhere to develop the notion that
philosophy—at least during its greatest moments—has al-
ways been linked to, and part of, the progressive seculariza-
tion of religion.* Even when it embraces materialism and
diverges radically from a religious worldview, philosophy

*A theme broached in *La sagesse des modernes* (1998), chapter 10, but also in
Qu'est-ce qu'une vie réussie? (2002).

maintains a hidden but no less fundamental continuity with religious attitudes. It derives its most important questions from religion, after all, which become properly philosophical only after being formulated within a religious context. It is this continuity beyond rupture that allows us to understand how philosophy will subsequently take up the question of the good life in terms of salvation, in relation to mortality and death, while jettisoning religious solutions. Whence, too, the claims of philosophy to address all individuals and not merely believers, and its ambition to overtake this or that localism in the interests of a universality that from the outset sets it apart from religious communitarianism.

That this rupture and this continuity are present in the Greek context, from the birth of philosophy, is clear from our analysis of myth, and has been demonstrated with great acuity by Jean-Pierre Vernant, who takes his lead from the work of his colleague Francis Cornford concerning the transition from religion—from myth—to philosophy in Greece. Vernant has shown how the birth of philosophy in antiquity is not the product of some unfathomable "miracle," as is so often claimed, but can be explained by a progressive "secularization" of the religious universe of the Greeks. The point merits attention, for this archaic "disenchantment of the world" bears a double aspect: on the one hand, the earliest philosophers *took over in their own name* a considerable portion of their religious heritage, such as this had been encoded in the mythic narratives of the birth of the gods and of the world; but on the other hand, this heritage would itself undergo considerable modification, *at once translated into and distorted by a new form of rational thinking*, which was to give it a quite new inflection and a new status. Thus, according to Vernant, Greek philosophy essentially

transposes, in secular form and at a more abstract level of thought, the system of representation already elaborated by religion. The cosmologies of the philosophers continue the cosmogonies of myth. . . . Nor is this a question of vague analogy. Between the philosophy of Anaximander and the theogony of a poet like Hesiod, Cornford shows that the structures correspond in detail.*

And in fact, from the dawn of philosophy, this secularization of religion—which is at once preserved but overtaken: questions of mortality and salvation kept in view but the religious answers abandoned—is firmly and visibly in place. What is especially interesting is how this process can be read in two ways: one can privilege what *connects* philosophy to the religions that precede and inform it; or, on the contrary, one can emphasize what *separates* philosophy in what might be termed its secular or rationalist moment. So, whereas Cornford is drawn to the links that connect the two, Vernant (without in any way denying the religious origins of early Greek philosophy) places greater emphasis upon what differentiates them. Clearly, he concedes,

> the first philosophers did not need to invent a system with which to explain the world; they inherited it ready-made. . . . But now that this is recognised, thanks to Cornford, the problem necessarily assumes a new form. It is no longer a question of deciding what was already there, in Greek philosophy, but of isolating what was truly new: in other words, the element by virtue of which philosophy ceased to be myth in order to become philosophy.†

Revolution with continuity, so to speak, and operating

*Jean-Pierre Vernant and Pierre Vidal-Nacquet, *Myth and Tragedy in Ancient Greece* (Boston: Zone Books, 1990).

†Vernant, *The Universe, the Gods, and Men.*

on at least three levels. Firstly, instead of speaking in terms of filiation—Zeus is the son of Cronus, who is the son of Uranus, and so forth—the rationalist and secularizing project of Greek philosophy will express things in terms of causality: this element gave rise to that element, this phenomenon produced these effects, and so on. Secondly, reference to Gaia or Uranus or Pontus is replaced by reference to the earth, the sky, the sea: the divinities begin to recede before the reality of the physical elements themselves (the moment of rupture), which in no way prevents the cosmos of the physicists from inheriting the fundamental features—harmony, aptness, beauty, etc.—that characterized the archaic mythical and religious imagination (which in turn represents continuity). Finally, the philosopher emerges historically as an individual figure quite distinct from the priest, his authority deriving not from the secrets he holds or withholds but from the truths that he clarifies and makes public, not from occult mysteries but from his capacity to conduct transparent rational argument.

Without going further down this road, we already gain an idea of the disruption wrought by philosophical reflection if we consider the second point in more detail, namely the manner in which the philosophers were to pass from the sacred to the profane, by endeavoring to "extract" or "abstract" from the Greek divinities the constituent material elements of which the universe is composed—by the transition from Pontus to water, from Uranus to sky, from Gaia to earth, and so forth. The process was, of course, more complex than I am able to elaborate here, but the principle remains: it was a case of replacing divine and religious entities with a new interest in natural and physical phenomena. A few centuries later, we still find in a writer like Cicero some amusing echoes of this "secular" revolution, according to which, in

his words, "the gods of Greek myth were re-interpreted by natural science." Taking the example of Saturn (the Roman name for Cronus) and Caelus (the Roman name for Uranus), the sky, Cicero explains the secularization introduced by Stoic philosophy in respect to ancient mythological "superstitions," in these terms:

> Greece long ago was possessed by the belief that Caelus had been mutilated by his son Saturn, and Saturn himself clapped in arms by his son Jupiter [*Zeus*]. But in these sacrilegious fables was contained a physical theory which is often studied. The point they make is that the ethereal or fiery element which holds the summit of heaven, and creates all things by its own agency, does not possess that bodily part which needs to fuse with another body for the purpose of procreation. By Saturn, again, they seek to represent that power which controls the cyclic course of times and seasons. This is the sense the Greek name of that god bears, for he is called Cronus, which is the same as *chronos* or "course of time." And he was later called Saturn because, it was supposed, he was "saturated" (*saturo*, "made full") with years; for it is because time swallows the course of the seasons, and is loaded, without being satisfied, with the years of the past, that Saturn is represented as having been accustomed to devour his own offspring.[*]

Leaving aside the questionable value of Cicero's home-spun etymology in explaining the great Greek theogonies, what is important here is that the underlying mechanism of "secularization" is clearly elucidated: it is less a question of breaking with religion than of rearranging the furniture, less a case of making a clean sweep than of diverting the major themes of myth into new channels. And it is this double aspect—rupture and continuity—that will determine, right

[*]Cicero, *The Nature of the Gods*, Book II, 64.

from the start, *and indelibly so*, the ambiguous relationship between philosophy and its only serious rival, religion. Nor is this dynamic by any means restricted to a consideration of Greek thought.* It possesses so general an application that we shall see it confirmed throughout the history of philosophy, up to and including those thinkers reputed to be least religious. I merely allude here to this aspect, which I propose to argue in closer detail in the succeeding volumes of *Learning to Live*. Let us merely remark here that this argument obtains, without exceptions, for all of the main practitioners in Western philosophy.

It is thus that Plato, the Stoics, Spinoza, Hegel, and Nietzsche, to name but a few, continue to be preoccupied with the dual problem of salvation and eternity—each after its fashion, and all thoroughly convinced that they are marking a radical break with constituted religion. It is no coincidence, therefore, that in Plato and Aristotle the wise man is one who may be said to die less—to be in some sense less mortal—than the fool; or that in the *Nicomachean Ethics* (Aristotle's great primer of the moral life), the object is "to make ourselves immortal, insofar as we can." Nor is it surprising that the *Ethics* of Spinoza, albeit from a very different starting point, claims likewise to bypass formal morality in order to lead us toward the "beatitude" of true wisdom—for whom, again, there can be no good life that is not emancipated from the fear of death, as if the successful life and the successful death were one and the same. We cannot discover how to live other than by conquering all fears, and the means of doing so is to have made one's life so wise, so distanced from folly, that one succeeds in "dying as little as possible." This is the theme, familiar to Spinozists and analyzed at length by Gilles Deleuze, one of

*As I have argued elsewhere, notably in *The Wisdom of the Moderns*.

his greatest interpreters, according to which (once again) "the wise man dies far less than the fool." In Hegel, likewise, the definition of "absolute knowledge," the apex of his entire system, is inherited directly from Christian apologetics: it consists of attaining to a point where, as with Christianity, the finite and the infinite, man and God, are finally reconciled—which parts ways with religion principally in that this reconciliation must, in Hegel's eyes, occur in "the sphere of the conceptual" rather than in that of belief. . . . It is no surprise either if those works in which Nietzsche puts forward his doctrine of "eternal return" so often borrow the parabolic form peculiar to the Gospel texts: here again, it is a case of finding a basis for distinguishing between an existence that is *in an absolute sense* worth the pain of living through, and one that, on the other hand, is barely worth prolonging. . . . From this we see once again how underlying continuity and sometimes radical rupture define the complex relation that both unites and divides philosophy and religion.

We shall return to these major philosophical turning points—and many others—in the future volumes of *Learning to Live*. My present observations, which no more than fleetingly touch upon these questions, lead me to two final remarks, which confirm the approach taken in volume one and equally indicate a direction for what follows.

Firstly, that we must, in order to understand philosophy, avoid committing the cardinal error (so commonplace today) of confusing ethics with spirituality. Ethics, in whatever sense we intend the term, means respect for the other, for his freedom, his right to find happiness on his own terms as long as no one else is harmed by it. Put simply, for we who are alive today, the notion of a common ethical practice is roughly speaking coterminous with our variously enshrined declarations about the rights of man. Were we to apply these

consistently, there would be no more rapes or thefts or murders, no more flagrant economic inequalities. . . . It would be no less than a revolution. And yet . . . it would not stop us from growing old, or from dying, or losing our loved ones, or merely being unhappy in love, or dying of boredom in a humdrum routine bogged down in banality. For these issues—death, love, unfulfillment—are not properly speaking ethical issues. You can live a saintly existence, respecting everyone else until it hurts, practicing the rights of man until you are blue in the face . . . and you will still suffer and get old and die. Once more: there is no connection between these things. It is this second category of existential questions that I refer to by the term "spirituality," as opposed to ethics, and as the argument of volume one in this series (*A Brief History of Thought*) argues, philosophy, unlike religion, is essentially a secular spirituality. In other words, it cannot be reduced to a straightforwardly ethical project.

But it would be equally mistaken to reduce philosophy to abstract theory. Too often students are taught that philosophy is merely reflection, or the critical spirit, or argumentation. There is no doubt that it is better to reflect, to criticize, to argufy, in order to think clearly—and this is obviously part of philosophy. But it is equally part and parcel of sociology, biology, economics, and even journalism. As I remarked in volume one, critical reflection is by no means the prerogative of the philosopher. The most important legacy of Greek myth to Greek philosophy, in which respect the latter is manifestly heir to the former, is its sense that the essential question is none other than how to achieve the good life, even after the gods have been traded in and the cosmos has been Platonically or Stoically secularized. If philosophy was born in Greece, this is because mythology had prepared the ground by reflecting in an extraordinarily profound manner

upon the plight of mortal men within the universe. Indeed, the fundamental question to be asked by philosophers had already been clearly formulated by the time they arrived on the scene: how to conquer the fear of mortality in order to achieve the wisdom that is the sole form of salvation, which saves us from the anguish of extinction consequent upon our mortal state.

This transition—from myth to philosophy—confirms the latter as being well and truly a "doctrine of salvation without god": an attempt to escape our fears without recourse either to belief or to a supreme being, but by exercising our reason and trying to pull through without assistance. Herein lies the real difference between philosophy and religion. And even if the Greek myths are full of gods, their philosophical grandeur, properly speaking, is to isolate the question of human salvation and cordon it off from the gods and their powers: to establish that it is down to us mortals to settle this question as far as possible, and down to us alone—imperfectly, no doubt, but by means of human reason, not with the assistance of religious belief or immortal gods and goddesses. As we shall see in the next volume, this is indeed the central challenge to be met by Greek philosophy. And part of its continued hold upon us today is that, starting from this particular problem, Greek philosophy was to "invent" such a wealth of inspired responses, which even today offer us so many ways of understanding our own lives.

INDEX

Procrustes, 289

Proetus, 214*n*, 304–5

Prometheus, 15, 20, 106, 131, 133, 137–43, 163, 164, 220, 271, 366
 Aeschylus on, 154–55
 arts and sciences stolen by, 150–51, 153, 157, 209, 211, 219
 brothers of, 138
 creation of humans and animals and, 151–53
 fire stolen by, 141, 150–51, 153, 209, 219
 Heracles' freeing of, 145–46, 272
 meaning of name, 138
 Pandora and, 145
 in Plato's *Protagoras*, 150–53, 155
 Zeus's chaining of, 145–46, 153, 155
 Zeus's request to sacrifice ox and apportion meat, 139–41, 143, 146, 150, 151
 Zeus's vengeance against mankind and, 138–39, 141–45, 150, 154–57

Prometheus Bound (Aeschylus), 154–55, 366

Protagoras, 151–53

Protagoras (Plato), 150–53, 155

Pyrrha, 163–64

Rhadamanthus, 292, 302

Rhea, 52*n*, 60, 61, 72, 237, 244
 Zeus protected by, 61–62, 75, 147

Rousseau, Jean-Jacques, 156*n*, 366

Salmoneus, 212, 213*n*

Sarpedon, 292

Sartre, Jean-Paul, 156*n*

Schopenhauer, Arthur, 128–29

science(s), 156–57
 contemporary, 31, 165–66
 Prometheus's theft of, from Athena, 150–51, 153, 157, 209, 211

Sciron, 287–88

Scylla, 200, 333

seasons, 237, 245–46

secular spirituality, 168–69, 381, 382–90

Semele, 65, 89, 228*n*, 370, 373

Seneca, 360, 361

Seven Against Thebes (Aeschylus), 349–50, 352–53

Sibyl, 281

sibylline words, 281

Silenus, 107, 108, 113, 129, 377

silver, age of, 135

sin, 212*n*

Sinis, 286–87

Sirens:
 Jason and, 332–33
 Odysseus and, 178, 199–200
 Orpheus and, 231

Sisyphus, 35, 102, 214*n*, 215, 224–28, 232, 236

Socrates, 207, 208*n*

Socratic Atomists, 370

Sophists, 370

Sophocles, 275, 340, 348–50

sown men, 330–31, 355–56, 373

space, birth of, 58–59

Spartans (*spartoi*), 330–31, 355–56, 373

Sphinx, 344–45, 356

Spinoza, Baruch, 34, 363–65, 387–88

spirituality, secular, 168–69, 382–90

Steropes, 52, 73

Stoicism, 26–27, 252, 360, 361, 363–65, 370, 386, 387, 389

Styx, 21, 79–80, 102, 145, 197, 232

Suitors, 172–73, 181, 201, 206

Syrinx, 114

Syrinx (Debussy), 114

Talos, 333–34

Talus, 295

Tantalus, 35, 104–5, 159, 169*n*, 214*n*, 232, 288, 327